The Early Churches of Constantinople:

Architecture and Liturgy

The Early Churches of
CONSTANTINOPLE:

Architecture and Liturgy

Thomas F. Mathews

The Pennsylvania State University Press

University Park and London

To my Mother and Father

Contents

Acknowledgments ix

List of Figures xi

List of Plates xiii

List of Principal Abbreviations xvii

Introduction 3

Part One: The Monuments

1 The Early Basilicas 11

The Old Hagia Sophia 11
Hag. Iōannēs Studios 19
Theotokos in Chalkoprateia 28
The Topkapī Sarayī Basilica 33

2 The Justinianic Period: The Smaller Foundations 42

Hag. Sergios and Bacchos; Hag. Petros and Paulos 42
Hag. Polyeuktos 52
Hag. Iōannēs Prodromos in Hebdomon 55
Hag. Euphēmia 61
Beyazit Basilica A 67

3 The Greater Foundations of Justinian 77

Hag. Eirēnē 77
Hagia Sophia 88

viii *Contents*

Part Two: Planning and Liturgy

4 The Problem of Liturgical Planning in Constantinople 105
Characteristics of the Constantinoplitan Plan 105
Reconstructing the Early Byzantine Liturgy 111

5 The Divisions of the Church 117
The Use of Nave and Aisles 117
Places for Catechumens and Penitents 125
Places for Women and the Imperial Court 130

6 The Liturgy of the Catechumens 138
The First Entrance 138
Readings and Preaching 147

7 The Liturgy of the Faithful 155
The Entrance of the Mysteries 155
The Concealment of the Mysteries 162
Communion and Exit 172

Conclusion 177

Bibliography 181

Index 189

Plates 195

Acknowledgments

The present study, a revision of my doctoral dissertation, owes its largest debt to my director, Dr. Richard Krautheimer of New York University. No professor has ever been more generous in sharing his knowledge and experience with students or more ready to listen to their ideas, even when at variance with his own. I only hope the work itself is worthy thanks for such a mentor. I would also like to thank in a special way the other two readers of my dissertation, Prof. Hugo Buchthal of New York University and Father Anselm Strittmatter, O.S.B., of St. Anselm's Abbey, Washington, D.C. Their corrections were most useful and their advice always welcome.

The research for this book was carried on in Rome and Istanbul over a two-year period, while I enjoyed an appointment as Fellow of the Samuel H. Kress Foundation to the Biblioteca Hertziana, Rome. I would like to express my gratitude to the Kress Foundation for their support and to Dr. Wolfgang Lotz, Director of the Biblioteca Hertziana, for all his kindness. In Rome I had the benefit also of the hospitality of the American Academy in Rome and the use of their excellent library, for which I am grateful both to Dr. Frank E. Brown, Director of the Academy, and Signora Inez Longobardi, Librarian.

In Istanbul I want to thank Dr. Nezih Firatli, Curator of the Istanbul Archaeological Museum, who did everything possible to facilitate work in my favorite city; it has always been a delight to see him and an education to talk with him. I am also grateful to Dr. Necati Dolunay, Director of the Museum, for permission to photograph; to Dr. Feridun Dirimtekin, Director of the Ayasofya Museum, for his assistance; to Dr. Bruce McGowan for the hospitality of the American Research Institute in Turkey during my visits; and to the Deutsches Archäologisches Institut for the use of their facilities. My thanks also go to the archaeologists working in Istanbul who have been most generous in showing me their work and discussing its results: to Mrs. Mualla Anhegger, Dr. Hans Belting, Dr. Martin Harrison, Mr. Ernest Hawkins, Dr. Y. D. Kuban, Dr. Rudolf Naumann, Dr. C. Lee Striker, and Mr. Robert L. Van Nice.

Finally, I am happy to acknowledge the help of the Jesuit Fathers of the Pontificio Istituto Orientale in Rome, particularly those of the liturgical section. Father Juan Mateos and Father William Macomber have always been ready to help with an occasional difficult text. And Father Robert F. Taft freely placed at my disposal his truly encyclopedic knowledge of the evolution of the Byzantine liturgy, though even more valuable than his learning has been the continued support and encouragement of his friendship.

Thomas F. Mathews

List of Figures

1. Old Hagia Sophia. Plan of propylaeum excavation (Schneider, *Grabung im Westhof*, pl. 1)

2. Old Hagia Sophia. Plan of skeuophylakion (Dirimtekin, *REB* 19 [1961], 398, plan 3)

3. Old Hagia Sophia. South-north section of skeuophylakion (Dirimtekin, *REB* 19 [1961], 394, plan 2)

4. Old Hagia Sophia. Hypothetical plan (Kleiss, *IM* 15 [1965], 173, fig. 5)

5. Studios Basilica. Plan (van Millingen, *Byzantine Churches*, p. 56, fig. 12)

6. Studios Basilica. Plan of atrium and suggested reconstruction (Mathews)

7. Studios Basilica. Plan of chancel remains (Mathews)

8. Studios Basilica. Reconstructed plan of chancel, altarsite, and synthronon (Mathews)

9. Studios Basilica. Profiles of stylobate and pier fragment (Mathews)

10. Studios Basilica. Crypt plan and section (Bittel, *AA* 64 [1939], 201, figs. 51–52)

11. Chalkoprateia Basilica. Plan (Kleiss, *IM* 15 [1965], 153, fig. 2)

12. Chalkoprateia Basilica. Atrium, reconstruction plan (Kleiss, *IM* 16 [1966], 228, fig. 8)

13. Chalkoprateia Basilica. East elevation (Kleiss, *IM* 16 [1966], 236, fig. 14)

14. Chalkoprateia Basilica. Chancel piers (Kleiss, *IM* 16 [1966], 232, fig. 10)

15. Chalkoprateia Basilica. Crypt, plan and section (Kleiss, *IM* 16 [1966], 225, fig. 6)

16. Saray Basilica. Site plan, second court of the Topkapī Sarayī (Ogan, *Belleten* 4 [1940], pl. 82)

17. Saray Basilica. Plan (Ogan, *Belleten* 4 [1940], pl. 83)

18. Saray Basilica. Hypothetical plan, inverted (Bittel and Schneider, *AA* 58 [1943], 249, fig. 26)

19. Hag. Sergios and Bacchos. Plan (Ebersolt and Thiers, *Les églises*, pl. VI)

20. Hag. Sergios and Bacchos. South wall, elevation (Ebersolt and Thiers, *Les églises*, p. 40, fig. 16)

21. Hag. Sergios and Bacchos. South wall, elevation; or north wall of Hag. Petros and Paulos (Mathews)

22. Hag. Sergios and Bacchos. North wall, elevation (Ebersolt and Thiers, *Les églises*, pl. VII)

23. Hag. Sergios and Bacchos. North wall, elevation (Mathews)

24. Hag. Sergios and Bacchos. Stair in narthex, plan and elevations (Ebersolt and Thiers *Les églises*, pl. 26, fig. 8)

25. Hag. Polyeuktos. Plan (Harrison, *DOP* 22 [1968], 195, fig. A)

26. Hag. Polyeuktos. Profile of stylobate and isometric of chancel pier (Mathews)

27. Hag. Iōannēs in Hebdomon. Plan (R. Demangel, *Contribution à la topographie de l' Hebdomon*, pl. III)

28. Hag. Iōannēs in Hebdomon. Reconstructed plan (Mathews)

29. Hag. Euphēmia. Site plan (Naumann and Belting, *Die Euphemia-Kirche*, p. 17, fig. 1)

30. Hag. Euphēmia. Plan (Naumann and Belting, *Die Euphemia-Kirche*, p. 46, fig. 13)

31. Hag. Euphēmia. Stylobate and chancel plan (Naumann and Belting, *Die Euphemia-Kirche*, pl. 97, fig. 30)

32. Hag. Euphēmia. Reconstruction of sanctuary furnishings (Naumann and Belting, *Die Euphemia-Kirche*, p. 100, fig. 32)

33. Hag. Euphēmia. Reconstruction of synthronon (Naumann and Belting, *Die Euphemia-Kirche*, p. 48, fig. 15)

34. Beyazit Church B. Plan (Fīratlī)

35. Beyazit Church C. Plan (Fīratlī)

36. Beyazit Basilica A. Profile of ambo base (Mathews)

37. Beyazit Basilica A. Plan (Fīratlī)

38. Hag. Eirēnē. Atrium, plan (Grossmann, *IM* 15 [1965], 194, fig. 3)

39. Hag. Eirēnē. Atrium, section (Grossmann, *IM* 15 [1965], 192, fig. 2)

40. Hag. Eirēnē. Atrium, reconstruction (Grossmann, *IM* 15 [1965], 203, fig. 5)

41. Hag. Eirēnē. Plan (by George, as published in van Millingen, *Byzantine Churches*, fig. 31)

42. Hag. Eirēnē. Reconstruction of first Justinianic phase (George, *Church of Saint Eirene*, p. 75, fig. 37)

43. Hag. Eirēnē. Area south of church, plan (Dirimtekin, *CA* 13 [1962], plan I)

44. Hag. Eirēnē. Plan of northeast corner of church (Mathews)

45. Hag. Eirēnē. Synthronon, elevation (Mathews)

46. Hag. Eirēnē. Doorframes of synthronon, profiles (George, *Church of Saint Eirene*, pl. 14)

47. Hag. Eirēnē. Synthronon, plan and elevations (George, *Church of Saint Eirene*, pl. 26, fig. 70)

48. Hagia Sophia. Plan of atrium (Schneider, *Grabung im Westhof*, pl. 8)

49. Hagia Sophia. Plan

50. Hagia Sophia. Imperial loge and throne site, reconstructed plan (Mathews)

51. North Syrian sanctuary plans. 1. Milayha. 2. Ruwayha. 3. Brad. 4. Fafartin. 5. Qasr Iblisu. 6. Kharab Shams (5th century). 7. Qalb Lozeh. 8. Kharab Shams (6th century). 9. Tourmanin. 10. Qal'at Sim'an. 11. Khirbat Tayzin. 12. Dana, south (J. Lassus, *Sanctuaires chrétiens de Syrie*, p. 63, fig. 32)

52. Constantinopolitan sanctuary plans, Middle Byzantine. 1. Myrelaion. 2. Lips church. 3. Atik Mustafa Paşa Camii. 4. Hag. Iōannēs in Trullo. 5. Eski Imaret Camii

53. Altar frontal fragment. Istanbul Archaeological Museum, depot

List of Plates

1a. Old Hagia Sophia. Stairs and column bases of propylaeum (photo Mathews 4916)

1b. Old Hagia Sophia. The skeuophylakion, from the northeast (photo Mathews 16308)

2. Old Hagia Sophia. Pediment of propylaeum, detail (photo Mathews 4866)

3. Studios Basilica. Eastern portion of atrium, or narthex (photo Mathews 3137)

4. Studios Basilica. Turning of atrium entablature, north end of narthex (photo Mathews 3322)

5. Studios Basilica. North wall of atrium (photo Mathews 4427A)

6. Studios Basilica. North wall of atrium, first (narthex) and second entrances (photo Mathews 4434A)

7. Studios Basilica. North wall of atrium, second to fifth entrances (photos Mathews 3220, 3211, 3216, 3217)

8. Studios Basilica. North colonnade of nave from the west (photo Mathews 3116)

9. Studios Basilica. North colonnade of nave from the east (photo Mathews 3125)

10. Studios Basilica. West wall, interior (photo Mathews 3109)

11. Studios Basilica. North wall of narthex showing gallery entrance (photo Mathews 3130)

12. Studios Basilica. South wall of narthex (right) showing gallery entrance (photo Mathews 3134)

13. Studios Basilica. Chancel remains (photo Mathews 3104)

14. Studios Basilica. Chancel stylobate (photo Mathews 3123)

15. Studios Basilica. Pier fragment (photo Mathews 4422A)

16. Studios Basilica. Pier fragment (photo Mathews 311)

17. Chalkoprateia Basilica. Apse (photo Mathews 4217A)

18. Chalkoprateia Basilica. Capital (photo Mathews 16360)

19. Chalkoprateia Basilica. North wall, from the east (photo Mathews 4109)

20. Chalkoprateia Basilica. North wall, from the west (photo Mathews 4106)

21. Chalkoprateia Basilica. Column base (photo Deutsches Archäologisches Institut, Istanbul, neg. KB 2937)

22. Saray Basilica. Pavement (Ogan, *Belleten* 4 [1940], pl. 74, fig. 7b)

23. Saray Basilica. Capital (Ogan, *Belleten* 4 [1940], pl. 76, fig. 7d)

24. Hag. Sergios and Bacchos. West façade (photo Mathews 2723A)

25. Hag. Sergios and Bacchos. Interior (photo Josephine Powell T7–6)

26. Hag. Sergios and Bacchos. East wall (photo Mathews 808)

27. Hag. Sergios and Bacchos. South wall (photo Mathews 2712A)

28. Hag. Sergios and Bacchos. South wall (photos Mathews 3912A, 3910A, 3909A, 3906A, 3905A, 3902A)

29. Hag. Sergios and Bacchos. Joint of narthex wall (left) with south wall (photo Mathews 3914A)

30. Hag. Sergios and Bacchos. South ambulatory, from the west (photo Mathews 6527)

31. Hag. Sergios and Bacchos. Capital in south ambulatory (photo Mathews 6609)

32. Hag. Sergios and Bacchos. North wall, general view (photo Mathews 15313)

33. a–f. Hag. Sergios and Bacchos. North wall (photos Mathews 3921A, 2809A, 3924A, 108, 2801A, 815)

34. Hag. Sergios and Bacchos. Northeast corner (photo Mathews 2906)

35. Hag. Sergios and Bacchos. Northeast corner, ground floor, from the north (photo Mathews 2814A)

36. Hag. Sergios and Bacchos. Northeast corner, ground floor, from the east (photo Mathews 2822)

37. Hag. Sergios and Bacchos. Narthex, looking south (photo Mathews 6525)

38. Hag. Sergios and Bacchos. Arch over narthex stair (photo Mathews 15965)

39. Hag. Polyeuktos. Chancel piers; no. 7098 nearest camera (photo Mathews 2929)

40. Hag. Polyeuktos. Stylobate fragment, no. 6900 (photo Mathews 2924)

41. Hag. Polyeuktos. Inlaid column (photo Dumbarton Oaks 65.43.1)

42. Hag. Iōannēs in Hebdomon. Apse from the west in 1965 (photo Deutsches Archäologisches Institut, Istanbul, neg. R.6)

43. Hag. Iōannēs in Hebdomon. Apse from the east in 1965 (photo Deutsches Archäologisches Institut, Istanbul, neg. R.4)

44. Hag. Iōannēs in Hebdomon. Inlaid column, Istanbul Archaeological Museum, no. 3908 (photo Mathews 1714)

45. Hag. Iōannēs in Hebdomon. Ionic impost capital in Ayasofya Museum garden (photo Mathews 4908)

46. Hag. Iōannēs in Hebdomon. Ionic impost capital in Ayasofya Museum garden (photo Mathews 4910)

47. Hag. Iōannēs in Hebdomon. Slab (photo Deutsches Archäologisches Institut, Istanbul, neg. KB 590)

48. Hag. Euphēmia. General view, from the west (photo Mathews 6618)

49. Hag. Euphēmia. Inlaid column, Istanbul Archaeological Museum, no. 5078 (photo Mathews 1720)

50. Hag. Euphēmia. Inlaid column, Istanbul Archaeological Museum, no. 5078, detail (photo Mathews 1726)

51. Hag. Euphēmia. New entrance in apse no. 3 (photo Mathews 516)

52. Hag. Euphēmia. Stylobate of chancel (photo Mathews 513)

53. Hag. Euphēmia. Synthronon (photo Mathews 515)

54. Beyazit Basilica A. Capital in Ayasofya Museum garden (photo Mathews 4814)

55. Beyazit Basilica A. Capital in Ayasofya Museum garden (photo Mathews 619)

56. Beyazit Basilica A. Ambo in Ayasofya Museum garden (photo Mathews 617)

57. Beyazit Basilica A. Detail of ambo (photo Mathews 419)

58. Beyazit Basilica A. Detail of ambo base (photo Mathews 4804)

59. Hag. Eirēnē. Atrium (photo Mathews 3324)

60. Hag. Eirēnē. Courtyard south of atrium (photo Mathews 6919)

61. Hag. Eirēnē. South stair-ramp (photo Mathews 6922)

62. Hag. Eirēnē. Interior (photo Mathews 7016)

63. Hag. Eirēnē. Southwest pier, showing addition of new narthex (brick) to earlier church (stone) (photo Mathews 3434)

64. Hag. Eirēnē. Two entrances flanking a niche in the north aisle (photo Mathews 3418)

65. Hag. Eirēnē. Northeast entranceway (photo Mathews 3414)

66. Hag. Eirēnē. Southeast entranceway (photo Mathews 713)

67. Hag. Eirēnē. Circular structure at northeast corner (photo Mathews 4204A)

68. Hag. Eirēnē. Synthronon (photo Mathews 3525)

69. Hag. Eirēnē. Synthronon, right side (photo Mathews 3403)

70. Hagia Sophia. View from the northwest, 1681 (G. Grelot, *Relation nouvelle*, p. 155)

71. Hagia Sophia. Plan, 1681 (G. Grelot, *Relation nouvelle*, p. 133)

72. Hagia Sophia. West façade and medrese, 1847–49 (drawing by Fossati in author's collection)

73. Hagia Sophia. Southwest view, 1847–49 (drawing by Fossati in author's collection)

74. Hagia Sophia. Atrium, northeast corner, from the south (photo Mathews 4932)

75. Hagia Sophia. Atrium, north exterior wall (photo Mathews 4940)

76. Hagia Sophia. Northwest vestibule, from the northwest (photo Mathews 3605)

77. Hagia Sophia. Northwest vestibule, from the west (photo Mathews 4824)

78. Hagia Sophia. Southwest vestibule, archway over entrance to narthex (photo Mathews 4136)

79. Hagia Sophia. Secondary arch in southeast pier, gallery (photo Mathews 4722)

80. Hagia Sophia. East end (photo Mathews 3630)

81. Hagia Sophia. Interior (photo courtesy of the Byzantine Institute)

82. Hagia Sophia. Paving of mihrab (photo courtesy of the Byzantine Institute)

83. Hagia Sophia. North aisle, from the east (photo Mathews 4651)

84. Hagia Sophia. Marble doors of south gallery (photo Josephine Powell T4–17)

85. Hagia Sophia. Marble doors of south gallery, detail (photo Mathews 6326)

86. Hagia Sophia. Underside of window mullion in southeast gallery (photo Mathews 4778)

87. Hagia Sophia. Imperial loge and throne site (photo Mathews 4118)

88. Hagia Sophia. Imperial loge and throne site (photo Mathews 7533)

89. Chancel piers. Istanbul Archaeological Museum, nos. 916, 4283 (photo Mathews 1828, 1834)

90. *First Entrance Procession.* Menologion of Basil II, Vat. Gr. 1613, fol. 142 (photo Vatican Library)

91. *First Entrance Procession.* S. Vitale in Ravenna (photo Alinari P2, 18224)

92. *First Entrance Procession.* S. Vitale in Ravenna (photo Alinari P2, 18336)

93. *The Preaching of the Apostles.* Homilies of Gregory of Nazianzus, Paris, B. N., Gr. 510, fol. 301 (Omont, *Miniatures,* pl. 44)

94. a. Ciborium in *Melchisedek* scene. Vienna Genesis, Vindob. Gr. 31, fol. 7 (Gerstinger, *Wiener Genesis,* pl. 7) b. *Cleansing of the Temple.* Rossano Gospel, fol. 3 (A. Muñoz, *Il Codice Purpureo di Rossano,* plate III)

95. Ciborium and sanctuary. Homilies of Gregory of Nazianzus, Paris, B. N., Gr. 510, fol. 367v. (Omont, *Miniatures,* pl. 52)

96. Ciborium and sanctuary. Octateuch, Vat. Gr. 747, fol. 135v (photo Vatican Library)

97. Ciborium and sanctuary. Menologion of Basil II, Vat. Gr. 1613, fol. 324 (photo Vatican Library)

98. Ciborium and sanctuary. Homilies of James the Monk, Vat. Gr. 1162, fol. 76v. (photo Vatican Library)

99. *Communion of the Apostles.* The Riha Paten. Dumbarton Oaks Collection, Washington, D.C. (photo Dumbarton Oaks 54.89.21)

List of Principal Abbreviations

AA	*Archäologischer Anzeiger*
AA.SS.	*Acta sanctorum* (Antwerp, 1643 ff.)
AB	*The Art Bulletin*
AJA	*American Journal of Archaeology*
Brightman, *Liturgies*	F. E. Brightman, *Liturgies Eastern and Western*, I, *Eastern Liturgies* (Oxford, 1896)
BZ	*Byzantinische Zeitschrift*
CA	*Cahiers archéologiques*
CSEL	*Corpus scriptorum ecclesiasticorum latinorum* (Vienna, 1866 ff.)
DACL	*Dictionnaire d'archéologie chrétienne et de liturgie* (Paris, 1907 ff.)
Deltion	*Archaiologikon deltion*
DOP	*Dumbarton Oaks Papers*
Ebersolt and Thiers, *Les églises*	J. Ebersolt and A. Thiers, *Les églises de Constantinople* (Paris, 1913)
Germanus, *Hist. eccl.*	Germanus Constantinopolitanus, *Il commentario liturgico di s. Germano patriarca constantinopolitano e la versione latina di Anastasio bibliotecario*, ed. N. Borgia (Grottaferrata, 1912)
IM	*Istanbuler Mitteilungen*
Janin, *Géographie*	R. Janin, *La géographie ecclésiastique de l'empire byzantin: Constantinople, Les églises et les monastères* (Paris, 1969)
JDAI	*Jahrbuch des deutschen archäologischen Instituts*
Kähler, *Hagia Sophia*	H. Kähler, *Hagia Sophia*, trans. E. Childs (London, 1967)
Lethaby and Swainson, *Sancta Sophia*	W. R. Lethaby and H. Swainson, *The Church of Sancta Sophia, Constantinople* (New York, 1894)
Mansi	*Sacrorum conciliorum nova et amplissima collectio*, ed. J. D. Mansi (Florence, 1759 ff.)
OCP	*Orientalia christiana periodica*
Orlandos, *Basilikē*	A. Orlandos, *Hē xylostegos palaiochristianikē basilikē* (Athens, 1950–59)
PG	*Patrologiae Cursus, series Graeca*, ed. J.-P. Migne (Paris, 1857 ff.)

PL

Patrologiae Cursus, series Latina, ed. J.-P. Migne (Paris, 1842 ff.)

Procopius, *Buildings*

Procopius, *Buildings,* trans. H. B. Dewing and Glanville Downey, Loeb Classical Library (London, 1959)

RAC

Rivista di archeologia cristiana

REB

Revue des études byzantins

Schneider, *Byzanz*

A. M. Schneider, *Byzanz: Vorarbeiten zur Topographie und Archäologie der Stadt,* Istanbuler Forschungen, 8 (Berlin, 1936)

Schneider, *Grabung im Westhof*

A. M. Schneider, *Die Grabung im Westhof der Sophienkirche zu Istanbul,* Istanbuler Forschungen, 12 (Berlin, 1941)

Script. orig. Const.

Scriptores originum Constantinopolitarum, ed. T. Preger (Leipzig, 1901 ff.)

van Millingen, *Byzantine Churches*

A. van Millingen, *Byzantine Churches in Constantinople, Their History and Architecture* (London, 1912)

Yillic

Istanbul Arkeoloji Müseleri Yilliği

The Early Churches of Constantinople:
Architecture and Liturgy

Introduction

Early Byzantine architecture can be said to have enjoyed two lives. One was the life of the ceremonial movement which the building was created to shelter. Colorful, vibrant, and fascinating, this life stirred into motion all those who had gathered for worship there; it both animated and justified the entire existence of the structure for a time but has since passed into the silence of history. This life was the liturgy, which has either wholly ceased to exist in the original buildings or has so evolved over the centuries as to be substantially different from its origins. The other life was the life of the structure itself, the static life of architectural forms, the idea that invigorated the building simply as a building. This life continues long after the first has disappeared, as long as stones enough remain to tell us what the building looked like.

The present study concerns the first, the more fragile life of Early Byzantine architecture. It attempts to reconstruct from the archaeological and historical sources the ceremonial use of Early Byzantine architecture as a contribution toward a more complete understanding of the meaning of that architecture. The method is two-fold: first, to examine archaeologically the remains of all the Early Byzantine churches of Constantinople in an effort to establish the characteristics of church planning in the capital; and second, to study all the liturgical sources in order to reconstruct the shape of the ceremonial for which the churches were planned.

The search for the religious meaning of Byzantine architecture has curiously neglected this avenue of approach. Preoccupation with the origins of the centrally-planned church has inspired attempts to assign celestial or cosmic symbolism to the dome and to associate the central plan with the early uses of the dome for martyria.[1] Byzantine commentators, however, seem to have attached no special cosmic meaning to the introduction of domes in church design, and in the period under consideration here basilicas and other longitudinal plans were still common. On the other hand, the devotional practices of venerating relics associated with martyria played a decidedly minor role in the liturgical design of Early Byzantine churches. The chief function for which Early Byzantine architecture was created was the liturgy of the Eucharist, and logically this use should best explain the meaning of the architecture.

Liturgical planning is a concept in general still poorly developed in the study of architectural history; in the study of Byzantine architecture, it is a shabby patchwork of vague suspicions and ill-considered generalizations. As the term is understood here, liturgical planning refers to the functional organization of the church building.

It abstracts as far as possible from considerations of the structural design of a church, the aesthetics of its proportions, or the kind and quality of its decoration in order to examine how the church worked and how it could have suited the religious ceremonial for which it was built. Confronting a monument, the pertinent questions which arise are those concerning its operation.

Access to the building and to all its various parts is a primary consideration. Ceremonial involves movement and action, and the means of entrance and exit tell us what kind of action was possible. It also involves drama and spectators; one must ask what kind of barriers were set up to separate the action of the clergy from that of the laity, or to divide the laity into different groups, as well as how the various parts of the church—sanctuary, nave, aisles, and galleries—might have been reached.

Liturgical planning also involves the furnishings of the church: in the period under discussion, these include the synthronon, altar, chancel barrier, solea, and ambo. The style and decoration of these furnishings would in itself constitute a separate study, but we are concerned instead with their placement and functions. They are the stations which constitute the principal bearings of the ceremonial action and determine the outward lines of the liturgy.

Finally, liturgical planning involves the disposition of whatever auxiliary rooms or buildings may have served as starting points or goals in the processional movements of the liturgy. These rooms, such as sacristies or diaconica, also mark out the lines of movement. Taken together, all the abovementioned elements constitute the workable layout of the church and establish its functional, liturgical planning.

The problem of defining these elements is as important as that of specifying the elements of design or decoration in Early Byzantine architecture. Liturgical planning must be seen as one of the dynamic constituents in the formation of the Early Byzantine style. While we cannot read an aesthetic of "form follows function" into the work of Anthemius and his contemporaries, neither can we accuse them of a bold Victorian disregard for the practical purposes of their buildings. Liturgical planning was one among many components of the Early Byzantine style: along with new ideas of spatial organization, new structural developments, and new ways of handling decoration, this planning made a positive contribution to the shaping of the new architecture. We must therefore investigate the characteristics of Constantinopolitan church planning in the fifth and sixth centuries, in order to distinguish it from church planning in other Mediterranean centers and in other periods. Whether it is new and creative, archaic, eclectic, or borrowed, the planning tells us a good deal about the character of the architecture of the capital in this critical period.

The choice of Constantinople as a unit of research is dictated both by the preeminent importance of the capital city in the ancient world and by the availability of the evidence. Sufficient archaeological evidence remains in the city to permit some secure generalizations and a number of reasonable hypotheses about Early Byzantine church planning; and only for Constantinople does liturgical evidence survive in the Early Byzantine world. In pre-iconoclastic times, in fact, one can identify the Byzantine liturgy only as the liturgy of Constantinople. In other centers, literary evidence is

either entirely lacking or it indicates a non-Byzantine liturgy. For Greece, which is generally considered to belong closely to the development of Early Byzantine archi- tecture, not a shred of literary evidence remains concerning the performance of the liturgy; moreover, the archaeological evidence indicates that the Greeks used rather a different rite. Only after the ninth century does one observe a uniformity of liturgical planning between Greece and Constantinople.

The chronological limits for this study have been accepted as pre-iconoclastic, although often post-iconoclastic literary sources are used if there is evidence that they bear witness to the state of the liturgy in earlier times. Within this group the churches form a more or less natural unit, clearly distinct from those of later times; the liturgy, too, underwent some far-reaching changes between Early and Middle Byzantine times. The earlier period was the more creative and formative one, and its evolution exerted a decisive influence on all subsequent Byzantine architecture.

In terms of liturgy, the study has been limited to the central liturgical act: i.e., the celebration of the Eucharist. This rite was certainly more important than any other in determining the layout of the building; moreover, our information is far too slight concerning the other rites of the liturgy in this period (Baptism, the chanting of the Divine Office, the ritual of coronation, etc.).

There are two simple but necessary ground-rules for the study of architecture and liturgy. The first is that the archaeological and liturgical evidence must geographically coincide: one must respect the integrity of local liturgical observances. One cannot, for example, interpret the early churches of Constantinople in terms of liturgical documents from Egypt or Syria, but only in the light of Constantinopolitan documents. The second rule is that the evidence must be more or less contemporary. Church ceremonial, like all living cultural products, undergoes a continuous evolution, and the later development does not always preserve the lines of the primitive ceremonial. One cannot interpret the early churches of Constantinople in terms of medieval litur- gical sources, unless in a given instance one has evidence that the later document remained faithful to the primitive liturgy. These basic rules of historical method should hardly require elaboration, but in treating architecture and liturgy historians have often shown themselves too ready to disregard one or the other, or even both rules at the same time. A study by Heitz, for example, proposes an interpretation of the Carolingian churches of Gaul based on Egeria's description of the fourth-century liturgy of Jerusalem.[2]

In contrast to the wealth of studies published on Early Christian and Byzantine architecture, and the equally impressive range of scholarly monographs and articles on the liturgy of the early Church, very few interdisciplinary studies have appeared that bridge the two areas. Liesenberg's survey of the field was both too ambitious and too premature in its attempt to cover the entire Mediterranean world, at a time when neither the archaeological sources nor the available liturgical texts could give more than spotty information on the subject.[3] On the other hand, Bouyer had at his disposal in his recent study our present vast resources of archaeological and liturgical material, but he chose to make an eclectic use of the sources and to present a popular survey.

In his attempt to trace the evolution of the church building from its origins in the synagogue to its developments in Syria, Rome, and Constantinople, he barely skims the surface of the subject and his conclusions are entirely fanciful.[4]

Studies of individual provinces or of individual features of early church planning have met with better success. Ever since Schneider's pioneering work, a great deal of attention has been given to Syria and to the peculiar arrangement of the bema in the nave that is found there.[5] Lassus and Bandmann have examined the problems of the pastophories or flanking chapels that are often found in Syrian churches, while Soteriou and Orlandos have made similar studies for the early churches of Greece.[6] Studies have been made of the various types of transept space and their different functions, and an attempt has been made to describe the early chancel arrangement of Rome and its liturgical uses.[7] But no comprehensive treatment of Constantinople has yet been attempted, nor have the individual problems been attacked with any thoroughness.[8] It has become traditional in studies of Hagia Sophia to include a chapter on the liturgy of the Great Church, but the author rarely manages to progress further than Constantine Porphyrogenitus' description of the Emperor's part in the liturgy of the tenth century. The earlier period has been handled only in cursory or incidental mentions, either by liturgists or architectural historians.

The absence of any comprehensive study of the liturgical planning in early Constantinople is not accidental. To an earlier generation, any generalization on the subject would have been based on so few monuments as to be almost conjectural. In addition to Hagia Sophia, only three churches could have been discussed in this connection: Hag. Iōannēs Studios, Hag. Sergios and Bacchos, and Hag. Eirēnē. Moreover, the widely differing building types involved in this group tended to discourage comparisons. Gradually, however, archaeologists have been expanding this nucleus into a more representative selection. Although it was not fully reported on until much later, an important Justinianic church of octagonal plan was excavated by French troops in 1923 in the former Hebdomon suburb of the city.[9] In 1937 a fifth-century basilica was discovered in the courtyard of the Topkapī Sarayī museum and excavated by the director of the museum.

New construction in the business district of the old city has turned up three additional churches belonging to our period. In 1939 the excavations for the new Ministry of Justice building uncovered the church of Hag. Euphēmia, the excavation of which was entrusted to the Deutsches Archäologisches Institut. New construction at the University of Istanbul in 1950 uncovered a sixth-century basilica in the Beyazit section, along with two later churches, which the Archaeological Museum excavated. And in 1960 the digging for an underpass in front of the new City Hall in the Saraçhane section turned up remains of Hag. Polyeuktos, which has been under excavation down to the summer of 1969 by Dumbarton Oaks and the Archaeological Museum. Meanwhile, Schneider's excavation in the courtyard of Hagia Sophia and Dirimtekin's exploration of the skeuophylakion have given us fragments of the pre-Justinianic Hagia Sophia; and finally, in 1964 and 1965 the Deutsches Archäologisches Institut and the Archaeological Museum sponsored a survey of the remains of the Chalkoprateia

basilica, a ruin that had long since been identified but had never been studied. To this number can be added the remains of a wall of Hag. Petros and Paulos at the church of Hag. Sergios and Bacchos, which had also been identified earlier but which has not yet been properly studied. Thus the number of monuments has almost trebled in the past few decades.

The total of twelve monuments that are discussed here obviously leaves many important churches unrepresented, and it is particularly regrettable that the entire fourth century and the first half of the fifth century are represented only by a few fragments of the Old Hagia Sophia. Nevertheless, the number we have is a not-insignificant representation of the overall picture of Early Byzantine church building in Constantinople. The total number of churches in the early years of the capital does not seem to have been very great: the *Notitia dignitatum* of 430 lists only fourteen churches, to which Janin has been able to add another five that were certainly in existence by that date.[10] The second half of the fifth century witnessed an acceleration of pace in church building; a number of important basilicas are mentioned in historical sources, and this group is represented here by the Studios basilica, the Chalkoprateia, and one basilica that is not mentioned by the historians, the Saray. Justinian's vast building campaign is slightly better represented. Thirty-three churches were constructed or reconstructed by him in Constantinople and its suburbs,[11] and of this number four (or five, counting Hag. Petros and Paulos) can be included; among them are two of his largest and most important foundations, Hagia Sophia and Hag. Eirēnē.

Thus the monuments examined here can be taken as a reasonable sampling of the building that was going on in the capital in Early Byzantine times, and as better than just a random one in that so many of the most important churches are represented. The patriarchal cathedral is included, as well as the main shrine of the Virgin (the Chalkoprateia) and the two most important shrines of the Baptist (Hebdomon and the Studios). The sampling cuts across a wide variety of building types (basilica, domed basilica, domed octagon, domed hexagon) and includes buildings of Imperial sponsorship and of private patronage, as well as a monastic foundation.

Three monuments of Early Byzantine date have been omitted because they are not relevant to the discussion of the Eucharistic liturgy. One is the martyrium substructure of Hag. Karpos and Papylos;[12] another is the hexagon in the Manganes section, tentatively identified as the Hodēgētria Shrine of the Well;[13] and the third is the baptistery of Hagia Sophia. There is no evidence that these structures were used for the celebration of the Eucharist.

Amid the variety of churches in the selection, one is impressed with the consistency of the liturgical planning. Similarities can be traced from monument to monument, and patterns begin to emerge that support at least tentative generalizations. The churches form a more coherent group than has been supposed: church planning in Constantinople begins to take on distinctive characteristics that set it apart from other metropolitan or provincial centers, and these characteristics are also somewhat different from what has been assumed. The liturgy, too, begins to take on flesh, and its appearance is not what the liturgists have imagined; enslaved by their texts, they

have generally treated their subject as simply prayer formulae. Instead, liturgy is an enormously complex symbol whose message is carried in gesture, motion, and display as much as in words. It is not a speculative statement of propositions, but an action—and its impact on its participants is to be discovered in its performance.

Notes

[1]André Grabar, *Martyrium: Recherches sur le culte des reliques et l'art chrétien antique* (Paris, 1943–46).

[2]Carol Heitz, *Recherches sur les rapports entre architecture et liturgie à l'époque carolingienne* (Paris, 1963).

[3]Kurt Liesenberg, *Der Einfluss der Liturgie auf die frühchristliche Basilika* (Neustadt a.d. Haardt, 1928).

[4]Louis Bouyer, *Architecture et liturgie* (Paris, 1967). This little book is an expanded version of a chapter in Bouyer's earlier *Rite and Man: Natural Sacredness and Christian Liturgy*, trans. M. J. Costelloe (Notre Dame, Ind., 1963). For a critical review of the latter see T. Mathews, "Bouyer on Sacred Space: A Re-appraisal," *Downside Review* 82 (April, 1964), 111–23.

[5]A. M. Schneider, "Liturgie und Kirchenbau in Syrien," *Nachrichten der Akademie der Wissenschaften in Göttingen, Phil.-hist. klassen* 3 (January, 1947), 1–68. For further bibliography and an up-to-date reevaluation of the entire problem see Robert Taft, "Some Notes on the Bema in the East and West Syrian Traditions," *OCP* 34 (1968), 326–59.

[6]Jean Lassus, *Sanctuaires chrétiens de Syrie* (Paris, 1947), pp. 194 ff; idem, "La liturgie dans les basiliques syriennes," *Studi bizantini e neoellenici* 8 (1953), 418–28. Günter Bandmann, "Über Pastophorien und verwandte Nebenräume im mittelalterlichen Kirchenbau," *Kunstgeschichtliche Studien für Hans Kauffmann* (Berlin, 1956), pp. 19–56; G. A. Soteriou, "Hē prothesis kai to diakonikon," *Theologia* 18 (1940), 76–100; Anastasios K. Orlandos, "Hē apo tou narthēkos pros to hieron metakinēsis tou diakonikou," *Deltion*, 1966, pp. 353–72. Gordana Babič's study, *Les chapelles annexes des églises byzantines: Fonction liturgique et programmes

iconographiques* (Paris, 1969), appeared too late to discuss in the present publication.

[7]R. Krautheimer, "S. Pietro in Vincoli and the Tripartite Transept in the Early Christian Basilica," *Proceedings of the American Philosophical Society* 84 (1941), 353–429; idem, "Il transetto nella basilica paleocristiana," *Actes du V^e congrès international d'archéologie chrétienne* (Aix-en-Provence, 1954), pp. 283–90; T. Mathews, "An Early Roman Chancel Arrangement and its Liturgical Uses," *RAC* 38 (1962), 73–95.

[8]Bibliography will be cited in connection with the description of the liturgy.

[9]Bibliography will be cited in connection with the treatment of the individual monuments.

[10]*Notitia dignitatum, accedunt notitia urbis Constantinopolitanae et Laterculi provinciarum*, ed. O. Speeck (Berlin, 1876), pp. 229–43; R. Janin, *La géographie ecclésiastique de l'empire byzantin: Constantinople, Les églises et les monastères*, 2nd ed. (Paris, 1969), p. xii.

[11]By actual count of the churches named by Procopius, who claims that his account of Justinian's church-building activities in and around the capital is complete. *Buildings*, trans. H. B. Dewing and Glanville Downey, Loeb Classical Library (London, 1959), I, 9, 17; I, 10, 1; II, 1, 1; pp. 78–79, 80–81, 96–97.

[12]A. M. Schneider, *Byzanz: Vorarbeiten zur Topographie und Archäologie der Stadt*, Istanbuler Forschungen, 8 (Berlin, 1936), pp. 1–4.

[13]R. Demangel, *Le quartier des Manganes* (Paris, 1939); Charles Diehl, "Les fouilles du corps d'occupation français à Constantinople," *Comptes rendues: Academie des inscriptions et belles lettres*, 1923, pp. 241–48. Schneider does not accept this identification. *Byzanz*, pp. 90–91.

Part One
The Monuments

1 The Early Basilicas

The archaeology of Constantinople has uncovered the plans, or parts of the plans, of four pre-Justinianic churches. Although they are seldom viewed together, they are strongly related to one another and seem to form a natural and fairly homogeneous group. In proportions they are much shorter and wider, closer to the square, than basilicas elsewhere in the Mediterranean world; but beyond this it is not easy to specify how they differed from other basilicas, except in the pattern of their planning. Since none of their elevations, not even that of the Studios basilica, can be fully established, we are left in the dark concerning many details of the construction. It is not known, for example, whether the galleried basilicas included a nave clerestory above the roof-line of the galleries; nor is it apparent whether or not the trabeation of the Studios nave colonnade was a feature that the other basilicas also employed. Construction aside, however, the planning of the basilicas can be discussed with reasonable certainty and in some detail.

The evidence, while not abundant, is generally reliable. The floor plans of three of the basilicas can be established in most essential features, and literary sources supply some of the missing information for the fourth, the Old Hagia Sophia. In all of the churches some evidence of the furnishings has come to light, and certain patterns begin to emerge in the archaeological material that are worth the historian's attention. Limited though their number may be, the four early basilicas of Constantinople represent a critical first phase of Byzantine architecture.

The Old Hagia Sophia

The most important of the early basilicas, the first cathedral of the new capital, was first consecrated by the patriarch Eudoxius in the reign of Constantius on 15 February 360, although it was probably begun by the latter's father as early as 326.[1] Janin points out, interpreting a passage of Socrates, that it was probably first known simply as "the Great Church" and only later came to be called "Hagia Sophia" in honor of Christ, the Wisdom of God.[2] The older name continued to be used alongside the newer one throughout the history of the church.

The Old Hagia Sophia is still for the most part beyond archaeology's horizons. The excavation in the atrium indicates that the foundations of the church were not destroyed but simply covered over in Justinian's building campaign of 532–37 and

probably lie more or less intact under the present church. However, with the exception of the fragments found in the atrium and the skeuophylakion, the lines of these foundations remain unknown; but this fragmentary archaeological information can be supplemented by a number of facts from historical sources, and at least a general picture of the plan can be formed. The scarcity of the information requires that it be handled with discretion, but the importance of Hagia Sophia as the first-ranking church of the city requires that all of the information be given its due weight.

Evidently Constantius' church was a timber-roofed basilica. The historians speak of it as being "shaped like a circus" ($\delta\rho\rho\mu\iota\kappa\dot{\eta}$)[3] or, simply, "oblong" ($\dot{\epsilon}\pi\dot{\iota}\mu\eta\kappa\epsilon\varsigma$).[4] Kähler has taken the former term in a literal sense as referring to a basilica of horse-shoe plan, with the aisles wrapping around the east end of the church in a semi-circular ambulatory like the churches of S. Sebastiano and the old S.ta Agnese in Rome.[5] But here he has overlooked the strict cemetery character of the ambulatory basilicas of Rome, which were all erected outside the city and were principally intended as covered graveyards rather than as Eucharistic halls.[6] The cathedral of Constantinople, built in the heart of the city, could hardly have served such a purpose, and it is unlikely that it had such a form. Moreover, the term $\delta\rho\rho\mu\iota\kappa\dot{\eta}$ is commonly used by Pseudo-Codinus to describe basilicas in general.[7]

From literary evidence, then, it is impossible to specify the plan of the Old Hagia Sophia beyond saying that it had a nave flanked by two, or possibly four, aisles. The tradition that it had a dome of wood is late and probably unreliable, even though attested to by three apparently independent sources.[8] The existence of galleries is much better established, not so much by Simeon Metaphrastes' miracle story about St. John Chrysostom as by Chrysostom's own reference in a sermon to the women "up above."[9]

On 9 June 404, in the riots accompanying the final expulsion of St. John Chrysostom from his see, the Old Hagia Sophia and the nearby senate building were ravaged by fire. The bare facts of the event are recorded in the *Chronicon paschale*,[10] but the life of Chrysostom written by his friend Palladius within a few years of the fire fills in the picture with details that are generally overlooked in discussions of the Old Hagia Sophia.[11] As Palladius tells the story, when word of his condemnation reached Chrysostom, along with news of the approach of the Imperial troops, the bishop decided to leave quietly to avoid a pitched battle between his followers and the armed forces. Therefore he "came down from the episcopate" with his bishops to pray in Hagia Sophia. In the sanctuary ($\dot{\iota}\epsilon\rho\alpha\tau\epsilon\hat{\iota}o\nu$) of the church he bade goodbye to the gathering of bishops, kissing many of them and weeping a great deal. He then went to the baptistery which went by the name of "Olympas," addressed a group of widows and virgins there, and dismissed them. Knowing that the crowds had gathered at the front (western) entrances of the church ($\tau\hat{\omega}$ $\delta\epsilon$ $\delta\nu\tau\iota\kappa\hat{\omega}$ $\mu\dot{\epsilon}\rho\epsilon\iota$, $\dot{\epsilon}\nu\theta\alpha$ \dot{o} $\tau\hat{\eta}\varsigma$ $\dot{\epsilon}\kappa\kappa\lambda\eta\sigma\dot{\iota}\alpha\varsigma$ $\pi\dot{\nu}\lambda\omega\nu$), he sent his mount there as a distraction while he himself went out through the eastern part ($\kappa\alpha\dot{\iota}$ $o\ddot{\nu}\tau\omega\varsigma$ $\dot{\epsilon}\xi\hat{\eta}\lambda\theta\epsilon\nu$ $\dot{\epsilon}\pi\dot{\iota}$ $\tau\dot{o}$ $\mu\dot{\epsilon}\rho\rho\varsigma$ $\tau\dot{o}$ $\dot{\alpha}\nu\alpha\tau\rho\lambda\iota\kappa\dot{o}\nu$).

At that point a fire—miraculous in origin, according to Palladius—broke out in the church, for with Chrysostom's departure the protecting angel of the church also depart-

ed. As Palladius describes its course, the fire rose up "from the middle of the throne on which John used to sit, placed like the heart in the middle of the body . . . and branched out above through the lamp chains to the roof, and like a serpent attacking the belly it ran across the top structures of the church." The flames then bridged over to the senate building, "which was located many paces away, opposite the church, toward the south," starting in a miraculous fashion not at the end nearer the church but at that nearer the palace. Thus it burned away like two mountains of flame, sparing only "the little building in which the many sacred vessels were kept" (μόνον ἐφρόντιζε τοῦ οἰκίσκου, ἐν ᾧ τῶν ἱερῶν σκευῶν ἀπέκειτο τὸ πλῆθος), thereby proving the superhuman nature of the conflagration.

The account contains several pieces of information concerning the planning of the Old Hagia Sophia. First, it excludes the hypothesis proposed by some scholars that the original Hagia Sophia, like most Constantinian foundations, pointed west with the façade entrances toward the east.[12] Palladius clearly informs us that the main entrances were at the west, where the people were waiting for Chrysostom to emerge; at the same time, he tells us of an entrance at the east by which the bishop made his unobtrusive departure. Secondly, we learn of the proximity of the patriarchal residence in an expression that was used much later to describe the way the patriarch entered Justinian's Hagia Sophia informally through the galleries adjoining his residence to "descend" into the church.[13] Third, we learn of a baptistery called Olympas, which seems to have been located not far from the sanctuary (or at any rate closer to the eastern than to the western end of the church). Fourth, a skeuophylakion or place for keeping the sacred vessels is mentioned; this is referred to as a "little building" (οἰκίσκον), whose survival was probably due as much to its separation from the body of the church as to the miracle.[14]

Finally, Palladius speaks of a throne for the bishop placed in the heart of the building, i.e., somewhere near the middle of the nave of the church. The fact that the course of the fire in Palladius' description had to follow the lamp chains to mount from the throne to the roof seems to bear out this interpretation. As we will see below, Chrysostom made use of two thrones, one in the usual place in the apse and one placed on the ambo for his preaching.[15] The text seems to refer to the latter and thus gives us grounds to suppose that the ambo of the Old Hagia Sophia was somewhere in the middle of the nave of the church. (Cedrenus tells us that the church was furnished with an ambo and a solea of stone similiar to onyx.[16])

A further detail is found in the *Chronicon paschale*, according to which the furnishings of Constantius' church, in addition to a jewel-incrusted altar of gold, included gold curtains "for the doors of the church" (τὰς θύρας τῆς ἐκκλησίας) and brightly-colored gold curtains "for the great doors outside" (τοὺς πυλεῶνας τοὺς ἔξω).[17] The author thus makes a distinction between the doors of the church proper and a second set of doors in front, very likely a propylaeum of some sort preceding the atrium; this outer set of doors was of grander proportions than the doors of the church itself. The information is of considerable importance in interpreting the excavations in the atrium.

How much of the church was actually destroyed—and therefore how much had to

be rebuilt before the new dedication by the patriarch Atticus under Theodosius II (10 October 415) —is not clear. Parts of the church were apparently still used to some extent in 405, when the relics of the Prophet Samuel were brought to Constantinople and deposited there,[18] but whether we should speak of a new, "Theodosian" Hagia Sophia, as is generally assumed, or simply of a rebuilding or repairing under Theodosius II is still undecided. However, elements of Theodosius' campaign have come to light in Schneider's excavation and can supply us with a few additional clues about the pre-Justinianic church.[19]

Schneider discovered the remains of a beautiful entrance portico and much of the architectural sculpture that belonged to it in the courtyard of Hagia Sophia (Plates 1 and 2). Located about 2 m. below the present church level and about 8 m. to the west of the present exonarthex, the portico was traced from a central door almost on axis with the present church to a point some 3 m. north of the north wall of Justinian's atrium (Figure 1). The full dimensions of the portico are often overlooked by readers of Schneider's report, although the latter is quite clear in this respect. The acanthus scroll in mosaic that decorates the border of the portico is reported as reappearing north of the present remnants of Justinian's atrium, where another trench could be opened up without disturbing the present building.[20] (This is faithfully recorded on the plan, marked "A" on Figure 1, as is the top step of the stair leading up to the portico at this point, marked "B" on the same Figure.) The end of the portico was still not in sight in this trench, and we do not know how much further it extended; nor is it clear whether it had only three or possibly as many as five doors. But it was over 66 m. long and was clearly wider than the narthex of the present Hagia Sophia; hence reconstructions that attempt to make it into a narthex or the western portion of an atrium, such as that of Kleiss (Figure 4), are simply not possible, considering the archaeological facts. An atrium in front of this portico would have had to be much wider than Kleiss has shown it and therefore would have extended proportionately further toward the west; but the land drops off sharply at the west in such a way that this would have been impossible.

In addition to the extraordinary length of the portico, the discovery of a roughly parallel roadway located in front of the flight of six steps that leads up to it also excludes any reconstruction that places an atrium in front.[21] Atria are not intersected by roadways, but are by definition enclosed areas. The steps would also have been an unusual feature within an atrium, and Kleiss significantly ignores them in his reconstruction.

Therefore we are left with only two alternatives: either the portico was the front entrance to the narthex of the Old Hagia Sophia, in which case one must reconstruct the church without an atrium and without the propylaeum referred to in the *Chronicon paschale*; or, as seems more likely, the portico is in fact this propylaeum, the "great doors outside" as distinct from the doors of the church itself. The latter alternative fits in better with the discovery of drainage canals in the pavement east of (i.e., inside) the entranceway (see location "C" in Figure 1); the presence of such canals would be difficult to explain in the narthex of a church, but would be quite natural in an open atrium. It is also significant that the inner (eastern) face of the portico wall is nowhere

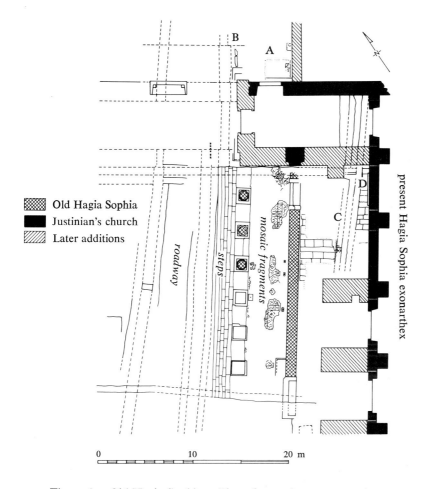

Figure 1. Old Hagia Sophia. Plan of propylaeum excavation

interrupted by the half-piers or pilasters that one might have expected in the interior of a narthex.

On the other hand, it is quite difficult to imagine the cathedral without an atrium, insofar as there is no other early Constantinopolitan church that we can be certain lacked an atrium or forecourt. The portico was most likely the propylaeum or grand entranceway from the road outside to the atrium or courtyard that preceded the church proper, and Schneider apparently adopted the hypothesis that it belonged to the narthex without examining the alternative possibilities. That suggestion has since gained rather general acceptance, although Keck pointed out the inconsistencies of Schneider's report soon after its publication.[22]

The date of this propylaeum has not yet been firmly fixed. The sculptural fragments seem certainly to belong to the rebuilding of Theodosius II, but the west wall was first believed by Schneider to belong to Constantius' church.[23] Ward Perkins, in his study

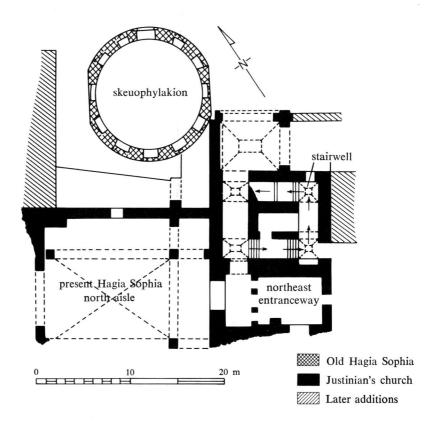

Figure 2. Old Hagia Sophia. Plan of skeuophylakion

of the evolution of building techniques in Constantinople, also opted for a fourth-century date for this wall, and Krautheimer favors the same position.[24] Clearly the pure brick masonry is quite different from the alternation of brick and stone in the Land Walls which we have come to accept as characteristically Theodosian, but unfortunately we have too few dated examples of Byzantine building in Constantinople from the fourth or early fifth century to support a firm decision. Even if we had more, the conservative character of Byzantine building techniques would probably still make it very difficult to decide between two dates that are only fifty years apart. Thus we cannot judge to what extent Theodosius' rebuilding in the propylaeum depended on the work of Constantius.

One further element of the Old Hagia Sophia, the skeuophylakion building located at the northeast corner of the present church, still remains (Figures 2 and 3; Plate 1b). A circular building of irregular dodecagonal plan, it has eleven niches and a door on the lower level, with (originally) twelve windows above. Dirimtekin's investigation confirmed a vague suspicion of long standing that the building antedated the Justinianic Hagia Sophia.[25] He dates the building roughly in the fifth century, basing his argument on comparison of the marble window frames to those of the

Figure 3. Old Hagia Sophia.
South-north section of skeuophylakion

Studios basilica (463) and of the masonry to that of the propylaeum and the Chalko-
prateia church; like the propylaeum wall, the masonry of the skeuophylakion is pure
brick rather than alternating brick and stone. However, as we have seen, the brick
wall of Hagia Sophia's propylaeum may very well belong to the fourth-century church;
moreover, if the skeuophylakion of Constantius' church survived the fire of 404, as we
are reliably informed by Palladius that it did, there would not have been any reason for
Theodosius to build a new skeuophylakion. (The tradition that identifies the small
building which survived the fire as the skeuophylakion is reasonably continuous and
will be discussed in connection with the latter's uses.[26]) In short, it is quite conceivable
that both the propylaeum wall and the skeuophylakion belonged to Constantius'
church.

While Dirimtekin's study has established the pre-Justinianic date of the skeuophylakion, it has left a great many other questions unanswered. The original floor-level was not reported, and it is not known where the original entrance, or entrances, lay. The present entrance and windows date from Mahmut I (1742), by evidence of the inscription above the door; but this is on the north side, away from the church. The east and west walls of the rotunda are both flattened on the outside, as if meant to accommodate entrances where they would seem to relate more obviously to the nearby church. A Middle Byzantine typicon speaks of the patriarch as going "through" the skeuophylakion, which would imply that the latter had more than one entrance.[27] It should also be noted that the axis of the building is turned slightly clockwise according to Van Nice's plan, relating it more closely to the propylaeum—which is also turned a degree or two toward the south relative to the present axis of the church.[28] Dirimtekin's plan does not indicate this, however, and it differs from Van Nice's plan in a number of other details as well. Further inspection of the building might reveal more of its history.

On the basis of such information as we now possess, it is obviously impossible to reconstruct the whole plan of the Old Hagia Sophia. But we can enumerate the elements that made up the plan and their relative positions, and this will have to serve for a plan. To the west of the church stood a grand propylaeum, the appearance of which in Theodosian times was established by Schneider's excavation. It consisted of a very long and lofty portico or stoa raised several steps above the roadway in front, with an impressive pedimented central entrance and side entrances. Beyond the propylaeum must have lain some kind of courtyard preceding the church proper. The principal entrances to the church were in the west façade, although we are informed of another

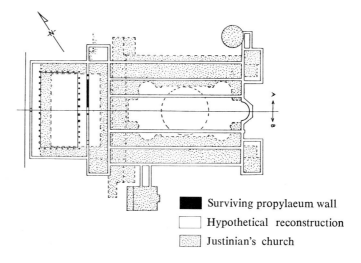

Surviving propylaeum wall

Hypothetical reconstruction

Justinian's church

Figure 4. Old Hagia Sophia. Kleiss' hypothetical plan

entrance in the east end as well. The church itself was a basilica, with a nave and two or possibly four aisles, and with a gallery story above the aisles. A baptistery called Olympas, which perished in the fire of 404, was located toward the east end, along with a skeuophylakion, which should be identified with the still-existing structure at the northeast. In the center of the nave stood the ambo.

These are the scanty facts we possess. On this basis one cannot even hypothesize on the length and breadth of the church, except to say that the frequent assumption that the lines of the Old Hagia Sophia were followed in the building of Justinian's church is not consistent with the facts.[29] The forecourt must have been east, not west, of the propylaeum and therefore must be extended under the nartheces of Justinian's church; the axis of the basilica, judging from the propylaeum wall, ran at an angle one or two degrees further toward the south, and hence at almost a perfect right angle to the axis of the hippodrome; and the size of the old basilica must have been noticeably smaller than that of Justinian's church, as we are informed by Leo Grammaticus:[30] the mammoth basilicas proposed in Kleiss' and Antoniades' reconstructions both emerge as larger in plan than the existing building (Figure 4).

Hag. Iōannēs Studios

The basilica dedicated to St. John the Baptist near the Golden Gate has always been recognized as pivotal in the study of Byzantine architecture. Its date is securely fixed in 463 when, according to Theophanes, the senator Studios built the church and located the *akoimetoi* monks there.[31] It is the only fifth-century church in Constantinople of which substantial portions still stand, and since the excavation of the other basilicas in Constantinople is fairly recent, the Studios church long had to serve as the unique representative of all the basilicas that once populated the capital. Its square, classical proportions (as they are usually interpreted) bear witness to the importance in Constantinople of basilica types belonging to the early fifth century, or even to Constantinian times, and its fine architectural sculpture forms an essential link in the development that leads from the Theodosian style a half-century earlier to the mature Justinianic style a half-century later.[32]

As far as church planning is concerned, it is difficult to overestimate the importance of the Studios church. Almost all the elements of the plan can be demonstrated with reasonable archaeological certainty, excepting only the solea and ambo. Sufficient evidence remains to propose a hypothetical reconstruction of the atrium; the nave, aisles, and galleries and their means of access can be demonstrated; and the chancel barrier, altar site, and synthronon all have left representative remains from which to reconstruct their original layout. The plan is simple and straightforward, and it establishes a fundamental pattern that recurs not only in other basilicas of the fifth century, but with slight adjustments even in the more complex domed structures of the sixth century.

Nevertheless, despite the great significance of the church, no adequate structural survey of the building has ever been prepared, although the Russian Archaeological

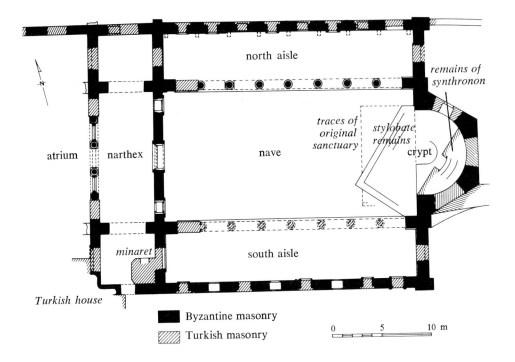

Figure 5. Studios Basilica. Plan

Institute began such a survey in 1907–9. They cleared the site of the remains of the Imrahor Camii, which had fallen to ruin, uncovered the marble pavement with its lovely inlaid animals, and excavated the crypt under the sanctuary; but they were unable to carry their work to completion, and the resulting publication was more concerned with the history of the monastery than with the archaeology of the church building and contains not a single plan, elevation, or photograph.[33] The studies by Ebersolt and van Millingen are still the most thorough surveys available,[34] but in several points they must now be supplemented by fresh observations.

No plans or measurements of the atrium have ever been made except for the eastern portion (i.e., the narthex), which both van Millingen and Ebersolt measured for their plans (Figure 5). This portion consists of three bays separated by two wide archways (Plate 3). The smaller bays on either side are simple, functional entryways; they are provided with a large door in each direction, except that the south door of the right or southern bay is somewhat smaller than the others. In the central bay, four handsome columns create a grand quinquepartite entrance from the courtyard of the atrium into the narthex bay; a pair of doorframes enriches the second and fourth intercolumniations, and the cutting of the column bases indicates that there were similar frames in the first and fifth intercolumniations as well. The columns carry a lavish entablature which makes a right-angle turn at either end, indicating that the colonnade was once continued toward the west along the north and south flanks of the atrium (Plate 4).[35]

All that remains of the north and south colonnades of the atrium is the northern exterior wall, but this tells us a good deal about the plan (Plate 5). The masonry, where it has not been disturbed or repaired, alternates bands of brick with bands of stone, which is exactly the same masonry as that of the body of the church; crosses and rosettes in brick decorate the intervals between the doors, and the same kind of decoration occurs between the windows on the aisle walls inside the church. Measured from the west wall of the church, 27.3 m. of the atrium wall are standing; this portion contains five doorways, all of which are now blocked up, although two still have their frames.

The first doorway (Plate 6) is the north entrance to the narthex and measures about 2.10 m. It was blocked up and a smaller door opened a little to the west, which was also blocked up later. Following this door, at an interval of 5.21 m., is a series of three doors measuring 1.40 m. each and separated by intervals of 2.54 m. (Plate 7). Only half of the fourth doorway can still be traced, but this half indicates a door of the same dimension as the other two and placed again at the same interval. Beyond this, at an interval of 5.09 m., is the fifth door, measuring 1.52 m. The masonry here has been much disturbed, especially above and to the right of the door, but the doorframe and the masonry in the lower part of the wall to the right are both original; hence the sequence at this point has not been altered, even though the wall has been extensively repaired. The greater interval of 5.09 m. and the larger size of the door seem to indicate that the fifth door marked the western corner bay of the atrium. It is impossible to fit this door into the unit sequence established by the preceding three doors. If one reconstructs the colonnade that must have stood opposite these three doors, the repeated unit of 3.94 m. (door plus intervening wall) would indicate an intercolumniation of half this length, or 1.97 m., which if extended would place a column directly opposite the fifth door.

The simple symmetrical design of the north wall—with its three evenly-spaced smaller doors grouped together in the middle and two larger doors spaced further out at either end—probably reflects a more or less symmetrically planned atrium within, consisting of a courtyard preceded and followed by porticoes of roughly the same size (Figure 6). Reconstructed on this basis, the atrium would echo the almost square proportions of the church itself, 27.29 m. long (including the narthex) by 26.30 m. wide. The courtyard within would be as wide as the nave, or 12.60 m. (40 Byzantine feet), and 14.24 m. long (45.2 Byzantine feet).[36] The total length of the atrium and church together, exclusive of the apse, would be 54.94 m., or 174.5 Byzantine feet. Theodore the Studite mentions a fountain in connection with the church (he calls it a λουτήρ), and its most likely location would have been in the middle of the atrium.[37] The Turkish fountain, or şadīrvan, is probably somewhat west of the fountain it replaced.

The atrium of the Studios church, therefore, was probably almost square, with a system of five entrances in the north wall: three in the middle bay and one in each end bay. The same entrance system could have been repeated on the west and south sides of the atrium, but one might expect that on the south side access would have been

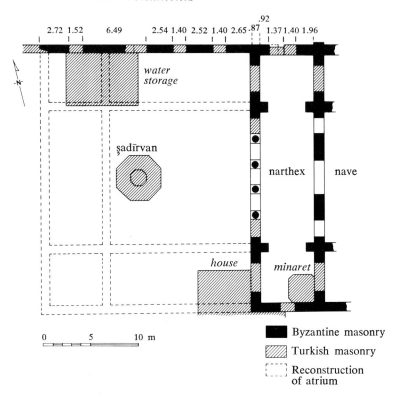

Figure 6. Studios Basilica. Plan of atrium and suggested reconstruction

more restricted, since the monastery lay along that side; actually the southern entrances to the church proper, both in the narthex and in the east end of the aisle, are smaller than the corresponding entrances on the northern side. On the whole, however, one is struck by the openness of the atrium plan.

A similar openness of plan is characteristic of the church proper. From the narthex five entrances open into the church: two side entrances to the aisles, and three central entrances communicating with the nave. The central door, larger than those beside it, is called "the Royal Door" (ἡ βασιλικὴ πύλη) by Theodore the Studite.[38] At the east end of the church four more entrances are provided, one leading in from the north and one from the south at the end of either aisle, and two more entering the aisles from the east on either side of the apse. The entrances flanking the apse are most significant; they are broad and framed in heavy molding, and apparently must be counted among the principal means of access to the church. We do not find at the Studios—nor will we find in the other early churches of Constantinople—a pair of flanking chambers north and south of the apse. The east end is simple and unobstructed, and the whole church, for that matter, seems to have been quite unencumbered by added rooms of any kind.

Space within the church was divided between the ground level and the gallery level. On the ground level the nave and aisles were entirely open to one another, without the

high stylobates or parapets that partition them in many of the fifth-century churches of Greece;[39] there are neither sockets nor drillings for the fastenings of any such barriers (Plates 8–9). On the second story the gallery surrounded the nave on three sides in a "U"-shaped plan, following the lines of the aisles and narthex below. The gallery over the narthex was eliminated when the church was converted to a mosque, but one can still observe in the west wall of the church the broad, arched entrances by which the narthex gallery communicated with the aisle galleries on either side. Column bases preserved above the nave entrances indicate that the narthex gallery opened onto the nave through a colonnade, in the same way that the aisle galleries did (Plate 10).

The problem of access to the galleries has not yet been properly investigated. Ebersolt remarked on the impossibility of fitting stairs where one might have expected them in the lateral bays of the narthex, for both bays have doors on all four sides; but he could suggest no alternative location.[40] Actually, there are very few possible alternatives. In the mosque the stairs were in the western end of the aisles, where the entrance from the narthex and the last intercolumniation of the nave colonnade were filled in.[41] They could not have been located at this point in the Early Byzantine church, nor anywhere else in the aisles, without being a great encumbrance. Instead, they appear to have been located outside the church building altogether.

A triangle of the narthex gallery wall has been preserved under the pitch of the mosque roof above the Turkish plaster of the narthex on the north and south walls, and this triangle shows traces of the original entrances to the gallery (Plates 11–12). The brickwork has not been disturbed; the seams are clean, and they reach down to the same level (i.e., the floor level of the gallery) as the doorways beside them that led from the narthex gallery to the aisle galleries. Hence external stairs must have led up to the narthex gallery from the outside, both on the north and on the south. North of the narthex a scar is visible where a wall 87 m. wide has been torn away from the north wall (Plates 6–7). That this was a wall and not simply a pilaster is indicated by Salzenberg's plan of the church, in which it is shown as a wall about 0.5 m. long and broken off.[42] It has been smoothed over at some time after the 1850's. Very possibly this abutting wall was part of the housing for the stair, which since it has left no mark must have been made of wood. Stairs will be found in similar positions at Hagia Sophia and Hag. Eirēnē, placed outside the body of the church at the side of the narthex, although in the latter examples they are of brick and stone. The nearest comparable monument to the Studios basilica which still exists is the galleried Acheiropoiētos church in Thessalonike; here, too, access to the gallery is located outside the church and in this case involves a ramp north of the narthex.[43]

A good deal more remains of the sanctuary furnishings than has been properly examined until now. Since the fragments belong to the earliest sanctuary plan in Constantinople, they are worth putting together. As van Millingen's plan (Figure 5) shows, the approximate lines of the sanctuary can be seen in the pattern of the inlaid marble pavement, for which a mid-eleventh-century date has been suggested by comparison with the floor of the Pantokratōr.[44] Where the marble pavement stops short

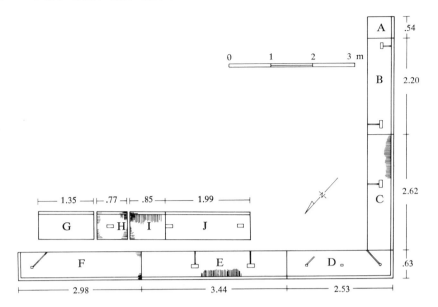

Figure 7. Studios Basilica. Plan of chancel remains

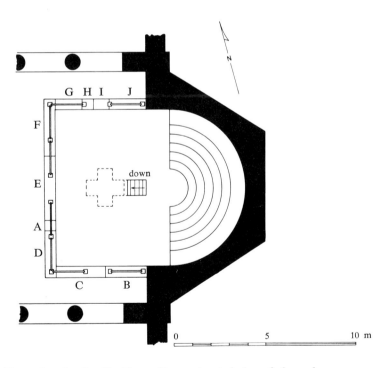

Figure 8. Studios Basilica. Reconstructed plan of chancel,
altarsite, and synthronon

one can see the outline of a "π"-shaped chancel projecting into the nave about 5.5 m. from the apse (Plate 13). Within this area, as the plan also indicates in a sketchy fashion, the Turks had laid out their mihrab platform, oriented toward the southeast. The whole interior of the church was cleared of a heavy growth of weeds in the summer of 1968, permitting a close inspection of these elements.

The Turks reused in their mihrab platform the stylobate of the Byzantine sanctuary, turning it at an angle toward the southeast and using the extra pieces as fill (Figure 7). The stylobate is of vert antique, massive in dimensions and simple in profile, but of fine workmanship (Plate 14 and Figure 9). There are a few easy clues to reassembling the pieces as they now lie in order to reconstruct the original layout. Pieces *D* and *F* are corner pieces with molding on one end as well as along the front. Pieces *B*, *E*, and *I* are heavily worn along the front edge, indicating the locations of the entrances. Sockets for chancel piers, some still filled with lead, occur on most of the pieces; on piece *D* there are two sockets indicating an intercolumniation, center to center, of 1.78 m. Juggling this set of clues, it becomes obvious that the Turkish masons have hardly disturbed the order of the pieces at all, and the plan can be easily reestablished as in Figure 8. Piece *A* was removed from between pieces *D* and *E* to shorten the front side, and the northern side was swung around in back to support the mihrab platform. The original chancel screen, therefore, projected into the nave 5.45 m. and was 9.49 m. wide; it had a single entrance in front and an entrance on each side.

Two chancel pier fragments were also found on the site, made of the same vert antique and exhibiting the same high craftsmanship as the stylobate (Plates 15–16 and Figure 9). Both pieces are grooved on two sides to receive the parapet slabs and ornamented on the other two with simple molding. Positioned on the stylobate, they would hold chancel slabs of about 1.60 m. length. The elevation of the chancel barrier cannot

Figure 9. Studios Basilica.
Profiles of stylobate and pier fragment

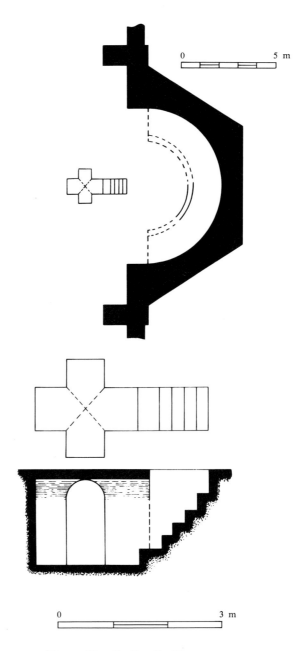

Figure 10. Studios Basilica.
Crypt plan and section

be reconstructed, but the first piece (Plate 15) is the top section of a pier and preserves the base of a colonnette that surmounted it. Hence we know that the chancel barrier was not simply a low parapet, but carried an architrave on top of colonnettes. Unfortunately the height of these elements is unknown.

There is no reason to suppose that the chancel barrier as thus reconstructed does not belong to the original foundation of the church in 463. The material is the identical vert antique of which the nave columns were made, and the profiles can be easily compared to other fifth-century material. The stylobate can be compared with that of Nea-Anchialos B and the pier with a pier from Chaliandos of Lesbos.[45] The basilica of Senator Studios had to have a chancel barrier, and the remains which survive probably belonged to it.

Within the chancel barrier, there is evidence both of the altar site and of the synthronon. The Russian Archaeological Institute discovered the little crypt within the sanctuary, although Bittel was the first to publish a plan of it, in 1939 (Figure 10). The crypt is entered from the east down a short flight of stairs that begins exactly on the chord of the apse. The plan is cruciform and is composed of the intersection of two little barrel-vaulted corridors, each less than 2 m. long. Which of the many relics belonging to the church was housed there is not known.[46] The close resemblance of the crypt to that of the Chalkoprateia would tend to confirm a fifth-century date for it, but the date cannot be any more firmly established than that. We can safely presume that the altar site was over the crypt and therefore was located approximately in the center of the rectangular area reserved by the chancel barrier. Nothing of the altar remains.

The Russian Archaeological Institute also uncovered a section of two and a half steps of the semicircular synthronon which was preserved behind the mihrab wall. This appears in van Millingen's and Bittel's plans (Figures 5 and 10), but it has never been discussed. Unfortunately, neither of the plans is detailed enough to yield accurate measurements, and the remains are now so ruined that the stairs cannot even be distinguished. From the plans, however, the steps appear to have been roughly .25 m. high and .30 m. deep, which would permit one to reconstruct between six and seven benches. These benches were obviously too small for comfortable sitting; very likely the top bench was deeper, the way they appear at Paros and the way Naumann has reconstructed the synthronon of Hag. Euphēmia.[47] Whether it was constructed over a vaulted, semicircular passage like the synthronons of Hag. Eirēnē and Hag. Euphēmia is not clear.

The evidence of the synthronon, however fragmentary, nicely completes our picture of the liturgical planning of Hag. Iōannēs Studios. The earliest Constantinopolitan church plan of which we have detailed information can be almost completely reconstructed: the disposition of the various parts of the church and access to these parts is quite clear; the plan of the chancel barrier can be reassembled; and the locations of the altar and synthronon are established. The only important detail still missing seems to be the location of the ambo and its solea.

Theotokos in Chalkoprateia

Situated within 150 m. of Hagia Sophia and served by the same clergy as the cathedral, the church dedicated to the Mother of God in Chalkoprateia was the most important shrine of the Virgin in Constantinople.[48] It housed the treasured relic of the Virgin's cincture and in the liturgy, at least by the end of the ninth century, it was either the goal or the starting point of the celebrations of all the major feasts of the Virgin.[49]

A number of buildings now infringe on its site: a mosque, the Acem Ağa Mescidi, which is now in ruins, was inserted into the east end of the church; the north wall has been incorporated into a school building; and private homes and businesses now occupy the south aisle, as well as the baptistery. Credit for discovering the church must go to Mamboury, who studied the site in 1912 before the construction of a cinema and other buildings took place there; but little attention was given to it until Kleiss' recent survey.[50]

The church is roughly contemporary with the Studios basilica, and it is difficult to be much more exact than this in dating it. Some historians attribute its foundation to Theodosius II (408–50)[51] and others to his sister Pulcheria, but the latter fail to specify whether this occurred during the reign of Theodosius or during Pulcheria's own reign (450–53).[52] The *Novellae* of Justinian attribute it to Verina, the wife of Leo I (457–74),[53] and in the latest dating of all the building is ascribed to Justin II (565–78).[54] This last attribution, however, should be taken as the restoration following an earthquake, as Pseudo-Codinus indicates.[55] The differing accounts of the founding are probably best reconciled by supposing that the building was begun by Pulcheria late in her brother's reign, i.e., shortly before 450, and was finished and dedicated by Verina perhaps a decade or so later. This solution was proposed by Lathoud and was later adopted by Ebersolt and Janin.[56]

The archaeology of the site does not permit any greater accuracy in dating than the literary sources do. The often-repeated story that the church was converted from a synagogue seems to be discredited by the fact that no evidence of an earlier building has appeared, and the building as it survives was clearly designed as a church. The masonry is pure brick, of a type that seems to anticipate Justinianic brickwork—high mortar beds of 5.5 cm. and a ten-course modulus of 91 cm. But here again, as in the Old Hagia Sophia, our sequence of dated examples of Early Byzantine masonry is too spotty to be of much help. The single capital from the church which Firatlı and Rollas discovered in a preliminary excavation in 1963 seems to be Middle Byzantine in date. It is a plain basket capital with a foliate neckband and abacus, and its carving is not crisp enough nor the relief high enough to place it in the Early Byzantine period (Plate 18). Probably it belongs to the restoration of the church under Basil I (867–86)[57] who, we are told, added a dome to the structure, thus transforming it into a domed basilica. We must therefore be satisfied with a rough dating of the original basilica to around the same time as the Studios church; the plan, insofar as it is known, reinforces this association.

An atrium is attested to by literary evidence dating as far back as 536, when a local council was held at the Chalkoprateia church.[58] The location of the newly-explored

octagonal structure in line with the north wall of the church must indicate the northern (and perhaps also the western) limit of the atrium (Figure 11). Nothing of the atrium itself has been found, however, apart from the northern wall of the narthex. Mamboury discovered what he identified as the entablature of the narthex in 1912, in a good state of preservation; but it has since disappeared, apparently without ever having been photographed.[59] If the octagonal structure marks the western limit of the

Figure 11. Chalkoprateia Basilica. Plan

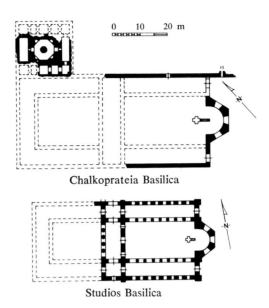

Chalkoprateia Basilica

Studios Basilica

Figure 12. Chalkoprateia Basilica. Atrium (reconstruction plan)

atrium, the proportions of the latter would be very close to those of the atrium of the Studios basilica: almost square and slightly longer than wide (Figure 12; cf. Figure 6).

The octagon has been identified by Kleiss as a baptistery, and this seems very probable. The building type of an octagon set within a square is a common baptistery form, the nearest example being the baptistery of the church of Theotokos in Ephesus. Even closer at hand, the baptistery of Hagia Sophia is an octagon in a square (although in this case the square is the outer wall of the octagon). In addition, the pier placed in the center of the substructure of the Chalkoprateia octagon seems to have been intended to carry a heavy load such as a baptismal font, as Kleiss proposes. The discovery at an earlier date of a baptismal font in the near vicinity (now in the Archaeological Museum) is further strong evidence.[60]

The apse, the southeast corner, and the north wall of the church proper survive to about half their original height (Figure 13 and Plates 17, 19–20). The church was a three-aisled basilica of broad proportions. It was considerably more spacious a building than the Studios church; its total width was 31 m., or 100 Byzantine feet,[61] making it the largest known basilica of the capital. The wide apse is three-faced on the exterior and semicircular on the interior, with three great windows.

As at the Studios, the apse was not flanked by side chambers but by entrances instead; since the eastern end of the church faces Hagia Sophia and the Palace of the Emperors, the eastern entrances must have been a principal approach to the church. To the south of the apse a very large, arched entrance 3.10 m. wide gave access to the southern aisle. Mamboury reported finding the remains of a colonnade and an entrance gate in front of this southeast entrance, where the cinema now stands: "A door was

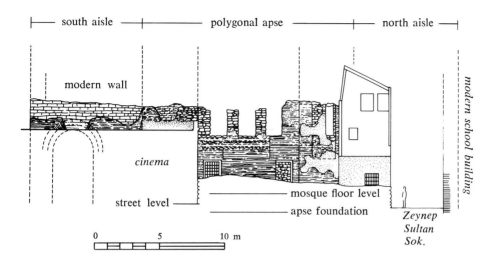

Figure 13. Chalkoprateia Basilica. East elevation

found at the end of the right-hand lateral nave which gave onto the staircase leading to St. Sophia; a monumental lateral gate was set against the right and lateral nave on one side and against a colonnade on the other."[62] Mamboury's "monumental lateral gate" is mentioned in the tenth-century *De ceremoniis* in connection with the Feast of the Annunciation. After the ceremony the Emperor, who assisted from the gallery, descended by way of a wooden stair on the left (i.e., northern) side; he passed through the synthronon (which may possibly mean *under* the synthronon: κατελθὼν τὰ γραδήλια τῆς κόγκης ἐν τῷ διδασκαλείῳ), and went out through the exit to "the porch gate" (τὸν ἔμβολον πύλην), where he mounted his horse.[63] Apparently the plan of the apse and eastern entrance was not affected by the remodelling of Basil I and the addition of the dome.

At the northeast corner of the church the east wall has been destroyed where the street Zeynep Sultan Sokağı runs through, so that it is not possible to say whether there was another entrance here balancing that on the south side of the apse (Figure 13). The north wall (Plates 19–20) extends about 9 m. beyond the point where the east wall has been broken away. Kleiss' plan of the north wall includes a door here (Figure 11), but this is not apparent in the wall itself, which has been reworked several times. Further to the west, however, there was an entrance halfway down the north aisle. This may have led to one of the adjoining churches of Sōtēr Christos or Hag. Iakōbos which were located in the vicinity, but the accounts of the pilgrims do not agree as to precisely where they were.

Galleries are known to have existed not only in the tenth century, as mentioned in the *De ceremoniis*, but also in the ninth century before the remodelling of Basil I. In the year 866 Photius administered an oath of loyalty (in vain) to the co-Emperors

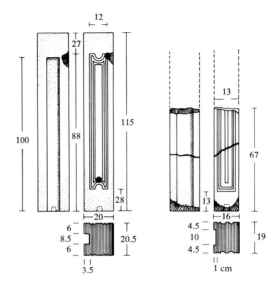

Figure 14. Chalkoprateia Basilica. Chancel piers

Michael III and Basil I in the galleries of the Chalkoprateia.[64] However, we know nothing of the layout of the galleries or of their means of access at this period.

We have few fragments to indicate the interior planning of the church. A single column base survives on the site in very battered condition; it was not published in Kleiss' report, although it is recorded in the photographic archive of the Deutsches Archäologisches Institut (Plate 21). The base is grooved on either side as if to receive parapet slabs. If it could be established that this base belonged to the aisle colonnade, the fact might indicate that nave and aisles were segregated here, as they were in many of the churches of Greece. But it more probably belonged to the gallery colonnade, where parapet slabs would have been indispensable. The base is considerably smaller than the nave colonnade bases at the Studios basilica, with a column-footing of 50 cm. as compared to 66 cm. at the Studios.

Two little piers of the chancel barrier have also survived (Figure 14). Because they are grooved on only one side they must be entrance pieces, and because they are of different widths we must assume they belong to two different entrances to the chancel. In contrast to the Studios piers these did not carry colonnettes or an architrave above, and the chancel barrier would have to be reconstructed as a low barrier with parapet slabs one meter high. The design of the piers is a common and very prosaic fifth-century type.[65] The layout of the chancel barrier is not known; the *De ceremoniis* refers to a solea in the middle of the nave by which one reached the Holy Doors of the sanctuary itself,[66] and the sanctuary enclosure must have extended into the nave the way it does at the Studios, in order to embrace the altar site over the crypt.

As at the Studios, a small cruciform crypt is located in front of the apse and is reached by a stair entering from the east side (Figure 15). The crypt is located at a deeper level because of the raising of the floor in the ninth century, a fact that seems

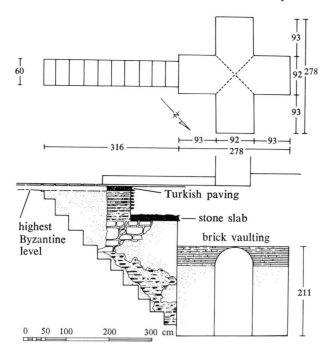

Figure 15. Chalkoprateia Basilica. Crypt (plan and section)

to guarantee the early date of its installation; but again we do not know what relic was contained there. The famous cincture of the Virgin, the church's prize possession, was reputedly kept in a little box on the altar itself.[67] The altar must have been located over the crypt, but nothing of it remains.

The Chalkoprateia church thus exhibits a basilica plan of the Studios type, although in a much more fragmentary condition. An atrium lay before the church; there were galleries above the aisles on either side and entrances to the aisles on the east end (at least on the southern side), without auxiliary chambers flanking the apse. There was a synthronon in the apse, and the sanctuary was laid out in front of the apse, including the altar site which is marked by the crypt. The only noticeable difference in planning seems to have been the low, more archaic type of chancel barrier, without colonnettes and architrave.

The Topkapı Sarayı Basilica

In 1937 Aziz Ogan, the director of the Topkapı Sarayı Museum, laid bare the remains of a fifth-century basilica in the second courtyard of the Saray, one or two meters below the present garden (Figure 16).[68] The church is the least known of the four early basilicas: the excavation was not reported in sufficient detail, and the site has since been covered over again. Nevertheless, the main features of the plan were revealed, and the discovery is important. Smaller in scale and more modest in design than the other early basilicas, the Saray church may give us some idea of more commonplace

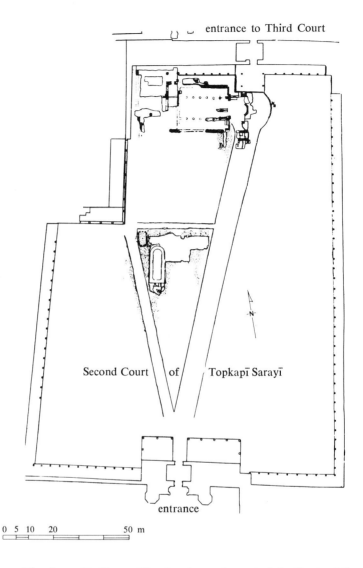

Figure 16. Saray Basilica. Site plan (second court of the Topkapī Sarayī)

church building in the fifth century. The church is also important for the harvest of tenth- and eleventh-century tiles taken from the site, but this lies outside the scope of the present investigation.[69]

The dedication of the Saray basilica remains unknown, and the date of the church is even less secure than that of the Chalkoprateia. Ogan assigned it to the second half of the fifth century, on the basis of general—though unspecified—building techniques,[70] and Bittel came to the same conclusion on the basis of the polygonal exterior of the apse and the resemblance of the marble paving to that of the sanctuary of the church of

Nea-Anchialos A (Plate 22).[71] However, the polygonal apse gives us no firm basis for dating, and the paving gives only a general indication of date, since parallels in Constantinople are lacking. The coin finds indicate an earlier fifth-century date, insofar as the heaviest concentration of coins at the floor level was from the reign of Theodosius II (408–50).[72] The fine Corinthian pier capital discovered in the excavation appears to reinforce an earlier date (Plate 23): both in the Theodosian character of the foliage and in the generalization of the helices it can be closely compared to a capital of unknown provenance now in the Istanbul Archaeological Museum, which Kautszch places in the period 430–60.[73] The basilica might therefore date from the last years of Theodosius' reign, which would place it earlier than the Studios basilica; but the evidence is not conclusive.

The Saray basilica is considerably smaller than the Studios and Chalkoprateia churches and differs from them in several details of planning. In the first place, the Saray basilica was approached through a forecourt placed off axis west and north of the church (Figure 17), instead of through a formal atrium placed on axis west of the church. The principal entrance to the church was the northern entrance of the narthex, which was emphasized by a porch of two columns. This porch-entrance thus stood approximately in the center of the forecourt, and the east wall of the forecourt abutted the north wall of the church at about its midpoint. One supposes, then, that the principal approach to the forecourt must have been from the north. A fountain was located in the southern portion of the courtyard, i.e., in front of the narthex, and two other entrances to the latter were provided: one along the central axis of the church, and one on axis with the north aisle. We have already encountered a fountain at the Studios basilica, and a third example will be found at Justinian's Hagia Sophia.

Fifty meters south of the forecourt, a small apsed chapel was uncovered.[74] Its date is unknown, but its distance from the church—together with the fact that it faces toward the south while the forecourt opens north—seems to rule out any connection between the chapel and the church. North of the church, in the third courtyard of the Saray, fragments of a baptistery are also said to have been found; these include a piece supposedly belonging to the font and a fragment of an inscription in large square capitals reading ΜΕΓΙΣΤΟΣ ΕΥΣΕΒ, which now lies beside the Sultan's audience hall. No plan was made, however.[75]

From the narthex one entered the church proper through three doors, one to the nave and one to each side aisle. Within the church, the usual basilica arrangement of nave and aisles was maintained. The aisles were not reported to be segregated from the nave, nor do the plans indicate any such division. The proportions of the body of the church are the same as those of the Studios and the Chalkoprateia churches, a squarish space that is only slightly longer than it is wide, but the dimensions are much more modest. The width of the church is about 19 m., or slightly over 60 Byzantine feet (at .309 m. per foot).[76] The Studios and Chalkoprateia measured 80 and 100 feet respectively.

The eastern end of the church was incompletely preserved, and this has caused some misunderstanding. The crown of the apse (which was apparently five-sided on the

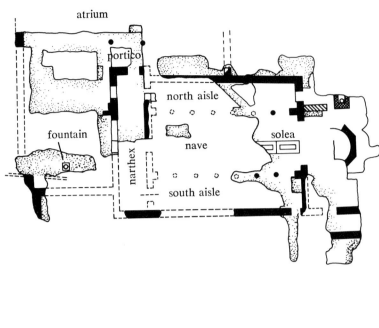

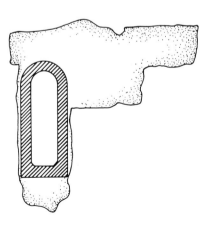

Figure 17. Saray Basilica. Plan

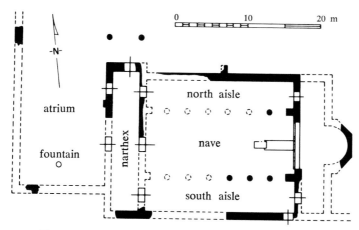

Figure 18. Saray Basilica. Bittel's hypothetical plan

exterior and circular on the interior) was discovered 7 m. east of the eastern wall of the church. Since the radius of the apse is only about 2.5 m., Bittel supposed that a narrow transept ran across the width of the church, separating the apse from the nave (Figure 18).[77] If correct, this reconstruction would give us the first and only example of a transept in Constantinople; but no transept walls were actually discovered, and Bittel's reconstruction contradicts the evidence as reported by the excavator. In the southeast corner of the church he proposes a doorway leading from the south aisle to the transept; however, the eastern wall of the south aisle was reported as continuous in Ogan's plan (Figure 17). The south aisle did have an entrance at this end, but it was from the south, not from the east. On the other side of the sanctuary, Bittel prolongs the north wall to include the transept, whereas Ogan's plan reports finding the exterior corner of the church here; moreover, the doorway east from the north aisle has a doorsill and is therefore clearly an exterior entrance and not the door to the transept. Finally, Ogan reported clearly finding the northern wall of the sanctuary bay on a line slightly north of the line of the nave colonnade and on the same level as the colonnade (however, he inconsistently indicates this on his plan with hatching instead of a solid line).[78]

The apse, therefore, was separated from the nave by a short rectangular bay, but this was not in any sense a transept. The rectangular bay was shut off from the nave by a straight chancel barrier (of which no details of the design are specified) that ran from pier to pier across the front. Thus the sanctuary of the Saray church was of about the same shape and proportions as the sanctuary of the Studios, but instead of projecting into the nave, here the sanctuary was added onto the nave. The little Beyazit basilica will supply us with another example of this arrangement. Perhaps the restricted dimensions of the nave in both instances dictated the addition of the sanctuary bay further to the east.[79]

In front of the sanctuary were located solea barriers reaching out into the nave of the church. Bittel reports that at the end of the solea the foundations of an ambo were found (Figure 18),[80] the earliest archaeological evidence we have of the solea and

ambo in Constantinople. Unfortunately, no details on them were reported, beyond their location. The latter permits us to observe, however, that the common Greek arrangement which placed the ambo to one side was not followed; instead the ambo was located on the central axis of the church about one-fourth of the way down the nave.

Whether or not galleries figured in the planning of the Saray basilica as they did at the Studios and Chalkoprateia is not clear, though the meter-wide walls were certainly heavy enough to sustain the load. But in other respects, the church fits into the same group as the other two: it has a forecourt and narthex, though the forecourt is shifted toward the north; it is three-aisled, with additional entrances at the east end of each aisle; and no subsidiary chambers were found, either flanking the apse or elsewhere. The projection of the sanctuary to the east is its most notable divergence from the pattern of the other two churches. The Saray church was destroyed in the conquest of the city, and a mosque seems to have stood over the site for some time.[81]

Taken together, the four early basilicas establish some definite and fairly consistent patterns in church planning. In the first place, each of the churches was oriented and had its principal approach from the west through an atrium or forecourt of some kind. At the Old Hagia Sophia the forecourt was preceded by a monumental propylaeum; at the Studios it was surrounded by a colonnade in the fashion of a quadriporticus or formal atrium, with a fountain in the middle; at Chalkoprateia its design is unknown, although its existence is certain; and at the little Saray church it was an informal precinct area, located off axis west and north of the church, containing also a fountain before the western entrances of the church. The west end of each of the three churches for which we have plans was further developed by a narthex, and one would suppose that there was a narthex at the Old Hagia Sophia as well, but evidence is lacking. All of the basilicas followed the traditional nave-and-aisle arrangement inside. At least three of the churches had galleries over the aisles; at the Studios, which is the only one in which parts of the gallery survive, the latter was reached by means of stairs located outside the body of the church proper.

In contrast to the ample development of the western end of the church, the eastern end was remarkably simple. There is no evidence either of transepts or of subsidiary chambers flanking or adjacent to the apse: at the old Hagia Sophia, the "little building in which the many sacred vessels were kept" was separate from the church, on the north side. Where one might have expected rooms, one finds instead broad entrances to the aisles at the eastern end on either side. At Chalkoprateia the southeast entrance was formalized with a porch and colonnade.

The evidence of the furnishings is less complete, but the indications are that the plans called for an ambo in the center of the nave (the Old Hagia Sophia and the Saray church), connected to the sanctuary by a solea (Saray). A synthronon occupied the apse, and the altar was located in front of the apse (Studios and Chalkoprateia). A chancel barrier enclosed the altar area, either in a straight line (Saray) or in

a "π"-shaped plan with entrances on three sides (Studios and Chalkoprateia). The barrier itself either was a low parapet (Chalkoprateia) or included a little colonnade with an architrave above (Studios).

While none of the four early basilicas of Constantinople represents a standard type mechanically reproduced, a general plan seems to underlie all the variations, and this plan is certainly noteworthy. Four churches are, of course, not a great number, and one would feel very insecure if conclusions concerning the ceremonial use of Early Byzantine architecture had to be based on so small a representation; but having examined the early basilica plans, one is in a better position to appreciate the issues involved in the planning of the Justinianic churches. The question is whether the pattern observed in the fourth- and fifth-century churches survived the innovations of the early sixth century, or whether it was transformed into something quite different under the impact of new architectural ideas.

Notes

[1]*Chronicon paschale*, ed. L. Dindorf (Bonn, 1832), I, 543–45.

[2]*Géographie*, pp. 455–56; Socrates, *Historia ecclesiastica*, II, 16, *PG* 67, 217.

[3]*Narratio de structura templi s. Sophiae*, Script. orig. Const., ed. T. Preger, I (Leipzig, 1901), 74.

[4]Nicephorus Callistus, *Ecclesiastica historia*, XVII, 10, *PG* 147, 244.

[5]Kähler, *Hagia Sophia*, p. 12.

[6]R. Krautheimer, "Mensa-Coemeteria-Martyrium," *CA* 11 (1960), 15–40.

[7]Pseudo-Codinus, *Patria Kōnstantinoupoleōs*, Script. orig. Const., ed. T. Preger, II (Leipzig, 1906), 214, 260, 286.

[8]Georgius Cedrenus, *Historiarum compendium*, ed. Immanuel Bekker (Bonn, 1838–39), I, 531; Michael Glycas, *Annales*, ed. I. Bekker (Bonn, 1836), p. 495; Georgius Codinus, *De antiquitatibus constantinopolitanis*, ed. I. Bekker (Bonn, 1843), pp. 130–31.

[9]Symeon Metaphrastes, *Vita et conversio s. Ioannis Chrysostomi*, *PG* 114, 1113; Ioannes Chrysostomus, *In psalmum 48: 17, Homilia* 5, *PG* 55, 507.

[10]*Chronicon paschale*, I, 568.

[11]Palladius, *Dialogus de vita sancti Ioannis*, ch. 10, *PG* 47, 35–36. For a critical text, see P. R. Coleman-Norton, *Palladii dialogus de vita s. Ioannis Chrysostomi* (Cambridge, 1928), pp. 61–63. On Palladius see Berthold Altaner, *Patrology*, trans. H. Graef (New York, 1964), pp. 254–55, and Coleman-Norton's introduction. Millet discussed the historicity of this document, but without exploiting its archaeological information. G. Millet, "Sainte-Sophie avant Justinien," *OCP* 13 (1947), 597–612.

[12]Lethaby and Swainson, *Sancta Sophia*, pp. 17–18; E. M. Antoniades, *Ekphrasis tēs hagias Sophias*, (Athens, 1907–9), I, 4–5. The Church of the Nativity in Bethlehem is the only other Constantinian church that faced east. The significance of the switch has not been satisfactorily explained. Cf. L. Völkl, " 'Orientierung' im Weltbild der ersten christlichen Jahrhunderte," *RAC* 25 (1949), 155–70.

[13]See below, p. 140.

[14]The fact that the skeuophylakion was spared is also mentioned by Symeon Metaphrastes, who probably relied on Palladius for this detail. *PG* 114, 1188.

[15]See below, pp. 150–51.

[16]Cedrenus, *Historiarum compendium*, I, 531.

[17]*Chronicon paschale*, I, 544–45.

[18]Ibid., p. 569.

[19]Schneider, *Grabung im Westhof*.

[20]Ibid., p. 38.

[21]Ibid., p. 4.

[22]Andrew S. Keck, "Review of E. H. Swift, *Hagia Sophia*," *AB* 23 (1941), 237–40.

[23]Schneider, "Die vorjustinianische Sophienkirche," *BZ* 36 (1936), 85. Schneider revised his opinion in *Grabung im Westhof*, p. 6.

[24]J. B. Ward Perkins, "Building Methods of Early Byzantine Architecture," in *The Great Palace of the Byzantine Emperors, Second Report* (Edinburgh, 1958), p. 64; R. Krautheimer, *Early Christian and Byzantine Architecture*, Pelican History of Art (Baltimore, Md., 1965), p. 318, n. 27.

[25]Feridun Dirimtekin, "Le skeuophylakion de sainte-Sophie," *REB* 19 (1961), 397–400. For other,

earlier opinions on the pre-Justinianic date of the building, see Lethaby and Swainson, *Sancta Sophia*, pp. 19–20; Antoniades, *Ekphrasis*, II, 146–53; Schneider, *Grabung im Westhof*, p. 73.

26See below, pp. 158–60.

27See below, p. 160 and n. 31.

28Robert Van Nice, *Saint Sophia in Istanbul: An Architectural Survey* (Washington, D.C., 1965), pl. 15.

29This assumption is made by Kähler, *Hagia Sophia*, pp. 20–21 and passim; also by Antoniades, *Ekphrasis*, I, pl. 2, and by Kleiss in his reconstruction plan. *IM* 15 (1965), 175, fig. 5 (see our Figure 4).

30Leo Grammaticus, *Chronologia*, ed. Immanuel Bekker (Bonn, 1842), p. 92.

31Theophanes, *Chronographia*, ed. John Classen (Bonn, 1839–41), I, 175.

32R. Krautheimer, *Early Christian and Byzantine Architecture*, p. 78; idem, "The Constantinian Basilica," *DOP* 21 (1967), 117–40; F. W. Deichmann, *Studien zur Architektur Konstantinopels*, Deutsche Beiträge zur Altertumswissenschaft (Baden-Baden, 1956), p. 103.

33B. Panchenko, "Hag. Iōannēs Studios," *Izvestiya russkogo arkheol. instituta* 14 (Sophia, 1909), 136–52; 15 (1911), 250–57; 16 (1912), 1–359.

34Ebersolt and Thiers, *Les églises*, pp. 3–18; van Millingen, *Byzantine Churches*, pp. 35–61. See also Janin, *Géographie*, pp. 430–40; Schneider, *Byzanz*, pp. 76–77.

35Van Millingen, *Byzantine Churches*, p. 51 and pl. VII.

36The Studios church is laid out on a Byzantine foot of .315 meters. Paul A. Underwood, "Some Principles of Measure in the Architecture of the Period of Justinian," *CA* 3 (1948), 72–73.

37Theodorus Studita, *Descriptio constitutionis monasterii Studii*, *PG* 99, 1717.

38*Descriptio constitutionis*, *PG* 99, 1705.

39Discussed below, pp. 118 ff.

40Ebersolt and Thiers, *Les églises*, p. 8.

41One of the stairs appears in a drawing by Charles Texier in the Royal Institute of British Architects, London, album I, St. Jean de Studios, sheet 1.

42W. Salzenberg, *Altchristliche Baudenkmale von Constantinopel vom V. bis XII. Jahrhundert* (Berlin, 1854), pl. II, figs. 1 and 2.

43S. Pelekanides, *Palaiochristianika mnēmeia Thessalonikēs* (Thessalonike, 1949), pl. I.

44Arthur H. Megaw, "Notes on Recent Work of the Byzantine Institute in Istanbul," *DOP* 17 (1963), 339.

45Orlandos, *Basilikē*, p. 523, fig. 495, and p. 519, fig. 479, 2.

46J. Ebersolt, *Sanctuaires de Byzance* (Paris, 1951), pp. 81–82.

47See below, p. 66 and Figure 33.

48Janin, *Géographie*, pp. 237–42; Schneider, *Byzanz*, p. 56; Ebersolt and Thiers, *Les églises*, p. 256, n. 3.

49Juan Mateos, *Le Typicon de la Grande Eglise* (Rome, 1962–63), entries under dates of Sept. 1 and 8, Nov. 21, Dec. 18, Feb. 2, and Mar. 25.

50Ernest Mamboury, *Constantinople, Tourists' Guide* (Constantinople, 1925), pp. 230–31; Wolfram Kleiss, "Neue Befunde zur Chalkopratenkirche in Istanbul," *IM* 15 (1965), 149–67; idem, "Grabungen im Bereich der Chalkopratenkirche in Istanbul, 1965," *IM* 16 (1966), 217–40.

51Pseudo-Codinus, *Patria Kōnstantinoupoleōs*, II, 135–289; Cedrenus, *Historiarum compendium*, I, 602.

52Theophanes, *Chronographia*, I, 158; Theodorus Lector, *Excerpta ex ecclesiastica historia*, I, 5, *PG* 86, 168; Nicephorus Callistus, *Eccl. hist.*, XIV, 2 and 49, *PG* 146, 1061 and 1233.

53*Corpus iuris civilis*, ed. T. Mommsen (Berlin, 1899–1902), III, *Novellae*, 3, 1, p. 20.

54Theophanes, *Chronographia*, I, 382.

55*Script. orig. Const.*, II, 227.

56D. Lathoud and P. Pezaud, "Le sanctuaire de la Vierge au Chalcoprateia," *Echos d'Orient* 23 (1924), 37; Jean Ebersolt, *Les anciens sanctuaires de Constantinople* (Paris, 1951), pp. 54–61; Janin, *Géographie*, p. 237.

57*Theophanes Continuatus*, ed. Immanuel Bekker (Bonn, 1838), p. 339.

58The term used is μεσαύλιον. *Mansi* 8, 878.

59Mamboury, *Constantinople*, pp. 230–31.

60*IM* 15 (1965), 163–65; Lethaby and Swainson, *Sancta Sophia*, pp. 81–82, fig. 10.

61Apparently the church used the "Bethlehem" measurement of a foot as .309 meters. This would also explain the measurement of the southeast entrance as a ten-foot dimension. Cf. Underwood, *CA* 3 (1948), 64–74.

62Mamboury, *Constantinople*, pp. 230–31.

63Constantinus VII Porphyrogenitus, *Le livre des cérémonies*, ed. Albert Vogt (Paris, 1935–40), I, 39 (30), p. 155.

64Leo Grammaticus, *Chronologia*, p. 342; Symeon Magister, *Annales*, in *Theophanes Continuatus*, p. 676.

65Orlandos, *Basilikē*, pp. 518–19, figs. 479, 481.

66*De ceremoniis*, I, 39 (30), ed. Vogt, p. 154; cf. S. Xydis, "The Chancel Barrier, Solea, and Ambo of Hagia Sophia," *AB* 29 (1947), 16.

67Nicephorus Callistus, *Eccl. hist.*, XIV, 49, *PG* 146, 1233; cf. S. G. Mercati, "Santuarii," *Rendiconti della Pontificia accademia romana di archeologia* 12 (1936), 150.

68A. Ogan, "Les fouilles de Topkapu Saray entreprises en 1937 par la Société d'histoire Turque," *Belleten* 4 (1940), 318–35.

69Elizabeth Ettinghausen, "Byzantine Tiles from the Basilica in the Topkapu Sarayi and St. John of Studios," *CA* 7 (1954), 79–88.

[70]*Belleten* 4 (1940), 333.

[71]K. Bittel, "Grabung im Hof des Topkapī Sarayī," *JDAI* 54 (1939), 180, n. 1, and 181.

[72]*Belleten* 4 (1940), 324.

[73]R. Kautzsch, *Kapitellstudien*, Studien zur spätantiken Kunstgeschichte, 9 (Berlin-Leipzig, 1936), p. 54 and pl. 13, no. 170.

[74]Bittel, *JDAI* 54 (1939), 181.

[75]Information kindly supplied by Mrs. Mualla Anhegger, architect of the Topkapī Sarayī Museum.

[76]The width is reported as "about 20 meters" by Bittel and as 21 meters by Ogan; but the latter dimension evidently includes the narthex, which is slightly wider than the church. We have taken our measurement from the plan. *JDAI* 54 (1939), 179; *Belleten* 4 (1940), 332.

[77]*JDAI* 54 (1939), 179. A brief report by Bossert also mentioned a transept, but without discussing the evidence involved. H. T. Bossert, "İstanbul akropolünde üniversite hafriyatī," *Üniversite konferansları*, no. 125 (1939–40), p. 208.

[78]*Belleten* 4 (1940), 332–33.

[79]Another arrangement of this kind might have been the church of Hag. Anthēmios across the Horn from the Blachernes section. Procopius described the church as square, except that—as he expressed it—the length exceeded the width by the dimensions of the sanctuary: an expression which may point to a sanctuary bay added onto the nave. *Buildings*, I, 6, 9, pp. 64–65.

[80]*JDAI* 54 (1939), 180.

[81]Ibid., 181.

2 The Justinianic Period: The Smaller Foundations

The sixth century confronts us with a far more diverse architectural situation than that of the fourth and fifth centuries. Justinian, who dominated the age, dominated also the architectural world with a building program that reached from Palmyra to Belgrade to Leptis Magna. Bridges, fortifications, aqueducts, churches, markets, and whole cities sprang up in the wake of Justinian's reconquest of the Empire and left a more enduring mark on civilization than the military victories themselves. The enormous volume of construction was a catalyst for the diffusion of a great many relatively new architectural ideas. New structural types, new decorative motifs, new styles in the figurative arts, all suddenly reach maturity in the early sixth century. The new churches of the capital must be seen as one part of this feverish and far-flung building activity; judging from the place Procopius assigns them in his *Buildings*, they were probably regarded by Justinian as the most important part.

The archaeological remains of the sixth-century churches of Constantinople give us a fair idea of the diversity of church design then in use in the capital. Alongside the basilicas, which continued to be built and whose importance must not be underestimated, we find new centrally planned buildings of double-shell construction, with domed cores surrounded by ambulatories and galleries. Some are strict in their central plans, while others compromise the logic of the central domed unit by introducing a longitudinal axis. Among the smaller foundations ("smaller" only in comparison with the grand, oversized foundations, to be treated separately), three were built under direct Imperial sponsorship and three were probably privately founded. One, the Hag. Euphēmia church, was a preexisting secular structure adapted for use as a church.

The fate of the early liturgical plan in these new architectural settings must be followed from church to church. The lines of liturgical continuity seem, for the most part, to be stronger than the forces for change.

Hag. Sergios and Bacchos; Hag. Petros and Paulos

Students of architecture have examined the structure of Hag. Sergios and Bacchos countless times, recording with various interpretations the subtle alternation of the rectangular and apsed recesses, the complexity of the design of the sixteen-sided dome, and the refinement of the architectural sculpture. Its system of central domed core with encircling ambulatories makes it a kind of miniature version of—and some would go so

far as to say an experimental model for—Hagia Sophia. However many precedents may be cited, it represents something genuinely new in architectural history; its close association with the Great Church puts it in a special class, which is shared only by S. Vitale in Ravenna among the surviving monuments of the Justinianic era. Nevertheless, surprisingly little has been said about the planning of the church, and a thoroughgoing structural analysis has never been undertaken.

The most complete published accounts of Hag. Sergios and Bacchos are still those of van Millingen, Ebersolt, and Gurlitt—all treatments that leave many details unnoticed.[1] Underwood made some new observations on the measurements of the building, but these were based on Ebersolt's measurements rather than on a new study.[2] More recently Sanpaolesi has made a fresh contribution to our knowledge of the shape of the dome,[3] but his observations on the rest of the structure are unreliable. Curiously, Ward Perkins omitted Hag. Sergios and Bacchos in his study of the building methods of Early Byzantine architecture.[4] Thus a good deal of the church still remains unknown: essential features of entrances, stairs, windows, and interior arrangement have received a minimum of attention, and the heavy layer of plaster covering the entire interior and the narthex façade still prevents accurate observation of some of these features. However, an analysis of the masonry which is now visible can yield some new evidence, and a careful reading of the sources may tell us how to interpret this evidence.

The building of Hag. Sergios and Bacchos was preceded by the construction of its neighbor Hag. Petros and Paulos, a church belonging to the end of the second or beginning of the third decade of the sixth century. Van Millingen suggests that the original inspiration for the church might have come as early as 499, when the Pope's legate requested of the Emperor Anastatius that the patron saints of Rome should be more solemnly honored in Constantinople, for at the time there was no church dedicated to the Princes of the Apostles.[5] The text, however, does not refer explicitly to the church of Hag. Petros and Paulos, contrary to van Millingen's assertion. The erection of the building was certainly the work of Justinian, as we are told both by Procopius and by the inscription that was placed in the church.[6] The site was Justinian's own private residence in the Hormisdas section, and the dedication was especially appropriate to him, for his baptismal name was Peter (Flavius Petrus Sabbatius). The accession of Justin I in 518, and the consequent prominence this gave to his nephew and adopted son Justinian, may have been the occasion for undertaking the new church; the construction must have been well under way in 519, for a letter of that date requests from Rome relics of Sts. Peter, Paul, and Lawrence.[7] Since the inscription within the church named Justinian without any title, one may infer that the church was finished (at least to the cutting of the inscription) before 520, when Justinian was given the title of Patricius. Certainly this could not have been later than 525, the year he was named Caesar.[8]

According to Procopius, Hag. Petros and Paulos lay "along the flank" of Hag. Sergios and Bacchos, and the nartheces of the two churches were continuous.[9] Van Millingen thought that its location must have been north of Hag. Sergios and Bacchos, because of remnants of spur walls that are still to be seen at the northeast corner of the

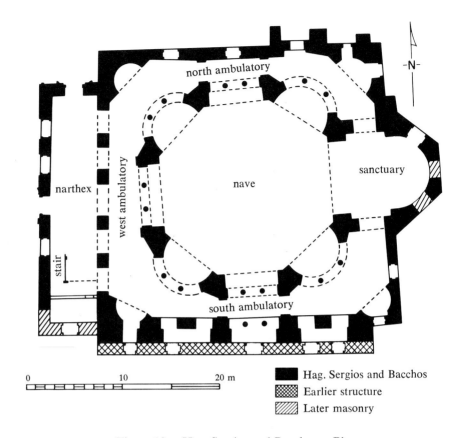

Figure 19. Hag. Sergios and Bacchos. Plan

latter (Figure 19 and Plate 33a).[10] But this location could not strictly be called "along the flank" of Hag. Sergios and Bacchos; nor could the nartheces of the two churches have been continuous on the north side where, as we shall see, the masonry of Justinian's church is fairly intact. A number of considerations make it evident that Hag. Petros and Paulos lay instead along the south, and that the present south wall of Hag. Sergios and Bacchos is in fact the north wall of the earlier Hag. Petros and Paulos. Ebersolt reached this conclusion in his close analysis of the structure sixty years ago;[11] little attention has been given to his proposal, but a fresh examination of the building confirms his observations, even if one or two details must be corrected.

Structurally it is apparent that the south wall of Hag. Sergios and Bacchos must belong to a different building campaign from the rest of the church. The east, north, and west walls, with the exception of areas of repair such as the northeast corner, are constructed of a uniform brick masonry with courses of stone occurring occasionally at intervals of about twenty courses; this is a Justinianic masonry observable at Hagia Sophia and Hag. Eirēnē as well (Plate 26). The south wall, however, is of an entirely different construction (Plate 27). Much of the wall is made up of an irregular

stone and brick patching, and most of this patching is modern. Paspates observed in 1877 that the south wall of Sergios and Bacchos was then in a state of extreme disrepair, with gaping holes and stones tumbling out every time a train passed.[12] The patchwork repairs are comparable to the modern repairs to the Ayasofya Baths and to recent work elsewhere in the city. In other parts of the wall, however, a more regular kind of masonry can be observed, consisting of an alternation of bands of brick (two to four courses) and bands of stone (three to four courses); this is a type of masonry common in fifth century Constantinople, although usually with five courses of brick. Hence one must assume that the south wall belongs to a different and earlier period than the rest of Hag. Sergios and Bacchos.

The irregularities of the ground plan also indicate two building campaigns at Hag. Sergios and Bacchos (Figure 19). Underwood has demonstrated that the measurements of the core of the building were laid out with considerable regularity, beginning from the east, in units derived from the 50-ft. diameter of the dome.[13] The east wall, the apse, and the octagonal core of the building are all coordinated along a single axis. On the other hand, the façade or west wall, which does not conform to this axis, is aligned at a right angle with the south wall (with a deviation of about a degree) and was evidently planned to conform with it. This is what one would expect if the south wall predated the building of Hag. Sergios and Bacchos and if the narthex of the church was made to line up with its neighbor, as Procopius tells us. Finally, if the south wall predated the building of Hag. Sergios and Bacchos, it would account for the fact that it is shorter than the north wall and leaves an indentation in the southeast corner.

Of the church of Hag. Petros and Paulos, then, we still have the north wall substantially preserved. The wall is 25.5 m. or slightly over 80 Byzantine feet, two meters short of the length of the Studios basilica. Ebersolt reported observing three large openings on both the ground and gallery levels of the outside (Figure 20); he proposed that the two churches communicated with one another through these openings on both levels. The extra half-bay that disturbs the symmetry of Hag. Sergios and Bacchos' plan on the south side is thus explained as an entryway from this church into its neighbor. There is a step-up from the ambulatory into the half-bay on the ground floor, which would be difficult to account for if the half-bay were meant only as additional space, but which makes sense if it is interpreted as an entryway into a building at a slightly different level (Plate 30). Furthermore, as Ebersolt noticed, the two columns that screen off the middle section of this half-bay were cut to receive some kind of doorframe, for a flat band runs up the side of the columns and over the capitals, containing holes for fastenings (Plate 31). However, there is no evidence for the triple arcade that Sanpaolesi introduces into his plan in the center bay of the south wall.[14]

Ebersolt's observation of the south wall can now be corrected with new photographs and a more detailed analysis of the masonry (Plates 27–28 and Figure 21). The wall is articulated in a series of three large bays plus a fourth half-bay to the west. On the ground floor appear three great arched openings of 4.9 m., separated by piers of 1.5 m. Evidence of two arches can be made out on the second floor, over the central and

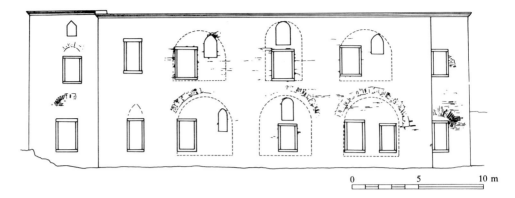

Figure 20. Hag. Sergios and Bacchos. South wall, elevation (Ebersolt)

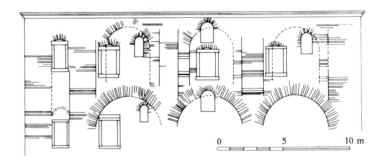

Figure 21. Hag. Sergios and Bacchos.
South wall, elevation (or north wall of Hag. Petros and Paulos)

western arches below; they measure about 3.4 m. Contrary to Ebersolt's opinion, both are centered over the arches below and are of the same height. Between the openings the wall is articulated with a series of vertical seams; the half-bay to the west has two of them, possibly indicating filled-in openings about 1.3 m. apart.

This articulation clearly belongs to the fabric of the wall and may reflect something of the interior structure of the church to which it belonged. It is difficult to imagine how the series of great arched openings could have functioned in concert with a colonnaded nave in the interior, and one is tempted to reconstruct an interior that also consisted of a series of piers and arches. It might be significant that in comparing the structure of Hag. Petros and Paulos with its neighbor, Procopius fails to mention columns in the former: "The length of one of them is worked out straight, while in the other the columns stand generally in a semicircle."[15] In any case, Procopius

informs us of the straight basilican lines of the church, and the wall indicates the presence of galleries over the aisles. Possibly the half-bay to the west marks an eso-narthex. The width of the church could not have exceeded about 20 m., which is the amount of space available between Hag. Sergios and Bacchos and the Sea Wall at this point.

Procopius' description tells us that the church was preceded by a narthex stoa, an atrium, and great entrances or propylaea preceding the atrium, all of which were shared with Hag. Sergios and Bacchos.[16] After the building of the latter, access to the north side of the church was had on both levels. It is impossible to say whether in the original plan the lower arcade was intended to function as doors or as windows. To the south, the church flanked the Sea Wall. Access was probably had also to Justinian's private quarters at the east, which became a part of the Imperial palace at his accession; Procopius speaks of the two churches as part of the palace and as ornaments of it.[17]

Hag. Petros and Paulos probably fell into ruin or disuse rather early. Subsequent references to the monastery connected with it all refer to this as the monastery of Saint Sergios alone; the pilgrims never mention it in their itineraries.[18] Gyllius in the sixteenth century was not able to find any remains of the church.[19]

The neighboring church of Hag. Sergios and Bacchos dates roughly from the first decade of Justinian's rule. Procopius supplies no information for dating the building; contrary to Ebersolt's reading, the text does not even tell us that it was built after Hag. Petros and Paulos, but only that the latter was the earlier of the two churches which the Emperor dedicated to the Apostles, referring to the great cross-domed church as the other.[20] But the inscriptions of the two buildings testify that the one was built by Justinian the citizen, and the other by the Emperor Justinian.[21]

According to Cedrenus, not a very reliable source in this regard, Justinian began the church in the very first year of his reign, 527.[22] Swainson proposed a date sometime before the death of Justin I (1 August 527), because of the church's connection with the Hormisdas palace and because Theodora is not named in the monograms of the capitals, although Justinian is.[23] But Theodora was crowned Empress the very day of Justinian's own coronation on Easter Sunday, 527, and she is mentioned in the inscription of the architrave; moreover, the Hormisdas palace was not abandoned when Justinian was crowned but was enlarged and renovated by him and joined to the main complex of the Imperial palace.[24] There is no evidence to support a dating of the church prior to Justinian's accession to the throne;[25] clearly he was Emperor by the time the capitals were set on the columns and the inscription cut in the architrave, and Theodora had been Empress at least long enough to claim a reputation for her charitable foundations, as she does in the inscription. The building was probably finished by 536 as an outside date, for the "hegumenos of Hag. Petros and Paulos and of the holy martyrs Sergios and Bacchos" is listed as present at the Council of that year.[26] He was not likely to have claimed an unfinished church in his title.

To the west, Hag. Sergios and Bacchos shared atrium, forecourt, and propylaea

with its neighbor. Procopius tells us that the narthex was continuous between the two churches, but unfortunately all evidence of such continuity has been destroyed in the successive repairs and rebuildings of the south wall of the narthex (Plate 28). In the lower portions the masonry is an *opus mixtum*, alternating a course of brick with a course of stone; this type of masonry was used to fill the triple doors on the north side. In the upper portions the masonry is the irregular stonework that occurs in the fill and repairs of the south wall. Not a single course of masonry is continuous between the narthex wall and the southwest corner of the church proper (Plate 29). Obviously the southern wall of the narthex has been so radically rebuilt that it is impossible to guarantee the originality of a single feature of it; one can only imagine an entrance here which conformed to Procopius' description. This rebuilding extended across the upper portions of the narthex façade as far as the second window (Plate 24).

The façade of the church also presents difficulties of interpretation. The lovely Turkish portico erected under Beyazit II (1481–1512) obscures the original entrances. Presently only a single entrance opens in the center of the façade, and this is unevenly flanked by three windows, one on the south and two on the north. In the nineteenth century, however, it appears that the façade was balanced with two windows on either side; this is indicated in an unpublished plan by Texier, as well as in Paspates' lithograph of the church (the latter even indicates a fifth, narrower window further to the south, a detail which may or may not be reliable).[27] Most probably all five openings were originally doors, matching the five doorways inside leading from the narthex into the body of the church (Plate 37); the other early Constantinopolitan churches all show multiple front entrances of three, five, or seven doors. The central door would have been larger than the side doors. The middle arch leading from the narthex into the body of the church is slightly higher and larger than the side ones and is referred to in the *De ceremoniis* as the "Royal Door."[28]

The north wall of the narthex has also been revised, this time with the addition of a Turkish portal (Plate 33f). The stonework obscures the brick surface on the outside and plaster covers it on the inside; but the large doorsill (about 2.2 m. wide) visible on the inside seems to belong to the original Byzantine door at this point.

The south flank of the church, as we have already explained, communicated on ground and gallery level with Hag. Petros and Paulos. The north side of the church seems also to have communicated with neighboring structures. Again Ebersolt has observed the wall more closely than anyone else (Figure 22), and a few details can be added to his observations (Plates 33–36 and Figure 23). The western half of this wall is regular in plan, its masonry undisturbed with the exception of a crack that appears along the western corner (Plates 33e–f). In the middle bay, however, one finds a triple arcade on both the ground and gallery levels. On the ground floor the arches rest on substantial cornices on either side and on two impost blocks in-between (Plates 33c–d). Apparently a tall triple entrance reaching from floor to ceiling was originally here; the cornices and imposts match the height of the cornice of the piers inside, on which the architrave rests. On the gallery level also the arches rest on a cornice at either side, at the same height as the gallery cornice within the church; the imposts are not evident

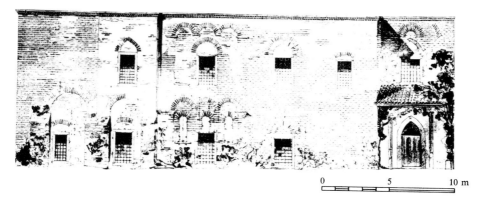

Figure 22. Hag. Sergios and Bacchos. North wall, elevation (Ebersolt)

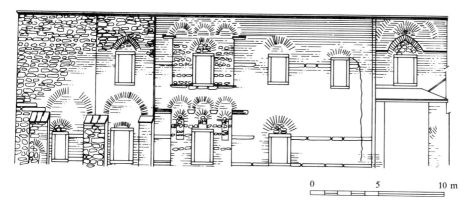

Figure 23. Hag. Sergios and Bacchos. North wall, elevation

in the gallery opening. Beneath this triple opening flooring-slabs are visible at the same level as the flooring of the gallery (Plates 32 and 33d). The brick masonry above the triple arches on both levels has been much disturbed, as if vaulting or roofing had been torn away here.

Further east, the structure of the wall is much more irregular both in plan and in masonry. It steps out a half-meter and then recedes again; three spur walls jut out from the surface in the lower story (Figure 19). The rationale for these irregularities is hard to explain. Between the two buttresses appear two large arches; the masonry filling them is genuinely Justinianic, including even courses of greenstone in the eastern one (Plate 33a and Figure 23). The first and third buttresses are composed substantially of Justinianic brick and are bound into the wall. The first spur wall (i.e., the one at the eastern corner) contains the springing of an arch about a meter from the ground

(Plate 35 and Figure 23); the springing of a second arch and the completion of a third occur at various heights in the eastern wall at this corner (Plate 36). The occurrence of arches in such strange positions and at such differing heights suggests the possibility that they belonged to a stair, but the evidence is insufficient to decipher satisfactorily. On the gallery level, the entire northeast corner of the building has been rebuilt in irregular stone (Plate 34 and Figure 23). The most one can say is that another building joined Hag. Sergios and Bacchos at the northeast corner, and that the spur walls must have belonged to this other structure. It is very possible that the two communicated through the corner niches of Hag. Sergios and Bacchos, for the northeast niches are .55 m. wider than those in the other corners of the church. In any event, the two buildings certainly communicated through the triple arches of the middle northern bay.

The Hormisdas palace to which the two churches belonged was probably the structure to which Hag. Sergios and Bacchos was joined on the north side. The *De ceremoniis* account of the Imperial liturgy for Easter Tuesday implies that a stair was located within the palace structure at this point and that the two intercommunicated. At the time of Communion the priest, in procession with other priests, is said to ascend to the Emperor's oratory in the gallery carrying the Eucharist; but a formal procession carrying the Eucharist is hardly possible on the present narrow, steep narthex stair, nor would proper ceremonial have had the priest passing through the entire church and narthex in order to reach the Emperor. Moreover, after the liturgy the Emperor is said to leave his oratory, "pass through the katēchumenon [i.e., gallery], and descend to the triclinium." This rubric seems to presuppose the use of a stair descending from the gallery into the triclinium within the palace quarters.[29] Unfortunately we have no information on the layout of the Hormisdas palace; Janin collected the scattered references in the historians, but they are few and, significantly, stop with the tenth century.[30] Possibly it was at this time that the ancient palace, first begun by Constantine, was finally abandoned for newer foundations.

Both van Millingen and Ebersolt indicate the narthex stair as an addition on their plans (Figures 19 and 24), and its insertion has been awkwardly handled: it probably blocks an entrance from the atrium at this point, and it renders useless the southernmost bay of the narthex and of the narthex gallery. If the little arch inserted over the stair is any indication of the date of the stair, it must have been installed in Middle Byzantine times (Plates 37–38). Van Millingen took this for a fragment of the original iconostasis of the church, but it has nothing in common with the other architectural sculpture there.[31] Its workmanship is delicate, dry, and formal, entirely lacking the vigor of sixth-century carving. The stair itself is mentioned in the *De ceremoniis*, giving us a tenth-century *terminus ante quem*; upon his arrival from the hippodrome, the Emperor was received and incensed at the door of the church before ascending to the katēchumenon.[32]

Nothing at all survives of the sanctuary furnishings, unless there is evidence concealed beneath the present wooden floor. Ebersolt made the observation, however, that the beautiful architrave carrying the dedicatory inscription is broken off sharply at the

corner of the northeast pier (Plate 25; the corresponding corner on the southeast pier is now covered by the mimber).[33] Ebersolt proposed that where the architrave breaks off, the architrave of the sanctuary barrier must have begun. Thus his reconstruction makes the barrier follow a straight line from pier to pier;[34] the sanctuary then seems to have been the square bay between the apse and the two eastern piers of the octagon, and one might imagine the altar centrally located in this space. In the arches on either side of this sanctuary bay, one can observe a single step-up in the pavement under the wooden floor.

The twin churches of Hag. Sergios and Bacchos and Hag. Petros and Paulos present a rather more involved liturgical plan than the earlier basilicas. The doubling of the churches, their sharing of narthex and atrium, their intercommunication with one another and with the neighboring palace are all complicating factors. But a certain basic continuity of church planning is still evident. To the west the church plan was developed with narthex, atrium, and even propylaeum, though only the narthex of Hag. Sergios and Bacchos now survives. To the east, on the other hand, the plan of Hag. Sergios and Bacchos is simple—a single sanctuary, not accompanied by subsidiary rooms or chapels. As in the early basilicas, the interior space of the church is distributed between ground floor and gallery; and as at the Studios basilica, the gallery wraps around the nave on three sides. The sanctuary, like that of the Saray basilica, seems to have been set back from the nave rather than projecting into it, and the chancel barrier probably ran straight across. Nave and aisles were open to one another without intervening barriers, and the plan of the ground floor opened up through a great many entrances, even through some of these were to the neighboring church and palace. In the original plan access to the gallery may have been restricted in order to give it the character of a private Imperial oratory; but access to it from Hag. Petros and Paulos may have made up for this.

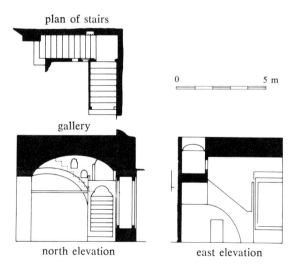

plan of stairs

0 5 m

gallery

north elevation east elevation

Figure 24. Hag. Sergios and Bacchos. Stair in narthex (plan and elevations)

Hag. Polyeuktos

Anicia Juliana's flowery and somewhat tedious dedicatory inscription, which has been preserved in the *Greek Anthology*,[35] supplied both identification and date for the remains of Hag. Polyeuktos when fragments of the inscription came to light.[36] Since it mentions her children and grandchildren but not her husband, the church must be dated between the death of Juliana's husband in 512 and her own death in 527–28. A miracle story of Gregory of Tours permits one to place the completion of the church at the start of Justinian's reign in 527,[37] and a scholium on the verses in the *Anthology* offers the information that it took three years to build the church.[38] In date, then, the church seems to lie between the two preceding foundations of Justinian; its destruction is also fairly accurately dated on the basis of coin finds to a time shortly after the reign of Isaac II (1185–95).[39] Unhappily, it is not possible to be this precise in describing its plan.

The discovery of the inscription fragments in 1960 led to an extensive excavation of the site, which in the summer of 1968 was in its fifth and final season.[40] A wealth of extraordinary architectural sculpture has been discovered, as well as fragments of the mosaic and marble revetment that decorated the interior. But of the church itself not a single wall is standing; nothing remains above the substructure, which is a massive foundation platform of brick-vaulted corridors and mortared rubble fill. Any hypothetical reconstruction of the church on this basis will obviously have to await the final publication of the excavation. The foundations give only tantalizing hints of what the superstructure may have been.

The plan of the atrium was the main objective of the last season's excavation (Figure 25). It is now clear that a marble-paved atrium, better called a forecourt because of its lack of colonnades, lay west of the church. This forecourt was on axis with the main entrance but was much narrower than the church itself. The forecourt was long and narrow, measuring over 38 m. in length (its western limit is uncertain) and about 26 m. in width. To the north Harrison found a long corridor or cryptoporticus, beyond which lay the foundations of a square centrally-planned structure with an apse at the east pierced by a doorway. Since the sources tell us that Anicia Juliana's residence was located next door to the church ("erat enim proximum domui eius"), it is likely that these foundations were the substructure of her home;[41] further evidence, however, is lacking. Thus at the north the forecourt was bordered by the foundations of a neighboring structure, whereas at the south the site remains unexcavated; at the east the narrow court gave access to the sub-narthex of the church on the ground level through four doors, two on either side, while it communicated with the narthex itself by a grand, broad stair, 8 m. wide and about 5 m. high. The sub-narthex consists of a long vaulted corridor extending the entire width of the church, and it is safe to assume that the narthex proper followed a similar plan.

Only the general lines of the church can be inferred from the plan of the foundation. It must have been divided into a nave and two aisles by an arrangement of piers and colonnades running along the lines of the two powerful, seven-meter-wide, mortared

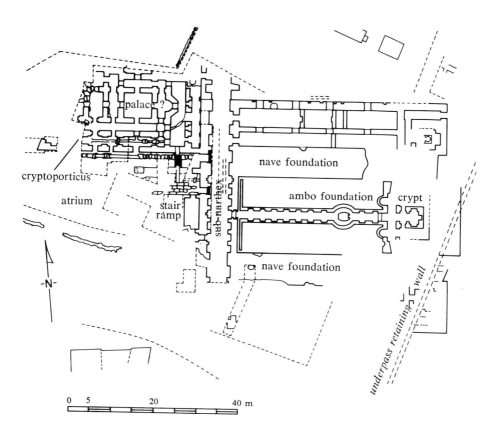

Figure 25. Hag. Polyeuktos. Plan

rubble foundation walls (Figure 25). As Harrison proposes, the exceptional width of these foundation walls must have accommodated the six elegant peacock exedrae, three on either side.[42] These exedrae and the intervening columns certainly sustained galleries above, for the inscription refers to "columns on columns" and "one story on another."[43] Whether the galleries in turn sustained a brick dome or simply a timber roof cannot be securely decided on the basis of present evidence; both the inscription and the story of Gregory of Tours speak of the gilded ceiling in ambiguous terms that could refer either to vaulted or timber-roofed constructions. But the strength of the foundations seems to argue to a vaulted construction, and it would be surprising if a building of such rich and refined decoration were not roofed in the latest and most ambitious architectural fashion.

Of the interior disposition of the church the only certain detail seems to be the location of the ambo in the center of the nave, about two-thirds of the way from the narthex. This, indeed, is the only apparent explanation for the great oval foundation

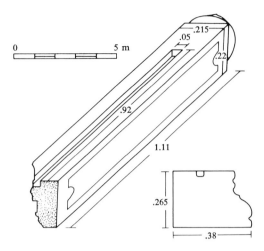

Figure 26. Hag. Polyeuktos.
Profile of stylobate and isometric of chancel pier

that occurs at this point.[44] In the substructure a vaulted passageway leading from the sub-narthex to the crypt under the sanctuary divides at the ambo foundation to circle it on both sides. It is tempting to imagine a solea above following the same lines from the narthex entrance to the sanctuary. A solea reaching the entire length of the church would not, as we shall see, be inconsistent with the Early Byzantine liturgy; but we know of no precedent in Constantinople for such an arrangement.[45] It seems logical to suppose that the north-south foundation wall which lies a bit to the east of the ambo foundation supported the sanctuary enclosure, and that the little crypt under the sanctuary marks the site of the altar. The way in which the corridor opens right and left in front of the crypt may indicate that access to the crypt was had through stairs on the right and left of the sanctuary; but on these points archaeological evidence is simply lacking.

Thousands of fragments of colonnettes, piers, slabs, stylobates, and other marble furnishings of the church survive, and it is difficult to isolate the sanctuary furnishings before a complete tabulation of the finds has been made. Slabs were found in abundance, which may have either belonged to a chancel enclosure or served as gallery parapets. But several piers surmounted by colonnettes have survived which must have belonged to the chancel barrier (Plate 39 and Figure 26), and these indicate a screen of full height carrying an architrave above, as at the Studios basilica. The piers held chancel slabs of about .92 m. height. The stylobate for this screen should probably be identified with three or four pieces of verd antique that survive, one piece of which shows the heavy wear of a doorsill (Plate 40 and Figure 26). The relative scarcity of these pieces must be due to the greater value of the colored marble, which made it a special object for looters after the collapse of the building.[46] The glass-inlaid marble columns of which three fragments were found must have belonged to the altar ciborium

(Plate 41),[47] as their size (.37–.43 m. in diameter) and their special richness seem to indicate.

The plan of the east end of Hag. Polyeuktos, unfortunately, is even less clear than the rest of the building.[48] A large rectangular foundation of mortared rubble supported the apse, but the lines of the latter are unknown. At either side of this foundation, but separated from it by about five meters, were found other brick-vaulted substructures. The plan of the one on the south was not completely laid bare, but it seems to mirror that of the one on the north. The latter showed a narrow north-south corridor with two chambers opening from it to the east: one square (through which a well shaft was later sunk), and the other (at the north) a barrel-vaulted corridor ending in a little post-and-lintel opening which would have been either a door or a window. These foundations must have supported some kind of structures at the northeast and southeast corners of the building; but, as Harrison points out, "a complex of sub-structures of this kind need bear no relation (except in outline) to the floor it supports."[49] The shape of these structures and their manner of access is therefore entirely unknown, but the fact that they were not entrances is clear since they would have been about five meters above the natural ground level. On the other hand, there is no reason to believe that they represent a triple sanctuary plan; the space intervening between the apse foundation and the flanking foundations indicates that the structures above did not communicate directly with one another. One might suggest that stairs to the galleries were provided here, as they were at the northeast and southeast corners of Hagia Sophia, the only Constantinopolitan church that presents any parallel in plan to this feature.

Apart from the grand central stair leading up to the narthex, little can be said of the sort of access that was had to the church itself; but it would be extraordinary if this were the only entrance to the body of the church. Possibly the narthex had stairs at the northern and southern ends as well; and if the structures north of the forecourt can be identified with the residence of Anicia Juliana, the latter must have communicated directly with the church. Entrances to the crypt system under the church were provided from the sub-narthex.

Hag. Iōannēs Prodromos in Hebdomon

The Church of the Baptist in the Hebdomon section (modern Bakirköy), about four km. outside the Golden Gate, was excavated in a perfunctory fashion by French soldiers under the direction of R. Demangel in 1921–23 and published only much later in 1945.[50] What little remained of the church was destroyed in 1965 when the site was cleared for a hospital of the Sosyal Sigortalar Kurumu.

The church has attracted all too little notice, though its importance is quite considerable. Before the excavation Wulff had already recognized from his reading of Procopius that the structure was closely related to Hag. Sergios and Bacchos and to S. Vitale in Ravenna.[51] The Hebdomon suburb was the Versailles of the Byzantine

Emperors, a summer residence consisting of the Magnaura and Iucundianae palaces; it was here that the Emperor, returning from foreign wars, was first received and began his triumphal procession into the city.[52] Justinian erected two other churches in the town, Hag. Theodotē and Hag. Mēnas and Mēnaios,[53] but the Church of the Baptist was by far the most important of the three foundations. The church was the shrine of the head of St. John and served as a special Imperial chapel, since it was the coronation site for a long series of Emperors.[54]

While the archaeological evidence is not extensive, the skeleton of the building can be traced, and this evidence is supplemented by the description in Procopius.[55] Procopius' description refers to Hag. Iōannēs obliquely, describing first the church of Hag. Michaēl in Anaplous and then adding that "this same description can be applied as well to the shrine of John the Baptist, which the Emperor Justinian recently dedicated to him at Hebdomon, as it is called. For these two shrines happen to resemble each other closely, except that the shrine of the Baptist chances not to be on the sea." Procopius uses the same term ἐμφερέστατα ("very similar") to describe the resemblance of Hag. Iōannēs in Ephesus to the Church of the Apostles.[56] At the same time, he supplies us with a date for the completion of the building, for he says it had been "recently" dedicated; this would mean shortly before 560, the approximate date of his writing, or twenty-five to thirty years later than Hag. Sergios and Bacchos.[57]

An earlier church on the same site was built by Theodosius the Great who, according to the historians, brought the head of John the Baptist from Cyzicus and built a beautiful basilica for it in Hebdomon.[58] The identification of the site with Justinian's Church of the Baptist rests principally on Procopius' and Pseudo-Codinus' references to it as a centrally-planned structure.[59] Prior to the excavations two other identifications of the site had been advanced: Glück identified it with the church of Hag. Iōannēs Theologos, in the belief that he was dealing with the remains of a basilica,[60] and Thibaut identified it with another Justinianic church, Hag. Theodotē.[61] But the latter is known only as having been located in the "campos" or military training ground which Demangel convincingly locates on the other side of the tribunal, about a kilometer east of our site.[62] There remains, then, the identification with Justinian's centrally-planned shrine of the Baptist.

Further confirmation of the identification of the church may be found in the Justinianic character of some of the sculptural fragments discovered. A colonnette was found, decorated with an overall inlay pattern of diamonds and triangles in a technique closely resembling that of the colonnettes from Hag. Polyeuktos and that of Hag. Euphēmia (compare Plates 41, 44, 49, and 50). Although the patterns differ, the technique and the idea of decorating the entire surface with inlay in geometric patterns is the same and seems to belong to the sixth century. An unfinished Ionic impost capital, now in the garden of the Ayasofya Museum, is also very close to Justinianic workmanship (Plates 45–46). The general design of the capital is that of the gallery capitals of Hagia Sophia:[63] the Ionic volutes are similarly placed, tucked in under the corners of the impost block, and their decoration is the same; the band that separates the Ionic member from the impost makes the same gratuitous little dip in the center;

the proportions of the impost are the same; and it is surmounted by a little band for decoration (unexecuted). The unfinished state of the work compares well with the two unfinished capitals that lie at the southeast entrance of Hagia Sophia.[64] Another plain Ionic impost capital compares well with capitals from Justinian's church of Hag. Iōannēs in Ephesus.[65]

When Demangel excavated, the only part of the church existing above the foundations was the apse, which had survived to a height of 1.40 m. Made of pure brick in very regular courses with high mortar-beds (a five-course modulus of .437 m., with an average brick length of .357 m.),[66] the apse was unusual in Constantinople in being semicircular on the outside as well as on the inside (Plates 42–43 and Figure 27);[67] our only other example of such an apse is the basilica at Beyazit. It rested on a foundation of large cut stones which Demangel interpreted as the foundation of the apse of the earlier Theodosian church, as the radius is slightly smaller than that of the rising wall; but the foundation walls are often broader than the rising walls, so that a set-back can be observed where one leaves off and the other begins.[68] Beneath the apse lay a crypt with entrances on the basement level to the exterior at the north and south. Such a crypt must have been much more extensive than the little cruciform crypts of Hag. Iōannēs Studios or the Chalkoprateia church, but its plan remains completely unknown. As in our other churches, there is only a single apse. Glück, who thought he was dealing with a basilica, reconstructed a three-apsed plan, and Ebersolt uncritically accepted the reconstruction as fact;[69] but Glück did not report finding other apses, only the beginning of a curve in the foundation north of the apse, which he interpreted as the anteroom to an apse by analogy with the Myrelaion (which, however, is four centuries later). Demangel could report only that the apse had been trimmed a little on its northern and southern extremities where it joined the wall, as if to accommodate something added here.[70] What was added is not known; however, it could not have belonged to the original plan.

Of the body of the church, all that remained were six pier foundations (Figure 27). Five of these radiate on an octagonal plan; the two to the south and the one to the north are complete and measure an impressive 2.40–2.75 m. in width by 6.00 m. in length. Of the two piers flanking the apse, only the eastern half of each was found; the exterior corners of all five fit neatly into the corners of a circumscribed octagon (Figure 28). The sixth foundation pier, that to the west, is an angle pier standing somewhat closer to the center of the octagon.

Such is the sparse archaeological evidence. The literary sources add a good deal to this skeleton, but their interpretation has been the source of much unnecessary confusion. After describing the harbor, the one feature which the Hebdomon did not share with its twin in Anaplous, Procopius tells of the marble courtyard (αὐλή) extending in front of the church and around the sides.[71] Demangel and Ebersolt refer to this as an atrium, but it is described in the text only as a courtyard or open paved area, setting the building apart.[72] Procopius then goes on to say that "a colonnade [στοά] surrounds the church in a circle, excepting only the east side. In the midst stands the church, adorned with stone of a thousand colors."[73] Demangel misin-

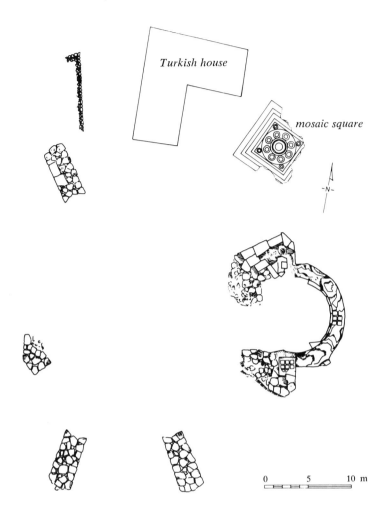

Figure 27. Hag. Iōannēs in Hebdomon. Plan

terprets this by supposing that the stoa refers to the colonnade inside the church,[74] but this is impossible in the context. The description of the interior does not begin until the third sentence following ($\tau\acute{\iota}\ \mathring{\alpha}\nu\ \tau\iota s$. . .); though not always precise, Procopius is usually orderly in his narration, and here he simply follows the path of the visitor to the shrine: first the courtyard, then the porch surrounding the church, then the exterior decoration of the church and dome, and finally the interior structure and decoration. Thus the account continues: "The high roof is raised up in a dome. How could one ever adequately describe the building's galleries, its niches, the elegance of the marble with which the walls and floors are everywhere covered? In addition, an exceptional amount of gold has been poured everywhere in the church, just as if native to it."[75] Dewing has mistranslated this passage entirely, reading the second sentence

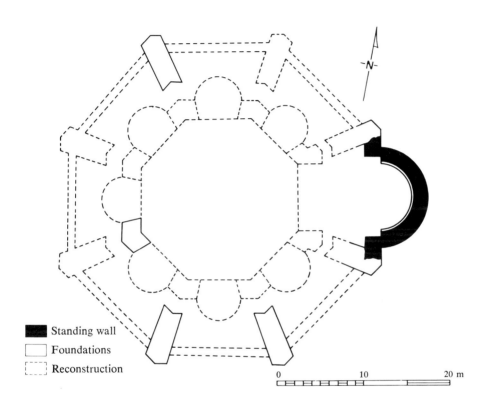

Figure 28. Hag. Iōannēs in Hebdomon. Reconstructed plan

as if it referred to a complex of auxiliary buildings surrounding the church;[76] but again this does violence to the order of the description. Procopius' architectural vocabulary as usual employs a collection of circumlocutions, but the meaning is clear: the galleries are called literally "the elevated stoas" or "the colonnades up above" (τὰς ἠωρημένας στοάς), and the niches are called literally "the receding chambers" (τὰς ὑπεσταλμένας οἰκοδομίας). This is standard vocabulary for Procopius, who consistently describes niches or apses as receding or retreating spaces.[77]

The information about the structure is not copious, but it is clear. We are told of a centrally-planned building preceded by a courtyard and surrounded by a porch, except on the east where the apse would have projected. The structure is domed, and it has galleries; this presupposes an ambulatory beneath the galleries on the ground

floor. Finally, it has a multiplication of niches. Pseudo-Codinus summarizes the character of the building very briefly by calling it "a circular monument with apses" (ὁ δὲ στρυγγολόστεγος ὁ ἔχων τὰς κόγχας).[78] Obviously we are dealing with a double-shell structure, a central dome surrounded by ambulatories on the ground and gallery level as in the most important Justinianic churches, Hagia Sophia, Hag. Sergios and Bacchos, and S. Vitale in Ravenna; the radiating piers must define the outer shell, the single angle pier the inner core (Figure 28). S. Vitale is closest in plan, with its octagonal exterior and its system of radiating piers at the corners taking up the lateral thrust of the dome. The exterior dimensions of the two buildings are almost exactly the same; the diameter of S. Vitale measured at the piers is 39 m. while the corresponding dimension at the Hebdomon is 40 m. The interior octagon of the Heb-domon, however, would have been considerably wider; the diameter of the octagon of S. Vitale, measured wall to wall, is 15.4 m. or 50 Byzantine feet (at .309 m.), while the corresponding dimension of the Hebdomon church is 18 m. or 58 Byzantine feet. If the walls were stepped back from the foundations, as was the case in the apse, this dimen-sion might have been an even 60 feet. In comparison with S. Vitale, therefore, the core of the building has been expanded, requiring a bulkier system of buttresses in the ambulatory zone and at the same time leaving a rather more restricted ambulatory in which to fit them.

Finally, one must reconstruct apses or niches expanding from the central core into the ambulatory, although nothing can be said about their number or distribution. Demangel proposed another solution, namely that the apses were exterior to the octagon as in some of the centrally-planned churches of Armenia,[79] but a number of considerations make this highly unlikely. First, the structural system of the Hebdomon is entirely different from the octagonal churches of Armenia, which are single-shell structures in which the external apses serve as buttresses for the dome; at Hebdomon the buttressing function has been assigned to radiating piers.[80] Secondly, it would be difficult to reconcile a system of exterior apses with the presence of galleries at Heb-domon; none of the Armenian churches has galleries. Finally, Procopius asserts that the surrounding porch was interrupted only on the east, which seems to indicate that only the eastern end was apsed.

In structure, therefore, Hag. Iōannēs in Hebdomon must have followed the same basic principles as S. Vitale: a double-shell octagon, with the domed inner core expanding into the ambulatories in a series of niches. It must have been entered from many sides, since a porch surrounded it on all but the eastern sides. The sanctuary, closely hemmed in by supporting piers, was probably restricted to the eastern section of the octagon. The crypt beneath the sanctuary was entered from the outside at the north and south of the apse.

Fragments of the church furnishings have been discovered: an inlaid colonnette which may have belonged to the ciborium (Plate 44); a small piece of verd antique from the ambo, and a great oval base of white marble very likely from the same ambo;[81] and a fragment of a slab barrier (Plate 47). However, nothing is known of their disposition in the church. Demangel tried to make a prothesis room out of the square

of marble pavement found northeast of the church (Figure 27),[82] but the orientation of the pavement indicates that it belonged to a separate structure not aligned with the church; moreover, the style of the pavement, which relates to the omphalos of Hagia Sophia, requires a date long after the ruin of Hag. Iōannēs.

The decline of the Hebdomon church can be dated to the ninth century when the feast of 5 June, a commemoration of a miraculous deliverance from the barbarians, ceased to be celebrated there and was transferred instead to the nearby church of Hag. Iōannēs Theologos.[83] The last mention of the church concerns a visit by Basil I in 873; later sources are completely silent.[84]

Although the liturgical planning cannot be followed at the Hebdomon in much detail, at least the general outlines are clear. We are informed of the *aulē* or precinct area that lay before and on the sides of the church. Instead of a narthex, the church apparently had a porch or stoa that wrapped around it. At the eastern end we clearly find a single-apsed sanctuary, as at Hag. Sergios and Bacchos; the interior space must also have been distributed more or less as at Hag. Sergios and Bacchos, with a gallery "U"-shaped in plan around the central domed nave. The existence of an ambo is indicated by fragments which were discovered, but its location is unknown.

Hag. Euphēmia

The church of Hag. Euphēmia has been among the most important Byzantine discoveries in recent years. A secular triclinium of the fifth century converted into a place of worship, it forms an important link in Lavin's argument for the takeover of palace architectural vocabulary in Early Byzantine architecture.[85] Its status as a martyrium has made it for Grabar a test case of his theory of the transfer of martyrium forms to Early Byzantine church building;[86] the frescoes, a martyrdom cycle of the thirteenth century, are also an unparalleled series in the capital. Finally, Hag. Euphēmia is of great significance for the history of church planning in Constantinople since it has preserved sufficient archaeological remains to permit a fairly complete reconstruction of the liturgical layout. Synthronon, altar site, chancel barrier, and solea have all left traces or very substantial remnants; only the ambo has disappeared completely.

The discovery in 1939 near the Hippodrome of a fresco cycle depicting the life and martyrdom of St. Euphēmia led to the ready identification of Hag. Euphēmia of Antiochos (ἐν τοῖς Ἀντιόχου).[87] Antiochos, an ambitious praepositus under Theodosius II, erected the building, probably in the years 416–18 (although 431–33 are also possible dates).[88] Situated on axis in the center of a sigma-plan colonnade, the triclinium hall was hexagonal with large niches on all but the entrance side, which were somewhat more than semicircular in depth (Figures 29–30). Little circular porches between the niches enlivened the exterior and provided oblique entrances into the niches. The chief entrance, that from the sigma-plan colonnade, was flanked on the outside by two semicircular niches, each with access to a spiral stair-tower; on the inside it opened into a rectangular niche, presumably barrel-vaulted above. The height of the walls now standing varies between one and three meters (Plate 48).

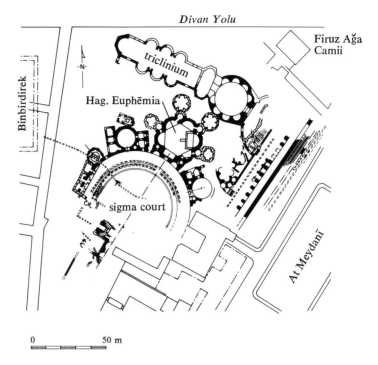

Figure 29. Hag. Euphēmia. Site plan

The *terminus ante quem* for the conversion of the palace hall into a church is the transfer of the relics of S. Euphēmia from Chalcedon by Heraclius, under pressure of the Persian incursions of either 615 or 626.[89] Belting argues for a sixth-century date on the basis of sculptural fragments from the sanctuary barrier, and the evidence is fairly convincing. A critical point of this argument, though by no means its only basis, is his sixth-century dating of the decorative technique of inlaying glass paste in marble, a technique we have encountered at Hag. Polyeuktos and at the Hebdomon church. At Hag. Euphēmia the technique is employed not only on colonnettes from the chancel barrier (Plates 49–50), but also on chancel slabs and on the ciborium arch.[90] Grabar, intent on a seventh-century date for the earliest Christian use of the building, has advanced a ninth-century date for these pieces.[91] He claims parallels with inlay work from the Fenari İsa of Constantinople in the tenth century and the Round Church of Preslav in the ninth, and posits an influence from Middle Byzantine metalwork. At the same time, he mistakes the identity of the colonnette from the Hebdomon and proposes that it came from Fenari İsa in the tenth century;[92] but the inlaid material of Fenari İsa and the colonnettes of Preslav are of quite a different character from the pieces from Hag. Euphēmia, Hag. Polyeuktos, and the Hebdomon. In the latter, the surface is laid out in a continuous grid-type pattern with the colored fill inserted in the interstices of the grid (Plates 41, 44, 49–50). The scheme is both simple and bold and is applied in an overall fashion. In the icon frame of Fenari İsa and the colonnettes of Preslav, on the other hand, the decoration consists of discrete insertions inlaid into a surface that is left basically

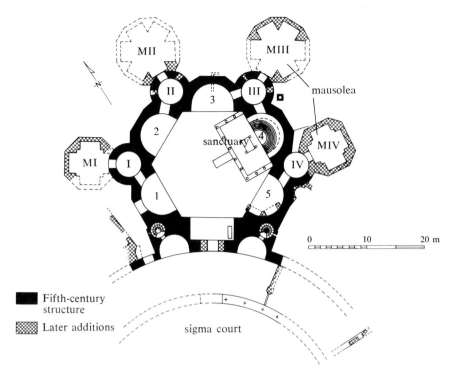

Figure 30. Hag. Euphēmia. Plan

intact:[93] it is not an overall scheme but a delicate, jewellike accentuation of parts of the surface.[94] If we look outside Constantinople for parallels, we find that the sixth-century colonnettes of Amida are, as Belting suggested, much closer to Hag. Euphēmia's pieces than anything at Preslav.[95] In fact, one can point to an exact parallel between the cross-and-octagon design of the chancel slab of Hag. Euphēmia and one of the Amida colonnettes.[96] The inlaid pieces of Hag. Polyeuktos, Hag. Euphēmia, and the Hebdomon church form a fairly consistent group, and this group is best dated in the sixth century.

In addition to the inlaid pieces, a sixth-century date seems to be indicated for most of the other sculptural fragments from the chancel. The octagonal column bases compare well with other octagonal column bases of fifth- and sixth-century date,[97] and the chancel-slab decorations fit convincingly into a sixth-century date. Moreover, the reverse of the inlaid chancel slab repeats a pattern common on sarcophagus frontals from Ravenna in the early sixth century.[98] The other panels employ different patterns—interlaces, quatrefoils, and crosses—familiar in sixth-century chancel slabs elsewhere; moreover, the broad, smooth quality of the carving has nothing to do with the delicacies of Middle Byzantine carving.[99] Only the epistyle seems to be Middle Byzantine and may be assigned (as Belting suggests) to a reworking of 797, when the relics of St. Euphēmia, which had been carried off by the iconoclasts, were returned to

the church.[100] In short, the bulk of the evidence seems to belong to the sixth century, and hence the conversion of the building into a church should probably be dated to that period.

The changes made in adapting the building into a church are instructive from the point of view of church planning, for without introducing any basic structural alterations the architect planned new lines of access to the building and laid out a complete new sanctuary plan. The new sanctuary did not lie opposite the old principal entrance but instead was placed obliquely to the right in the apse, on an axis that points more nearly due east (Figure 30). A new entrance was opened up across from the sanctuary on this new east-west axis; and the old entrance remained in use, although later it was narrowed down.[101] According to Belting, it is not possible to date the introduction of the new entrance archaeologically any more precisely than to say that it precedes the frescoes that overlap it; however, the change seems to be associated with the placing of the sanctuary on the new axis and therefore is probably contemporary with it. The architect must have felt that it was important to provide an entrance directly opposite the sanctuary, for the old entrance was still the more convenient one due to the proximity of other buildings to the new one.

The installation of the sanctuary called for one other change in the system of entrances, as the synthronon blocked the door that originally led to the porch north of the sanctuary (Porch no. III, Figure 30). This lack was overcome by cutting a new door through two meters of heavy masonry from the neighboring apse (Apse no. 3,

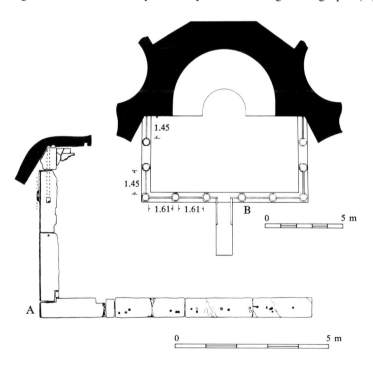

Figure 31. Hag. Euphēmia. Stylobate and chancel (plan)

Figure 30, and Plate 51). Thus the building still had five entrances, including the two flanking the sanctuary. As later at Hag. Eirēnē, these two entrances were eventually closed off with auxiliary rooms, in this case mausolea built sometime after the late sixth century when the neighboring building was destroyed.[102] Belting suggests in passing the possibility that Porch no. III, once it had been closed off, might have served as a diaconicon, but he advances no evidence to support this proposal[103] (in later Byzantine architecture, of course, the room north of the sanctuary is not the diaconicon but the prothesis). These porches were not originally enclosed, however, but were open entryways; they do not seem to have been enclosed before the building of the mausolea, which Grabar reasonably associates with the transfer of the relics of St. Euphēmia in the seventh century.[104] In the sixth century the planning of the hexagonal church must have been just as open as that of the fifth-century basilicas of Constantinople.

The other major alteration in converting the secular hall into a church was the laying out of the sanctuary. The stylobate of the chancel barrier, two-thirds of which is still in place, exhibits markings for the columns and chancel slabs (Plate 52 and Figure 31). The plan is that of the "π"-shaped chancel of the Studios basilica (Figure 8). Three entrances were provided, one in the center and one on each side; the latter are attested to by column bases which were cut to receive chancel slabs on one side but left intact on the other. There are two fewer colonnettes than at the Studios, since those next to the wall are omitted, and the proportions of the plan are slightly wider and shallower. The width is about 10.7 m. and the length 5.2 m., as compared with 9.49 m.

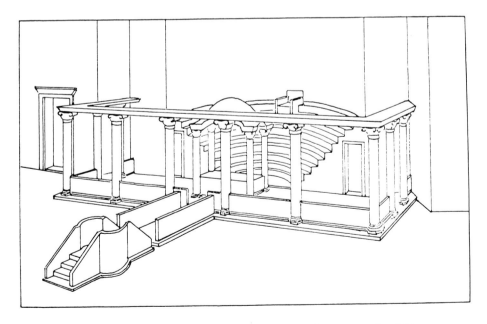

Figure 32. Hag. Euphēmia. Reconstruction of sanctuary furnishings

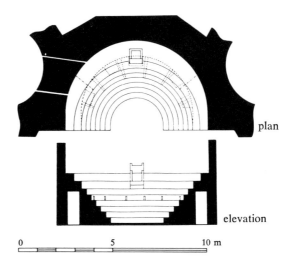

plan

elevation

0 5 10 m

Figure 33. Hag. Euphēmia. Reconstruction of synthronon

and 5.45 m. at the Studios. In front of the central entrance the beginnings of a narrow processional way could be seen in the fittings for parapet slabs. This solea was attached to the entrance in such a way that it was impossible to enter the sanctuary here except through the solea. The solea probably led to an ambo placed in front in the center, where Naumann has reconstructed it (Figure 32), but unfortunately no traces of the ambo were actually found.

As at the Studios basilica, the apse contained a synthronon (Plate 53). The semi-circular tier of benches had a passage underneath, but when excavated it already lacked the vaulting of the passage and the upper ranges of seats. The construction was covered with a marble revetment, and the core was made of a careless fill-masonry which is too nondescript to be datable.[105] However, there is no reason not to date the synthronon in the sixth century with the chancel barrier. The steps now in place indicate a structure such as Naumann has reconstructed (Figure 33): six narrow little benches, .29 m. high and .23 m. deep, rise up to two larger benches. Since the plan of the synthronon is semicircular, in an apse that is deeper than a semicircle, the top bench becomes wider in the deepest part of the apse. The inconvenience of sitting on all but the top bench is obvious, and both Belting and Schneider have remarked on it;[106] the lower steps, therefore, must have been simply steps to the top, as we see in the sixth-century synthronons still intact on Paros.[107] The passageway under the benches was lighted by six slot windows cut through the benches and has five niches on its inner wall.[108] The passage is only .80 m. wide, and the niches are no more than little shelves about .50 m. deep; Belting's suggestion that this space might have been used as a diaconicon, or place for vesting, is most unlikely:[109] there would have been room neither for the vestments nor the clergy.

The sixth-century altar site is identified by the sockets for the altar ciborium (Figure

30) located in the center of the rectangular sanctuary area. The ciborium itself was a massive, monolithic, shallow dome, the crown and border of which have survived;[110] the supporting columns were spaced in the corners of a square 1.80 m. on a side. The form of the original altar is not known, but once the relics of St. Euphēmia were brought to the church in the early seventh century, they were placed within a box-type altar with a confessio. This seems to be the meaning of the references by Constantine of Tios to a box (λάρναξ or γλωσσόκομος) directly beneath the altar table, into which one could put his hand to touch the relics.[111] This is a new variation on the relation of altar to relics, and as Belting suggests, it reopens the whole question of the martyrium in Constantinople.[112] Instead of burying the relics in the crypt as at the Studios, Chalkoprateia, and the Hebdomon, the remains of the saint are introduced into the church itself and deposited under the altar. Grabar's suggestion that the martyr's remains were placed in Niche no. 3 (opposite the entrance from the sigma courtyard) is an a priori hypothesis that has no archaeological evidence behind it and neglects the available information of literary sources.[113] Unfortunately, the original altar has completely disappeared, and Schneider found only the powerful foundations of a later altar.[114] The second altar was rectangular in shape, 2.00 by 1.10 m., and somewhat wider than the ciborium above it.

The liturgical design of Hag. Euphēmia thus appears to have been exactly the same in many features as that of Hag. Iōannēs Studios, although the buildings themselves could hardly be further apart in structural design. Apart from the omission of the crypt, the sanctuary plan was very similar—the same sort of synthronon, the same site for the altar, and the same plan for the chancel barrier. Though the niches right and left of the sanctuary would have easily suited a triple-sanctuary plan, they were not used in this way but were left outside the sanctuary barrier and provided with entrances comparable to the eastern entrances in the aisles of the Studios church. At the west the narthex was missing, but the sigma court could have readily served the functions of an atrium. A gallery is also missing, but these omissions could not have been made up in converting the building to a church without a complete reconstruction. Within the given limits of the preexisting structure, the earlier pattern of liturgical planning was rather closely adhered to.

Beyazit Basilica A

Basilica A near Beyazit Square, along with two other churches, was discovered by accident during the excavations for an addition to the University of Istanbul.[115] The pressure of the contractor's schedule prevented a thoroughly satisfactory archaeological reporting of the finds, and the site was subsequently destroyed by the new building. However, the find is of great importance as it provides the only complete plan of a Justinianic basilica in the capital, and it is surprising that archaeologists have consistently neglected to discuss the excavation.[116]

The Beyazit churches lay north of Ordu Caddesi and east of Büyük Reşit Paşa Caddesi in the immediate vicinity of the ancient Forum Tauri, just west and north of

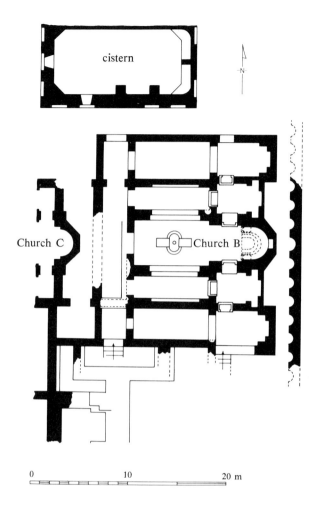

Figure 34. Beyazit Church B. Plan

the remains of the tetrapylon of Theodosius I. All three churches of the site are as yet unidentified, though a number of possibilities are open. Literary sources make references to four churches in the vicinity of the Forum Tauri: (1) Hag. Markos; (2) a church of the Theotokos called τὰ κουράτορος; (3) another church of Hag. Iōannēs Prodromos in Taurus; and (4) Hag. Theodōros by the Bronze Tetrapylon.[117] The sources describe the first two as domed churches, which cannot refer to Basilica A, though one or the other may be connected with Churches B or C.[118] The third and fourth titles, however, are both possible identifications for Basilica A; but unfortunately nothing is known of them except their proximity to the Forum Tauri and their feast days as recorded in the synaxaries.[119]

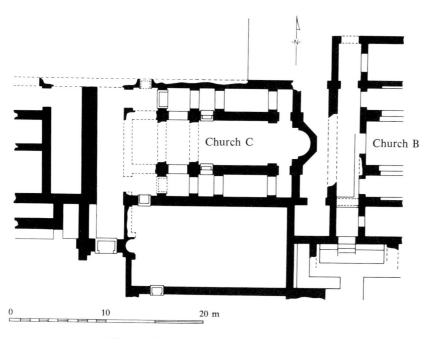

Figure 35. Beyazit Church C. Plan

Firatli has proposed a sixth-century date for Churches A and C and a later date for Church B, since the latter is at a higher level and none of its walls is bonded to those of A and C.[120] Schneider accepted this dating.[121] The fact that the closeness of B to C prevented its having western entrances also suggests that B was built after C (Figure 34). Church C, however, is difficult to fit into the general picture of sixth-century architecture (Figure 35): the plan is quincunx; the walls indicated between "nave" and "aisles" on the plan are foundation walls.[122] This, together with the double narthex and the diminutive scale of the building, all point to a Middle or Late Byzantine date. The fifth-century capitals that were found in the area of Churches B and C (locations not specified) must have been reused from an earlier foundation; both Hag. Markos and the Theotokos church were originally fifth-century foundations.

Only Basilica A, therefore, is securely dated in the sixth century, and this date rests on the workmanship of the architectural sculpture discovered there. Three foliage-covered impost capitals were found which are of the same pattern and high workmanship as the arcade and aisle capitals of Hagia Sophia (Plate 54).[123] They exhibit the same neck and impost bands, the same deeply undercut acanthus, and the same volutes; they are actually so close that one might imagine they had been left over from the construction of the Great Church, except that they are smaller and the leaves are slightly more slender.[124] Three other capitals were found of Ionic impost design (Plate 55).[125] These present slight variations on a type well known from Hag. Iōannēs in Ephesus.[126] The excavation also brought to light fragments of a cornice divided into a series of discrete vertical panels, in a way very similar to a cornice discovered at Hag.

Polyeuktos.[127] The column bases compare well with those in Hagia Sophia; one in particular has a rather unusual design that can be paralleled line for line with examples in the Great Church: a broad half-torus element, followed by a scotia, followed by a broad flat band with a little groove in it.[128] The consistency of such comparisons seems to justify assigning a Justinianic date to Basilica A, a date perhaps contemporary with or soon after Hagia Sophia.

Figure 36. Beyazit Basilica A.
Profile of ambo base

The ambo is the most impressive of the church's sculptural remains; it has been preserved almost entire and reassembled in the Ayasofya Museum garden (Plates 56–58 and Figure 36).[129] It is of singular importance, as it is the only ambo that has survived from the Early Byzantine churches of Constantinople. The workmanship is fine, the profiling deep and bold; the decoration consists of a repetition of simple crosses in high relief. The plan is familiar from parallels in Greece and Ravenna: a platform with steps leading up from either side. The surprising aspect is its size; in a church of such modest dimensions (only 50 Byzantine ft. long), an ambo seven steps high and approximately 3 m. long must have made a grand impression. It was obviously the most important focus of attention in the nave of the church. The material, a lovely red-veined marble that must have been acquired at considerable expense, matches its architectural importance. The ambo's exact location within the church, however, is unknown.

The planning of Basilica A presents a number of features that are not encountered in the other fifth- and sixth-century churches of Constantinople (Figure 37). The narthex extended across the entire façade and beyond the width of the church on either side. It opened at the west into an area that might have been an atrium but

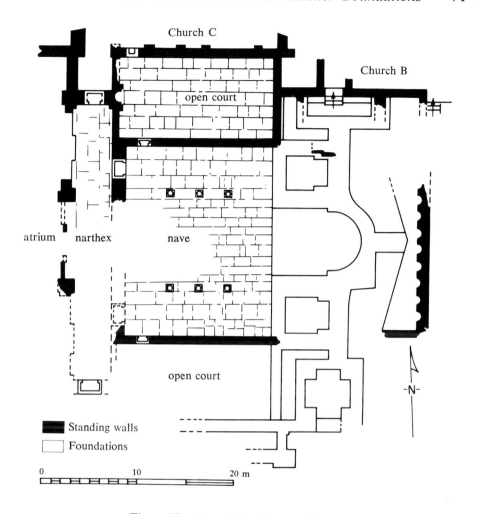

Figure 37. Beyazit Basilica A. Plan

which was not excavated, with a triple entrance in the center and possibly other entrances on either side. At the north it had a little square entrance bay, with another at the south, since a doorsill was found *in situ* there. The total length of the narthex was about 38 m.: a considerable size, longer even by a meter than the narthex of Hag. Eirēnē. In contrast to this spaciousness, the body of the church was relatively small, and wider than it was long. The interior width was 19 m. and the length 15.40 m., approximately 60 by 50 Byzantine feet (at .315 m.). The additional width of the narthex was accounted for by open paved courtyards that flanked the church on either side. These courts extended the length of the body of the church; the one on the south was 7.5 m. wide (interior dimension), and the one on the north 8.0 m. Both courts communicated with the church through doorways into the westernmost bay of either aisle. The northern court also communicated with the exonarthex of Church C to the north, and it preserved in its western wall a semicircular niche set between piers, about 1.35 m. in

diameter. We have no evidence of the sort of shrine this niche may have housed. A barrel-vaulted cistern was found beneath the north court.[130]

The body of the church was divided into a nave and two aisles by little colonnades whose bases have remained *in situ*, three on either side. Here for the first time we encounter a feature that is not evident in any of the other early churches: the column bases were cut on either side in order to fit parapet slabs in the intercolumniations, thus forming a barrier separating the aisles from the nave. While many parallels for such barriers can be found in Greece, in Constantinople it seems to have been an exception.

In the east end of the church nothing has survived above the foundations, which as indicated on the plan (Figure 37) were much wider than the rising walls.[131] The apse, which appears to have been semicircular on the outside as well as on the inside, was separated from the body of the church by a rectangular sanctuary bay, an arrangement that recalls the plan of the little Saray basilica (Figure 17). This bay measured 5.5 m. deep and 6.7 m. wide at the foundations. The fact that the pavement of the nave was intact up to the edge of this bay suggests that the barrier separating the sanctuary from the nave followed this line straight across.

North and south of the sanctuary bay stood two small flanking rooms 4.3 by 3.5 m. (at the foundation). Firatli reports finding doorsills in the immediate vicinity of these rooms; since doorsills are too heavy to stray far from their original locations, this fact indicates that these chambers were used as entrances giving access to the east of the church.[132] The area at the east of the church was designed as still another courtyard, enclosed on the east by a retaining wall set into the rising terrain and decorated with niches in which traces of mosaic and fresco were found;[133] thus entrances at the east of the church are to be expected. A straight wall enclosed the courtyard on the south, while on the north it apparently communicated with the later Church B. The niched wall was continued east of Church B (Figure 34).

Further to the north and south, the eastern entrances were in turn flanked by other complex chambers. Those on the north seem to have been halved in the construction of Church B, leaving one very narrow chamber running east-west, with an entrance at the north to Church B and one little "L"-shaped chamber. At the south the design is more intelligible; a little cruciform chapel opens to the south and an "L"-shaped space is left over between the chapel, the south court, and the church proper. The fact that the entrances in both cases led away from the church may indicate that these structures were later than the church, or at least were not planned as integral parts of the church itself. They must have lain beyond the roof-line that included the aisles of the church and would have been roofed (or vaulted) separately.

The Beyazit basilica presents an interesting contrast to the basilicas of the fifth century. While the body of the church was much smaller and simpler and lacked galleries, the surroundings of the church were more fully developed: the narthex was extended to the north and south, and courtyards were laid out in a very formal fashion at the north, south, and east of the church in addition to the atrium which probably preceded it at the west. One might almost say that the approaches to the church were more important than the church itself. The liturgical design followed that of the Saray

basilica, with the sanctuary added onto the nave instead of projecting into it; here, however, the aisles were clearly segregated from the nave. In addition, the church has supplied us with the one complete ambo that survives from Early Byzantine times in Constantinople.

The evidence of the smaller Justinianic foundations is more difficult to summarize than that of the early basilicas. The two basilicas in the group, Hag. Petros and Paulos and Beyazit A, serve to remind us of the strength of the basilican building tradition throughout Justinian's reign, despite the new style of central domed buildings. If Procopius' account represents the situation accurately in this regard, we must surmise that Justinian's foundations included as many basilicas as centrally-planned churches. Of the thirty-three Justinianic churches mentioned by Procopius, only ten are described in sufficient detail to inform us of their plans. Of these, one (the Apostles' church) is cruciform, four are domed, centrally-planned buildings (Hagia Sophia, Hag. Sergios and Bacchos, Hag. Iōannēs in Hebdomon, and Hag. Michaēl in Anaplous), and five are basilicas. Two of the basilicas, Hag. Akakios and the Blachernes Church of the Virgin, were restorations or rebuilding projects of preexisting basilicas. The other three, however—the church of Hag. Anthēmios on the Horn, Hag. Michaēl in Sinator, and Hag. Petros and Paulos—were built entirely anew. Thus a strong conservative tradition of basilica building must have persisted alongside the dramatic introduction of new church types.

Conservative, too, is the only word to describe the liturgical planning involved in the churches of this group as a whole. The development of the western end of the church with narthex and atrium persisted; all of the churches apparently had atria (with the possible exception of the Beyazit), and only Hag. Euphēmia lacked a narthex. The eastern end is equally consistent, with its single sanctuary apse which sometimes, though not always, had entrances at either side. The sanctuary furnishings, wherever they are in evidence, also repeat earlier plans. The synthronon and chancel barrier of Hag. Euphēmia repeat those of the Studios, and the straight chancel plans of Hag. Sergios and Bacchos and the Beyazit church repeat that of the Saray basilica; the ambo in the center of the nave at Hag. Polyeuktos and the solea at Hag. Euphēmia repeat the plan of these features at the Saray basilica. In general, a similar openness of plan characterizes all of the churches, except for the apparently anomalous occurrence of stylobate barriers between the nave and aisles at the Beyazit church.

Notes

[1]Van Millingen, *Byzantine Churches*, pp. 62–83; Ebersolt and Thiers, *Les églises*, pp. 21–51; C. Gurlitt, *Die Baukunst Konstantinopels* (Berlin, 1912), I, 18–20.

[2]Paul A. Underwood, "Some Principles of Measure in the Architecture of the Period of Justinian," *CA* 3 (1948), 64–74.

[3]Piero Sanpaolesi, "La chiesa dei ss. Sergio e Bacco a Costantinopoli," *Rivista dell'istituto nazionale d'archeologia e storia dell'arte*, n.s. 10 (1961), 116–80. Otto Feld has corrected several mistakes in Sanpaolesi's article and added a few observations of his own. "Beobachtungen in der Küçük Ayasofya zu Istanbul," *IM* 18 (1968), 264–69.

⁴*The Great Palace of the Byzantine Emperors*, pp. 52–104.

⁵Theophanes, *Chronographia*, I, 220.

⁶*Buildings*, I, 4, 1–8, pp. 42–49; *The Greek Anthology*, trans. W. P. Paton, Loeb Classical Library (London, 1916), I, 8, pp. 4–7.

⁷*Epistolae imperatorum pontificum aliorum*, CSEL 35, pt. 2 (Vienna, 1898), 679–80.

⁸Charles Diehl, *Justinien et la civilization byzantine au VIᵉ siècle* (Paris, 1901), p. 5.

⁹The phrase ἐκ πλαγίας does not mean "at an angle to" as Dewing has translated it, but "alongside" or "on the flank" in a military sense. *Buildings*, I, 4, 3 and 4, pp. 44–45. On the shared narthex of the churches, see I, 4, 7, pp. 44–45.

¹⁰Van Millingen, *Byzantine Churches*, p. 66.

¹¹Ebersolt and Thiers, *Les églises*, pp. 37–38.

¹²A. G. Paspates, *Byzantinai meletai topographikai kai historikai* (Constantinople, 1877), p. 334.

¹³*CA* 3 (1949), 64–74.

¹⁴Sanpaolesi, "La chiesa dei ss. Sergio e Bacco," pl. I.

¹⁵*Buildings*, I, 4, 6, pp. 44–45.

¹⁶Ibid., I, 4, 7, pp. 44–45, 48–49.

¹⁷Ibid., I, 4, 7–8, pp. 48–49.

¹⁸See references in Janin, *Géographie*, pp. 451–53.

¹⁹Petrus Gyllius, *De Constantinopoleos topographia* (Lyons, 1632), II, 14, pp. 137–40.

²⁰*Buildings*, I, 4, 1 and 9, pp. 42–43 and 48–49; van Millingen, *Byzantine Churches*, p. 56.

²¹Transcription and translation of the inscription on the architrave of Hag. Sergios and Bacchos in van Millingen, *Byzantine Churches*, pp. 73–74.

²²Cedrenus, *Historiarum compendium*, I, 642–43.

²³H. Swainson, "Monograms of the Capitals of S. Sergius at Constantinople," *BZ* 4 (1895), 106–8.

²⁴Procopius, *Anecdota*, trans. H. B. Dewing, Loeb Classical Library (London, 1935), IX, 53–54, pp. 118–21; Diehl, *Justinien*, pp. 39–40; Procopius, *Buildings*, I, 10, 4, pp. 80–81.

²⁵R. Krautheimer, *Early Christian and Byzantine Architecture*, p. 162.

²⁶*Mansi* 8, 1010E. Cf. 882C, 930D.

²⁷Drawing in the Royal Institute of British Architects, London, album I, SS. Sergius et Bacchus, sheet 1; A. G. Paspates, *Byzantinai meletai*, facing p. 332.

²⁸*De ceremoniis*, I, 20 (11), ed. Vogt, pp. 79–80.

²⁹Ibid.

³⁰R. Janin, *Constantinople byzantine* (Paris, 1950), pp. 333–34.

³¹Van Millingen, *Byzantine Churches*, p. 71.

³²*De ceremoniis*, I, 20 (11), ed. Vogt, p. 79.

³³Ebersolt and Thiers, *Les églises*, p. 29.

³⁴Ibid., pl. XI bis, reconstruction.

³⁵*Greek Anthology*, I, 10, trans. Paton, I, pp. 6–11.

³⁶Cyril Mango and Ihor Ševčenko, "Remains of the Church of St. Polyeuktos at Constantinople," *DOP* 15 (1961), 243–47; cf. an earlier note by Ševčenko, in *Byzantion* 29–30 (1959–60), 386.

³⁷*Libri miraculorum*, I, 103, *PL* 71, 793–95.

³⁸*Anthologia graeca*, ed. H. Stadtmüller (Leipzig, 1894), I, 6, note on lines 5–6.

³⁹R. M. Harrison and Nezih Fıratlı, "Excavations at the Saraçhane in Istanbul: Fourth Preliminary Report," *DOP* 21 (1967), 275. Cf. Janin, *Géographie* pp. 405–6.

⁴⁰R. M. Harrison and Nezih Fıratlı, "Excavations at the Saraçhane in Istanbul," *DOP* 19 (1965), 230–36; 20 (1966), 222–38; 21 (1967), 272–78; 22 (1968), 195–216. Briefer reports in R. M. Harrison and N. Fıratlı, "Discoveries at Saraçhane, 1964," *Yıllıc* 13–14 (1966), 128–30; M. J. Mellink, "Archaeology in Asia Minor: Istanbul—Saraçhane," *AJA* 69 (1965), 149; 70 (1966), 159; 71 (1967), 173. On the foundress of the church, see Carmelo Capizzi, "Anicia Giuliana (462 ca–530 ca): Ricerche sulla sua famiglia e la sua vita," *Rivista di studi bizantini e neoellenici*, n.s. 5 (1968), 191–226.

⁴¹*Libri miraculorum*, I, 103, *PL* 71, 794.

⁴²*DOP* 21 (1967), 276.

⁴³*Greek Anthology*, I, 10, lines 56 and 69, trans. Paton, I, 10–11.

⁴⁴*DOP* 20 (1966), 225.

⁴⁵Solea barriers that reach more than two-thirds the length of the nave are known in Rome at S. Clemente, S. Marco, and S. Pietro in Vincoli. Cf. Mathews, *RAC* 38 (1962), 73–75.

⁴⁶I am indebted to Mr. Harrison for letting me study and photograph these fragments, and for discussing the whole excavation with me.

⁴⁷*DOP* 19 (1965), 234.

⁴⁸The completion of the underpass of Atatürk Bulvarı required filling in the whole east half of the church, so that none of this is still visible.

⁴⁹*DOP* 19 (1965), 233.

⁵⁰R. Demangel, *Contribution à la topographie de l'Hebdomon* (Paris, 1945).

⁵¹O. Wulff, *Altchristliche und byzantinische Kunst* (Berlin, 1913–14), p. 372.

⁵²R. Janin, *Constantinople byzantine*, pp. 137–39, 408–11.

⁵³Procopius, *Buildings*, I, 4, 28 and I, 9, 16; pp. 54–55 and 78–79.

⁵⁴Ebersolt, *Sanctuaires de Byzance*, pp. 79–81; Janin, *Géographie*, pp. 413–15.

⁵⁵*Buildings*, I, 8, 1–16, pp. 68–73.

⁵⁶Ibid., V, 1, 6, p. 318.

⁵⁷Ibid., introduction, p. ix.

⁵⁸Sozomenus, *Historia ecclesiastica*, VI, 21, *PG* 67, 1481–84; *Chronicon paschale*, I, 564; Nicephorus Callistus, *Eccl. hist.*, XII, 49, *PG* 146, 916–17.

[59]*Script. orig. Const.*, II, 260.

[60]H. Glück, *Das Hebdomon und seine Reste in Makriköi*, Beiträge zur vergleichenden Kunstforschung, vol. 1 (Vienna, 1920), p. 30.

[61]Jean-Baptiste Thibaut, "L'Hebdomon de Constantinople," *Echos d'orient* 21 (1922), 31–44.

[62]Janin, *Géographie*, p. 146; Demangel, *Hebdomon*, pp. 5–16 and fig. 1.

[63]Cf. Kähler, *Hagia Sophia*, pl. 77.

[64]Cf. ibid., pls. 78–79.

[65]Compare Demangel, *Hebdomon*, p. 25, fig. 11, with Kautzsch, *Kapitellstudien*, no. 566d.

[66]Demangel, *Hebdomon*, p. 19.

[67]Demangel was not able to oversee the drawing of his plans (*Hebdomon*, p. 17, n. 5), and their execution leaves a great deal to be desired.

[68]This can be observed at Hag. Eirēnē and the Beyazit basilicas in Constantinople, and at Basilica B in Philippi. Lemerle, *Philippes et la Macédoine orientale* (Paris, 1945), pl. LXXX.

[69]Glück, *Das Hebdomon*, p. 30; J. Ebersolt, *Monuments d'architecture byzantine* (Paris, 1934), p. 134, n. 9.

[70]Demangel, *Hebdomon*, pp. 19–20.

[71]*Buildings*, I, 8, 10, pp. 72–73.

[72]Demangel, *Hebdomon*, p. 29; Ebersolt, *Monuments*, p. 144, n. 50.

[73]*Buildings*, I, 8, 12, p. 72. Our translation.

[74]Demangel, *Hebdomon*, p. 29. Ebersolt also mistakes it for an interior colonnade in *Monuments*, p. 144, n. 50; but he interprets it as an exterior porch in *Les églises*, pp. 254–55.

[75]*Buildings*, I, 8, 13–14, p. 72. Our translation.

[76]Ibid., I, 8, 13–14, p. 73.

[77]Procopius has three other similar expressions for apses or niches. *Buildings*, I, 1, 35; I, 2, 4; I, 3, 17; pp. 18, 38, 42.

[78]*Script. orig. Const.*, II, 260.

[79]Demangel, *Hebdomon*, p. 31.

[80]Géza de Francovich, ed., *Architettura medievale armena* (Rome, 1968).

[81]Demangel, *Hebdomon*, p. 28; G. Mendel, *Catalogue des sculptures grecques, romaines et byzantines* (Constantinople, 1912–14), III, 535–37.

[82]Demangel, *Hebdomon*, p. 32.

[83]Janin, *Géographie*, p. 414.

[84]*De ceremoniis*, ed. J. J. Reiske (Bonn, 1829–30), Appendix I, p. 498.

[85]Irving Lavin, "The House of the Lord," *AB* 44 (1962), 1–27.

[86]A. Grabar, "Études critiques: R. Naumann, Die Euphemiakirche," *CA* 17 (1967), 251–54.

[87]Preliminary reports: K. Bittel and A. M. Schneider, "Das Martyrion des hl. Euphemia beim Hippodrom," *AA* 56 (1941), 296–315; A. M. Schneider, "Grabung im Bereich des Euphemiamartyrions zu Konstantinopel," *AA* 58 (1943), 255–89; R. Duyuran, "First Report on Excavations on the site of the New Palace of Justice at Istanbul," *Yıllıc* 5 (1952), 33–38; idem, "Second Report . . .," ibid., 6 (1953), 74–80. Final publication: R. Naumann and H. Belting, *Die Euphemia-Kirche am Hippodrom zu Istanbul und ihre Fresken*, Istanbuler Forschungen, 25 (Berlin, 1966). The loss during the war of Schneider's diary of the excavation makes the final report less definitive than it should have been. I am indebted to Profs. Naumann and Belting for the opportunity of discussing the excavation with them.

[88]Naumann and Belting, *Die Euphemia-Kirche*, pp. 20–21. On the masonry, see J. B. Ward Perkins, in *The Great Palace of the Byzantine Emperors*, pp. 68–69.

[89]*AA.SS.*, Sept., V, 275; Naumann and Belting, *Die Euphemia-Kirche*, pp. 23–24.

[90]Naumann and Belting, *Die Euphemia-Kirche*, pls. 8c, 9a, 11b and c.

[91]*CA* 17 (1967), 253.

[92]A. Grabar, *Sculptures byzantines de Constantinople* (Paris, 1963), pl. 58, 2, and p. 112.

[93]T. Macridy and others, "The Monastery of Lips," *DOP* 18 (1964), 249–317, figs. 74–83; K. Miatev, "Die Rundkirche von Preslav," *BZ* 30 (1929), 561–67, pl. 8, 4–5.

[94]The persistence of this style in Middle Byzantine times must be responsible for inlaid columns in the West (e.g., in Sicily and southern Italy).

[95]Naumann and Belting, *Die Euphemia-Kirche*, pp. 64–67.

[96]Compare Naumann and Belting, *Die Euphemia-Kirche*, p. 58, fig. 21 with M. van Berchem and J. Strygowski, *Amida* (Heidelberg, 1910), p. 158, fig. 78, 9.

[97]Naumann and Belting, *Die Euphemia-Kirche*, pl. 9b and d; cf. Orlandos, *Basilikē*, figs. 217–19.

[98]Naumann and Belting, *Die Euphemia-Kirche*, p. 60, fig. 24; cf. Marion Lawrence, *The Sarcophagi of Ravenna* (New York, 1945).

[99]Naumann and Belting, *Die Euphemia-Kirche*, pp. 74–77, figs. 26–27, and pl. 13; cf. Orlandos, *Basilikē*, figs. 477–78.

[100]Naumann and Belting, *Die Euphemia-Kirche*, pp. 70–71.

[101]Ibid., p. 45.

[102]Ibid., pp. 49–53.

[103]Ibid., p. 45.

[104]A. Grabar, *CA* 17 (1967), 251.

[105]Naumann and Belting, *Die Euphemia-Kirche*, pp. 47–49. Schneider had suggested a seventh-century date on the evidence of the masonry. *AA* 58 (1943), 263.

[106]Naumann and Belting, *Die Euphemia-Kirche*, pp. 93–94; Schneider, *AA* 58 (1943), 263.

[107]cf. Orlandos, *Basilikē*, fig. 452.

[108]Belting speaks of six in the text, but plans show only five. Naumann and Belting, *Die Euphemia-Kirche*, p. 93.

[109]Ibid., p. 93.

[110]Ibid., pl. 11.

[111]*AA.SS.*, Sept., V, 275.

[112]Naumann and Belting, *Die Euphemia-Kirche*, pp. 106-11.

[113]*CA* 17 (1967), 251–54. Grabar has retracted his earlier interpretation which dated the martyrium use of Hag. Euphēmia from the fifth century. A. Grabar, *Martyrium* (Paris, 1943–46), I, 149–50.

[114]Naumann and Belting, *Die Euphemia-Kirche*, pp. 94–95.

[115]Nezih Fıratlı, "Decouverte de trois églises byzantines à Istanbul," *CA* 5 (1951), 163–78. A. M. Schneider published a note of the excavation with an impossibly foggy photograph of the site in "Funde in der Büyük Reşit Paşa Caddesi," *AA* 59–60 (1944–45), 75. I am greatly indebted to Dr. Fıratlı, who discussed the excavation with me and allowed me to study his plans of the site.

[116]Lemerle's bibliographical note was unnecessarily critical, considering the difficulties of the excavation, and by no means closed the question. "Bulletin Archéologique III, 1950–51," *REB* 10 (1952), 193.

[117]Janin, *Constantinople byzantin*, pp. 69–72.

[118]Janin, *Géographie*, pp. 327, 191.

[119]Ibid., pp. 441, 153–54.

[120]Fıratlı, *CA* 5 (1951), 168, 171.

[121]A. M. Schneider, bibliographical note in *BZ* 45 (1952), 222–23.

[122]Fıratlı clarified this in private conversation. Schneider's hypothesis that the building was not a church but a refectory is quite unnecessary. *BZ* 45 (1952), 222.

[123]Cf. Kähler, *Hagia Sophia*, pls. 70–75; Fıratlı, *CA* 5 (1951), pl. III c, d.

[124]The Beyazit capitals measure 1.05 meters at the impost and .40 at the column fitting, as compared with dimensions of 1.24 meters and .66 for the capitals of the gallery arcades in Hagia Sophia. The intercolumniation at Beyazit is scaled down in the same proportion—3 meters as against 3.3 at Hagia Sophia (column-center to column-center).

[125]Fıratlı, *CA* 5 (1951), pl. IV e, f.

[126]Kautzsch, *Kapitellstudien*, nos. 567 a-e.

[127]Fıratlı, *CA* 5 (1951), pl. V c, d; cf. Harrison, *DOP* 20 (1966), figs. 14–15.

[128]Fıratlı, *CA* 5 (1951), pl. V a; cf. Kähler, *Hagia Sophia*, pl. 81.

[129]Fıratlı, *CA* 5 (1951), pl. VI a-c.

[130]Ibid., pl. II d, e.

[131]Ibid., p. 167.

[132]From private conversation with Dr. Fıratlı.

[133]Fıratlı, *CA* 5 (1951), 164.

3 The Greater Foundations of Justinian

Among Justinian's foundations, Hagia Sophia stands apart architecturally and ecclesiastically, and thus it requires separate treatment: its rank as the patriarch's church, its extraordinary size, and its prominence in the history of Byzantine building put it in a class by itself. For similar reasons two other of Justinian's foundations seem also to stand apart from all the other churches of the capital—Hag. Eirēnē, mate and neighbor of Hagia Sophia, and the since-destroyed Church of the Apostles. Architecturally they were far more ambitious than any of the smaller foundations; they were more impressive in height, richer in decoration, and more complex in engineering, with great broad domes carried on massive piers and buttressed by other domes or semi-domes. They were the three largest churches of the city and were also of special importance politically: the Apostles' church was the burial place of the Emperors, and the cathedral complex was their usual place of coronation and preferred place of worship. These churches, or at least the two surviving members of the group, deserve to be considered separately in our investigation of the liturgical planning of Constantinople.

The evidence of liturgical planning at Hagia Sophia and Hag. Eirēnē carries a special weight for several reasons. Here, if anywhere, the ceremonies of the Byzatinne liturgy must have been celebrated in all their purity and solemnity in every respect. The liturgy of the patriarchal churches would have been not only standard but normative, for it set the example for the other churches to follow. In the execution of the architectural design, too, nothing was either haphazard or lacking. We are dealing here with the masterworks of the best mathematicians, architects, and engineers of the day, men who had the command of the Emperor for their inspiration and the treasury of the Empire at their disposal. In these churches, moreover, we fortunately have the advantage of dealing with buildings that have been preserved reasonably complete, in which the beauty of the structure goes a long way toward suggesting the brilliance of the rites for which they were built. Again, one is impressed with the conservative character of the liturgical plan.

Hag. Eirēnē

After Hagia Sophia, Hag. Eirēnē is the largest surviving church in Constantinople; of all the fifth- and sixth-century churches in the capital it was probably surpassed in

size only by the Church of the Apostles. Procopius actually says that it was second only to the Great Church, but he may have been judging from a layman's general impressions rather than from actual measurements.[1] The interior width of the church does not quite match that of the Chalkoprateia church, the largest of the basilicas (28.5 m. against 31 m.), but its far greater length and its lofty dome gave it a spaciousness that all of the basilicas of the city had lacked.

Like Chalkoprateia, Hag. Eirēnē was closely associated with Hagia Sophia. It is located about 110 meters from the north side of Hagia Sophia; its apse is aligned with that of the Great Church, and it is oriented along almost the same axis. In pre-Justinianic times, and probably later as well, the two churches were regarded as a single sanctuary and were enclosed in the same precinct wall.[2] The fortification wall of the Saray now effectively divides the two churches, but in the sixth century they communicated across a series of courtyards containing various charitable foundations (the hospice of Samson[3]) and possibly, as Janin suggests, the chancellery offices.[4] The excavations of Ramazanoğlu and Dirimtekin south of Hag. Eirēnē revealed part of a courtyard, a cistern, and a series of corridors, but these elements have not been further identified.[5] Another, much more vast, cistern starts not far from the northeast corner of Hagia Sophia and runs under the precinct wall of the Saray to a point near the southeast corner of Hag. Eirēnē.[6]

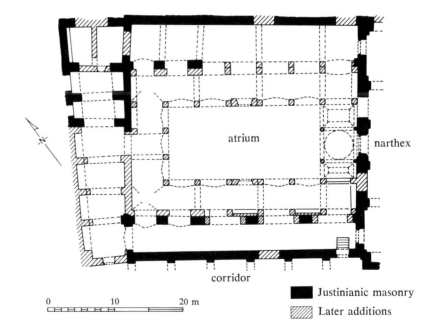

Figure 38. Hag. Eirēnē. Atrium (plan)

The two churches both belonged to the patriarchate and were administered by the same clergy; before the construction of the Old Hagia Sophia, and during its reconstruction after 404, Hag. Eirēnē served as the cathedral church of the city.[7] Like Hagia Sophia, Hag. Eirēnē was dedicated to Christ under the title of one of his divine attributes, Holy Peace. Procopius is explicit on this point, grouping the two together in his first section of churches, i.e., those dedicated to Christ; but his remark has been overlooked in previous discussions of the dedication.[8]

Justinian began the present church of Hag. Eirēnē contemporaneously with Hagia Sophia, after the two of them had perished by fire in the Nikē riot of 532. The date of its completion is not known, and three subsequent periods of rebuilding or remodelling have modified its appearance since then. A second fire, still within Justinian's reign, damaged the church in 564, destroying the atrium and part of the narthex;[9] unspecified damage was done by an earthquake in 740 requiring further repairs;[10] and, finally, alterations undertaken by the Turks have further complicated our picture of the original appearance of the building. Still, the planning of the church in its two Justinianic phases is fairly clear in the essential outlines; the chief issues in doubt concern the manner of vaulting the building and are problems that need not detain us.

The only monograph on Hag. Eirēnē is that prepared by W. S. George, who made a structural survey of the church in 1909–10.[11] Van Millingen's treatment was based on George's study, and Ebersolt's chapter on the church was written about the same time but independently.[12] Very little has been done since then to further our knowledge of the church building, though the recent stripping of the plaster now makes a more thorough survey possible. On the other hand, a number of discoveries have been made in the immediate surroundings of the church in the meantime: Dirimtekin completed the excavation of the area south of the atrium and narthex, uncovering a large paved courtyard and one of the stair ramps that originally led to the gallery; he also discovered the foundations of a small circular building at the northeast corner of the church.[13] More recently a survey has been made of the atrium.[14]

In its present condition, the atrium of Hag. Eirēnē consists of a double portico, one inside the other, which reduces the grand dimensions of the original design to a cramped little courtyard (Plate 59 and Figure 38). George's examination of the atrium revealed that the inner portico was a Turkish addition and that the outer portico was largely Byzantine, although he was unable to decide between a sixth- and an eighth-century date.[15] Grossmann's survey, however, revealed the Justinianic character of the masonry—a fine brick masonry with occasional greenstone bands (Figure 39). In the southern aisle he observed the pattern of the original arcading—a sequence of pier and two columns, supporting triple arches as in the atrium of Hagia Sophia. At a later date (738, according to Grossmann, although 740 would be more correct) the columns were eliminated, the piers strengthened, and the triple arch replaced with a single broad arch constructed of masonry with a double course of brick and a single course of broken red stone. One may assume that the northern arcade matched the one on the south, but on the west we do not know how the atrium was finished. Grossmann chose the most elegant of several possible solutions in his reconstruction,

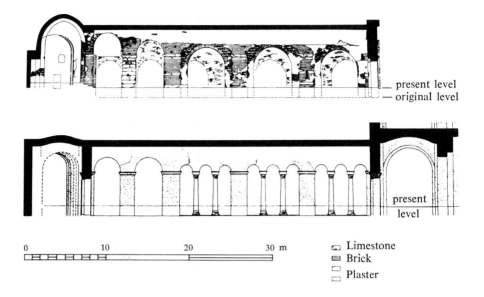

present level
original level

present
level

0 10 20 30 m

⌐ Limestone
▤ Brick
▭ Plaster

Figure 39. Hag. Eirēnē. Atrium (section)

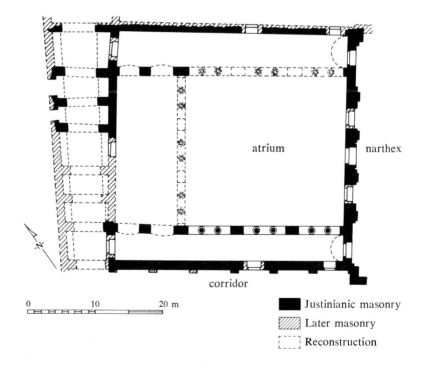

atrium narthex

corridor

0 10 20 m

■ Justinianic masonry
▨ Later masonry
⌐⌐ Reconstruction

Figure 40. Hag. Eirēnē. Atrium (reconstruction)

making an exact square with three times three arcades on each of three sides; but he admits the possibility of other reconstructions (Figure 40).[16]

Grossmann has also clarified that the outer portico at the west in the present disposition of the atrium did not belong to the atrium of the church as such, but constituted a kind of arched passageway running at a slightly oblique angle across the front of the original atrium.[17] From this small passage three entrances opened into the westernmost part of the atrium, one in the center and one into each side portico. In addition, each side portico was also reached through two more entrances from the side, one approximately in the center of the portico and one at the eastern end. To the south these entrances communicated with the area explored by Ramazanoğlu and Dirimtekin—a marble-paved corridor followed by an elegant *cortile* farther south (Plate 60).

This atrium plan, as Grossmann points out, must belong to the second of the two Justinianic phases of Hag. Eirēnē; the earlier atrium, Theophanes tells us, was destroyed in the fire of 564.[18] It is also clear that the arcade is bound into the narthex of the present church, which is of the same masonry and is known to belong to the second Justinianic phase;[19] from the south court it can be observed that the south wall of the

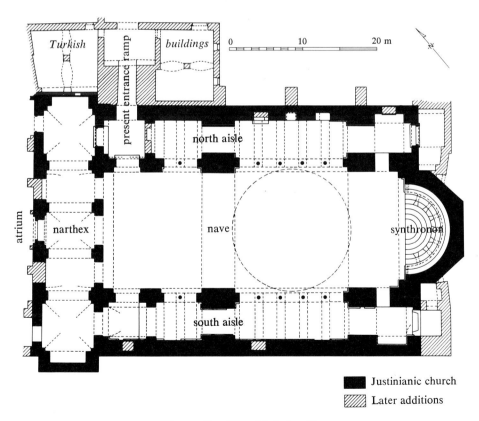

Figure 41. Hag. Eirēnē. Plan

atrium is continuous with the south wall of the narthex. Nothing is known of the atrium of the first Justinianic phase, apart from the fact of its existence.

The atrium is a few meters wider than the church itself, as its north wall is farther north than that of the church. The narthex that intervenes between atrium and church is, in turn, a few meters wider than either. It consists of five bays, alternately groin- and barrel-vaulted, with five entrances from the atrium and five entrances to the church, although only three of the former are still open (Figure 41; the southernmost entrance has been opened since George made his plan). The narthex, as we have pointed out,

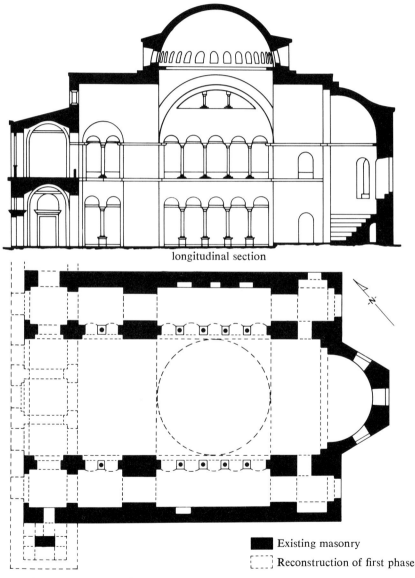

longitudinal section

■ Existing masonry

⌐ ⌐ Reconstruction of first phase

Figure 42. Hag. Eirēnē. Reconstruction of first Justinianic phase

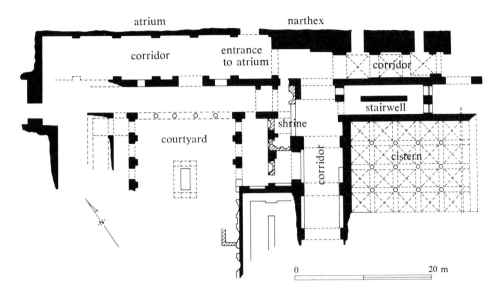

Figure 43. Hag. Eirēnē. Area south of church (plan)

belongs to the second Justinianic plan of the building; that of the first phase must have stood eight meters farther to the east, in the present first half-bay of the nave.[20] Massive piers more than three meters wide mark its original eastern limits on either side of the nave, while seams in the northwest and southwest corner piers of the present nave show where the second narthex was added to the earlier church (Plate 63).

The plan of the narthex in its first phase differed from the later narthex in that its width did not exceed the width of the church; in the first phase, additional entrances were provided to the north (the present principal entrance) and to the south, somewhat in the same manner as George has indicated in his reconstruction (Figure 42). The south entrance, however, did not communicate directly with the stair tower as George proposed, but with the wide corridor discovered by Ramazanoğlu and Dirimtekin (Figure 43) running along the flank of the church.

Access to the gallery of the church was provided through a ramp located just south of this corridor (Plate 61 and Figure 43). The ramp was entered from the west through an entrance of large limestone blocks; its first turn still survives, reaching a height of about three meters. Three turnings would have been required to bring one to the height of the gallery, nine meters above the floor level; at this point some kind of bridge must have vaulted over to the church. It is clear that the ramp belonged to the first phase of the building, for it is aligned with the narthex of the first phase rather than with that of the second, and the large blocks of limestone match the masonry of the first phase in the lower ranges of the body of the church, rather than the brickwork of the second phase in the atrium and later narthex.

The church proper consists of a nave (whatever its original vaulting may have been), aisles on either side, and galleries above the aisles, as well as above the narthex (Plate

62). In this respect the planning seems to have been the same in both Justinianic phases of the building; its lines are clearly readable in the massive limestone masonry of the lower parts of the building. In the central bay of the church the aisles could be entered directly through side doors leading north and south, or indirectly through the entrance bays at the eastern end of each aisle. The recent removal of plaster makes it evident now that the plan originally called for two entrances flanking a niche in the north aisle (Plate 64).

The east end of the church was provided with further entrances in the corner bays at either side of the apse. These entrance bays, located behind the eastern piers of the great dome, have doors leading to the north and south of the church, plus larger entrances with massive, elaborate doorframes leading east. The irregularly shaped chambers further east that now close off these eastern entrances are clearly later additions, as George and Ebersolt observed. The masonry is a rough alternation of five or six courses of brick with three or four of stone (Plate 65). Wulff was mistaken in speaking of a triple sanctuary at Hag. Eirēnē, and Deichmann also erred in citing Hag. Eirēnē as prototype for the appearance of the triple sanctuary in Italy.[21] The corner bays were entrance bays, and it is clear that these entrances belonged to the first Justinianic phase as well as to the second. The massive doorframe in the northeast bay can be firmly dated to the first phase by the fact that the lintel was sheared off when the pier to the south was rebuilt in the second phase (Figure 44 and Plate 65). The sequence of masonry is the same in the southeast corner (Plate 66), though the doorframe is now missing.

Figure 44. Hag. Eirēnē. Plan of northeast corner of church

North of the northeast corner of the church Dirimtekin reported finding a circular building which he called a skeuophylakion.[22] Unhappily no plan was published, and the location is now partly filled in and heavily overgrown (Plate 67), so that our plan does not represent the floor level of the building (Figure 44). The plan apparently consisted of a circle within a square, the circle having a diameter of 4 m. and the square a width of 5.25 m. The masonry is the same as that of the little chamber added to the eastern entrance—a rough alternation of brick and stone bands—but the two structures are not bonded together. Thus the circular structure dates somewhat later than the added eastern chamber, which itself is later than the sixth century.

All that now remains of the sanctuary arrangement is the synthronon (Plate 68). At present it consists of six benches, each rising between .55 and .60 m. (except the top one, which rises about .45 m.). An examination of the masonry reveals that none of the benches except the topmost one rests on the original masonry (Plate 69 and Figure 45). Like the lowest sections of the nave walls, the substructure of the synthronon is of squared stones, though here the stones are much smaller. On this foundation, the semicircular ranges of seats were built up in brick—the masonry having a ten-course modulus of .95 m. identical with that of the second Justinianic phase in the atrium and narthex. A passageway runs under the benches, covered with a half-barrel vault of brick; the entrances of the passage on either side are framed with characteristically Justinianic mouldings of the same workmanship as those of the rest of the building (Figure 46). Hence there is no reason to doubt that the substance of the synthronon belongs to the sixth century.[23]

The distribution of the benches is problematical, however. The seam between the Justinianic masonry and the present arrangement of benches is quite clear, yet this is substantially the arrangement observed by George under the wooden Turkish

1.65 .93 1.05

Figure 45. Hag. Eirēnē. Synthronon (elevation)

benches inserted to display armaments (Figure 47). Ebersolt, on the other hand, noted an entirely different series of steps, some much larger and some much smaller, that does not coincide in any way with George's observations.[24] The discrepancy cannot be resolved, and one can only say that the present arrangement cannot be guaranteed as original although the number of benches—and therefore their general proportions—is probably not far wrong. At Hagia Sophia, the benches of the synthronon are said to have been seven in number; the apse of Hag. Eirēnē, it should be noted, measures a generous 11.6 meters, about one meter less than that of Hagia Sophia. The present benches, therefore, probably provide a fairly accurate picture of the original appearance of the synthronon—lofty, spacious, and impressive. Intermediate steps, perhaps made of wood, would probably have been provided to make climbing more convenient.

Nothing remains of the chancel barrier, and it is impossible to say exactly how far the sanctuary extended. The altar must have stood in front of the synthronon, and the barrier enclosing it would probably have followed a "π"-shaped plan. An ambo is mentioned in Photius' time (patriarch 858–67 and 877–86), but we have no information on its location.[25] The floor was repaved in Turkish times, and no traces of these elements remain.

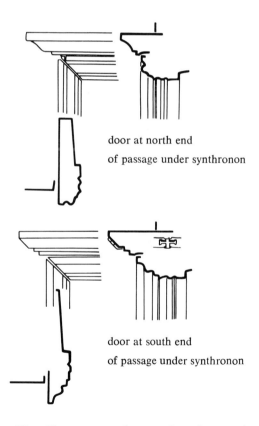

door at north end
of passage under synthronon

door at south end
of passage under synthronon

Figure 46. Hag. Eirēnē. Doorframes of synthronon (profiles)

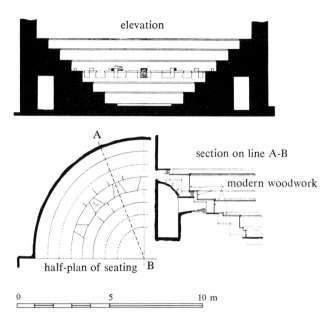

elevation

A

section on line A-B

modern woodwork

half-plan of seating ¦B

0 5 10 m

Figure 47. Hag. Eirēnē. Synthronon (plan and elevations)

Those elements of the design that can be ascertained with confidence at Hag. Eirēnē are very significant for the history of liturgical planning in Constantinople. In its second Justinianic phase it provides the latest dating of any church in our group, just a little over a hundred years later than the Studios basilica. Yet despite the extraordinary architectural revolution that had taken place in the meantime and which had left its mark on the structural design of Hag. Eirēnē, the liturgical planning of the building is not significantly different from the basilica of 463.

West of the church lies an atrium; it is now arcaded, unlike the trabeated colonnade of the Studios, but the plan still called for a portico along three sides (the fourth being the narthex) and a multiplication of entrances to the atrium. The narthex is entered by five doors instead of the seven at the Studios basilica, making it somewhat less a part of the atrium; doors at the north and south of the narthex were not necessary, since they still existed in the earlier narthex bay a few meters to the east. Again, five entrances open from the narthex to the church, and the church still preserves the general lines of nave and aisle spaces. Extra entrances are provided at Hag. Eirēnē to the aisles in the center bay, but the eastern entrance system is retained; monumental doorways lead into the eastern end of either aisle, and smaller doors lead north and south at these points. The gallery above still follows the "U"-shaped plan, with access still from outside the building near the narthex. Finally, what little we have of the sanctuary—the banked synthronon in the apse—repeats the earlier plan of the Studios church. The one notable exception is the skeuophylakion at the northeast corner, but this is clearly later than the second Justinianic phase; unfortunately we do not know where

its entrances were. Significantly, the chambers that were added to the eastern end of the building at about this time still preserved the access to the east, although through smaller doors.

Hagia Sophia

Justinian's Hagia Sophia has been purposely left until the last, so that the other Early Byzantine churches of Constantinople might be given their due. Hagia Sophia looms so large in the story of Byzantine architecture—and indeed in the history of all architecture—that it easily overshadows all the buildings in its near proximity, throwing them into obscurity. The attention given the building, however, still falls far short of doing it justice, and in many important features it is still poorly known. Only very recently has an adequate structural survey been undertaken (by Van Nice), and the work is still far from finished.[26] Many details of the interior arrangement of the building and the accessibility of its various parts are yet without a satisfactory solution and are likely to remain so for some time. In some cases, the best one can hope for is a careful juggling of various possibilities.

The bibliography on Hagia Sophia is immense and has not been systematically collected: a recent attempt in Kähler's volume on the church includes only the more important works on the subject,[27] and Swift's bibliography, while far more complete, is now badly out of date.[28] Of the extensive literature on the church, a large part is understandably devoted to structural problems. The intricate engineering involved in vaulting such grand spaces at such a daring altitude has still not been adequately explained, and the repeated collapses of and repairs to the vaulting make the structural study especially difficult.[29] Our own treatment must be content to bypass most of these problems in order to concentrate on a simple description of the space available and its liturgical organization.

The story of the destruction of the Old Hagia Sophia in the uprising of 15 January 532 and of the erection of the new structure by Justinian, who presided over its dedication on 24 December 537, is well known from Procopius.[30] We also know that, apart from the loss of the atrium, the building now stands substantially as Anthemius and Isidore, the architects, left it. It is true that the dome was raised more than seven meters when it was reconstructed after its first collapse on 7 May 558, and the piers were strengthened somewhat at the same time. As far as the planning of the church is concerned, however, such changes are of minor importance; there is no need to distinguish the two phases of Justinianic building here as there was at Hag. Eirēnē. The planning of the church as far as we know it usually belongs indiscriminately to both phases. Only in our information regarding the furnishings are we for the most part restricted to a discussion of the second phase, since our information on this point relies heavily on Paul the Silentiary's description composed on the occasion of the church's second dedication.[31] Other changes in the course of the building's history—the addition of buttresses, the disappearance of a stair, or the repaving of parts of the floor—may have destroyed valuable evidence, but have altered very little the planning of the church.

The atrium of Hagia Sophia has disappeared gradually in relatively modern times. In the sixteenth century, Gyllius described an "area" west of Hagia Sophia with a fountain in the middle located several steps lower.[32] This atrium was entered by bronze-clad doors, one to the north and one to the south. It was still intact in the following century when Grelot represented it, in a fairly generalized fashion, in his engravings of the church (Plates 70–71); but by the middle of the nineteenth century a medrese had been built over the area, destroying or covering most of it, as can be seen in Fossati's drawing of the western façade (Plate 72).[33] However, two columns and two piers on the southern side were still standing free with their arches, as represented in another of Fossati's views (Plate 73).[34] This pair of columns survived as late as 1873, when they appear in a photograph published by Wulff.[35] The northern exterior wall of the atrium was also largely intact, as indicated on Salzenberg's plan, permitting the latter to reconstruct the entire atrium with a very small margin of error.[36] Schneider's excavation has recovered the complete plan.

The plan called for twelve piers disposed along three sides of an open court, with a pair of columns between each pair of piers (Figure 48). This alternating arcade enclosed a rectangular area, wider than it was long, measuring 47.7 by 32.3 m. (or roughly 150 by 105 Byzantine feet). The easternmost bay-and-a-half of the atrium on either side is still more or less intact, though now entirely walled up, and the pilasters on the faces of the first pier on either side can still be seen (Plate 74). The northern wall of the northeast bay is also visible now, although it was concealed by other buildings in Schneider's time and went unobserved (Plate 75). It reveals a large arched entrance about a meter-and-a-half in width, an entrance that is not noted on Schneider's plan (location A on Figure 48). Besides this entrance, three others were traced by Schneider on the northern side of the atrium, and three on the south. Hence the atrium had the same kind of openness that characterized the atria of the Studios and Hag. Eirēnē, at least along the northern and southern flanks. The foundations of the western wall of the atrium must lie somewhere under the present street, Caferiye sok., where they cannot be excavated. A trench opened here in connection with the laying of drainage pipes revealed a niched wall—the niches facing Hagia Sophia—the relationship of which to the atrium is unknown.[37] The terrain falls away rather rapidly at this point, and the western approaches would have to have been by means of a flight of stairs.

As at the Studios and Hag. Eirēnē, the arcade of the atrium ran along only three sides; the fourth side was the outer narthex of the church itself, as the Silentiary observed in his description.[38] The Silentiary extols the marble revetment of the atrium, a detail confirmed by Schneider's find of fragments of a kind very similar to the marble revetment of the interior of the church itself.[39] He also mentions a great marble fountain in the middle of the atrium, whose water was extremely healthy, and even miraculous, in its effect.[40]

Little is known of the other surroundings of Hagia Sophia. The baptistery, which is octagonal in plan and independent of the structure of the church itself, still stands at the southwest corner of the church, and the skeuophylakion, which we described above, is at the opposite corner on the northeast. The Silentiary would have us believe that the atrium at the west was only one of a series of courtyards that surrounded the church.

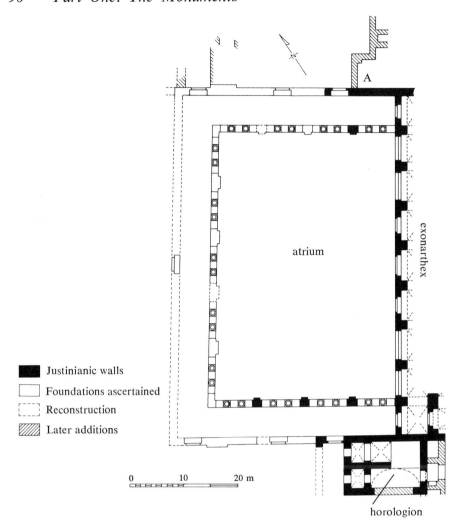

Figure 48. Hagia Sophia. Plan of atrium

Concluding his description of the atrium he remarks, "In addition, here and there around the sides and further extremities you would see many open-air courts [πολλὰς αὐλὰς ἀσκεπέας] outside the divine building. This has been contrived with beautiful design around the sacred temple to make it appear flooded with bright-eyed daylight, the early-born."[41] It is impossible today to reconstruct the plan of these subsidiary courtyards,[42] but the Turkish courts that flanked the building in the seventeenth century in Grelot's engravings may be some reflection of the kind of arrangement that originally existed (Plate 70).[43] Besides leaving the flanks of the building open to the daylight, the courts would have afforded pleasant gathering-places for the faithful.

This detail of the plan is generally overlooked in descriptions of Hagia Sophia,

but it would fit well into the pattern observed in other Justinianic churches. The Hebdomon church had a courtyard surrounding it on all but the eastern side, and the Beyazit Basilica A had courtyards on all four sides; Hag. Eirēnē, according to the excavations, had courtyards on at least two sides, and Justinian's church of the Holy Apostles also enjoyed a multiplication of surrounding courts, according to the description of Nicholas Mesarites.[44]

The outer narthex constitutes the fourth side of the atrium. Of the nine groin-vaulted bays that make up this corridor, the two extreme ones open through doorways into the north and south wings of the atrium, while the three central ones have doors into the middle of it. This seems to have been the original arrangement, with great windows filling the four remaining bays. Kähler has tried to make a case for entrances in all nine bays of the original Justinianic plan, which he says was revised in late Justinianic times by the insertion of windows in four bays.[45] But the passage in Paul the Silentiary to which he refers describes the narthex of the church, not the exonarthex; by a curious slip Kähler himself uses the same passage later in his description of the narthex.[46] Schneider had better reason to suppose that one of the windows might have been a door, for under the northernmost window of the exonarthex he found what he thought was a doorsill (see "D" on Figure 1).[47] The supposed sill, however, which is very irregular and is not squarely set in the opening, must simply be part of the foundation work. Van Nice does not indicate it in his plans,[48] and it is no longer visible today.

Thus we have no reason to believe that access from the atrium to the exonarthex was originally any different from that which is observed today, i.e., a door from each side arcade of the atrium and three doors in the center. The complicated, changing pattern of entrances that confronts the visitor as he progresses from atrium to exonarthex to inner narthex to church proper is one of the extraordinary subtleties of Hagia Sophia's design, the special effect of which has been described by Zaloziecky.[49] The first set of five doors, with three bunched together in the middle, is followed by a second set of five doors which are equally spaced out; this is followed in turn by a set of nine doors leading into the church itself, which are arranged in three groups of three (Figure 49). The inner narthex also has doors on the north and south, adding up to the seven counted by the Silentiary.[50]

At the north and south of the inner narthex are vestibules. Each of these has a large portal leading outside (north or south) and a door leading onto the stair ramp just to the east. The south vestibule has two additional doors, one leading west into the "horologium" and the other east into a little closet space in the northeast corner. The north vestibule is clearly Turkish and until fairly recent times led out into a narrow alley that ran north between the medrese and the imaret of the Ayasofya Mosque.[51] The portal is of cut stone with a slightly ogival arch (Plate 76). The masonry of the exterior wall is of small stone blocks laid in slightly irregular courses, a type common in Istanbul (Plate 77). Originally one entered the north door of the inner narthex, as well as the stair ramp at this corner, directly from the outside.

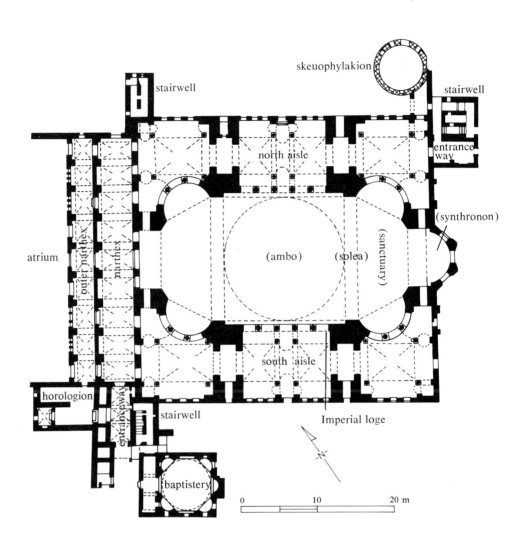

Figure 49. Hagia Sophia. Plan

Indications are that the south vestibule was also an afterthought, as archaeologists have usually assumed,[52] although one which was added in pre-iconoclast times. Dirimtekin's study of the structures at the southwest corner confirms an early date on the basis of the masonry, but the sequence in which these structures were added has not been completely clarified.[53] The shape of the vestibule is trapezoidal rather than rectangular, as it is .60 m. wider at the southern end. The vaulting consists of a series of groin vaults of unequal size that bear no relationship to the room below, which is not characteristic of the vaulting elsewhere in Justinian's building. Over the entrance to the narthex is a deep semicircular archway sheltering the door, rendered superfluous by the addition of the vaulting overhead (Plate 78). In the western wall of the vestibule a filled-in opening conceals a heavy molded doorframe set back about three meters.[54] This doorframe faces east, i.e., with its inner face toward the vestibule. The impression given is that the whole vestibule is simply the leftover space, later closed in, between the southwest stair ramp and the subsidiary structures farther to the west (the horologium). Possibly the need for a room adjoining the narthex gallery above prompted the closing off of this space on the ground floor. The mosaics in the room above require that the addition be dated in pre-iconoclast times;[55] thus both the stair ramps and the northern and southern entrances to the narthex were originally reached directly from the outside.

The stairwell at the northeast corner of the church is also entered from the outside by means of a passageway that runs between it and the east wall of the building. Reconstruction plans of Hagia Sophia generally presume that a similar stair existed in the southeast corner of the building,[56] the site of which is now occupied by an enormous battered buttress of undetermined date. At the point where this stair would presumably have emerged on the gallery level, there are no seams in the revetment or in the plaster of the east wall and no signs of special wear in the pavement; but Van Nice points out that the revetment and paving are not original, and the present plaster may conceal seams here as it does in the southern wall of the bay.[57]

The existence of a stair at this corner in the ninth century is demonstrated by Mango in his discussion of the Shrine of the Holy Well located nearby.[58] In addition to the texts Mango has cited, one should also cite those for the feasts of Holy Saturday, the Annunciation, and Orthodoxy, which refer to it as being made of wood ($\dot{\eta}$ ξυλίνη σκάλα).[59] Its door still exists, as Antoniades noted, set in the northern corner of the bay's great east window in the gallery (Plate 80).[60] Whether the wooden stair existed from the beginning or whether it was thrown up to replace a stair ramp which had been supplanted by a buttress is impossible to decide on the basis of the existing evidence; but it seems safe to assume that some kind of stair existed at this corner from the beginning.

Access to the galleries, therefore, seems to have consisted of four stair ramps placed at the four corners of the building and communicating with the outside, like the stairs of the Studios basilica and those of Hag. Eirēnē. There is, in addition, a fifth stair ramp

that connects the gallery with the ground floor; this is the stair added outside the south-west pier, between the baptistery and the church. Its date is not known exactly, but the masonry visible inside indicates that it is Middle Byzantine. Significantly, it does not communicate with the public sections of the gallery, but with that section behind the barrier in the south gallery.[61]

At the east end of the building, beside the two eastern stair ramps, were two vestibules sheltering the grand doorways that led into the easternmost bay of each aisle. The vestibule at the southeast has been rebuilt, probably at the time the buttresses at this point were constructed (Plate 80). In the tenth century, it was connected to the Chapel of the Holy Well, which had the form of a tetrapylon (i.e., a chamber with an entrance on each of its four sides), as Mango explains.[62] The northeast vestibule still survives, bound into the Justinianic masonry of the east wall. A third eastern entrance, much smaller than these two, was located in the northeast corner of the southeastern bay. It is now blocked by the buttress, but the doorframe is still in place and is visible from the inside. In the tenth century a chapel dedicated to St. Nicholas seems to have been located in this vicinity, and a passageway called the Passage of St. Nicholas ran behind the apse of the church, connecting the two vestibules.[63]

One would like to know more about the Byzantine additions to the east wall of Hagia Sophia which have been suppressed by the buttresses and by Turkish additions. Nevertheless, it is quite clear that the sacristies or prothesis and diaconicon chapels that Lethaby and Antoniades proposed to reconstruct on either side of the church's main apse did not exist.[64] As indicated on Van Nice's plan, the east wall of Justinian's church is complete and intact its entire length, following a straight line on either side of the apse.[65]

In the overall picture of Early Byzantine architecture no example could have been of greater weight that that of the cathedral church of the capital city, and here we find but a single apse flanked by eastern entrances, not by prothesis and diaconicon. It is not necessary to follow Jantzen's interpretation of this arrangement as the victory of pure architectural logic over the practical needs of cult,[66] for as we have seen it conforms perfectly with the pattern of liturgical planning developed in the other churches of Constantinople in the fifth and sixth centuries. Instead, we must begin to reconsider the liturgical forms that might have required chambers flanking the apse in Early Byzantine architecture. It is possible, as Ebersolt suggests, that the functions of prothesis and diaconicon were carried out in the irregular little corners of the northeast and southeast bays that are closest to the sanctuary;[67] but there is absolutely no archaeological evidence indicating barriers to segregate these areas (which would be a makeshift arrangement at best), and such an hypothesis becomes quite unnecessary as we come to understand better the workings of the Early Byzantine liturgy.

The northern and southern walls of the church also contained a number of entrances. Most important of these are the entrances in the center of the central bay on either side, as they constitute a kind of secondary cross-axis to the church. They are large entrances, about two meters across, each preceded by a pair of columns on the inside, providing a certain formality. Lesser entrances occur in the eastern bay of each aisle—

the one in the northeast bay is located in the extreme northeast corner, and the one in the southeast is in the center of the bay.

The interior space of Hagia Sophia is a good deal more involved than that of the other Early Byzantine churches of Constantinople (Plates 81, 83–84). The complex interplay of domed, half-domed, and apsed areas in the center with the complementary porticoed areas in the aisles and galleries, many of them convex in plan, creates a spatial effect that is as difficult for the viewer to comprehend completely as it is for the archaeologist to describe adequately. In the first place, although we continue to refer to the aisles and galleries as if they were continuous corridors of space, it is obvious that this is not the way they are meant to be experienced. The four great piers that support the dome of the nave are concealed within the surrounding galleries and aisles; they divide these areas into six large compartments or bays on each floor, three on either side, joined to one another by great arches opened through the piers. Kähler has argued that the strengthening of the arches in the piers with jambs and secondary arches, which greatly increased the effect of compartmentalization, was part of the first Justinianic design of the building and not part of the revision of 558–63.[68] Indeed, although these secondary arches are made of limestone and contrast with the brick to which they are added, neither the paving, the revetment, nor the mosaic decoration around the piers and arches show any signs of having been revised or readjusted to accommodate a change in plan (Plate 79). In order to date the jambs and secondary arches to the rebuilding after the fall of the dome, one would have to assume that all the paving, revetting, and mosaic work in the aisles and in the galleries also dates from this rebuilding. According to Procopius, however, the mosaics of the aisles and the marble revetment throughout were completed before the first dedication of the church, and it seems most unlikely that they would all have been taken down and redone after the fall of the first dome.[69] A precise definition of the differences between the two Justinianic phases of construction will have to await Van Nice's full report, but in any case the division of the aisles into three distinct bays must have been evident from the start.

The effect of this compartmentalization was further strengthened by the use of barriers, one of which (in the southern gallery) is still in position (Plates 84–85). These heavy marble panels imitating bronze doors divide the southern gallery between its central and western bays. Swift tried to date this barrier in the ninth century on the basis of what he called "careless workmanship"[70]; however, Middle Byzantine workmanship is not careless, but instead is neater, more refined, and somewhat more feminine than Early Byzantine. The character of the panel's carving is bold and broadly worked, like elements of the sculpture observable on the underside of the window mullions (Plate 86); moreover, the wooden tie-beam that crowns the barrier is of sixth-century workmanship and design.[71] Hence the barrier must belong to the original design of the church, and we can assume that these two bays of the gallery (i.e., two-thirds of the south gallery) were always partitioned off in this manner.

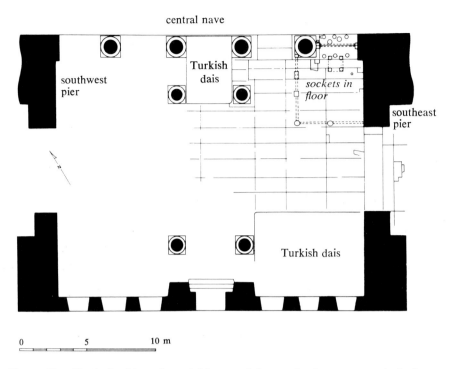

central nave

southwest pier

Turkish dais

sockets in floor

southeast pier

Turkish dais

0 5 10 m

Figure 50. Hagia Sophia. Imperial loge and throne site (reconstructed plan)

Other barriers were constructed in the south aisle on the ground floor to screen the Emperor's box and metatorion (Plates 87–88 and Figure 50), but the evidence for them will be discussed below in connection with the Emperor's participation in the liturgy.[72]

This compartmentalization aside, the overall disposition of floor space in Hagia Sophia does not differ notably from that of the Studios basilica seventy years earlier or the second Justinianic Hag. Eirēnē thirty years later. The layout of the Early Byzantine churches, despite the considerable variety of structural designs involved, is remarkably consistent. At Hagia Sophia we still find a wide nave flanked by generous aisles and galleries; the galleries still follow a "U"-shaped plan extending over the narthex as well as over the aisles. The plan is still characterized by a remarkable openness, with entrances on all sides, although Hagia Sophia—by reason of its entirely different scale—has a great many more entrances than any of the other buildings. Chambers flanking the apse are still missing, and access to the galleries is still had through exterior stairs or ramps. The only noticeable divergence of Hagia Sophia from the pattern in the other churches is its doubling of the narthex on the ground floor, a detail which is significant but certainly not revolutionary.

A great many attempts have been made to reconstruct the sanctuary of Hagia Sophia, with its chancel barrier, ambo, and solea. The various reconstructions and the rather extensive bibliography behind them have been reviewed by Xydis, who has advanced a new and generally plausible reconstruction of his own;[73] on the whole, however, it must be admitted that the restorers have relied more heavily on their own

ingenuity than on the evidence. The problem of a detailed restoration of the elevations and decoration of the church furnishings is of less concern to us than simply establishing the locations and layout of these various elements.

The evidence is complicated by the checkered history of Hagia Sophia. The original sanctuary furnishings, referred to by Procopius as embellished with 40,000 pounds of silver,[74] were destroyed by the first collapse of the dome in 558. Justinian's replacements as described by Paul the Silentiary survived until they were pillaged by the Crusaders in 1204. After the reconquest, the patriarch Arsenius restored the Byzantine sanctuary furnishings under Michael Palaeologus.[75] Another fall of the dome in 1346 again destroyed the sanctuary, which the Empress Anna, wife of Andronicus Palaeologus, subsequently rebuilt.[76] This fourth sanctuary lasted until the Turkish Conquest, when it was replaced with the mihrab by Sultan Mehmet Fatih.[77]

Some archaeological evidence of the sanctuary, unfamiliar to Xydis, still remains. The first step up to the mihrab, which runs obliquely across from Fossati's Sultan's loge to the muezzin's platform, seems to consist largely of the undisturbed pavement of the fourth sanctuary plan, as the slabs are not aligned obliquely with the mihrab but instead directly with the apse (Plates 80–81). Evidently the Turkish builders simply trimmed the existing sanctuary platform to the new orientation of their mihrab, adding a little on the north where the fourteenth-century paving gives way to smaller supplementary slabs.[78] The fourth sanctuary thus seems to have followed a "π"-shaped plan, projecting into the nave from the two piers that flank the eastern apse; but this in turn seems simply to repeat the earlier sanctuary plans. During a limited excavation in 1955, Dirimtekin discovered a green marble stylobate with drillings for chancel fastenings underneath the mihrab paving. This stylobate ran from east to west in front of the northern pier of the apse and must therefore represent the northern side of an earlier chancel barrier; but the question remains of which earlier chancel it belonged to. Although the details of this important excavation have not yet been published, we may surmise that the stylobate belonged not only to the third sanctuary plan (as restored by Arsenius), but also to that of Justinian's second sanctuary. It is very unlikely that the Crusaders' pillage of Justinian's sanctuary in the thirteenth century would have gone to the extent of uprooting the pavement; moreover, the green marble fits in nicely with the stylobate examples from the Studios church and Hag. Polyeuktos.

It is not clear how far into the nave this "π"-shaped plan projected, but if it is safe to judge from the disturbance of the nave paving, it may have extended out to the great eastern arch of the dome. The basic pattern of paving in the nave consists of long slabs of veined white marble about 2.85 by 1.25 m. laid in an east-west direction and interrupted five times by a band of green marble that runs across from north to south.[79] This pavement is at least the second pavement in the nave, as a probe made by Ramazanoğlu in 1948 near the northeast pier established; at this spot another pavement, thoroughly fragmented by the impact of the vault's collapse in 558, was revealed at a depth of 15–20 cm. beneath the present pavement.[80] This seems to establish a *terminus post quem* for the existing pavement; on the other hand, the extensive damage and repairs to the existing pavement under the western half-dome seem to date that

pavement before the collapse of the western section in 986. The bands in the pavement must be the "rivers" referred to in literary sources as early as the first half of the ninth century.[81] Therefore, if the pavement is not actually from Justinian's rebuilding of 563, it seems to have been laid at a time when the Emperor's sanctuary was still in existence. Unfortunately the disturbances in the eastern half of the pavement give only a vague indication of how far the sanctuary reached; one might imagine that the solea and ambo were located where the "river" by the porphyry disk leaves off, but precise markings are lacking.

Kähler has proposed that "recently disclosed markings show the altar on the bema was placed well forward, outside the apse proper, in a central position between the two eastern conches";[82] but he fails to identify the markings to which he refers or to tell us who made this discovery. Examination of the pavement shows a series of five slabs of colored marble with borders enlivening the pavement of the fourteenth-century sanctuary (Plate 82). A great many markings occur in this area, but none of them resembles the fastenings for an altar and one can only hypothesize that this was the approximate site of the altar.[83]

The literary sources confirm and add detail to the archaeological evidence. The "π"-shaped plan can be inferred from references to the "sides" of the sanctuary barrier in Paul the Silentiary, who uses the term $\pi\lambda\epsilon\acute{\nu}\rho\alpha$, and in the *De ceremoniis*, where we find the term $\pi\lambda\alpha\gamma\acute{\iota}\alpha$.[84] It would be difficult, however, to support Xydis' argument for the "π"-shaped plan from a comparison with other sanctuary plans, in view of the fact that some of the other Constantinopolitan churches (the Saray and Beyazit, and probably Hag. Sergios and Bacchos) had barriers that ran straight across. From the Silentiary's description a few details of the plan can be filled in: the barrier consisted of twelve columns carrying an architrave adorned with images of angels, Apostles, the Virgin, and Christ himself;[85] below were a series of chancel slabs between the columns, bearing the monograms of Justinian and Theodora.[86] As at Hag. Euphēmia and the Studios basilica, three doors, a central one with smaller ones on each side, were provided to the sanctuary.[87]

The ambo was located a little to the east of the exact center of the nave. The Silentiary refers to it three times as being in the middle of the church, and once he modifies this by saying that it "nods toward the east."[88] Like the Beyazit ambo, it was reached by two flights of stairs, one at the east and one at the west; the plan of the platform was oval or circular ("crescent-shaped" on the north and south), and it was supported by eight columns.[89] The dimensions of the ambo must have been proportionate to the enormous size of the nave; the platform was high enough so that it served as a "roof" over the place for the cantors beneath,[90] and the whole ambo was given added visual importance by being encircled with eight larger columns, which had chancel barriers between them and supported an architrave above.[91]

The ambo was connected to the central door of the sanctuary by a solea, or a path with a wall on either side. Here the chancel barrier was only waist-high, consisting of a series of chancel slabs held by little rectangular piers.[92] Unlike the plan reconstructed by Naumann and Belting for Hag. Euphēmia, the barriers of the solea did not reach

all the way to the door of the sanctuary, but stopped just short so that one could pass from side to side at this point.[93]

As in three other of our churches, the apse was filled with the benches of the synthronon. In the Silentiary's words, "The middle apse holds the mystical seats and the circular steps. Some of them [the steps] are gathered and drawn closer together at the lowest step around the center on the pavement; but those that rise above widen out the interval little by little until they reach the seats of silver; thus with increasing circles they wind about the starting point."[94] The anonymous ninth-century writer tells us that the steps were seven in number,[95] which must have made them about the same proportions as the steps of the synthronon of Hag. Eirēnē; they probably reached to the height of the wall that is now covered by plain grey marble slabs in the apse. But here again, as seems to have been the case at Hag. Euphēmia and Hag. Iōannēs Studios, only the top bench was meant to be sat upon. The Silentiary distinguished in his description between the seats or thrones ($\theta\hat{\omega}\kappa\omega$) and the steps ($\beta\acute{\alpha}\theta\rho\alpha$) by which one reached them: only the seats at the top were made of silver, and elsewhere we are told that the "learned priests" sat on the silver thrones in the apse.[96]

The altar site, as we have seen, is not precisely known. The altar itself, the Silentiary tells us, was composed of a gold mensa, gold columns, and a gold base, ornamented with precious stones; above it stood a ciborium of silver.[97] In addition to the altar, we hear of four service tables referred to by the anonymous ninth-century writer, which are probably to be identified with the $\pi\alpha\rho\alpha\tau\rho\acute{\alpha}\pi\epsilon\zeta\alpha\iota$ mentioned in the *Chronicon paschale* under the year 630.[98] Except for this detail, the sanctuary furnishings and their arrangement at Hagia Sophia, while exceptionally rich and much grander in scale than those of any of the other churches in the city, fit into the same pattern of church planning.[99]

Notes

[1]*Buildings*, I, 2, 13, pp. 36–37.

[2]Socrates, *Hist. eccl.* II, 16, *PG* 67, 217.

[3]*Buildings*, I, 2, 14–15, pp. 36–37.

[4]Janin, *Constantinople byzantine*, p. 174.

[5]Ramazanoğlu's contribution to the study of Hag. Eirēnē and Hagia Sophia constitutes one of the most fanciful chapters in the story of Byzantine archaeology. Writing in a highly polemic tone, he claimed to have confuted all previous archaeologists who had dealt with the subject by discovering the remains of three successive churches of Hagia Sophia, all earlier than the present one and lying in various positions between Hag. Eirēnē and Hagia Sophia. The actual Hagia Sophia is a reworking of three pagan temples on the site. Muzaffer Ramazanoğlu, *Sentiren ve Ayasofyalar Manzumesi (L'ensemble Ste. Irène et les diverses Ste. Sophies)* (Istanbul, 1946); idem, "Neue Forschungen zur Architekturgeschichte der Irenenkirche und des Complexes der Sophienkirche," *Actes du VIe Congrès International des Études Byzantines* (Paris, 1951),

II, 347–57; idem, "Neue Forschungen zur Architekturgeschichte der Irenenkirche und des Complexes der Sophienkirche," *Atti del VIII Congresso di Studi Bizantini* (Palermo, 1951), II, 232–35. His successor continued the excavation at Hag. Eirēnē and did much to rescue its scientific value. Feridun Dirimtekin, "Les fouilles faites en 1946–47 et en 1958–60 entre Sainte-Sophie et Sainte-Irène à Istanbul," *CA* 13 (1962), 161–85.

[6]Stanley Casson, *Preliminary Report upon the Excavations Carried out in the Hippodrome of Constantinople in 1927* (London, 1928), pp. 23–24, fig. 34.

[7]Janin, *Géographie*, pp. 103–6.

[8]*Buildings*, I, 2, 18–19, pp. 36–39.

[9]Theophanes, *Chronographia*, I, 371.

[10]Nicephorus Patriarcha, *Breviarium historicum*, *PG* 100, 965; Theophanes, *Chronographia*, I, 634.

[11]W. S. George, *The Church of Saint Eirene at Constantinople* (London, 1912).

[12]Van Millingen, *Byzantine Churches*, pp. 84–104; Ebersolt and Thiers, *Les églises*, pp. 55–72.

[13]See above, note 5.

[14]Peter Grossmann, "Zum Atrium der Irenenkirche in Istanbul," *IM* 15 (1965), 186–207.

[15]George, *Saint Eirene*, pp. 12–16 and pls. 1, 5, 7.

[16]*IM* 15 (1965), 199–203.

[17]Ibid., 205–7.

[18]Theophanes, *Chronographia*, I, 371. His term for atrium is μεσίαυλον.

[19]J. B. Ward Perkins, in *The Great Palace of the Byzantine Emperors*, pp. 73–74.

[20]Pending a more extensive examination of the building, we rely here on George's reconstruction of the first Justinianic phase.

[21]O. Wulff, *Altchristliche und byzantinische Kunst* (Berlin, 1913–14), p. 384; F. W. Deichmann, "Caratteristiche dell'architettura proto-bizantina nel occidente," *Corsi di cultura sull'arte ravennate e bizantina*, 1957, fasc. 2, p. 54.

[22]*CA* 13 (1962), 162 and 165, fig. 2.

[23]Hamilton believed it was later. J. A. Hamilton, *Byzantine Architecture and Decoration*, 2nd ed. (London, 1956), p. 82.

[24]Ebersolt and Thiers, *Les églises*, pl. XIII. Van Millingen, on the other hand, counted eleven steps in the synthronon. Van Millingen, *Byzantine Churches*, p. 96.

[25]Cyril Mango, trans., *The Homilies of Photius* (Cambridge, 1958), pp. 41, 55, 124. Mango believes the titles that tell us where and when the homilies were given are the work of an informed contemporary of Photius who collected the sermons. Cf. *Ho megas synaxaristēs*, ed. K. Dukakē (Athens, 1948 ff.), V, 522, 27 January.

[26]Robert L. Van Nice, *Saint Sophia in Istanbul: An Architectural Survey* (Washington, D.C., 1965). Additional plates and a text, with the collaboration of Rowland Mainstone and Cyril Mango, are still in preparation.

[27]Kähler, *Hagia Sophia*, pp. 70–72.

[28]E. H. Swift, *Hagia Sophia* (New York, 1940), pp. 203–9.

[29]Since the secularization of the building in 1934, a series of studies have been made of the statics of the great dome and the various modifications introduced to counter its thrusts. K. J. Conant, "The First Dome of St. Sophia and its Rebuilding," *AJA* 43 (1939), 589–91; W. Emerson and R. L. Van Nice, "Hagia Sophia: Preliminary Report of a Recent Examination of the Structure," *AJA* 47 (1943), 403–36; idem, "Hagia Sophia: The Collapse of the First Dome," *Archaeology* 4 (1951), 94–103; idem, "Hagia Sophia: The Construction of the Second Dome and its Later Repairs," *Archaeology* 4 (1951), 162–71; R. L. Van Nice, "The Structure of St. Sophia," *Architectural Forum* 118 (1963), 131–39; R. J. Mainstone, "The Structure of the Church of St. Sophia, Istanbul," *Transactions of the Newcomen Society* 38 (1965–66), 23–49; idem, "Justinian's Church of St. Sophia, Istanbul: Recent Studies of its Construction and First Partial Reconstruction," *Architectural History* 12 (1969), 39–49.

[30]*Buildings*, I, 1, pp. 2–33.

[31]Paulus Silentiarius, *Descriptio ecclesiae sanctae Sophiae et ambonis*, ed. Immanuel Bekker (Bonn, 1837); this edition is reprinted in *PG* 86, 2119–263. Critical edition by Paul Friedländer, *Johannes von Gaza und Paulus Silentiarius: Kunstbeschreibungen justinianischer Zeit* (Leipzig, 1912), pp. 225–305. A partial English translation, not very accurate, is available in Lethaby and Swainson, *Sancta Sophia*, pp. 35–60.

[32]Petrus Gyllius, *De Constantinopoleos topographia*, p. 107.

[33]This drawing, now in the author's possession, is reproduced with minor changes in Fossati's lithograph of the west façade. Gaspard Fossati, *Aya Sofia, Constantinople, As Recently Restored by Order of H. M. the Sultan Abdul Mediid* (London, 1852), pl. 16.

[34]This drawing, also in the author's possession, corresponds to pl. 15 in Fossati's publication.

[35]Wulff, *Altchristliche und byzantinische Kunst*, p. 380, fig. 327.

[36]W. Salzenberg, *Altchristliche Baudenkmale* (Berlin, 1854), pl. VI.

[37]Cf. Mamboury's plan in Schneider, *Byzanz*, pl. 10.

[38]Paulus Silentiarius, *Descr. s. Sophiae*, lines 590–93; ed. Bekker, p. 29; ed. Friedländer, p. 244.

[39]Ibid., lines 607–11; ed. Bekker, p. 30; ed. Friedländer, p. 244. Schneider, *Grabung im Westhof*, p. 23.

[40]*Descr. s. Sophiae*, lines 594–604; ed. Bekker, pp. 29–30, ed. Friedländer, p. 244.

[41]Ibid., lines 612–16; ed. Bekker, p. 30; ed. Friedländer, p. 244. Our translation.

[42]A single Byzantine wall was found in 1939 running south from the baptistery, but the masonry was of the fourteenth or fifteenth century. Mamboury "Fouilles de Ste. Sophie," in Cyril Mango, *The Brazen House*, Arkaeologisk-Kunsthistoriske Meddeleser, Vol. 4 (Copenhagen, 1959), pp. 182–83.

[43]These courts are the work of Selim II (1566–74), who found the mosque encumbered with a great many houses, which he had torn down. Feridun Dirimtekin, *Saint Sophia Museum* (Istanbul, n.d.), p. 20.

[44]Glanville Downey, "Description of the Church of the Holy Apostles at Constantinople," *Transactions of the American Philosophical Society*, n.s. 47 (1957), 857–924.

[45]Kähler, *Hagia Sophia*, p. 28.

[46]*Descr. s. Sophiae*, lines 425–43; ed. Bekker, pp. 22–23; ed. Friedländer, p. 239. Kähler, *Hagia Sophia*, p. 29.

[47]Schneider, *Grabung im Westhof*, pp. 26–27.

[48]Van Nice, *Saint Sophia*, pl. 9, location W55, N20.

[49]W. R. Zaloziecky, *Die Sophienkirche in Konstantinopel*, Studi di antichità cristiana, Pontificio istituto di archeologia cristiana, 12 (Vatican City, 1936), pp. 21–28.

[50]See above, note 46.

[51]See plan in Dirimtekin, *Saint Sophia Museum*, p. 63.

[52]Usually the vestibule is assigned to the ninth century, a dating which is no longer acceptable. Lethaby and Swainson, *Sancta Sophia*, p. 123; Swift, *Hagia Sophia*, p. 94; A. M. Schneider, *Die Hagia Sophia zu Konstantinopel* (Berlin, 1939), plan p. 36; Jantzen, *Die Hagia Sophia des Kaisers Justinian in Konstantinopel* (Cologne, 1967), p. 28, fig. 5; Antoniades, *Ekphrasis*, I, 145–46.

[53]Feridun Dirimtekin, "Le local du patriarcat à sainte Sophie," *IM* 13–14 (1963–64), 113–27. The identification of the structures as pertaining to the patriarchate can be accepted, but obviously they would have been only a small part of it. There are no rooms that can reasonably be identified as living quarters, and administrative offices with connections all over the Byzantine world must have required considerably more space than is available here. It was not possible to examine these structures at first hand in the preparation of this study.

[54]Van Nice, *Saint Sophia*, pl. 13, location S40, W50.

[55]Cyril Mango, *Materials for the Study of the Mosaics of St. Sophia at Istanbul* (Washington, D.C., 1962), pp. 45–46.

[56]Antoniades, *Ekphrasis*, I, pl. 17; Lethaby and Swainson, *Sancta Sophia*, fig. 5; Kleiss, *IM* 15 (1965), 175, fig. 5; cf. our Figure 4.

[57]In private correspondence with the author.

[58]Mango, *The Brazen House*, pp. 65–66.

[59]*De ceremoniis*, I, 37 (28) and I, 44 (35); ed. Vogt, pp. 145 and 173.

[60]Antoniades, *Ekphrasis*, I, 51; Piero Sanpaolesi, *Santa Sofia a Costantinopoli* (Florence, 1965), pl. 6.

[61]Ernest Hawkins of the Byzantine Institute has recently been occupied in cleaning mosaics in a little cruciform chapel at the top of these stairs.

[62]Mango, *The Brazen House*, pp. 69–70.

[63]Ibid., pp. 70–72, and p. 23, fig. 1.

[64]Lethaby and Swainson, *Sancta Sophia*, pp. 75–76; Antoniades, *Ekphrasis*, I, pl. 17.

[65]Van Nice, *Saint Sophia*, pl. 11.

[66]Jantzen, *Hagia Sophia*, p. 37.

[67]J. Ebersolt, *Sainte-Sophie de Constantinople: Étude de topographie d'après le Livre des Cérémonies* (Paris, 1910), p. 40, plan. Hamilton follows Ebersolt in this regard; *Byzantine Architecture and Decoration*, p. 75.

[68]Kähler, *Hagia Sophia*, pp. 37–38.

[69]*Buildings*, I, 1, 56 and 59–60, pp. 24–27. However, Rowland Mainstone's tentative report attributes these reinforcing arches to Justinian's rebuilding of 558–63. Mainstone, "Justinian's Church," pp. 39–49.

[70]Swift, *Hagia Sophia*, p. 78.

[71]Carl D. Sheppard, "A Radiocarbon Date for the Wooden Beams in the West Gallery of St. Sophia, Istanbul," *DOP* 19 (1965), 240.

[72]See below, pp. 133–34.

[73]Stephen G. Xydis, "The Chancel Barrier, Solea, and Ambo of Hagia Sophia," *AB* 29 (1947), 1–24.

[74]*Buildings*, I, 1, 65, pp. 28–29.

[75]Georgius Pachymeres, *De Michaele et Andronico Palaeologis*, ed. I. Bekker (Bonn, 1835), I, 1, pp. 172–73.

[76]Cantacuzenus, *Historia*, ed. L. Schopen (Bonn, 1828–32), III, pp. 29–30.

[77]Dirimtekin, *Saint Sophia Museum*, p. 22.

[78]Van Nice, *Saint Sophia*, pl. 11.

[79]Ibid., pl. 10.

[80]A copy of Ramazanoğlu's photograph, as yet unpublished, can be seen in the Dumbarton Oaks photoarchive, Washington, D.C.

[81]*Script. orig. Const.*, I, 102–3. These "rivers" are referred to again by Nicholas of Andida (11th century) and by Codinus. Nicolaus Andidorum, *Protheoria* = Theodorus Andidorum, *Brevis commentatio de divinae liturgiae symbolis*, *PG* 140, 436–37; Georgius Codinus, *Excerpta*, ed. Immanuel Bekker (Bonn, 1843), pp. 144–45.

[82]Kähler, *Hagia Sophia*, p. 34.

[83]Mamboury, who was the first to roll back the carpets to inspect the pavement of the sanctuary, located the altar on the five colored slabs. E. Mamboury, "Topographie de sainte-Sophie, le sanctuaire et la solea, le mitatorion, etc.," *Atti del V Congresso di Studi Bizantini, Rivista di studi bizantini e neoellenici* 6, pt. 2 (1940), 203.

[84]*Descr. s. Sophiae*, line 719; ed. Bekker, p. 35; ed. Friedländer, p. 247. *De ceremoniis*, I, 32 (23), ed. Vogt, p. 123.

[85]*Descr. s. Sophiae*, lines 686–711; ed. Bekker, pp. 34–35; ed. Friedländer, pp. 246–47.

[86]Ibid., lines 712–19; ed. Bekker, p. 35; ed. Friedländer, p. 247.

[87]Ibid., lines 717–19; ed. Bekker, p. 35; ed. Friedländer, p. 247.

[88]*Descriptio ambonis*, lines 50–51, 229, 232; ed. Bekker, pp. 50, 56; ed. Friedländer, pp. 258, 263.

[89]Ibid., lines 53–54, 67–68, 107; ed. Bekker, pp. 51–52; ed. Friedländer, pp. 259–60.

[90]Ibid., line 113; ed. Bekker, p. 52; ed. Friedländer p. 260.

[91]Ibid., lines 163–70; ed. Bekker, p. 54; ed. Friedländer, p. 261.

[92]Ibid., lines 240–51; ed. Bekker, p. 56; ed. Friedländer, pp. 263–64.

[93]Ibid., lines 294–96; ed. Bekker, p. 57; ed. Friedländer, p. 265.

[94]*Descr. s. Sophiae*, lines 362–68; ed. Bekker, p. 19; ed. Friedländer, p. 237.

[95]*Script. orig. Const.*, I, 94.

[96]*Descr. s. Sophiae*, lines 418–22; ed. Bekker, p. 22; ed. Friedländer, p. 239.

[97]Ibid., lines 720–54; ed. Bekker, pp. 35–36; ed. Friedländer, pp. 247–48.

[98]*Script. orig. Const.*, I, 94; *Chronicon paschale*, I, 714.

[99]Further details on the altar and ciborium are discussed below, pp. 166–67.

Part Two

Planning and Liturgy

4 The Problem of Liturgical Planning in Constantinople

Characteristics of the Constantinopolitan Plan

The architectural remains of church planning in early Constantinople are tantalizingly sketchy. We have in all only a handful of churches, and many of these are unsatisfactorily preserved. Nevertheless, some conclusions can be drawn from the material: certain patterns are immediately evident, and others can be traced at least tentatively. Special characteristics emerge which distinguish the Early Byzantine plan in Constantinople from early church planning elsewhere, as well as from church planning in the capital in post-iconoclast times; these are the characteristics which define the problem of liturgical planning in early Constantinople, for they are the characteristics which must be explained in terms of their practical functions in the liturgy.

In the first place, early Constantinopolitan church planning is distinguished by its extraordinary openness of design. Wherever we have evidence of the entrance system of these churches, this evidence indicates an abundance of entrances on all sides. Hag. Polyeuktos seems to constitute the only significant exception, in that its lofty platform probably made it less accessible from the sides and from the east. But in the other churches—the early basilicas, the small, centrally-planned Justinianic foundations, and the great churches of Hag. Eirēnē and Hagia Sophia—the evidence is fairly uniform, and its most striking aspect is the indication of doors at the east end of the church flanking the apse. These doors appear to have been more than simply service entrances or "back doors," and were principal approaches to the church. The clearest examples are the Chalkoprateia church, with its colonnaded southeast entrance, and Hag. Eirēnē and Hagia Sophia, where the doors are monumental in size; but in the other churches as well this feature is fairly consistent and requires some explanation. When the palace hexagon was converted into the church of Hag. Euphēmia, the new door north of the apse had to be cut through two meters of solid masonry.

This feature alone (i.e., entrances flanking the apse) distinguishes the Constantinopolitan plan from church planning in many of the other Early Christian centers. Contrary to the long-standing assumption, the planning of the eastern end of the Byzantine church does not involve a closed triple sanctuary, consisting of a central sanctuary apse flanked by smaller subsidiary apses or chapels.[1] Among the churches of the capital

for which archaeological remains exist, none exhibits the triple-sanctuary plan. Procopius adds another instance of the characteristic Constantinopolitan plan in his description of Justinian's church of Hag. Michaël in the section called Byzantium, the eastern wall of which was straight except for a receding apse in the middle.[2]

This arrangement is not typical of other centers. In northern Syria the triple sanctuary is the usual pattern, whether the side chambers and central apse are flush with a flat terminating east wall or the three chambers are articulated on the outside of the church (Figure 51). In Ravenna, too, church plans beginning with that of the basilica of S. Giovanni Evangelista in the early fifth century consistently feature a pair of small apsed or square chambers flanking the central apse of the church.[3] In Greece the picture is somewhat more complex: the handful of churches that have a simple, single-apsed east end generally lack the flanking east entrances seen in Constantinople,[4]

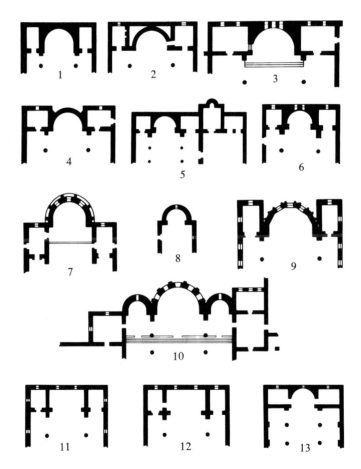

Figure 51. North Syrian sanctuary plans. 1. Milayha.
2. Ruwayha. 3. Brad. 4. Fafartin. 5. Qasr Iblisu.
6. Kharab Shams (5th century). 7. Qalb Lozeh.
8. Kharab Shams (6th century). 9. Tourmanin. 10. Qal'at
Sim'an. 11. Khirbat Tayzin. 12. Dana (south)

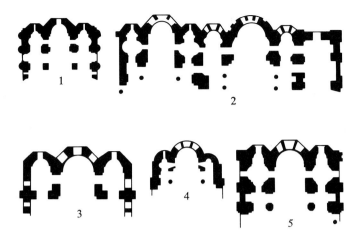

Figure 52. Constantinopolitan sanctuary plans, Middle
Byzantine. 1. Myrelaion. 2. Lips church. 3. Atik
Mustafa Paşa Camii. 4. Hag. Iōannēs in Trullo.
5. Eski Imaret Camii

but more often the east end is complicated by a transept arrangement preceding the
apse or by the addition of one or more subsidiary rooms.[5] In Rome, where the simple,
single-apsed plan is the rule, the eastern ends of the aisles generally belong to the
chancel area; thus entrances in the eastern end are exceptional.[6] In later churches in
Constantinople itself, the planning of the east end is again quite different. Starting with
the Budrum Camii and the north church of the Fenari İsa Camii, both from the early
tenth century, later Constantinopolitan church planning regularly flanks the central
apse with two small side apses, each of which is preceded by a diminutive sanctuary bay
of its own (Figure 52).

The explanation of this feature in Early Byzantine churches necessarily involves a
reinterpretation of the performance of the Early Byzantine liturgy. One must ask how
the functions that were served by side chambers in other churches were accommodated
in the churches of Constantinople. We must establish where the vestments and
scriptural texts were kept, where the clergy might have prepared for the liturgy, and
how they would have entered their places in the sanctuary. We must also discover
where the prothesis ceremony might have taken place, where the bread and wine
could have been prepared for the Eucharist, and how these elements would have been
brought to the altar for the liturgy. In short, our present knowledge of the design of the
church sanctuary requires that we reconsider the performance of the Entrance cere-
monies of the Early Byzantine liturgy. Archaeological evidence indicates that we are
dealing with a liturgical usage substantially different from that in other Early Chris-
tian centers, and one would hope to find in the liturgy itself some explanation for these
differences.

While at its eastern end the Constantinopolitan plan is distinguished by its simplicity
and lack of development, at its western end the plan is amply developed, with the
recurring use of propylaea, atria or forecourts, and nartheces. Although atria are

fairly common in the Early Christian world at large, in no other center do they seem to be a rigorously required feature. We have positive evidence of an atrium of sorts in all twelve of the churches which we have considered, with the exception of the Beyazit Basilica A where the area in front of the church was not excavated. At times the plans call for formal rectangular atria set on axis with the nave of the church, as at the Studios basilica, Hag. Eirēnē, or Hagia Sophia; at other times they call for a simple forecourt or precinct area, which may surround the church on three sides (the Hebdomon) or be located in front of it, either on axis (Hag. Polyeuktos) or off axis (Saray). At Hag. Euphēmia we find a sigma court before the church. To these examples, for which archaeological evidence remains, we may add several more mentioned by Procopius: Hag. Akakios was preceded by an atrium or peristyle;[7] Hag. Theodōros and Hag. Priskos and Nicholas were set in precinct areas;[8] and Hag. Anthēmios and Hag. Michaēl in Anaplous had aulae or forecourts.[9] Apparently the feature of atrium, forecourt, or precinct area was standard in fifth- and sixth-century church planning in Constantinople.

The use of the narthex seems to have been equally consistent. In six of the churches the narthex plan is securely known, and it was generally accessible both from the front and the sides. The only church that clearly seems to have lacked a narthex is Hag. Euphēmia, which was adapted from a palace hall. At Hagia Sophia, the largest of the churches, we find that the narthex space has been doubled. In no instance, however, do we find the narthex equipped with auxiliary rooms, whether for use as prothesesor some other purpose, as commonly occurs in Greek churches.[10] An adequate description of the ritual of these churches ought to suggest usages that would explain the persistence of these features in Constantinople.

Other characteristics also stand out. Almost all of the churches examined had galleries; only the Beyazit basilica, the smallest of the churches, and Hag. Euphēmia, converted from a secular hall, clearly seem to have lacked them. The others had galleries of rather spacious dimensions, generally following a "U"-shaped plan wrapped around the central nave on three sides. At the Studios church, Hag. Eirēnē, and Hagia Sophia, access to the galleries was provided through stairwells or ramps located outside the body of the church; at Hag. Sergios and Bacchos the stairs seem to have been located in the neighboring palace structure to the north. No other Early Christian center makes such an extensive use of galleries, with the possible exception of nearby Macedonia. At Philippi (Basilicas A and B) and at Thessalonike (Acheiropoiētos and Hag. Dēmētrios) galleries are a fairly common occurrence, but elsewhere they appear as the exception rather than the rule.[11] It is important to establish who used these galleries and when in explaining the liturgical use of the early churches of Constantinople; one wants to know whether they were in demand for a practical purpose or whether they were simply part of an inherited building tradition.

Closely associated with this problem is that of the allotment of space in the church as a whole. The space within the churches was usually distributed between aisles and nave, roughly speaking; how much of this space was available to the laity and how

the laity may have been divided are important issues in understanding the use of church space. In the Beyazit Basilica A, evidence was found of barriers separating the aisles from the nave, but this is an exception to the openness of the other interiors.

Concerning church furnishings, the evidence is much more fragmentary. The arrangement of all the church furnishings is not completely known for any one of the churches; yet most of them preserve one or more elements of these furnishings, and taken together they give us at least a tentative picture of the sanctuary of the Early Byzantine church. Three churches preserve remains of the synthronon—the Studios, Hag. Euphēmia, and Hag. Eirēnē—and literary sources describe a fourth at Hagia Sophia.[12] The Church of the Holy Apostles should be counted as a fifth example; the description by Nicholas Mesarites mentions a square sanctuary in the central bay of the cruciform plan, which was "semicircular at the east—so much of it as lies about the steps of the sacred throne."[13] The excavation of Hag. Iōannēs in Ephesus, the twin of the Holy Apostles, shows a semicircular synthronon, slightly splayed in plan, closing the eastern side of the central bay; a passageway runs under the benches, as in examples in Constantinople itself.[14] Unlike the Greek synthronon, which was often raised on a podium in the apse and was generally supplemented by a pair of straight benches in front, north and south of the altar site,[15] the synthronon in Constantinople consisted of a simple yet monumental semicircular tier of benches or steps. The importance of these clergy benches in the liturgy has not yet been explained. It must be significant that in later Byzantine architecture the synthronon was reduced to a simple bench on a step, of the kind found in Early Christian basilicas in the West.[16]

The presence of the synthronon precluded placing the altar in the apse of the church; the apse was exclusively the place for the clergy. At three sites—the Studios, Chalkoprateia, and Hag. Euphēmia—archaeological evidence locates the altar a few meters in front of the apse. Two of these churches had small cruciform crypts under the altar, reached by short flights of stairs descending from the apse side; two more, the Hebdomon and Hag. Polyeuktos, had crypts that were reached from the outside behind the apse or from a subnarthex. Literary sources mention jewelled altars of gold in Hagia Sophia and a box altar with confessio in Hag. Euphēmia in the seventh century, but none of the altars at the sites we are considering has survived. The one altar fragment that has survived in Constantinople indicates a box-type altar familiar in Ravenna in the sixth century. The altar frontal seems to have had a pair of colonnettes in relief supporting an arch of acanthus containing a cross, with the confessio door placed beneath the cross (Figure 53). The fragment was found in the area of the Topkapī.[17]

The chancel barrier enclosing the altar site assumed various forms. At the Studios basilica and Hag. Euphēmia, where we can reconstruct the plans in detail, the barrier was "π"-shaped with an entrance on each side; this was also the plan used at Hagia Sophia. The type was fairly common in Greece and elsewhere.[18] On the other hand, different types are also known in Constantinople. At the Saray and Beyazit churches and probably at Hag. Sergios and Bacchos, where the apse was set back somewhat from the body of the nave of the church, the chancel barrier ran straight across in a plan

Figure 53. Altar-frontal fragment
(Istanbul Archaeological Museum, depot)

that was to become standard in Middle Byzantine architecture. At the Church of the Apostles the barrier enclosed a square area in the center of the church.[19] In elevation we have examples both of the old-fashioned low chancel screen (at Chalkoprateia) and of the new high barriers with colonnettes and architrave (at the Studios, Hag. Sergios and Bacchos, Hag. Euphēmia, Hag. Polyeuktos, and Hagia Sophia). Other sixth-century chancel piers in the Istanbul Archaeological Museum show another design for the high chancel barrier (Plate 89),[20] in which colonnettes seem to have been mounted separately on top of the small piers.

At three churches (the Saray basilica, Hag. Euphēmia, and Hag. Polyeuktos), the archaeological evidence shows a solea or passageway leading from the central entrance of the chancel down the nave of the church; at two of these churches (the Saray and Hag. Polyeuktos), the site of the ambo can be ascertained at the end of the solea. Paul the Silentiary has preserved another example of this arrangement for us in his description of the ambo and solea of Hagia Sophia; and if the church of Hag. Iōannēs in Ephesus can be allowed to represent the Church of the Holy Apostles in this regard, it would provide still another instance of a solea leading from the center door of the chancel to the ambo.[21] Only one ambo has actually survived, that of the Beyazit basilica, and it consists of a double stair leading to an oval platform. The description of the ambo of Hagia Sophia conforms to this plan, and the oval ambo bases at Hag. Polyeuktos, at the Hebdomon church, and at Hag. Iōannēs of Ephesus indicate the same kind of plan. The size of the ambo, from all indications, was very impressive, but its prominence and its functions in the liturgy have yet to be properly explained.

The sanctuary plan seems to be distinctively Constantinopolitan. Examples from Greece generally differed from those of the capital, as Xydis has pointed out, in that they featured a small porch or arch which emphasized the central entrance, omitted the solea, and placed the ambo off to one side.[22] Moreover, the Greek ambo was often a one-stair affair, a type which was then still unknown in Constantinople. It goes without saying that no evidence of a Syrian-type ambo ever appears in Constantinople, contrary to Bouyer's opinion.[23]

The evidence of the furnishings is thus rather sparse. Yet it is fairly uniform, and the archaeological evidence confirms what might have been expected from the literary

descriptions and provides at least a tentative framework on which to reconstruct the performance of Early Byzantine liturgy.

This, in summary, is the existing archaeological evidence of liturgical planning in the Early Byzantine churches of Constantinople. The evidence differs from that in other Early Christian centers; it also presents rather a different picture than has generally been assumed. This demands an interpretation, which in turn requires that we re-examine the practical uses of the various parts of the liturgical plan. The proper explanation of the shape of Early Byzantine church planning lies in a reconstruction of the external shape of the Early Byzantine liturgy. Archaeology, therefore, presents us with a problem that can be solved only in terms of the history of the performance of the liturgy.

Reconstructing the Early Byzantine Liturgy

If we compare the history of the Byzantine liturgy with that of the Roman liturgy, we are immediately struck by the stability and the profoundly conservative character of the Byzantine. The Roman liturgy has undergone several far-reaching revisions or restructurings since Early Christian times. Paralleling the succession of artistic styles in Western Europe, Latin worship developed a series of styles of its own: an Imperial Early Christian style, one of Early Medieval monastic devotion, a florid style of Late Medieval embellishments, and a period of post-Tridentine severity, followed by one of rococo theatricality.[24] The styles were widely different, and the change from one to another was sometimes abrupt, effected by papal or conciliar decree rather than by gradual evolution. The Byzantine liturgy has been preserved from such cultural upheavals, and its performance as observed in the present-day Orthodox Church differs little from its performance in medieval times.

This relatively greater stability in the Byzantine liturgy, however, has tended to mislead the historian into supposing that the liturgy has never changed.[25] Small differences are overlooked and elements that were slow in developing are assumed always to have been the way they eventually emerged. Lacking clear evidence to the contrary, the historian has assumed that the present, essentially medieval liturgy faithfully represents the liturgy of the Early Byzantine church. The underlying basis of this assumption, however, is the critical question of the present study: we must ask whether the great cultural upheaval which intervened between early and medieval Byzantium and which so drastically affected the quality of life in the Eastern empire did not also radically change the shape of the Byzantine liturgy.

At present the performance of the Byzantine liturgy is structured around a series of appearances of the celebrants, who emerge from the iconostasis in two solemn processions (the "Entrances") or come forward alternately to bless, incense, read to, or lead in prayer the congregation assembled outside. The latter see little of the sanctuary, glimpsing only what is visible when the doors are open. Their contact with the continuity of the rite depends more on their continuous response to the celebrants in song and litany than on their visual observation of what is being done by the celebrants.

The great moments of drama or movement in the liturgy are the two processions, the Little Entrance and the Great Entrance, when the clergy emerge in solemn file from the north door of the inconostasis and circle back through the central door, the Holy Door. These processions, however, are exclusively the part of the clergy; aside from song and litanies, the laity take little active part in the performance of the liturgy. Their participation lies in prayer and devotion, which demonstrates itself externally only in making the sign of the cross, or kissing an icon, or making proskynesis. Generally not even Communion involves the laity, since reception of the Eucharist is usually restricted to three or four great feasts during the year. Instead, a blessed bread (the antidoron) is taken after the conclusion of the rite, when the faithful come forward to kiss the crucifix offered for their veneration by the celebrant. Restraint, dignity, and mystery characterize the whole ceremony.

Our reconstruction of the Early Byzantine liturgy must not presume that this picture faithfully reflects the earlier ceremonial. Each part of the liturgy must be systematically reexamined in its primitive state to establish critically the appearance of the early liturgy, the participation required of both clergy and laity, and the relationship of the whole to the architectural planning we have traced. Central to this, of course, is the reconstruction of the original shape of the Entrances, which in their present condition seem to be abbreviations of more elaborate ceremonies. Other rites must also be examined which may explain the uses of the solea, ambo, synthronon, and chancel barriers. In addition, the use of the various areas for congregation in the church and the extent to which the liturgy was screened from the faithful are questions which basically affect the shape and appearance of the ceremonies.

A proper reconstruction of the performance of the Early Byzantine liturgy has not yet been undertaken, nor is there a critical history of the subject. No work exists in Byzantine studies comparable to Jungmann's monumental treatise on the history of the Roman liturgy;[26] however, a vast number of monographs on various aspects of the Byzantine liturgy have appeared, and the field is developing rapidly.[27] The history of the text of the Liturgy of St. John Chrysostom has been prepared and will soon be published;[28] a detailed history of this liturgy, which promises to become the definitive treatment of the subject, has been begun and the first installment has appeared. The work was initiated by Fr. Juan Mateos and is now being continued by Fr. Robert Taft at the Pontifical Oriental Institute in Rome.[29] In the meantime, we have Hanssens' valuable collection of source material for the history of the liturgy,[30] and two useful surveys of the subject by Salaville and Schulz.[31]

The primary sources for reconstructing the appearance of the Early Byzantine liturgy are as fragmentary as the archaeological evidence. There are several classes of material available, and it is necessary to distinguish the different values that each one has for our purposes.

First there are the liturgical books, properly speaking, which contain the texts and prescribe the prayers and the order of the ceremonies. Obviously this material is extremely authoritative in describing the Byzantine liturgy; the problem is that the texts, in the form in which we have them, are all post-iconoclastic. The earliest

manuscript of the liturgies of St. John Chrysostom and St. Basil the Great is the Barberini manuscript published by Brightman, which dates to around 800.[32] The best manuscript of the Typicon, a book that details the changeable parts of the liturgy according to the year-long cycle of feasts, is the manuscript from the Monastery of the Holy Cross in Jerusalem, dating around 900.[33] These sources contain a great deal of valuable material about the liturgy of the Early Byzantine church, but it must always be used with discretion, since many changes had already taken place in the liturgy by the ninth and tenth centuries.

The *De ceremoniis* of Constantine Porphyrogenitus constitutes a different type of material altogether, as it is concerned with the Emperor's own liturgy—his receptions and ceremonial appointments within the palace itself, and his part in the celebration of the divine liturgy. Woven into the meticulous description of Imperial protocol is a wealth of information about the topography of Constantinople in general, and about the layout of the various parts of Hagia Sophia in particular; Ebersolt's systematic study of the latter material is the basic treatise on this subject.[34] Its color and attractiveness, with the splendid pomp of the Emperor's comings and goings, have proven irresistible to Byzantine architectural historians: so much so that it has become their single standard source for the description of the Early Byzantine church ceremonial.[35]

However, the limitations of this material as a liturgical source have not been carefully observed. In the first place, the evidence in the *De ceremoniis* is generally restricted to the participation of the Emperor and his court in the liturgy, so that the parts of the celebrating clergy and the people in general are not mentioned except in passing. Second, in order to discuss the liturgy of Early Byzantine times accurately we must face the difficult problem of distinguishing earlier strata from later additions in the text of the *De ceremoniis*. Third, we must take into account the fact that the text does not describe the standard Byzantine liturgy, but rather the liturgy of those special occasions on which the Emperor publicly took part. In the tenth century the Emperor took part in the liturgy on not more than nineteen occasions during the course of the year, and of this number, four of the feasts were clearly introduced in post-iconoclastic times. The custom of going to the Nea for the feast of St. Elias and for the feast of the dedication of the Nea was introduced by Basil I, who built the church; Leo VI began the custom of going to Hag. Dēmētrios for the feast of that church's dedication; and clearly the feast of Orthodoxy, celebrating the defeat of Iconoclasm, is a post-iconoclastic introduction. On two other occasions the Emperor's attendance at the liturgy was informal and his participation minimal, i.e., on Palm Sunday and on the Sunday after Easter. Hence the Emperor's active participation in the public liturgy in pre-iconoclastic times may have occurred on no more than a dozen occasions; normally the liturgy was conducted in his absence.

A third class of material available for the reconstruction of the Early Byzantine liturgy consists of the dozens of scattered incidental references to the liturgy that occur in the historical sources for the period. The Councils, the chronicles, the law codes, the histories, and the biographies all have occasion to refer from time to time to events that took place in connection with the liturgy, and these references have been

systematically collected by Hanssens. The fragmentary nature of the material makes it difficult to piece together a coherent picture; yet its reliability is very high, since the references usually date reasonably closely to the events in question, and since liturgical details are usually safe from any "axe-grinding" interests on the part of the historians who transmit them.

The commentators are a fourth source. Taking their initial inspiration from Pseudo-Denis' *Ecclesiastical Hierarchy*, the spiritual writers of Byzantium developed the treatise on the spiritual meaning of the various liturgical ceremonies into a new literary genre; these works are generally known as "commentaries" on the divine liturgy.[36] Much neglected information on the external shape of the liturgy is couched in these spiritual treatises, for although their purpose was not so much to describe the ritual as its inner meaning, the latter could not have been accomplished without remarking on the visible and external succession of ceremonies in the liturgy.

The advantages of this kind of document for our reconstruction are manifold. The standpoint of the treatises is that of the lay participant in the liturgy, for they were written for his edification and to increase his understanding of the liturgy; thus they describe what he saw and heard at it, omitting prayers or ceremonies that belonged to the celebrant alone or that were not accompanied by any significant external action. Their intention requires that they describe the standard liturgy, the liturgy as commonly celebrated, rather than that which might be held under special circumstances or on special occasions. Thus they give us a basis for interpreting what seem to be standard features in liturgical planning. Finally, and most important, the earliest of the commentators, Maximus the Confessor, lived reasonably near the time of Justinian.

The *Mystagogia* of Maximus is the earliest Byzantine liturgical work, properly speaking.[37] Composed in 628–30 during the reign of Heraclius, it postdates Justinian by only a little over sixty years, a period of minor significance in the gradual evolution of the Byzantine liturgy.[38] Its author ranks as the most important Greek theologian between Justinian and Iconoclasm.[39] After serving as first secretary to Heraclius around 610–14, Maximus left the civil service to enter the monastery at Chrysopolis (Scutari) and then that at Cyzicus (Erdek) on the Marmara. Though the *Mystagogia* was actually written during Maximus' stay in Africa, it is the liturgy of Constantinople that is the subject of his commentary. The work is relatively brief; after a preface, it is divided into three parts: seven rather long chapters explaining the spiritual significance of the principal divisions in the church building (chs. 1–7) are followed by fifteen short chapters explaining the significance of the principal ceremonies of the liturgy (chs. 8–22). These are followed by two lengthy chapters (23–24) containing no less than three successive recapitulations of the treatise, each reviewing the progress of the ceremonies of the liturgy and developing new spiritual applications of the symbolism involved. Hence the work in effect outlines the structure of the Byzantine liturgy four times in succession, so that details which are obscure in one account are sometimes clarified in another.

One other commentary on the liturgy can be used in reconstructing the performance of the Early Byzantine liturgy, the *Historia ecclesiastica* of St. Germanus, patriarch of

Constantinople (d. 733). Earlier verdicts that denied, or at least questioned, the attribution of the work to St. Germanus must be reconsidered in the light of Bornert's study. On the basis of the oldest manuscript tradition, the most ancient historical witnesses to the work, the state of the liturgical evolution described in it, and a comparison of its style with that of Germanus' authentic works, Bornert assigns a high degree of probability to its attribution to the patriarch.[40] Hence, although a century later than Maximus' *Mystagogia*, the *Historia ecclesiastica* still pre-dates the iconoclastic upheaval (St. Germanus was deposed for his iconophile position in 730) and contains valuable information on the Early Byzantine liturgy. Often its importance is negative, documenting the changes that had taken place since Maximus' time and thus clarifying the shape of the primitive liturgy. The chief problem in using the *Historia ecclesiastica* is its extremely complicated textual history.[41] Owing to its continued popularity (its theology is much simpler than that of Maximus) the treatise was revised and updated over and over again in subsequent periods. No critical edition of the text exists which discriminates among the many revisions, and the text most commonly referred to represents its most highly developed recension.[42] However, the most primitive recension of the text—represented by a manuscript in the Vatican Library and another in Naples—has been published by Borgia, and this can be used with reasonable security.[43]

Within the limitations of this material, fragmentary as it is, one can begin to piece together the general lines of the Early Byzantine liturgy. The picture is not always as complete as one might wish, but it offers the only explanation presently available for the characteristics observed in the liturgical planning of the churches of Constantinople.

Notes

[1] E.g., Charles Diehl, *Manuel d'art byzantin*, 2nd ed. (Paris, 1925), p. 175.

[2] *Buildings*, I, 3, 17, pp. 42–43.

[3] C. Ricci, *Guida di Ravenna*, 2nd ed. (Ravenna, 1884), passim.

[4] G. A. Soteriou, *Hai palaiochristianikai basilikai tēs Hellados* (Athens, 1931), pp. 179–88.

[5] Ibid., pp. 197–212; Orlandos, *Deltion*, 1966, 353–72.

[6] R. Krautheimer, *Corpus basilicarum christianarum Romae* (Vatican City, 1939 ff.), passim; T. Mathews, *RAC* 38 (1962), 73–95.

[7] *Buildings*, I, 4, 25, pp. 54–55.

[8] Ibid., I, 4, 28 and I, 5, 4; pp. 54–55 and 60–63.

[9] Ibid., I, 6, 12 and I, 8, 10; pp. 64–65 and 72–73.

[10] Orlandos, *Basilikē*, pp. 132–38.

[11] R. Krautheimer, *Early Christian and Byzantine Architecture*, index, pp. 378–79, listing churches with galleries.

[12] Prof. C. Lee Striker has unearthed archaeological remains of another synthronon of pre-iconoclastic date at the Kalenderhane Camii. As in the other churches, a semicircular set of benches was erected over a passageway against the wall of the apse. This discovery was made too late to be included in the present study, but it will be covered in detail in Prof. Striker's monograph on the church, which is now in preparation.

[13] G. Downey, *Transactions of the American Philosophical Society*, n.s. 47 (1957), 890.

[14] Österreichisches Archäologisches Institut, *Forschungen in Ephesos*, IV, pt. 3, *Die Johanneskirche* (Vienna, 1951), 171–72, figs. 45–46.

[15] Orlandos, *Basilikē*, pp. 489–503.

[16] Cf. the synthronon in the south church of the Pantokrator in the twelfth century. Arthur H. S. Megaw, *DOP* 17 (1963), 340.

[17] Naumann and Belting, *Die Euphemia-Kirche*, p. 110, n. 33; Unger, *AA*, 1916, p. 28, fig. 16, no. 30.

[18] Orlandos, *Basilikē*, pp. 509–35.

[19] Procopius, *Buildings*, I, 4, 12, pp. 48–49; Downey, *Transactions of the American Philosophical Society*, n.s. 47 (1957), 890.

[20] Pier no. 916 is from the Tokapī area; no. 4283, from the vicinity of Nuri Osmaniye; another such

pier, no. 5141, is from Bakirköy. Nezih Fīratlī, *A Short Guide to the Byzantine Works of Art in the Archaeological Museum of Istanbul* (Istanbul, 1955), pp. 34–35.

[21]*Forschungen in Ephesos*, IV, pt. 3, pl. 66.

[22]Orlandos, *Basilikē*, pp. 541–63; Xydis, *AB* 29 (1947), 18–19.

[23]Bouyer, *Architecture et liturgie*, pp. 55–62.

[24]Josef A. Jungmann, *Missarum sollemnia*, 5th ed. (Vienna, 1962), I, pt. 1.

[25]For example, Downey describes the Justinianic liturgy as if it differed in no way whatsoever from the modern ceremony. G. Downey, *Constantinople in the Age of Justinian* (Norman, Oklahoma, 1960), pp. 114–35.

[26]Cited above, note 24. An English translation of the earlier and less definitive edition exists; *The Mass of the Roman Rite, Its Origins and Development*, trans. F. A. Brunner (New York, 1951).

[27]A detailed bibliography of liturgical studies from the beginning of the century down to 1960 can be found in J. M. Sauget, *Bibliographie des liturgies orientales* (Rome, 1962). This coverage has been extended down to 1967 by Sebastià Janeres, *Bibliografia sulle liturgie orientali* (Rome, 1969).

[28]André Jacob, "Histoire du formulaire grec de la liturgie de saint Jean Chrysostome" (Diss., Université Catholique de Louvain, 1968).

[29]Juan Mateos, *Evolution historique de la liturgie de saint Jean Chrysostome*, pt. 1 (Rome, 1968); first published in *Prôche-orient chrétien* 15 (1965), 333–51; 16 (1966), 3–18; 17 (1967), 141–76.

[30]I. M. Hanssens, *Institutiones liturgicae de ritibus orientalibus: De missa rituum orientalium* (Rome, 1930–32), II.

[31]S. Salaville, *Liturgies orientales* (Paris, 1932–42); Hans-Joachim Schulz, *Die byzantinische Liturgie* (Freiburg-im-Breisgau, 1964).

[32]Brightman, *Liturgies*, I, 307–52. For a detailed index of the contents of this MS, see Anselm Strittmatter, "The 'Barberinum s. Marci' of Jacques Goar: Barb. gr. 336," *Ephemerides liturgicae* 47 (1933), 329–67.

[33]Juan Mateos, *Le typicon de la Grand Église*, Orientalia christiana analecta, vols. 165–66 (Rome, 1962–63).

[34]J. Ebersolt, *Sainte-Sophie*.

[35]Among recent works see Kähler, *Hagia Sophia*, pp. 61–66; Krautheimer, *Early Christian and Byzantine Architecture*, pp. 159–60; Schneider, *Hagia Sophia*, pp. 18–28.

[36]A reliable guide to the commentators, their texts, and the literature about them has recently appeared. René Bornert, *Les commentaires byzantins de la divine liturgie du VII^e au XV^e siècle* (Paris, 1966).

[37]A critical text is still lacking. The standard edition is that of F. Combefis (Paris, 1675), reprinted in *PG* 91, 657–717. This has been reprinted with an Italian translation in Raffaele Cantarella, *S. Massimo Confessore, La Mystagogia ed altri scritti*, Testi cristiani, vol. 4 (Florence, 1931), pp. 119–215.

[38]Polycarp Sherwood, *An Annotated Date-List of the Works of Maximus the Confessor* (Rome, 1952), p. 32.

[39]Berthold Altaner, *Patrology*, transl. H. Graef (New York, 1964), pp. 629–33. A complete bibliography on Maximus has been prepared by Polycarp Sherwood in *The Earlier Ambigua of St. Maximus and his Refutation of Origenism* (Rome, 1955) and "A Survey of Recent Work on St. Maximus the Confessor," *Traditio* 22 (1964), 428–37. See also I. H. Dalmais, "Place de la Mystagogie de saint Maxime le Confesseur dans la théologie liturgique byzantine," *Studia Patristica*, Texte und Untersuchungen zur Geschichte der altchristlichen Literatur, vol. 80 (Berlin, 1962), V, 277–83. The most authoritative study of his theology is that of Lars Thunberg, *Microcosm and Mediator, the Theological Anthropology of Maximus the Confessor* (Lund, 1965).

[40]Bornert, *Les commentaires*, pp. 142–60.

[41]Ibid., pp. 124–42.

[42]Ed. A. Galland (Paris, 1779), published in *PG* 98, 384–453.

[43]Nilo Borgia, *Il commentario liturgico di s. Germano patriarca costantinopolitano e la versione latina di Anastasio bibliotecario* (Grottaferrata, 1912); first published in *Roma e l'oriente* 2 (1911), 144–56, 219–28, 286–96, 346–54. Borgia's text is not always consistent; passages enclosed in parentheses or brackets or printed in smaller type are all missing from Vat. Gr. 790 and presumably were supplied from Nap. Gr. LXIII, but the rationale behind this system is not apparent. Another MS of the same recension, Sin. 327 (fol. 258–72), has been edited by Nikolai T. Krasnoseltsev in *Svedenija a nekotorykl liturgiecskikl Vatikanskij biblioteke* (Kazan, 1885), pp. 323–75.

5 The Divisions of the Church

The Use of Nave and Aisles

Where the faithful stood is a fundamental question for understanding the performance of the liturgy. Logically we cannot take up more detailed questions of ritual until we have determined what parts of the church the faithful occupied, into what groups they may have been segregated, and how much space was left free for the movement of the celebrants performing the liturgy. Even apart from the issue of liturgical planning the divisions of the church are of considerable importance architecturally, for the position of the faithful in the church determined not only the vantage they generally enjoyed of the liturgy but also the kind of impression they ordinarily had of the building itself. The way in which the church was divided therefore involves critical questions of how the building was meant to be seen and experienced.

An adequate treatment of the divisions of the church involves not only the architectural divisions—atrium and narthex, nave, aisles, and galleries—but also the divisions of the faithful in classes or ranks of clergy and laity. One must discuss the divisions for catechumens and baptized, for men and women, for layfolk and clergy, for common people and members of the Imperial court.

The accepted opinion has assigned to the faithful the use of the nave, aisles, and galleries of the Early Byzantine church with men on the ground floor and women above, and to a certain extent this is reflected in current usage in the Greek Orthodox church.[1] The faithful generally occupy both nave and aisles of the church, women standing on the left and men on the right; in the rare cases in which a gallery is provided, it is reserved for women, although women are also allowed below. It is usually assumed that this arrangement reflects rather faithfully the original one in the Early Byzantine church, but there has nevertheless always been significant dissent from this opinion.

In the first edition of his *Historia byzantina* published in 1670, Du Cange maintained that the Byzantine church (as well as the Latin church) was traditionally divided into three parts, and that the faithful did not occupy the nave: "In tres autem potissimum apud Graecos, ut et apud Latinos, templum dividitur, βῆμα scilicet, ναόν, et eam in qua fideles consistunt."[2] In confirmation of his statement Du Cange cites Symeon of Thessalonike, who also divides the church into three parts, the βῆμα,

the ναός, and the area in front of the ναός (i.e., the narthex).[3] But here Du Cange has misrepresented Symeon, who in no way excludes the faithful from the ναός; he mentions a three-fold division of the church only after explaining the more basic two-fold division between parts that are inaccessible (ἄδυτα)—the sanctuary—and parts that are accessible outside (ἐκτός) the sanctuary. In his discussion of the narthex or the area in front of the ναός, Symeon tells us that this part of the church is used in the chanting of the divine office before the liturgy.[4] For the performance of the liturgy, the congregation enters the ναός; catechumens and those who are excluded from Communion may enter the ναός only partway; the lapsed alone are entirely refused entrance into the ναός and must therefore remain in the narthex. Symeon's testimony, of course, is very late (d. 1429) and can hardly be used to establish the Early Byzantine practice.

Yet it was not only his reading of Symeon but also his interpretation of Paul the Silentiary that led Du Cange in the first edition of the *Historia byzantina* to restrict the faithful from the nave of the church. He believed that the Silentiary's description (see texts discussed below) placed the choir of clergy in the four conches of the nave that are placed diagonally, flanking the sanctuary in the east and the entrances in the west.[5] The entire nave is thus identified with the "chorus" of the church: "Ναόν et chorum conficiebat totum illud spatium, quod intra quattuor pilas maiores continetur."[6]

In the second edition of the *Historia byzantina* published in 1680, Du Cange reversed his position entirely on this point; apparently the chief reason for this revision was his discovery of Maximus the Confessor's treatment of the parts of the church. Quoting from the second chapter of this work, Du Cange concludes, "Ex quo loco omnino conficitur ναόν non fuisse aedis sacrae locum in quo Clerus constiterit, sed plebs ipsa, seu fidelium coetus."[7] Hagia Sophia, he explains, had no division that could properly be called a "chorus." His summarizing statement on the three divisions of the Byzantine church is revised to read: "In tres autem potissimum apud Graecos, templum dividitur, βῆμα scilicet, Ναὸν in quo fideles consistunt, et Narthecem."[8] Despite his effort to correct himself in his second edition, it was the first edition of Du Cange's work that enjoyed a wider circulation, as it was reprinted both in the Bonn Corpus and in the Migne Patrology editions of Paul the Silentiary;[9] hence his earlier hypothesis has continued to receive a good deal of attention.

Crostarosa took this theory and applied it to Early Christian churches generally, in the West as well as in the East, reconstructing continuous curtains in the nave and gallery arcades that might have served to hide the mysteries of the liturgy from the profane eyes of the laity, who occupied the aisles and galleries.[10] Crostarosa's documentation, however, is no more specific than the donation lists of the *Liber Pontificalis*, which sometimes mention arcade curtains. Selhorst adopted the same position on the basis of the same slender evidence.[11] Among liturgists, Salaville also proposed that in the East the central nave was generally reserved for the free movement of the clergy, but he offers no documentation for his remark.[12]

More recently, archaeological discoveries in the Aegean have supplied weighty evidence of another kind in support of this position, for a whole series of fifth- and sixth-century churches in Greece and the Islands show the nave to have been effectively

segregated from the aisles on either side.[13] In these churches the stylobates on which the nave colonnades rested were elevated above the floor level, often a half-meter or more, and in many of them the division was also indicated by marble parapet slabs between or alongside the nave columns. The peculiarity of this kind of arrangement, unknown outside the Aegean area, was remarked upon by Soteriou, although he offered no explanation of its purpose.[14]

Lemerle turned to the ancient church orders—the *Apostolic Tradition* of Hippolytus, the *Didascalia*, and the *Testamentum Domini*—for his explanation of Basilica A in Philippi. These documents mention the division of various classes of worshippers in the early church. The *Testamentum Domini*, for example, prescribes as follows: "But let the bishop stand first in the middle, and the presbyters immediately behind him on either side, and the widows immediately behind the presbyters on the left side, and the deacons also behind the presbyters on the right hand side, the readers behind them, and the sub-deacons behind the readers, and the deaconesses behind the subdeacons."[15] Similar divisions, Lemerle infers, must have existed among Greek congregations. The ordinary lay men and women therefore, he assigned respectively to the aisles and galleries of the church, while he reserved the nave for people specially consecrated to God: ascetics, teachers, virgins, widows, etc.[16]

Orlandos offered two other possible interpretations for the stylobate barriers in Greece: either they were intended for the separation of the sexes (presumably men standing in the nave and women relegated to the aisles), or they served to close off the nave for exclusive ceremonial use in the liturgy proper.[17] Of these two alternatives, Krautheimer adopted the second in his interpretation of the liturgical use of the Early Byzantine churches of Justinianic and post-Justinianic times (spanning the centuries from the fifth to the ninth).[18] Presupposing a general liturgical uniformity between Constantinople and the Aegean, Krautheimer restricted the laity to locations behind barriers in the aisles and galleries, from which they watched the unrolling of the liturgical action in the middle of the nave; at Hagia Sophia only the clergy, the Emperor, and his court had access to the broad expanses under the central dome.

> The large mass of the faithful, gathered in aisles and galleries, saw only fragments of the building, just as the solemn celebration of the services was revealed to them only in fragments. It had long been liturgical custom in the Aegean coastlands to reserve the nave for the performance of the clergy: the preparation and celebration of the Mass, and the procession of the Lesser Entrance, when the bishop was accompanied to the altar. In Justinian's reign, a second procession—no doubt previously customary but not codified—became a main element in the Mass of Constantinople. This was the Great Entrance, in which the elements of the Eucharist were brought from the prothesis to the altar accompanied by the clergy emerging from the chancel into the nave, and retiring back into the chancel. In the H. Sophia, both the Lesser and the Great Entrance and the entire celebration of the Mass were interwoven with the appearance of the Emperor and his court.

> The nave, then, was a stage on which the procession moved along a solemn path from the royal gate towards the solea, and along the solea into the bema.[19]

From a dramatic point of view this hypothesis is extremely attractive, and it offers a new interpretation of the first centralized Byzantine church plans: the central domed space is made into the principal arena of action for the public parts of the liturgy, and the surrounding spaces are made into spectator spaces. This is a fresh attempt to tell us how the building actually worked, which is something architectural historians have seldom tried to visualize; but the evidence deserves to be scrutinized more carefully.

The chief problem in reconstructing the liturgy of Greek churches in the fifth and sixth centuries is the sheer absence of literary sources describing the Greek liturgy. One is simply confronted with a gap in the evidence, a gap without even the barest scattering of fragments to suggest how to make up the deficiency. Lemerle's solution is hardly satisfactory, and there is no basis for interpreting the church plans of Greece by recourse to the early church orders of Syria and Egypt. Politically and ecclesiastically, Greece was related to the province of Illyricum rather than to the provinces of the East and was subject to the jurisdiction of the bishop of Rome down to the time of Leo III (717–41).[20]

Liturgically, the plans of the Syrian churches indicate quite a different ceremony from that indicated by the church plans of Greece. The triple sanctuary, the altar in the apse, the semicircular bema in the center of the nave, the transverse barriers across the nave—these are all local features peculiar to church planning in Syria which specify a liturgical usage quite different from that indicated by the plans of the Greek churches, where none of these features occur.[21] Finally, it must be pointed out that Lemerle's use of the early church orders manages only the most general kind of analogy between the Greek plan and the Syrian documents; the documents generally divide the congregation in transverse ranks, placing the lower ranks behind the higher, while the Greek plan indicates a longitudinal division between aisles and nave.

Similar problems are encountered if one tries, with Krautheimer, to associate church planning in Greece with that in Constantinople. The archaeological evidence, as we have seen, indicates a rather different liturgical usage in Greece from that in the capital. The Greek sanctuary plan with its extended synthronon, its entrance porch, and its off-center ambo is not genuinely Constantinopolitan; a tripartite transept, which never occurs in Constantinople, is a frequent feature of the larger Greek churches, laterally expanding the space available around the sanctuary. Prothesis or offertory rooms are also common in Greece, either in the narthex or near the sanctuary. Finally, the very feature under discussion, the stylobate barriers, seem to have been an exception in the capital, though they are standard in Greece. We have clear evidence of such barriers only at the Beyazit basilica.

In other churches barriers did not exist. At the Studios and the Saray basilicas of the fifth century the colonnades were quite free of them (Plates 8–9 and Figure 17); at Hag. Eirēnē there is no evidence either way, since the original columns and revetments

have all been removed; and in other sixth-century churches—Hag. Sergios and Bacchos, Hag. Euphēmia, Hag. Polyeuktos,[22] and Hagia Sophia—it is clear that no such barriers existed. Hagia Sophia provides the most significant example, as it was the cathedral of Constantinople, the largest of its churches and one in which effective control of the crowd would have been all the more difficult without barriers if people were not to be allowed in the nave.

Thus the liturgical plans of Greece and Constantinople are sufficiently well distinguished to presuppose some fundamental differences in liturgical observance during the Early Byzantine period. Exactly what these differences were remains unknown for the Greek liturgy. For Constantinople, the proper point of departure must be a careful examination of the literary sources of the Early Byzantine liturgy. Grouping Constantinople with Greece is more likely to confuse than to assist in the undertaking.

The commentators do not give us a great deal of specific information on the location of the faithful in the church, but what information they do give is important and worth considering. Symeon of Thessalonike, the last of the commentators, indicates the presence of the faithful in the nave of the church, and similar evidence can be found in the earliest of his predecessors.

Maximus explains the essential divisions of the church in his introductory chapters on the symbolism of the church building. Significantly, the divisions he discusses are not structural divisions such as nave and aisles or dome and ambulatories, but functional divisions related to the liturgical planning of the building. In his explanation there are only two divisions to the building, the sanctuary (ἱερατεῖον) and the nave or body of the church (ναός). These are the two essential parts of the building, and Maximus, in the passage cited by Du Cange, defines them in very simple terms: the ἱερατεῖον is the "place which is assigned to the priests and the ministers," and the ναός is the "place which is of open access to all the lay faithful."[23] This division is made to carry a variety of symbolic interpretations: it represents the whole created universe divided into the invisible angelic world and the corporeal world of men,[24] or the visible world divided into heaven and earth,[25] or man himself in his two-fold nature of soul and body,[26] or the soul of man in its division between higher and lower faculties.[27]

The repeated comparisons always employ the same terminology. The term ἱερατεῖον is not very accurate architecturally and might conceivably apply to a somewhat extended sanctuary, perhaps even including the whole central part of the church. In this case, however, the fact that the archaeological evidence indicates sanctuaries in the eastern parts of churches would require that we postulate a "sanctuary within a sanctuary," an arrangement Maximus is unlikely to have overlooked. The ναός, on the other hand, has two possible meanings: either the "temple" (i.e., the church building as a whole), or the central part of the temple or church (i.e., the "cella" of the temple or the "nave" of the church in a technical architectural sense).[28] If we suppose that the sanctuary actually included the whole nave of the Early Byzantine

church, Maximus could not—without endless ambiguity—have used the term ναός for the congregational space, but would instead have had to employ a term such as στοαί or αἴθουσαί to designate the peripheral parts of the building exclusive of the nave. Maximus' use of the term ναός for the place of congregation for the lay faithful implies that the sanctuary as he knew it at the start of the seventh century was not coextensive with the nave of the church.

Writing at the beginning of the eighth century, Germanus took a different approach to the symbolism of the church building. He bypasses the division between places for the clergy and laity and develops instead the meaning of the various furnishings within the church. The argument is different, but when he arrives at a discussion of the chancel barriers (κάγκελλα) the implication is the same. "There are barriers," he remarks, "to define the place of prayer; by which is meant [that] the people [have] access to the area outside, while inside the place [is] reserved as the Holy of Holies and [is] accessible only to the priests. The barrier is even of bronze as a holy reminder, so that no one may enter there simply by accident."[29] The mention of bronze is probably significant, for chancel barriers were generally not of bronze but of marble. The one famous exception was Hagia Sophia, where we know from Paul the Silentiary that the sanctuary barriers were of silver. Probably the patriarch had his own cathedral church in mind, and bronze is mentioned either because he mistook the metal or, more likely, because the barriers actually were of bronze and were only plated with silver. In this case, the passage can be interpreted not only as a general reference to chancel barriers, but also as a specific reference to the sanctuary barrier of Hagia Sophia and to its function of excluding the laity, who stood immediately outside it.

The commentators give the impression that there was only a single sanctuary barrier and that this reserved not the nave of the church but a more limited area, leaving the rest of the space free to the laity. The historians, however, provide more precise information, especially regarding the sanctuary of Hagia Sophia. Both Paul the Silentiary and Procopius are quite clear regarding the limited extent of the latter: as we have seen, the Silentiary described the silver sanctuary barrier as enclosing "as much of the Great Church by the eastern arch as was set apart for the bloodless sacrifice."[30] Procopius refers to the eastern part of the church as "the part which faces the rising sun, that portion of the building in which they perform the mysteries in worship of God";[31] further on he identifies this area as the silver-fenced sanctuary: "That part of the church which is especially inviolable and accessible only to the priests, which they call the sanctuary [θυσιαστήριον], is endowed with forty thousand pounds of silver."[32] This is the sanctuary whose restoration the Silentiary described.

Procopius, moreover, seems to deny explicitly the existence of any barriers between nave and aisles. In a passage describing the colonnades on either side of the nave, he tells us that "there are colonnades on either side, two of them, and these are not divided off by any structure of the nave but rather serve to augment its width."[33] Procopius regarded the aisles as a continuation of the space of the nave and did not consider the two as separated by boundaries; his expression seems to rule out curtains or parapet barriers that would have segregated the aisles from the nave.[34]

References to the sanctuary in other churches are equally clear, both as to its limited extent and its character as the one place in the church to which the laity were denied access. Concerning the Church of the Holy Apostles, Procopius writes: "At the crossing of the two straight lines—that is to say, at about the middle—there was set aside a place which may not be entered by those who may not celebrate the mysteries; this, with good reason, they call the sanctuary [ἱερατεῖον]."[35] And in his description of Hag. Anthēmios, the same writer speaks of the sanctuary as "an inaccessible place, in which the sacred mysteries are rightfully celebrated, along the side facing the rising of the sun."[36]

Church law tends to reinforce this impression. No part of the church is ever said to be inaccessible except the sanctuary, and legislation is firm on this point. The Council of Laodicea (ca. 368) allowed none but the sacred ministers to enter and communicate in the sanctuary (θυσιαστήριον) and in a separate canon specifically forbade that women should enter it.[37] The Emperor himself, after Ambrose's encounter with Theodosius the Great, was allowed in the sanctuary only to present an offering.[38] The Council in Trullo (692) repeats the ancient legislation, decreeing that no layman is allowed within the sanctuary (θυσιαστήριον) except the Emperor when making his offering.[39] There is no reason to suppose that the use of the term "sanctuary" in canon law is any different from its use by Procopius or the Silentiary, or that their use is any different from that of the commentators, referring to the rather restricted area enclosed by chancel barriers at the east end of the church, where only the clergy were allowed. If the nave had also been reserved, it would be difficult to explain the continued silence of the sources about this custom.

Finally, and most important, the historians have preserved for us a series of references to the presence of the lay faithful in the nave of the church. The earliest reference is that of Sozomen, describing the eagerness with which the crowd used to listen to the preaching of St. John Chrysostom: "While the people pressed around him and could not get enough of his words, so that they actually incurred danger pushing here and there and pressing one another, each one forcing his way to go farther so that by standing near he might hear more accurately what John was saying, he placed himself in the midst of them upon the platform of the readers and, having taken a seat, taught the multitude."[40] The scene was the patriarch's cathedral, the Old Hagia Sophia, at the close of the fourth and beginning of the fifth century. Early in the sixth century a similar situation must have existed in the same church (after Theodosius' rebuilding), according to an account we have of the tumultuous proceedings under the pro-monophysite patriarch John II.[41] When the Severus crisis came to a head in 518 the patriarch, on entering the Great Church with his clergy, was greeted by an uproar from the people demanding that he ascend the ambo and ana-thematize Severus. The patriarch answered with mild words and entered the sanctuary to begin the liturgy, but the demonstration continued until he was forced to ascend the ambo. Again he tried to pacify the crowd, but they would not let him descend from the ambo until he had promised to draw up the anathema of Severus. The following day the crowd made a similar demonstration demanding the reinsertion of Pope Leo's

name in the commemorations of the liturgy, and again the patriarch was forced to capitulate. When the time came for the reading of the commemorations, the congregation thronged about the sanctuary to listen quietly and hear if their request had been fulfilled. The reading of Pope Leo's name was greeted with wild cheering. The whole account, both the demonstration about the ambo and the crowding about the sanctuary, presupposes the presence of the laity in the nave.

Concerning Justinian's Hagia Sophia, Paul the Silentiary refers three separate times to the presence of the lay faithful in the central nave of the church. Two of these passages have been consistently misinterpreted. The first occurs when the Silentiary turns from his description of the sanctuary apse to a description of the conches: "And westward again are two conches on columns, one on either side, projecting as if stretching out bent arms to embrace the people singing in the church."[42] The second appears in his description of the chancel screen, when he states that the Emperor has placed plates of silver "on the walls which separate the priests from the many-tongued crowd."[43] These expressions have always been taken to refer to a choir of clergy located in either two or four of the nave conches. Du Cange made this mistake in the first edition of his *Historia byzantina*, and the other commentators all followed him;[44] the interpretation is not possible, however. In the first reference, the term for "people singing" is λαὸν πολύυμνον; in the second the "many-tongued crowd" is πολυγλώσσοιο ὁμίλου. Λαός and, even more strongly, ὅμιλος refer to the common multitude of men, precisely as opposed to men of special rank or class.[45] It is not possible to make the singing multitude into a special clerical choir, because such a choir simply did not exist in the Early Byzantine liturgy.[46] The chief burden of music belonged to the congregation itself, and the Silentiary described the common multitude as entering the church singing on the day of its consecration: "The entire people gathered and all the councilors who serve at the behest of the mighty king; carrying gifts of thanksgiving to Christ the King, they sang hymns of petition with melodious voice, silver-white candles in the willing hands of all."[47] A nucleus of cantors (ψάλται) was appointed to lead the congregation by singing the more difficult antiphons and intoning the psalms. Their number in the sixth and seventh centuries did not exceed twenty-five serving the three patriarchal churches of Chalkoprateia, Hag. Eirēnē, and Hagia Sophia.[48] They did not stand at either side of the sanctuary, as they do currently in the Greek liturgy, but at the ambo, where the Council of Laodicea located them.[49] The earliest reference to the Trisagion hymn again places them there (512);[50] Paul the Silentiary mentions them in the same place in his description of the ambo;[51] and they still appear there in the ninth- and tenth-century liturgical sources.[52] Therefore, it must be the common laity which Paul the Silentiary mentions as standing in the conches and grouped about the barriers of the sanctuary, chanting their hymns.

The third reference in the Silentiary speaks of the lay faithful crowded about the ambo. In a ceremony no longer extant in the Byzantine liturgy, the deacon, after finishing the reading of the Gospel, offered the book to the faithful to be kissed as he carried it back the length of the solea to the sanctuary. Speaking of the solea, the Silentiary writes: "Now for these fence walls they have not placed lofty slabs, but

they are as high up as the navel of a man standing by them; and here the priest [lit., "the gospel man"] as he holds the golden Gospel passes along, and the surging crowd strive to touch the sacred book with their lips and hands, while moving waves of people break around."[53] The "waves of people" (κύματα δήμων) can only refer to the lay congregation.

It is clear, therefore, that the lay congregation freely occupied the nave in Early Byzantine churches; moreover, they pressed with eagerness about the holiest parts of the church: the sanctuary barrier, ambo, and solea. Only the latter parts can be said to have been reserved for the use of the clergy. One cannot attribute any special "holiness" to the nave or to the space under the dome in the earliest domed plans of Constantinople nor can one imagine that this space was meant to be viewed only in fragmentary fashion from the aisles and galleries. In Maximus' terminology, the faithful were already the initiates invited to the full revelation of the mysteries; all that was kept from them was the full import of the mysteries as they would be apprehended in heaven.[54]

The liturgical evidence for the use of the nave and aisles in Constantinople stil leaves unexplained the stylobate barriers of Greece and the appearance of this Greek liturgical usage in the Beyazit Basilica A in the capital. The explanation of the Greek usage, however, must derive from Greece and not from Constantinople, and literary sources are of very little use. It is possible that a careful comparative examination of all the sites at which this feature appears, including a study of the means of access to all the various parts of the churches involved, may provide some answers to the mystery; but this lies beyond the scope of the present study.

Places for Catechumens and Penitents

Concerning special places in church for catechumens and penitents, the seventeenth-century byzantinists have left us a legacy of confusion which modern authors have been reluctant to untangle. A great deal of information is available in historical sources concerning the conduct of the catechumenate and the discipline of penitents in the third and fourth centuries, but from the fifth century onward information becomes more scarce, indicating a general decline in these institutions.[55] Concerning their part in the Byzantine liturgy, moreover, our information is very slight indeed, and it is not sound methodologically to try to make up for this lack by citing third- and fourth-century sources from Palestine, Syria, and Cappadocia.

It is this same methodological error that invalidates most of Allatius' erudite *discursus* on the uses of the narthex.[56] For example, he cites Pseudo-Denis to support his claim that the catechumens stood in the narthex in the Byzantine church;[57] but the liturgy of Pseudo-Denis was Syrian, not Byzantine, and Pseudo-Denis does not in fact say where the catechumens stood, but only that they were sent out before the recitation of the creed.[58] In another passage Allatius cites the Council of Laodicea (ca. 368) to prove the same point;[59] but in addition to being rather early and belonging to another province, the Council—like Pseudo-Denis—is explicit only in excluding catechumens

and penitents from the Eucharist proper, without assigning them any special places. The canon prescribes that after the homilies of the bishops the prayer of the catechumens should be said separately, then after the catechumens have gone out the prayer for those doing penance; when these have received their blessing and gone out, then the prayers of the faithful are to begin.[60]

In a similar fashion Jacobus Goar, in his description of the Byzantine church, proposed a more elaborate distinction of places within the church for penitents and catechumens on the basis of Gregory Thaumaturgus' *Canonical Letter*.[61] Gregory had distinguished five degrees of participation in the liturgy, based on the individual's standing in the community: "weeping," which was done outside the door where one asked the prayers of the faithful who entered; "listening," which was done in the narthex where one heard the scripture and preaching, but left before the prayers and before the catechumens had gone out; "falling down," which was done within the doors of the church before one left with the catechumens; "standing by," which meant remaining with the faithful throughout the liturgy but abstaining from Communion; and, finally, "communicating."[62] Thus Gregory seems to place two classes of penitents outside the body of the church, one outside the doors and one in the narthex, and a third class with the catechumens in the body of the church; the latter remain through the readings, preaching, and Litany of the Catechumens before they are dismissed. But Gregory (d. 270) was a mid-third-century writer from Pontus, and he can hardly stand as a witness to the Early Byzantine tradition. Modern scholarship, moreover, does not accept that "classes" of penitents existed as such even in the third century.[63]

Concerning Hagia Sophia, the sources cited by the seventeenth-century byzantinists are equally vague and remote. Grelot and Du Cange assigned penitents and catechumens generally to the narthex of the church, citing as corroboration the above-mentioned passage from Gregory Thaumaturgus and the canons of the Council of Nicaea (325).[64] But while the canons of Nicaea refer to the penitential discipline of the early church and witness the existence of a class of catechumens, the references supplied give no specific information on their places in church.[65]

More modern authors have done little to clarify the confusion of the earlier byzantinists. Texier, in a chapter on the liturgy of the Justinianic period, was content simply to repeat Allatius' treatment of the subject.[66] Antoniades' discussion of penitents and catechumens at Hagia Sophia is drawn from Grelot, Goar, and Du Cange; the same texts are referred to, and his conclusions, while slightly different, are no better founded than those of his predecessors. Antoniades assigned the atrium of Hagia Sophia to the penitent "weepers" and the narthex to the "listeners," "kneelers," and catechumens (after their dismissal); the area of the nave behind (i.e., west of) the ambo was assigned to the catechumens before their dismissal.[67]

Methodologically, there are two questions that must be posed at this point: we must ask critically to what extent the discipline of the classes of penitents and catechumens was observed in Constantinople in the fifth century and later, and what evidence exists of a separate part of the church having been assigned for this purpose.

Regarding the penitents, it is evident that once the fourth-century crisis over re-admitting sinners to the church was past, penitents as a separate class simply ceased to exist. Sozomen speaks of the abolition at Constantinople during the reign of Theodosius the Great of the office of the priest appointed to take charge of penitents.[68] He adds that this step was subsequently taken by most of the other metropolitan sees. The most pertinent reference in Chrysostom indicates that that writer knew only of excommunication as a penalty for sinners; he might exclude transgressors from church altogether, but he does not say that they can be placed among the penitents.[69] After Laodicea the canons of the church councils cease to refer to or to invoke the practice of public penance. The only exception is the 87th canon of the Council in Trullo at the end of the seventh century, which invokes the early church discipline against adulteresses "by decree of our Fathers." But this canon has an archaic and unrealistic tone, and the state of church discipline in the late seventh century is probably better reflected by the canon immediately following, which forbids anyone to bring cattle into church "without a good cause."[70] The other canons invoke only the penalties of excommunication (for laity) and loss of office (for clergy).

A penitential class is simply not known to have existed in Constantinople in the fifth century or later; therefore it is wholly unnecessary to ask what place might have been assigned them in Early Byzantine architecture. On the other hand, the existence of a catechumenate can be traced at least to the end of the seventh century, though their assignment to a definite place in the church is still difficult.

In the early fifth century, in a homily on the Acts of the Apostles, Chrysostom indicates the presence of catechumens in his congregation within the body of the church, although their location is not specified. "If you do not yet profess that Christ is God," he says, "stand outside and do not listen to the readings nor count yourself among the catechumens."[71] The implication is that the catechumens do not "stand outside" but within the church, where they listen to the readings and the homily. This seems to be consonant with the earlier usage described by Gregory Thaumaturgus and by the Council of Laodicea. During the Eucharist, however, the catechumens—according to Chrysostom—"do not hear the words of the Mysteries, but stand somewhere far off; and if they do hear, they cannot understand what is said."[72] About thirty years later Nestorius also refers to the presence of catechumens in the church for the fore-mass. He detects a basic betrayal of Christ in those of the faithful who leave church before the Eucharist has been celebrated, who "are driven out like chaff in a breeze of laziness, along with the catechumens."[73]

Also in the fifth century, an addition was made to the 7th canon of the First Council of Constantinople requiring converted heretics to go through the discipline of the catechumenate before being readmitted to the church: "On the first day we make them Christians; on the second, catechumens; on the third, we exorcise them by breathing thrice in their face and ears; and thus we instruct them and oblige them to spend some time in the church, and to hear the Scriptures; and then we baptize them."[74] The number of catechumens who were thus preparing for baptism was still considerable in

Chrysostom's time. On the bishop's expulsion from his see in 404, we hear of no less than three thousand awaiting baptism, suggesting a rather large number, even allowing for Palladius' exaggeration.[75]

In the sixth century, the Synod of Constantinople under the patriarch Mennas appointed a special post for the priest who was to take down the names of those to be baptized, a ceremony which traditionally marked the passing from the ranks of the ordinary catechumens to that of "competentes."[76] In the seventh century catechumens are still appearing in church legislation. The 78th canon of the Council in Trullo prescribes that the "competentes" are "to learn the creed by heart and recite it to the bishop or presbyters on Thursday of Holy Week."[77] Canon 95, regarding the acceptance of repentant heretics back into the church, repeats the fifth-century rule requiring that they go through the catechumenate and be rebaptized.[78]

Maximus the Confessor also seems to testify to the existence of an active catechumenate. The fact that he comments on the dismissal of the catechumens would not alone prove the existence of a catechumenate, for the formal dismissal of catechumens was never dropped from the Byzantine liturgy; however, he speaks of the catechumens "being dismissed and put out by the ministers," and compares the ministers in their role to the angels of the Last Judgment separating the good from the evil.[79] This one small, vivid detail points to a familiarity with an actual rite which is missing in later commentators.[80]

Thus a class of catechumens, however diminished in size, seems to have survived at least until the seventh century. Perhaps it was Constantinople's foreign population of merchants, diplomats, and travellers—often from non-Christian nations—that explains the perpetuation of the catechumenate in the capital long after it had disappeared elsewhere. However, none of the sources cited gives us any information on what part of the church, if any, might have been set aside for catechumens. Chrysostom and Maximus imply that they stood somewhere in the body of the church before their dismissal, but no more precise details are offered. Neither Procopius nor the Silentiary ever mention the catechumens at Hagia Sophia.

The only significant clue one has of a part of the building being assigned especially to catechumens is found in the use of the term "catechumenate" (κατηχούμενον, κατηχουμενεῖον, or the plurals of these) to designate the galleries of churches. By the time of Constantine Porphyrogenitus this usage was standard and had generally replaced the architectural term ὑπερῷα. In the *De ceremoniis*, the term is used consistently to designate the galleries, whether at Hagia Sophia, Hag. Sergios and Bacchos, the Church of the Apostles, or Chalkoprateia. The Emperor is always said to ascend to reach the κατηχούμενα and to descend upon leaving. The term continued in this usage down to the fifteenth century, but its origins have not been properly examined. Du Cange has collected the longest series of instances of the usage, but his explanation that the galleries were so called "because women used to listen to the homilies and prayers in the galleries" is hardly adequate.[81] Two things can be noted in the various occurrences of the term: first, the fact that the term came into use in the seventh century, at a time

when the catechumen class was still a living institution; and second, the variety of uses which we hear the κατηχούμενα being put to.

The earliest known use of the term is connected with Maximus the Confessor. In the life of the saint written in 680–81,[82] we read that prior to his final trial and condemnation in 662 Maximus was being held prisoner at the monastery of Hag. Theodōros in Rhegium, where the Emperor sent representatives to speak with him. "They ascended to see him," we are told, "in the κατηχούμενον of the church of the same monastery," where they sat down to "discuss" their differences.[83] The term designates the galleries, which St. Maximus apparently used as a place of private prayer. We find the galleries being similarly used by the patriarch Nicephorus who, when the hour of his death was at hand (815), insisted on going "to the famous κατηχούμενον of the Great Church" where he had been accustomed to spend whole nights in prayer.[84] In Pseudo-Codinus' description of Constantinople, a tenth-century document, we find such places of private devotion referred to as oratories (εὐκτήρια). Speaking of the foundation of the church of Hag. Geōrgios in Chalcedon (631–38), he tells us that the patriarch Sergiosl "made oratories like all the oratories in Hagia Sophia in the κατηχούμενα, and he made gifts there of many vessels of gold and silver, and purple cloth of gilded linen and abundant treasures."[85]

Another seventh-century occurrence of the term refers to a somewhat less edifying use of the galleries: the Council in Trullo found it necessary to inveigh against the shocking behavior of some who were having intercourse in the κατηχούμενα.[86] It is clear that the galleries are being referred to, because when Leo VI found it necessary to repeat the prohibition he used both the terms κατηχούμενα and ὑπερῷα.[87] It is also clear that the legislator was not thinking simply of Hagia Sophia, but of churches in general.

Other uses of the galleries by the Imperial court or by women will be taken up separately further on. We might tentatively suggest, however, that archaeologists have been too quick to identify them as the place for women. In planning, they would be most inappropriate as such, because they would effectively exclude the women from any participation in the celebration of the liturgy below, and especially from receiving Communion. It is not known that women were ever, in any period of Byzantine history, excluded from receiving Communion. In the fifth century, man and wife were equally expected to receive it, as Sozomen implies in his story of a man who forced his wife to go to Communion against her better judgment. "If you will not share the mysteries with me," he told her, "neither will you share my life from now on."[88]

In the churches which are known to us, it is clear that the galleries did not communicate with the ground floor, but rather with the outside; and since indications are that the doors of the church were closed after the dismissal of the catechumens,[89] communication between the gallery and ground floor would have been awkward, to say the least. On the other hand, such an arrangement would have been quite appropriate for a place for catechumens, facilitating their exit after the first part of the liturgy without disturbing the rest of the faithful. Moreover, it is hard to imagine that the term κατηχούμενον was applied to galleries in purely an arbitrary fashion. The multiplication

of uses of the galleries, as well as their disuse and subsequent abuse as a place for making love, may be a consequence of the gradual decline of the number of catechumens and the availability of gallery space for purposes not clearly defined earlier; but the other uses of the galleries must also be examined.

Places for Women and the Imperial Court

The question of where women stood in the Early Byzantine church is somewhat more involved than is generally assumed. Archaeologists almost universally agree in assigning them to the galleries, leaving the whole ground floor for men. Allatius' contention that women belonged in the narthex is documented only by his reference to another seventeenth-century author, Gabriel Corinthius; apparently it was a local custom at that time in some of the churches of Greece.[90] Yet the texts supporting the more common opinion are surprisingly few, and other texts tend to contradict their testimony. The issue's resolution lies in weighing the probabilities involved.

The presence of women in the gallery of the Old Hagia Sophia is attested to around the year 400 by Chrysostom's reference in one of his sermons to the women "up above" (ἄνω),[91] but the references that have been most often used in this connection are those of Paul the Silentiary. The Silentiary refers several times to women being on the second floor of Hagia Sophia, which he describes alternately as the "women's galleries" (θηλυτέρω ὑπερώια), the "women's place" (γυναικεῖον), or the "women's ambulatory" (θηλυτέρη αἴθυσα).[92] Clearly there were women in the gallery in Justinian's time, and a special place was set up for them there; but it would be stretching the evidence to say that the Silentiary's reference excludes the possibility of their being on the ground floor as well.

Procopius gives a somewhat different account, mentioning a women's gallery but assigning them also to one of the aisles on the ground floor. The passage is difficult and is usually badly translated,[93] the difficulty being that the word στοαί can refer either to aisles or galleries; one might translate it as "colonnades" to preserve this ambiguity. In the first sentence, Procopius refers to two "colonnades" on either side in a construction which, taken by itself, can mean either two on each side (and therefore four) or simply one on each side (only two). In context, however, it is plain that he means the second alternative, for the next sentence and the one following keep referring to the colonnades in the dual: ταύταιν δὲ ταῖν στοαῖν and ἀλλήλαιν and αὐταῖν, which would not be possible if he were speaking of four of them. Moreover, if one imagined that Procopius is speaking of galleries and aisles together and is assigning women to the galleries, then one would have him dividing his four "colonnades" between upper ones and lower ones. But he explicitly divides them between right and left with the word ἑκατέρωθι, i.e., "on either side," which indicates one colonnade on one side and another on the other. He tells us that the two colonnades are exactly alike (an observation which he manages to make in four different ways), the equality of the two serving to balance the church. These observations would be much less appropriate

if the passage were interpreted as a comparison of aisles to galleries. It should read as follows:

55 There are aisles on either side, two of them, and these are not divided off by any structure of the nave but rather serve to augment its width; in length
56 they reach to its very end, while in height they are inferior. / They too have vaulted ceilings and gold decorations. One of these two aisles has been assigned to men at worship and the other was dedicated to women engaged
57 in the same activity. / But there is no distinction between them, nor do the two differ in any way, but the equality of the two of them serves to enhance the beauty of the church and their resemblance is an ornament.
58 / Who, then, could tell of the women's place in the galleries or who could enumerate the abundance of the colonnades or the columned halls with which the nave is surrounded?[94]

The change of subject in the last sentence is signaled, as frequently in Procopius, by a rhetorical question.

Procopius therefore assigns women to one side of the church on the ground floor, while he locates men on the other side. At the same time he mentions a "women's place" (γυναικωνίδες) in the galleries, which agrees with a statement by Evagrius, who adds another piece of information to our knowledge of the building. Writing toward the end of the sixth century (ca. 594) he tells us—not without some exaggeration—that the church is so large that "looking up from below one can hardly see the dome, and those [masculine] who are above would never dare, however bold they be, to look down and cast their gaze on the floor. . . . On the right and on the left columns made of Thessalian marble are disposed, and these support the galleries which are adorned with other similar columns, offering a place for those [masculine] who want to look down on the proceedings. The Empress on feast days is accustomed to attend the divine liturgy from here."[95]

Two pieces of information can be gathered from the text. In the first place, Evagrius does not seem to be aware that the galleries are reserved exclusively for women, for he refers to the people in the galleries as masculine. Perhaps in the first line he had in mind the tourist who might stroll about the galleries just to see how large the church was. (Procopius, too, may have had such tourists in mind when he remarked that the church is so high "that the whole city is viewed from there as from a watch-tower."[96]) But in the next sentence he refers to those who attend the liturgy from the gallery, and he adds that the Empress, presumably with her court, also attended the liturgy here. Ebersolt and others have located the Empress in the west gallery above the narthex, but this contradicts Evagrius' statement that she used one of the side galleries.[97] In the tenth century, the Empress apparently attended the liturgy from the gallery on Easter Sunday; at the commencement of the service she emerged from the metatorion in the gallery and took her place on a throne to receive the wives of the members of the Imperial court.[98] The metatorion is not in any way distinguished here from the one

which is usually referred to in the gallery (i.e., the Imperial gallery on the south side of the church).

It is regrettable that Early Byzantine sources do not give us further information on where the women stood. It is quite possible that the only women who had a reserved place in the gallery were the Empress and her court. Other women as a rule would have stood below in the aisle, where Procopius locates them. This is clearly the usage described in the *De ceremoniis*, and there are some indications in this respect of a continuity between Early and Middle Byzantine customs.

In Middle Byzantine sources the "women's place" (γυναικίτης) refers always to the aisles, generally the left (north) ones, while the galleries are referred to only in connection with Imperial uses. On four feasts the Emperor, instead of taking an active part in the liturgy, is said to have followed it from the gallery of Hagia Sophia.[99] His loge was located in the south gallery, for he is described as entering it through the wooden stair by the Shrine of the Holy Well, which was located outside the southeast entrance. Beside his loge was a metatorion which communicated with the patriarch's metatorion. At Communion time the Eucharist was brought up to the Emperor and his court there. An apartment into which the Emperor could then retire existed, and a place where the patriarch and Emperor could breakfast together was presumably within the patriarchate itself.

The *De ceremoniis* supplies information about four other Early Byzantine churches, and in all four of them we find that the gallery has been preempted for Imperial use and the women gather on the ground floor on the left. At Chalkoprateia we are told that the Emperor assisted at the liturgy in the gallery on the feasts of the Annunciation and the Nativity of the Virgin. The patriarch brought him Communion in the gallery, and the entire senate received it there after him. After the liturgy, the Emperor received the patriarch in the gallery and they exchanged gifts.[100] When Photius administered an oath to the co-Emperors Michael III and Basil the Macedonian not to proceed against Caesar Bardas, this ceremony was also carried out in the gallery of the Chalkoprateia.[101] Hence, even before Basil's remodelling of the church, there was an Imperial loge in its gallery. The women's place, on the other hand, was located on the ground floor at the left. On the feasts of the Annunciation and the Birth of the Virgin the Emperors left the sanctuary by the door at the left and passed through the women's place (γυναικίτης) to be received by the senate and proceeded from there to the shrine of the Virgin's cincture, located somewhere south of the church. On leaving the church they descended the stair on the left to the women's place, and from there they exited to the portico.[102]

At Hag. Mōkios, a fourth-century foundation, a similar situation existed. The Emperor, we are told, had an apartment (κοιτών) within or connected with the gallery of the church. After accompanying the patriarch to the sanctuary, he passed through the side of the women's section (διὰ τῆς πλαγίας τοῦ γυναικίτου) to the stair leading to his loge in the gallery. This stair was located on the left. After the liturgy, a table was set for breakfast with the patriarch in the gallery.[103] At Justinian's church of

Theotokos in Pēgē we read of an apartment or bedroom for the Emperor, a dining room where he entertained the patriarch and representatives of the factions, and a loge from which he could observe the liturgy.[104] The stair in this church is said to have been on the right, and thus it is not mentioned that he passed through the women's section to reach these parts.

Finally, at the Church of the Apostles the Emperor and patriarch would venerate the tombs of the patriarchs and then pass "through the left-hand part of the church, that is, the women's place." The patriarch returned to the sanctuary, but the Emperor went out to the narthex and up the stairs on the left side to the gallery. His place during the liturgy was on the right-hand side as it was at Hagia Sophia, but he received Communion at an antimension placed "opposite the sanctuary" where patricians, the military honor guard, and others of the court also received, and he had a throne nearby on which to sit while the others were going to Communion. The gallery communicated directly with an apartment for the Emperor, where he breakfasted with the patriarch and received personal friends and clergy.[105]

Although at Hag. Sergios and Bacchos we find no mention of the women's place, it must have also been below in the tenth century. The space in the gallery is not very extensive, and the Emperor's private oratory, metatorion, and Imperial loge were located there, all neatly distinguished in the *De ceremoniis*.[106]

It is difficult to judge when the term $\gamma\nu\nu\alpha\iota\kappa\iota\tau\eta s$ first began to be used for one of the aisles on the ground floor. The earliest known mention is by the anonymous author of the description of Hagia Sophia at the beginning of the ninth century. He uses the term several times indiscriminately, meaning either the right or the left aisle of the church.[107] Du Cange's treatment of the word does not attempt to collect its various occurrences but simply refers the reader to his *Descriptio s. Sophiae*, where its use is not pursued beyond its occurrence in Procopius;[108] and, relying on Du Cange, byzantinists have excused themselves from the onus of making an independent evaluation of the material. The latter is not very abundant, but it clearly does not indicate that one can identify the $\gamma\nu\nu\alpha\iota\kappa\iota\tau\eta s$ with the $\kappa\alpha\tau\eta\chi\sigma\iota\mu\epsilon\nu\alpha$ as Du Cange has done. The evidence indicates that in Early Byzantine times women were located on the ground floor where they might participate in the liturgy, while a special place was set aside for some women—perhaps only the Empress and her court—in the gallery. The original and principal use of the galleries was probably for catechumens; we hear them referred to as the catechumen's place in the seventh century. But other uses of gallery space came in quite early: still within the seventh century we hear of oratories for private devotion there and of the profanation of apparently unused galleries by lovers, and by the tenth century there was a multiplication of Imperial loges and reception rooms in them.

Most probably the Emperor's attendance in the galleries is late in the course of this development, and the earlier custom is reflected in his more solemn attendance at Hagia Sophia on the ground floor. At Hagia Sophia the Emperor's throne was located in the southern aisle; modern authors generally propose to locate it in the

easternmost bay of the southern aisle, i.e., behind the southeast conch.[109] But the literary evidence does not specify its exact location. From Early Byzantine times we have only a single reference concerning the Emperor's place. Paul the Silentiary says: "On the south side you will see a long aisle just as on the north, but there is something more; for it has a place set apart with a certain wall for the Emperor of the Romans for the holy feast days. Here my ruler, seated on his customary throne, gives ear to the sacred books."[110] Thus we are informed simply that the Emperor's throne was located in a screened-off place in the southern aisle.

The information in the *De Ceremoniis* fills in a few details but still leaves the location of the throne imprecise. One reads that the Emperor leaves from the side of the sanctuary after depositing his gift and goes to the metatorion.[111] A little oratory ($\epsilon \dot{\upsilon} \kappa \tau \acute{\eta} \rho \iota o \nu$) is located in front of the metatorion, where the Emperor pauses a moment, there are doors by which he enters and leaves the metatorion.[112] In one passage he enters the metatorion after the liturgy to take breakfast with the patriarch, but in another he leaves it for the triclinium for breakfast.[113] He is also said to change his robes in the metatorion, a custom which may explain the origin of this term.[114] Thus in the tenth century a complex of places was reserved for the Emperor at the sanctuary end of the southern aisle, including an oratory, a metatorion, a triclinium (possibly outside the church itself), and the Imperial loge proper with his throne. We can infer that all of this would have taken up a great deal of space, but from this information we cannot infer the exact dimensions of the space reserved, nor can we locate the throne precisely.

Nevertheless, there does seem to be archaeological evidence on this point which has been overlooked until now. Expecting a priori to find the throne behind the southeast conch, archaeologists have failed to notice a set of markings in the central bay of the southern aisle, next to the southeast pier. Here, among other markings of uncertain purpose, one can make out four round sockets marking a square of .80 m. on a side, the approximate dimensions of a grand throne. These sockets are located between the last column of the nave arcade and the great southeast pier, set back just behind the line of the columns (Plate 87). Between the last column and the pier appear traces of a balustrade that closed the loge in front. In back of the throne site, moreover, four other sockets appear, marking off a large rectangular box approximately 5 by 6 m. (Plate 88). These sockets must have held little piers that carried slabs between them somewhat like a chancel barrier, for the fitting of the last slab is still visible in the corner of the southeast pier even though it has been carefully cemented over. The horizontal veining of the marble guarantees the originality of the revetment in this bay, and the paving likewise shows no signs of revisions. On the basis of these markings one might reconstruct the plan of the Emperor's box as shown in Figure 50. His oratory, metatorion, and triclinium might have been located farther east, in the last bay of the south aisle, but during the celebration of the liturgy proper he would have presided on his throne in the Imperial box. This location in the last intercolumniation of the south nave colonnade would have given the Emperor much greater prominence during the liturgy than the place usually assigned to him behind the southeast conch, where he would have scarcely been visible to most of the congregation.

Notes

[1]Alphonsus Raes, *Introductio in liturgiam orientalem* (Rome, 1947), p. 31.

[2]Charles du Fresne Du Cange, *Historia byzantina duplici commentario illustrata* (Paris, 1670), pt. 2, bk. III, section ii. Since this first edition is rarely available, reference will be made instead to Immanuel Bekker's reprinting of the section describing Hagia Sophia in his edition of Paulus Silentiarius, *Descriptio s. Sophiae et ambonis* (Bonn, 1837), pp. 61–157. For the present citation see ch. 49, p. 107; cf. also ch. 81, p. 148.

[3]Symeon Thessalonicensis, *Expositio de divino templo*, 4, *PG* 155, 704.

[4]Symeon Thessalonicensis, *De sacro templo*, *PG* 155, 360; *Expositio de divino templo*, 21–22, *PG* 155, 708.

[5]*Descr. s. Sophiae*, ed. Bekker, ch. 69, p. 136.

[6]Ibid., ch. 78, p. 147.

[7]Du Cange, *Historia byzantina* (2nd ed., Paris, 1680), pt. 2, bk. III, section ii, "Ecclesia s. Sophiae," ch. 77, p. 70. This change of opinions between the first and second editions was noticed by Lethaby and Swainson, *Sancta Sophia*, pp. 66–67.

[8]Du Cange, *Historia byzantina* (2nd ed.), "Ecclesia s. Sophiae," ch. 49, p. 41.

[9]Paulus Silentiarius, *Descr. s. Sophiae*, ed. Bekker, lines 61–157; *PG* 86, 2, 2159–2252.

[10]Pietro Crostarosa, *Le basiliche cristiane* (Rome, 1892).

[11]Heinrich Selhorst, "Die Platzordnung im Gläubigenraum der altchristliche Kirche" (Diss., University of Münster, 1931), pp. 45–49.

[12]Sálaville, *Liturgies orientales*, I, 100.

[13]A partial listing would include the following: Aphentelle; Evangelidēs in Argales; Assos; Ilissos basilica in Athens; Hag. Isimoros, Chios; Hag. Leonidas, Corinth; Eleusini; Hag. Andreas in Eressos on Lesbos; Hag. Dēmētrios, Hypselometopēs on Lesbos; Hypatēs; Laï on Pelios; Lemnos; Olympia; Laureotikēs in Olympos; Basilicas A and B in Nea-Anchialos; Basilica A and basilica outside the walls in Philippi: Theotokos in Speiada on Pelios; Stobi. Cf. G. Soteriou, *Hai palaiochristianikai basilikai tēs Hellados*, catalogue of churches, passim.

[14]Ibid., p. 216.

[15]*Testament of Our Lord*, trans. James Cooper and A. J. Maclean (Edinburgh, 1902), p. 70.

[16]P. Lemerle, *Philippes et la Macédoine orientale* (Paris, 1945), pp. 355–57.

[17]Orlandos, *Basilikē*, p. 265.

[18]R. Krautheimer, *Early Christian and Byzantine Architecture*, pp. 76, 158–60, 212.

[19]R. Krautheimer, *Early Christian and Byzantine Architecture*, p. 159. Otto von Simson suggested a similar interpretation of Byzantine church space in *Sacred Fortress: Byzantine Art and Statecraft in Ravenna* (Chicago, 1948), pp. 113–14.

[20]F. Dölger, *Regesten der Kaiserurkunden des oströmischen Reichs* (Munich–Berlin, 1924), I, no. 301.

[21]H. C. Butler, *Early Churches in Syria* (Princeton, 1929), and J. Lassus, *Sanctuaires chrétiens de Syrie* (Paris, 1947), passim. See also R. Taft, *OCP* 34 (1968), 326–59.

[22]A great many column bases were found at Hag. Polyeuktos without cuttings for stylobate barriers.

[23]τὸν μόνοις ἱερεῦσί τε καὶ λειτουργοῖς ἀπόκληρον τόπον, ὃν καλοῦμεν ἱερατεῖον· καὶ τὸν πᾶσι τοῖς πιστοῖς λαοῖς πρὸς ἐπίβασιν ἄνετον, ὃν καλοῦμεν ναόν. *Mystagogia*, ch. 2, *PG* 91, 668.

[24]Ibid., ch. 2, *PG* 91, 668–69.

[25]Ibid., ch. 3, *PG* 91, 672.

[26]Ibid., ch. 4, *PG* 91, 672.

[27]Ibid., ch. 5, *PG* 91, 672–73. These interpretations are recapitulated in ch. 24, *PG* 91, 705.

[28]H. G. Liddell and R. Scott, *Greek-English Lexicon*, 9th ed. (Oxford, 1940), s.v. The technical architectural sense of ναός as "nave" is post-classical (not mentioned in Liddell and Scott)-but it is part of Procopius' vocabulary (he prefers the Attic form, νεώς) when he contrasts the aisles with the nave of Hagia Sophia. *Buildings*, I, 1, 55 and 58, pp. 24–25. The newly published *Patristic Greek Lexicon*, ed. G. W. H. Lampe (Oxford, 1961–67) is very little use in its articles on the various parts of the church building.

[29]*Hist. eccl.*, ch. 9, pp. 12–13. Our translation.

[30]*Descr. s. Sophiae*, lines 682–85; ed. Bekker, p. 33; ed. Friedländer, p. 246. Trans. Lethaby and Swainson, *Sancta Sophia*, p. 46.

[31]*Buildings*, I, 1, 32, pp. 16–17.

[32]Ibid., I, 1, 65, pp. 26–29. Our translation.

[33]Ibid., I, 1, 55, pp. 24–25. Our translation. This passage is discussed in detail below, p. 131.

[34]Krautheimer proposes curtains in the colonnades between nave and aisles. *Early Christian and Byzantine Architecture*, p. 158. See below, pp. 163–64.

[35]*Buildings*, I, 4, 12, pp. 48–49.

[36]Ibid., I, 6, 14, pp. 64–65.

[37]*Concilium Laodicenum*, canons 19 and 44, *Mansi* 2, 567 and 571.

[38]Sozomenus, *Hist. eccl.*, VII, 25, *PG* 67, 1496–97.

[39]*Concilium in Trullo*, canon 69, *Mansi* 11, 973.

[40]Sozomenus, *Hist. eccl.*, VIII, 5, *PG* 67, 1528.

[41]Document inserted in proceedings of the Synod of Constantinople of 536. *Mansi* 8, 1058–66.

[42]*Descr. s. Sophiae*, lines 372–75; ed. Bekker, pp. 19–20; ed. Friedländer, p. 237. Trans. Lethaby and

Swainson, *Sancta Sophia*, p. 37. It is not entirely clear whether the conches referred to are the eastern or the western pair, since all are located "westward" of the eastern apse he has just described.

43 *Descr. s. Sophiae*, lines 686–87; ed Bekker, p. 34; ed. Friedländer, p. 246. Our translation.

44 See above, pp. 95–96. Lethaby and Swainson, *Sancta Sophia*, p. 47, n. 1, and pp. 78–79; *Descr. s. Sophiae*, ed. Friedländer, p. 277.

45 Liddell and Scott, *Greek-English Lexicon*, s.v.

46 Egon Wellesz, *A History of Byzantine Music and Hymnography* (Oxford, 1949), pp. 24–32, 108–9.

47 *Descr. s. Sophiae*, lines 339–43; ed. Bekker, p. 18; ed. Friedländer, p. 236.

48 Iustinianus I, *Corpus iuris civilis*, ed. T. Mommsen (Berlin, 1899–1902), III, *Novellae* 3, 1, p. 21; F. Dölger, *Regesten*, I, no. 165.

49 Conc. Laodic., canon 15, *Mansi* 2, 567.

50 Marcellinus Comes, *Chronicon*, PL 51, 937–38.

51 *Descr. ambonis*, lines 111–12; ed. Bekker, p. 52; ed. Friedländer, p. 260.

52 Mateos, *Typicon*, II, 328, *index liturgique*; *De ceremoniis*, I (10), ed. Vogt, p. 67.

53 *Descr. ambonis*, lines 244–51; ed. Bekker, p. 56; ed. Friedländer, pp. 263–64. Trans. Lethaby and Swainson, *Sancta Sophia*, p. 58. The only other mention of this ceremony is in Sophronius' commentary on the liturgy; *Commentarius liturgicus*, 18, PG 87, 3997–4000. It is not known whether the author was Sophronius II (1059–64) or Sophronius III (1235–73), patriarch of Jerusalem. Cf. R. Bornert, *Les commentaires*, p. 211.

54 Maximus, *Mystagogia*, ch. 21, PG 91, 696–97.

55 P. de Puniet, "Catéchuménat," *DACL*, II, 2, 2579–621.

56 Leo Allatius, *De templis graecorum recentioribus, de narthece, de graecorum hodie quorundam opinionibus* (Cologne, 1645). Allatius' two letters that make up the *De templis* have been translated by Anthony Cutler as *The Newer Temples of the Greeks* (University Park, 1969).

57 Allatius, *De templis*, pp. 56, 66–67, 78.

58 Dionysius Areopagita, *Ecclesiastica hierarchia*, ch. 3, 6, PG 3, 432–33.

59 Allatius, *De templis*, p. 80.

60 Conc. Laodic., canon 19, *Mansi* 2, 567.

61 Jacobus Goar, *Euchologion sive rituale Graecorum* (Venice, 1730), pp. 17–18.

62 Gregorius Thaumaturgus, *Epistola canonica*, 11, PG 10, 1048.

63 E. Schwartz, *Busstufen und Katechumenatclasse*, Schriften der wissenschaftlichen Gesselschaft in Strassburg, vol. 7 (Strassburg, 1911).

64 Guillaume J. Grelot, *Relation nouvelle d'un voyage à Constantinople* (Paris, 1681), p. 123; Du Cange, *Historia byzantina* (2nd ed.), "Ecclesia s. Sophiae," ch. 18, pp. 16–17.

65 Concilium Nicaenum I, canons 11 and 14, *Mansi* 2, 673.

66 Charles Texier and R. P. Pullan, *Byzantine Architecture* (London, 1864), pp. 59–63.

67 Antoniades, *Ekphrasis*, I, 138–39, 172–73; II, 44.

68 Sozomenus, *Hist. eccl.*, VII, 16, PG 67, 1457–64.

69 Ioannes Chrysostomus, *In epist. 1 ad Thessal.*, Homilia 10, 1, PG 62, 455; cf. F. van de Paverd, "Zur Geschichte der Messliturgie in Antiocheia und Konstantinopel gegen Ende des vierten Jahrhunderts: Analyse der Quellen bei Johannes Chrysostomos" (Diss., Pontificio Istituto Orientale, Rome, 1968), pp. 421–27.

70 Conc. in Trullo, canons 87–88, *Mansi* 11, 980–81.

71 Ioannes Chrysostomus, *In acta apostolorum*, Homilia 1, 8, PG 60, 24; van der Paverd, "Messliturgie," pp. 419–20.

72 Ioannes Chrysostomus, *In epist. II ad Cor.*, Homilia 2, 5, PG 61, 400.

73 A homily found among those of Chrysostom, *Homilia in Illud. Hebr. 3:1*, Homilia 9, PG 64, 489; van der Paverd, "Messliturgie," pp. 420–21.

74 Concilium Constantinopolitanum I, canon 7, *Mansi* 3, 564: P. de Puniet, "Catéchuménat," 2594.

75 Palladius, *Dialogus de vita s. Ioannis*, ch. 9, PG 47, 34.

76 Conc. Const., *Mansi* 8, 874 ff.

77 Conc. in Trullo, canon 78, *Mansi* 11, 977.

78 Conc. in Trullo, canon 95, *Mansi* 11, 984.

79 *Mystagogia*, ch. 14, PG 91, 692–93.

80 Cf. Germanus, who simply says the catechumens leave because they are not baptized. *Hist. eccl.*, ch. 45, p. 28.

81 Du Cange, *Glossarium ad scriptores mediae et infimae graecitatis* (Lyons, 1688), s.v.

82 R. Devreesse, "Le texte de la vita de Saint Maxime," *Analecta Bollandiana* 46 (1928), 44.

83 *Vita et acta s. Maximi confessoris*, ch. 25, PG 90, 161.

84 Ignatius Deaconus, *Vita s. Nicephori*, PG 100, 129.

85 *Script. orig. Const.*, II, 280.

86 Conc. in Trullo, canon 97, *Mansi* 11, 985.

87 P. Noailles and A. Dain, *Les nouvelles de Leon VI le Sage* (Paris, 1944), p. 261, novella 73.

88 Sozomenus, *Hist. eccl.*, VIII, 5, PG 67, 1528–29.

89 *Mystagogia*, ch. 15, PG 91, 693.

90 Allatius, *De templis*, pp. 9–11.

91 Ioannes Chrysostomus, *In Ps. 48:17*, PG 55, 507; cf. van der Paverd, "Messliturgie," pp. 397–98.

92 *Descr. s. Sophiae*, lines 389, 562, 587; ed. Bekker, pp. 20, 28, 29; ed. Friedländer, pp. 238, 243, 244.

93 *Buildings*, I, 1, 55–58, pp. 24–26.

[94]I am indebted to Prof. Helen H. Bacon of the Barnard College Department of Classics for assistance on this troublesome passage.

[95]Evagrius, *Hist. eccl.*, IV, 31, *PG* 86, 2, 2760.

[96]*Buildings*, I, 1, 27, pp. 12–13.

[97]Ebersolt, *Sainte-Sophie*, p. 25; Kähler, *Hagia Sophia*, p. 74; Dirimtekin, *Saint Sophia Museum*, p. 29; et alii.

[98]*De ceremoniis*, I, 9, ed. Vogt, pp. 61–62.

[99]The feasts of the Sunday after Easter, the Holy Cross, the Purification, and Orthodoxy. *De ceremoniis*, I, 25 (16), 31 (22), 36 (27), 37 (28); ed. Vogt, 90–91, 116–17, 140, 145–48.

[100]*De ceremoniis*, I, 1 and I, 39 (30), 44 (35); ed. Vogt, pp. 24–26, 154–55, 173.

[101]See above, ch. 1, n. 64.

[102]*De ceremoniis*, I, 1 and I, 39 (30); ed. Vogt, pp. 24–26, 155.

[103]Ibid., I, 26 (17), ed. Vogt, pp. 93–97.

[104]Ibid., I, 27 (18), ed. Vogt, pp. 104–5.

[105]Ibid., I (10), ed. Vogt, pp. 70–73.

[106]Ibid., I, 20 (11), ed. Vogt, pp. 78–80.

[107]*Script. orig. Const.*, I, 79, 80, 100, 103.

[108]Du Cange, *Glossarium ad scriptores mediae et infimae graecitatis*, s.v.; idem, *Historia bizantina* (2nd ed.), "Ecclesia s. Sophiae," ch. 38, pp. 33–34.

[109]Antoniades, *Ekphrasis*, I, pl. 17; Ebersolt, *Sainte-Sophie*, pp. 16–17; Kähler, *Hagia Sophia*, p. 34.

[110]*Descr. s. Sophiae*, lines 580–85; ed. Bekker, p. 29; ed. Friedländer, pp. 243–44.

[111]*De ceremoniis*, I, 1 and I, 9; ed. Vogt, pp. 12–13, 59.

[112]Ibid., I, 1 and I, 37 (28); ed. Vogt, pp. 12 and 147.

[113]Ibid., I, 32 (23) and I, 9; ed. Vogt, pp. 124 and 61.

[114]Du Cange, *Glossarium ad scriptores et infimae graecitatis*. Du Cange connects metatorion with "mutare."

6 The Liturgy of the Catechumens

The First Entrance

The Byzantine liturgy in current usage opens with a number of prefatory rites and prayers.[1] First comes the prothesis ceremony, or *proskomidē*, which is celebrated privately by the priest at a table in the left (northern) part of the sanctuary or in a separate, apsed prothesis chapel left of the sanctuary. This ceremony consists of a preparation of the Eucharistic elements of bread and wine. The cutting of the bread is ceremonially arranged to commemorate Christ and the saints; then the elements are incensed and covered with two veils. Next comes the incensing of the church. The deacon begins by incensing the altar, then incenses the sanctuary and the whole body of the church; finally he returns to the sanctuary and incenses the altar a second time. The litanies follow. After the incensing, the priest takes his place at the altar and the deacon his place outside and to the left of the sanctuary door; the priest then starts the litanies, singing "Blessed be the kingdom of the Father and of the Son and of the Holy Spirit." There are three litanies, a longer and two shorter ones, each followed by a prayer and an antiphon.

These three prefatory rites lead up to the Little Entrance, or, following the terminology of Maximus, the First Entrance.[2] In the Early Byzantine liturgy, however, the celebration began simply with the First Entrance; the three prefatory rites are all later additions. Evidence for the prothesis ceremony does not antedate the eighth century.[3] In the Barberini manuscript of the ninth century, the ceremony consisted of only a single prayer invoking God's blessing on the elements.[4] The incensing is also a late addition. Although Brightman inserted an incensing of the church in his reconstruction of the Early Byzantine liturgy on the basis of a mention of incensing in the life of Eutychius (582),[5] the text in question, as Hanssens remarks, does not tell us at what point in the ceremony the incensing took place, nor does it indicate that this was standard procedure.[6] The occasion was the midnight celebration of Easter, which is by no means an everyday kind of celebration. The Easter incensing of the church is a special rite; it is prescribed in the ninth-century typicon of the Studios monastery as well as in the tenth-century typicon of Hagia Sophia.[7] Maximus mentions no incensing in his description of the liturgy of Constantinople (even though his predecessor, Pseudo-

Denis, had described the opening incensing of the Syrian liturgy);[8] nor does Germanus mention an incensing of the church at this point, though he later mentions incensing before the reading of the Gospel.[9] Moreover, the litanies with their prayers and antiphons are also a later addition to the primitive rite, and their origin has been discussed by Mateos.[10]

In Early Byzantine times, therefore, the celebration of the liturgy began with the First Entrance. Chrysostom bears witness to the simplicity of the early liturgy when he remarks in a homily against "judaizers": "When the celebrant enters, he does not mount up to the throne before invoking peace on all of you."[11] The order was: (1) the entrance of the celebrant; (2) his greeting of peace; (3) his ascension of the throne in the apse; (4) the beginning of the readings. The ceremony of the Entrance opened the liturgy, but the way in which this ceremony was conducted has not been properly investigated and since it does not involve any prayer texts of great importance it is easily neglected by liturgists.[12] It was a ceremony of great importance, however, very meaningful for the commentators and quite impressive visually. We are told that the Sunday before he died the patriarch Eutychius went to the Great Church for vespers, "and a great crowd of people was there because they especially liked to see him when he made his entrance in his patriarchal vestments."[13] For the Eucharistic liturgy the ceremony of the First Entrance must have been even more impressive, as it involved a greater number of clergy and, as we will see, the laity as well. It is in precisely such ceremonies of external display and movement that the relationship of the liturgy to its architectural setting becomes most evident.

In the present Byzantine liturgy, the First Entrance consists of an abbreviated procession of the Gospel. "The priest and the deacon," the rubric prescribes, "standing before the holy table make three reverences; then taking the Holy Gospel, the priest hands it to the deacon, and thus going out through the north side preceded by candles they make the Little Entrance."[14] The "Little Entrance" traces a half-circle, more or less, from the north door to the center door of the sanctuary. The celebrant follows the deacon, who is carrying the book. Arriving at the door, the celebrant privately says the Prayer of Entry; the deacon raises the book on high and makes the sign of the cross; and the priest and deacon enter the center door and replace the Gospel on the altar, while the lesser clergy enter the south door of the sanctuary.[15] The shape of this rite in Early Byzantine times was quite different.

The first difference was that the Entrance in the Early Byzantine rite was a true entrance, a coming into the church for the first time, and not simply a loop made from the sanctuary into the church and back again to the sanctuary. Chrysostom refers to it as an entering of the church itself, and Maximus terms it "the First Entrance of the celebrant into the church."[16] Since the prefatory rites that now begin the liturgy are later additions, there was no reason for the celebrant to have come to the sanctuary before the First Entrance.

One must imagine, then, that the Early Byzantine First Entrance followed a formal entrance route from the narthex through the central entrance of the nave and up the length of the nave to the sanctuary. Such is the route still prescribed for the great

feasts in the *De ceremoniis* for the ninth and tenth centuries.[17] Arriving with his court at the narthex of the Chalkoprateia, the Church of the Apostles, or Hagia Sophia—as the particular feast might require—the Emperor would take a seat in the narthex to await the arrival of the patriarch. The patriarch would then arrive with the procession, and the patriarch and Emperor would exchange greetings. Standing before the Royal Door (αἰ βασιλικαὶ πύλαι), candles in hand, they would make a triple reverence while the patriarch said the Prayer of Entry (ἥ εὐχὴ τῆς εἰσόδου);[18] then the entrance itself would take place. Together they would traverse the length of the nave, pass by the side of the ambo, and enter the solea, proceeding thus to the Holy Door of the sanctuary (αἱ ἅγιαι θύραι).[19] The same line of entrance is indicated in a general way in the typicon of the Great Church, in that the patriarch is described as celebrating the liturgy at stational churches around the city which he reached from Hagia Sophia, approaching, one assumes, in the formal manner through atrium and narthex. When attending the chanting of the divine office at Hagia Sophia, the patriarch would enter the church informally through the gallery, for he is said to "descend" and enter the side of the sanctuary.[20] For the Eucharistic liturgy, on the other hand, it is simply noted at which point he "makes his entrance," referring apparently to the more formal way of entering through the narthex.[21] One must remember, however, that while the path of the entrance was the same, the actual entrance in the standard liturgy in the ninth and tenth centuries was delayed somewhat by the chanting of the antiphons, which began to be introduced in the eighth century. Only for the more solemn celebrations, such as those described in the *De ceremoniis*, would the antiphons be omitted and the primitive custom observed, opening the liturgy with the First Entrance.

The First Entrance, therefore, involved the formal procession of the celebrant into the church and up to the sanctuary. A second and most important difference between the present liturgy and the primitive liturgy is that the early First Entrance involved the entrance of the people as well as the bishop or celebrant. In the Early Roman liturgy the opposite was observed: the people and the lesser clergy all took their places in the church first, and the bishop's entrance was dramatically planned to climax their entrance.[22] In Constantinople the people entered with the bishop. Maximus tells us, "The entrance of the people into the church with the celebrant stands for the turning of unbelievers from their wandering and ignorance to the recognition of God, and the conversion of the faithful from immorality and ignorance to virtue and knowledge, according to our Father [Pseudo-Denis]. . . . Such a one [who has been converted] really and truly makes his entrance with Christ our God and High Priest, let it be understood, into a life of virtue, which is symbolized by the church."[23]

The entrance of the bishop stands for the coming of Christ. "The First Entrance of the celebrant into the church represents the type and symbol of the first coming into the world of the Son of God, Christ our Saviour, in the flesh."[24] But more important to Maximus' moral purpose is the entrance of the people, for their entrance should be matched by an interior conversion of heart. Hence, in another passage, "the First Entrance of the Holy Liturgy" symbolizes a turning from the distractions of the

material world to the life of contemplation. In its conversion, "the soul comes and even flees as into a church and inviolable sanctuary of peace into the natural contemplation of spirit, a tranquil contemplation free of all disturbance, entering with the Word and under the leadership of the Word, our great and true God and High Priest."[25] Or, again, "By the First Entrance is meant the rejection of disbelief, the increase of faith, the restraining of immorality, the growth of virtue, the removal of ignorance, the addition of knowledge."[26] And, finally, "The First Entrance signifies in general the first appearance of our God; but in particular it signifies the conversion of those who enter through him and with him, a conversion from disbelief to faith, from immorality to virtue, from ignorance to knowledge."[27]

Maximus, therefore, testifies to the involvement of the lay faithful in the First Entrance and attaches considerable moral significance to this involvement. Prayers also accompanied the First Entrance, and they too witness the part the laity took in the ceremony. The present Prayer of Entry recited privately by the celebrant before entering the doors of the sanctuary is found in manuscripts of the Liturgy of St. Basil in the ninth century; the text makes only general reference to the faithful by asking that "an entrance of angels may accompany our entrance."[28] The corresponding prayer in the Liturgy of Chrysostom, however, is more explicit and must date from a time when the whole church entered with the celebrant. "Benefactor and Maker of all creation, receive the church as it approaches, accomplish what is best for each person, lead all to perfection and make us worthy of your kingdom."[29] The prayer, Mateos points out, was intended to be said aloud.[30]

In addition, the blessing that is now pronounced just before entering the doors of the sanctuary seems also to refer to the entrance of the people. The deacon asks the priest to bless their entrance, and the celebrant answers, "Blessed be the entrance of your saints at all times, now and always and forever. Amen."[31] Mateos takes the expression τῶν ἁγίων σοῦ as if it were a neuter: "the entrance [i.e., door] of your holies," referring to the doorway of the sanctuary.[32] This, however, would be a very unusual form of expression; the more common term for the sanctuary is the "Holy of holies," τὰ ἅγια τῶν ἁγίων, and the usual term for its door is the "Holy Door," τὰ ἅγια θυρία.[33] Moreover, the neuter term τὰ ἅγια in liturgical language refers to the Eucharist, as in the exclamation, "Holy things to the holy."[34] Originally, then, both the blessing and the preceding prayer must have been pronounced not at the entrance to the sanctuary but at the entrance to the nave of the church (the Royal Door), when the celebrant and with him the entire congregation were on the point of entering into the nave of the church. As we have already noted, the *De ceremoniis* places the Prayer of Entry at this point.[35]

The patriarch in his First Entrance ceremony was naturally accompanied by the clergy as well as by the faithful. Among these the first in importance was the deacon carrying the Gospel. The present ritual seems to reflect fairly accurately the primitive ceremony in this respect. The deacon carries the Gospel in front of the celebrant and is accompanied by candle-bearers and incense-bearers who precede him. As in the early Roman ceremony, the Gospel is carried up to the altar and placed upon it as a way of enthroning Christ, the Word of God—a motif common in Early Christian and

Byzantine art.[36] The fact that the book precedes the celebrant gives it precedence of rank over the celebrant, since—as will become clear—the place of honor in Byzantine processional order is the first place, contrary to the Roman *"juniores priores"* rule.

In the *De ceremoniis* we regularly find the Gospel in the patriarch's First Entrance for the liturgy, but another element is also mentioned in the procession—a subdeacon carrying a cross.[37] The cross must have accompanied the entrance whenever the procession came to the church from some other part of town. When the Emperor encountered the procession, generally in the narthex, he greeted the patriarch, the Gospel, and the cross;[38] but another order was sometimes observed, according to which the Emperor greeted the Gospel before greeting the patriarch, and this was perhaps the more proper way of doing it.[39] The Gospel stands more immediately for Christ and so should be reverenced first.

In Germanus, too, we find the Gospel borne in ahead of the bishop, since the entrance of the Gospel is described before the bishop has taken a seat on his throne.[40] Although Maximus does not explicitly mention the carrying in of the book, he may allude to it when he speaks of the First Entrance taking place "with the Word and under the leadership of the Word."[41]

The other clergy must also have taken part in the First Entrance, accompanying the celebrant all the way to the synthronon in the apse. Neither Germanus nor Maximus mentions their part in the ceremony, but the *De ceremoniis* mentions different classes of clergy with the bishop. The common clergy (κοινοὶ κληρικοί) would not enter the Royal Door with the bishop but would use the door immediately to the right of it, entering along with the civil government of the city.[42] The cantors are also mentioned on one occasion as "walking in front of the patriarch's procession,"[43] and entering immediately with the patriarch were the metropolitans and bishops.[44] The *De ceremoniis* is not clear on whether they preceded or followed the bishop, but in the present Byzantine ritual when the bishop is accompanied by concelebrants they follow behind him.

Finally, the Emperor had his part in the First Entrance. We must be careful, as we have said, not to overestimate the Emperor's role, since it was the exception rather than the rule that he should take part in the liturgy. But on those occasions when he did take part, the usual order involved his arriving at the narthex ahead of the patriarch and his procession and sitting to wait for them there. After greeting the Gospel and the patriarch, he would join the patriarch before the Royal Door to begin the prayers that marked the start of the First Entrance. Walking side by side the two would proceed down the center of the nave, past the ambo, and through the solea to the Holy Door of the sanctuary.[45] On these occasions the First Entrance would also be enriched with the Emperor's honor guard. This guard is referred to simply as chamberlains in two passages,[46] but another passage enumerates scepters, insignia, standards, and the guard of the Roman veil.[47] These go in ahead of the procession and take up places in two files that stand at the left and right of the solea. The similarity of this guard of honor to that which is provided for the entrance of the bishop of Rome in the stational liturgy of the seventh century is too striking to be coincidence. In Rome the honor

guard consisted of cantors, soldiers carrying standards, cross-bearers, and candle-bearers.[48] These stood on either side in the processional way or solea that was located in the center of the nave before the sanctuary in the early churches of Rome.[49] Very likely the custom in Constantinople dates back to Early Byzantine times and was borrowed by Rome at an early date; the ultimate derivation of both from Late Roman Imperial ceremonial can be taken for granted.[50]

Arriving at the Holy Door, the Emperor would let the patriarch (and apparently the metropolitans as well) enter the sanctuary first, while he stood without, praying with a lighted candle in hand.[51] He then entered, left a gift of gold on the altar, and departed by the side door of the sanctuary to go to his place in the south aisle.

The goal of the First Entrance ceremony was the synthronon in the apse of the church. Chrysostom, as we have seen, testifies to the sequence: (1) the entrance of the celebrant, (2) his greeting of peace, (3) his ascension of the throne in the sanctuary.[52] Maximus omits any mention of the celebrant's ascension of his throne, but goes directly from the First Entrance to the Readings; yet once the readings are over he does mention the descent of the bishop from the throne.[53] Germanus is more explicit and attaches spiritual meaning to the action of ascending the synthronon.

> Ch. 26. That the celebrant ascends into the synthronon and blesses the people, this is the Son of God [who], when he fulfilled the work of salvation, lifted up his hands and blessed his holy disciples telling them, "Peace I leave you," meaning that Christ gave the same peace and blessing to the world through his apostles.

> Ch. 27. His sitting down signifies that the Son of God clothes himself with flesh and has raised up the sheep on his shoulders, which the omophorion signifies, and this is the bulk of humanity; this flesh he raised up above every principality and power and domination of the virtues above, and he offered it to God the Father. This God the Father received as a sacrifice and pleasing offering in behalf of the human race; and he said to him, "Sit at my right hand," who thus sat at the right of the throne of majesty on high.[54]

Hence the ascent to the synthronon signifies both Christ's sacrificial self-offering and his consequent glorification at the right hand of the Father. The order is slightly different from that of Chrysostom in that the blessing is given from the synthronon just before the bishop sits down instead of before he ascends the throne; but the detail is not important. Bouyer's hypothesis that the clergy took seats in the nave of the church until the end of the readings is not supported by any of the liturgical evidence.[55]

The other clergy also entered the sanctuary with the celebrant, the concelebrants taking places on either side of the bishop in the synthronon after he himself had taken his place. This is the order prescribed by the Council of Laodicea and presently observed in the Byzantine liturgy. "The priests ought not to enter and sit down on the bema before the entrance of the bishop, but should enter with the bishop, unless he is

sick or absent," the Council prescribes.[56] Again the order is the reverse of that in Rome, where the priests took their places in the apse to await the bishop's entrance. The evidence of the synthronons at the Studios and Hag. Euphēmia, as well as the Silentiary's description of the synthronon at Hagia Sophia, indicate that only the top bench was intended for sitting on. The ancient church councils forbade deacons and lesser clergy to sit with the priests.[57]

Thus we know a good deal about the conduct of the First Entrance ceremony in its Early Byzantine setting. We know the participants: the celebrant, the deacon carrying the Gospel, the clergy, the lay faithful and, on about a dozen occasions in the year, the Emperor and his guard. We know the sequence and the route of the celebrant's procession—from the Royal Door where he said the Prayer of Entry, down the center of the nave, past the ambo and into the solea, through the double file of the Imperial guard when present, into the Holy Door of the sanctuary, to the altar where the Gospel would be enthroned, and then up into the synthronon where the bishop would invoke peace on the congregation before taking his seat on the top bench, surrounded by the other priests and/or bishops. We have also examined the architectural setting in which the ceremony unfolded in the early churches of Constantinople, and a number of connections between the ceremony and the architecture deserve to be underscored.

In the first place, the strong longitudinal lines of the celebrant's entrance procession is clearly connected with a number of longitudinal features that appear in Early Byzantine church planning. A clear axis exists between the Royal Door and the Holy Door. The former was always designed on a considerably grander scale than the other doors from the narthex. The only exception is Hag. Euphēmia, where remodelling of the former palace hall into a church involved shifting the axis away from the main large entrance; but this made the existence of the axis even more noticeable, since a new door had to be opened up on the new axis to permit the First Entrance to be performed with proper formality. The solea, too, emphasizes this longitudinal character in Early Byzantine church planning, and the parallel between the Roman and Constantinopolitan rites in this respect is striking. Possibly we should explain the reluctance of Early Byzantine architecture to break with the basilican lines of earlier churches by the strength of the liturgical tradition. Whether or not one can attach a causal significance to this association, it is nevertheless true that as long as the First Entrance retained its character as a formal processional entry from narthex to apse, church design tended to preserve a longitudinal emphasis—even in domed plans such as Hag. Eirēnē and Hagia Sophia. On the other hand, after the First Entrance had been reduced in Middle Byzantine times to a simple emergence from and return into the sanctuary, the longitudinal emphasis tended to disappear entirely in the geometry of central plans.

In the second place, the fact that the celebrant's procession originated outside the church obviated the need of a diaconicon for vesting in the church itself. The celebrant made his entrance already vested for the liturgy, and—as was apparent from the remark from the life of Eutychius—the people "liked especially to see him when he made his entrance in his patriarchal vestments."[58] It is therefore quite pointless to try to assign this

or that corner of Hagia Sophia for use as a diaconicon or to try to imagine that the cramped passage hidden under the synthronon might have served this purpose.

The clergy vested before coming to the church, either in the patriarchate or wherever the procession for a given feast day happened to originate. In the fifth and sixth centuries, of course, vesting was much less a formality; the bishop was simply clothed in the standard dress of the patrician, to which he added a stole (the omophorion).[59]

Other associations between the ceremonial and church planning are obvious. The simple needs of organizing large numbers of people to take part in the First Entrance must have dictated the disposition of atrium and narthex in front of the church and the multiplication of entrances. The part played by the laity in this respect is especially important, and it is regrettable that more information is not available on their role. Liturgical sources are generally concerned only with the parts of the most important actors in the liturgy—the clergy and the Emperor and his court—while the part of the common man is taken for granted. But the inclusion of an atrium in all the church plans for which we have any information whatsoever must be connected with the fact that the congregation had to await the arrival of the celebrant before entering the church. A sheltered place had to be available in front of the church where people could gather before the bishop's arrival and cheer him upon his appearance. When the Emperor approached Hagia Sophia by way of the horologion, there were always people there to greet him with acclamations.[60] This was certainly the most important liturgical use for the atrium.

The narthex, on the other hand, seems to have served the First Entrance as a place for organizing the start of the procession. The protocol of the meeting of Emperor and patriarch was observed there, and there the clergy and court took their positions in the procession, while the Emperor and patriarch took places before the Royal Door for the beginning of the liturgy. The faithful, too, seem to have taken positions there when the liturgy was about to begin. While the Emperor was awaiting the approach of the patriarch, we are told that the master of ceremonies began the troparion or antiphon, "and all who took part in the procession entered the narthex of the Great Church singing the troparion."[61] Chanting the Byzantine equivalent of the introit of the Roman rite, they entered the narthex to wait for the bishop to lead them into the church. The doubling of the narthex at Hagia Sophia may be no more than a practical accommodation for the larger crowds using the church and the more elaborate processions which were organized there. The idea of the narthex as a porch for catechumens and penitents, as explained in the last chapter, must be finally laid to rest.

The order in which the faithful entered the church is not known, although people of rank must have preceded the common folk. Once their leaders had entered, the faithful must have simply flooded into the church through the multiplication of entrances in the narthex and from the sides of the church as well, in order to reach their places in the nave and aisles by the time the patriarch arrived at his throne and turned to greet them with his "Peace be with all." The ceremonial action must have been exciting both to witness and to take part in, as it suddenly brought the entire building to life with the surge of the singing multitude and the candled procession of Gospel and clergy.

Two representations of the First Entrance add color to the picture we have tried to reconstruct. In the tenth-century Menologion of Basil II, one of the many processions represented in the miniatures is clearly identifiable as the First Entrance (Plate 90). The miniature represents the celebration of the 26th of October, the feast commemorating the deliverance of the city from the earthquake of 740. The bishop leads the procession, carrying in his left hand the Gospel book, bound in gold with precious stones, and in his right a censer; artistic economy has thus assigned to the bishop tasks that would ordinarily fall to his accompanying deacons. At the bishop's right stands the cross-bearer, who wears a strap around his neck from which to support the heavy cross he carries. The cross itself is an extraordinary piece of jewelry, of gold completely inlaid with pearls and gems, with jewelled pendants swinging from the cross-arms. At the cross-bearer's right walks a layman, evidently a senior citizen of high rank, who carries a candle.

In the second row of figures appears a young deacon in his white *linea*, likewise carrying a candle, and at his right another cleric, who carries in his right hand a parchment scroll which, from the position of his fingers between the rolls, he seems to be reading. This figure, as the editor of the Menologion has reasoned, must be the cantor who led the litanies in approaching the church or intoned the troparion upon entering.[62] The other clergy follow behind these more important figures, and behind them are ranged the crowd of common layfolk carrying candles. Thus, in the smallest imaginable scope, the miniaturist has represented all the essentials of the First Entrance—bishop, book and cross, cantor, deacon and clergy, and, finally, laity. The church they are about to enter is the famous Early Byzantine basilica of the Theotokos of Blachernēs, a fifth- and sixth-century building.[63]

The First Entrance is also represented in the sanctuary mosaic of S. Vitale in Ravenna, with the difference that in this case the Imperial court also participates, which has caused some problems of interpretation (Plates 91–92). The polemic between Stričević and Grabar did not succeed in resolving the basic iconographical problem of the panels, for neither of the alternatives proposed was entirely acceptable.[64] Stričević's proposal that the mosaics represent the carrying in of the bread and wine in the Great Entrance (which was the earlier hypothesis of Lanzoni and von Simson before him[65]) is iconographically impossible, as Grabar maintained—not because the ceremony did not exist in the Early Byzantine liturgy (Grabar's contention), but because the Great Entrance, or the Entrance of the Mysteries, did not in any way resemble the event depicted in the mosaic. As we will see in our reconstruction of the Great Entrance below, neither bishop nor book nor cross had a part in that procession, and the carrying of the gifts was exclusively assigned to deacons; the Emperor, when he took part, simply accompanied the deacons with a candle.[66]

Grabar, on the other hand, tried to ignore entirely the liturgical context of the representations in order to emphasize parallels with other scenes of Imperial donation, such as the panel in S. Apollinare in Classe.[67] The parallels with other donation scenes, however, are only general. The very specific context of the donation in the S. Vitale panels is the First Entrance of the Divine Liturgy, and all the passages cited by

Grabar from the *De ceremoniis* refer explicitly to this ceremony, even through Grabar fails to notice the connection. Bishop Maximianus leads the procession, wearing his archepiscopal stole or pallium and carrying in his right hand a jewelled cross (Plate 91). He is immediately accompanied by two other members of the clergy, a deacon carrying the Gospel (bound in gold set with pearls and heart-shaped emeralds) and another carrying incense.

As he begins his procession into the nave of the church, the bishop is followed by the Emperor, who has met him in the narthex. Nordström prefers to locate the scene in the narthex itself, because Justinian is still wearing his crown;[68] but even in the narthex the Emperor should have removed his crown before meeting the bishop, and actually the crown, like the halo, is part of the ordinary identification of the Emperor in any particular situation. The procession already seems to be in motion. The Emperor is accompanied by three high court officials, sometimes identified as the banker Argentarius on his left and the general Belisarius on his right. Behind them come a military guard.

At the same time, in the opposite panel (Plate 92), the Empress Theodora is seen entering one of the doors of the church from the atrium, the location indicated by the fountain. She, too, wears her diadem, which is more elaborate than Justinian's, with pendants that reach to her shoulders; her necklace is of unparalleled sumptuous display. On her right she is accompanied by two chamberlains, one of whom draws the door-curtain aside for her, and on her left are two ladies-in-waiting. These principal figures are followed by a crowd of women only slightly less lavishly dressed. The Empress carries a chalice which she extends in a gesture of presentation, just as the Emperor carries a paten, or shallow golden bowl. The presentation of a gift by the Emperor, as we have seen, was a regular part of his participation in the First Entrance. In the tenth century the gift usually mentioned was a purse of gold, although occasionally we read of a chalice and paten being presented.[69] (According to Paul the Silentiary, everyone entered the church carrying gifts on the occasion of the consecration of Hagia Sophia.)[70]

The artist of the S. Vitale panels has reduced to three essential figures the clergy participating in the First Entrance. In compensation, however, he has given us an imposing picture of the impression made by the Emperor and Empress when they took part with their court in full regalia. The two panels also suggest the diversity of movement involved in the ceremony; while the bishop led the principal file into the nave from the Royal Door, other elements of the congregation were streaming in from other entrances. The visual sources thus complement the literary ones in this reconstruction of the great popular commotion involved in the opening ceremony of the Early Byzantine liturgy.

Readings and Preaching

Once the bishop had reached his place in the synthronon with the clergy on either side of him and the people had arrived at their places in the body of the church, the

Liturgy of the Word began. The basic components of the Liturgy of the Word were standard in all the Early Christian liturgies: a series of readings from scripture, usually relieved by the chanting of psalms between them, and sermons. While liturgists have given a good deal of attention to the text of the readings and the sequence in which they were distributed throughout the liturgical year, very little attention has been given to the manner of performing this rite, and still less to the ceremony of preaching.[71]

It is clear from frequent references in the sermons of St. John Chrysostom that the Early Byzantine liturgy had three readings from scripture: one from the Old Testament, referred to loosely as the Prophets; one from the Acts or the Epistles, referred to as the Apostle; and the final, culminating reading from the Gospel.[72] Maximus testifies to the endurance of this custom in his day, for even though he does not enumerate the readings he always refers to readings before the Gospel in the plural.[73] By the time of Germanus, however—or certainly by the ninth century—the readings had been reduced to the present two, the Epistle or Acts and the Gospel.[74]

From earliest times a distinction seems to have been made between the solemnity with which the Prophets and the Apostle were read (or chanted) and that with which the Gospel was read. The former were assigned to minor clergy of the class of lectors. In Justinian's time we read of 110 lectors attached to Hagia Sophia, and by the time of Heraclius this number was set at 160.[75] Sozomen tells us that the Gospel was usually read only by the deacon in Constantinople, although once a year, on Easter Sunday, the bishop himself would read the solemn account of the Resurrection of Christ.[76]

The place for the readings is generally accepted as the ambo, as the Silentiary explicitly states.[77] The amount of ceremony that accompanied the first two readings may have been minimal: unlike the Gospel book, which had been carried in procession ahead of the bishop to its place on the altar, the books for the first two readings were probably kept at the ambo itself. This is the most probable interpretation of Paul the Silentiary's reference to the ambo as "a tower set aside for the usual untrammelled place of the holy books."[78] Thus, with little ceremony except for the exchange of greetings—the bishop's greeting of peace and the reader's calls for attention—the reader could ascend the ambo and begin, without the formality of a procession. In a similar manner, the cantors would ascend the ambo to lead the intervening psalms; the Council of Laodicea explicitly mentions cantors ascending the ambo to sing.[79] Maximus is our witness to the presence of such musical interludes in the Early Byzantine liturgy.[80]

In contrast to the first two readings, the reading of the Gospel was accomplished with a great deal of solemnity. The Gospel book in Early Christian times was the image of Christ *par excellence*; whether enthroned on the altar or the cathedra or carried in solemn procession, it was an object of profound veneration, as it stood for Christ himself. Thus in the iconoclastic controversy the Gospel was cited as the primary analogate of icons of Christ, and the conciliar decision approving the worship of images of Christ simply put such images on the same footing as the Gospel had always been in Christian worship.[81] Hence one would expect that when

the deacon left his place in the sanctuary to carry the book from the altar to the ambo he did so with considerable solemnity.

In the present Byzantine ritual, the deacon first incenses the altar and sanctuary, the iconostasis, and the congregation; then he goes to the altar to receive the book from the celebrant, who blesses him; lastly he carries the book, preceded by candles, to his reading place before the Holy Door of the sanctuary (the ambo has generally disappeared).[82] All of this formality probably reflects the ceremony of the primitive Byzantine rite. Jerome testifies to the use of candles in the Gospel procession when he tells us that "in all the churches of the East, when the Gospel is going to be read, candles are lighted, even though the sun may already be up—not to dispel the darkness, but demonstrating a sign of joy."[83] Jerome, of course, is speaking from his personal experience of the Eastern liturgies, including that of Constantinople, where he visited between 379–81.[84] Germanus testifies to the use of incense in the Early Byzantine liturgy at this point in the ceremony, although Maximus does not mention it.[85]

When one adds to the incense and candles the richness of the Gospel book itself, which was usually bound in gold and jewels, it is not difficult to understand the Silentiary's statement that the ascent of the Gospel was an impressive ceremony which had "the people stretching their eyes in attention" at the sight.[86] The people, who might have sat or squatted wherever they were able to during the first two readings, all stood for the Gospel, and the Emperor removed his crown. After the reading, the descent of the Gospel from the ambo and its procession back along the solea to the sanctuary attracted a more active interest when the deacon offered the book to be touched or kissed by the faithful; "waves of people" would press forward with eagerness around the solea to pay their worship to the holy book.[87] In terms of the attention which it excited, the reading of the Gospel and its accompanying processions out and back must have been the climax of the three scriptural readings.

Throughout the readings, the bishop kept his place in the apse within the sanctuary. The bishop's greeting of "Peace be with all," which prefaced each of the readings, was called out, Maximus says, "from within the sanctuary."[88] As president of the assembly, the bishop oversaw the development of the Liturgy of the Word from his elevated position in the synthronon. Maximus interprets his greetings as assurance of the authenticity of the proceedings and as an angelic voice contradicting the heresies of the diabolical enemy. Throughout the readings his presence must have been strongly felt, even though the focus of attention was on the ambo in the center of the nave; and when the third reading, that of the Gospel, was concluded, all eyes must have turned to him with expectation to hear how he would interpret the divine message which had just been heard.

Surprisingly little attention has been given to the rite of preaching in the Early Christian liturgy. The best treatment is a chapter by Bingham that is now a hundred years old and is never mentioned in the liturgical literature.[89] Most liturgists seem to have forgotten that the sermon or homily was an integral part of Early Christian worship; Hanssens, Salaville, Schultz, and others pass over the subject without a single word. Yet insofar as the sermon tried to summarize and interpret the content of the

three readings, it must have been the high point of the instruction of the first half of the liturgy. There was a certain climactic order in listening first to lectors, then to a deacon, then finally to the bishop himself successively announcing the message of Christ. The homily was the only personal or spontaneous part of the ceremony. With an eloquent preacher it was likely to become the longest single portion of the ceremony, and we know that Chrysostom pleaded at length to justify his long sermons, many of which lasted for two hours.[90]

As Bingham has demonstrated, the general custom in the early Church regarding preaching was the reverse of the present one; whereas now the congregation sits and the preacher stands, in the early Church the preacher sat on his episcopal throne and the congregation stood. Like much of the Liturgy of the Word, the custom doubtless owed a great deal to its Jewish origins. In the synagogue service we are told that Christ stood up to read the book of Isaiah, but when he had finished he sat down to teach the people (Luke 4:20); and the "chair of Moses" was identified with the teaching role of the rabbi who sat upon it. The repeated representations in Early Christian art of Christ teaching, seated in the semicircle of his disciples, contained for the faithful a very specific point of comparison with the view they had every Sunday of the bishop teaching, seated in the semicircle of his clergy. Germanus makes the comparison explicit: "The bema is the stepped place and throne where Christ, the ruler of all, presides in the midst of his apostles."[91]

How common the sermon was in the Early Byzantine liturgy can only be rather roughly estimated. In the Council of Laodicea it was taken for granted that sermons (in the plural) followed the readings and preceded the dismissal of the catechumens.[92] In the fifth century, the unparalleled body of homiletical literature of St. John Chrysostom is ample testimony to the frequency of sermons in his day; both the Sunday liturgy and the weekday liturgies during Lent were embellished with the instruction of the great patriarch. Sozomen, writing early in the fifth century, also testifies to the frequency of sermons in Constantinople in his observation that sermons were not customary in Rome.[93] According to the Codex of Theodosius, for the bishop to neglect to preach or to preach inaccurately were both classified as *sacrilegii*.[94] This legislation is repeated in the Codex of Justinian,[95] and the Council in Trullo at the end of the seventh century legislates that bishops should preach every day, but especially on Sunday.[96] The explicitness of the latter legislation, however, strongly suggests that by this time the custom of preaching had fallen somewhat into disuse in Constantinople. It is noteworthy that no single sermon-writer of any importance emerges in the sixth century in Constantinople, and neither Germanus nor Maximus mentions the sermon as a distinct rite in his exposition of the liturgy.

Specific information on how the sermon was preached in Constantinople is entirely lacking except for the fact that St. John Chrysostom had the habit of preaching from the ambo. Sozomen, in the passage which tells how eagerly the crowd would press around to hear his teaching, says that Chrysostom would "present himself in the midst of all, seated upon the readers' bema."[97] Socrates, describing Chrysostom's tirade against Eutopius, tells us that Chrysostom was seated upon the ambo, "where he preferred to

preach that he might be better heard."[98] As van de Paverd points out, the passage intimates that this was not the customary manner of preaching in Constantinople, but instead was an exception that needed to be explained by referring to Chrysostom's desire to be better heard.[99] And, indeed, on another occasion of considerable importance in Chrysostom's life, we hear of him preaching from the expected place, the bishop's throne. After his one-day exile in 403, Chrysostom's supporters went to the suburb of Anaplous and forced him to return to his church, Hagia Sophia. They then "forced him to pronounce his peace upon the people, as is customary for priests, and to sit on the episcopal throne [τὸν ἐπισκόπικον θρόνον]. Then they required him to deliver a little extemporaneous sermon."[100] The significance of the event was clear to all. The saint's partisans did not feel that they really had a bishop until he took the throne and preached as a bishop. His adversaries, on the other hand, later used this as a charge against him, that he had reclaimed the episcopal throne before the synod had formally reinstated him.[101] The proper place for the bishop was his cathedra in the apse, which was the symbol of his authority both to govern and to teach the flock under him.[102] Chrysostom himself alludes to the teaching symbolism of the bishop's throne when, in enumerating the requisites of a bishop, he says: "One who does not know the things he ought to teach concerning true doctrine ought to be far from the teaching throne."[103]

Thus under Chrysostom the church in Constantinople saw the rather unusual arrangement of two thrones: the ordinary formal episcopal throne or cathedra in the apse, and a temporary throne, perhaps no more than a seat, provided for the bishop on those occasions when he preached from the ambo. The ambo is still referred to by Sozomen as the "readers' bema" in contradistinction to the priests' bema, which was in the sanctuary. To ascend the ambo was a step down for the bishop; it belonged to the lesser clergy and could even be used for purely secular business. In 625 we hear of a *comes* and a *spatharius* ascending the ambo in Hagia Sophia to settle a dispute over the price of bread.[104]

We do not know whether Chrysostom's example was followed by any of his successors, for the sources are silent on this point. Maximus tells us that after the Gospel, when the bishop was about to dismiss the catechumens (i.e., after the sermon if there was one), "the bishop comes down from his throne."[105] Thus at that time, at least, the general practice was not to preach from the ambo.[106]

The only representations in Byzantine art that actually show a bishop preaching from the synthronon are the representations of Pentecost, in which we find not one but all twelve of the first bishops, the Apostles, preaching simultaneously. The representations are clearly liturgical in their setting and give us at least a hint of how the ceremony was conducted in the liturgy. As depicted in the Paris manuscript of Gregory of Nazianzus (Plate 93), the Apostles are seated on a semicircular bench which is raised on a step. Holding Gospel books or scrolls, they gesture vigorously as they impart their inspired messages. At the center, instead of the single elevated bishop's place, a vision of the *hetoimasia*, the Word enthroned with the Holy Spirit brooding above, appears above their heads. Below the preachers on either side stand

the crowds, labelled *ΦΥΛΑΙ* and *ΓΛΩCAI*—i.e., the people of every race and tongue who listen to the preaching, each in the language of his native land.

The Liturgy of the Word concludes with the dismissal of the catechumens. Maximus describes it as follows: "After the sacred reading of the holy Gospel, the bishop comes down from his throne and there takes place the dismissal and expulsion by the priests of the catechumens and the rest who are unworthy of the sacred vision of the mysteries which are about to be shown."[107] This rite was a sign for Maximus of the way in which the angels would separate the faithful from the nonbelievers at the Last Judgment, after the Gospel had been preached in the whole world. The writer continues: "But after the reading of the Gospel and the dismissal of the catechumens, there takes place the closing of the doors of the holy church of God, which signifies the passing of the material world and the entrance of those who are worthy into the spiritual world, that is, into the bridal chamber of Christ after that fearful separation and more fearful sentence."[108]

The dismissal of the catechumens is prefaced with a prayer on their behalf;[109] then the catechumens are asked to leave and the doorkeepers go about closing up the doors (we read of 110 doorkeepers assigned to Hagia Sophia).[110] As pointed out earlier, the closing of the doors would effectively prevent communication between the ground and gallery levels if rigorously carried out, since entrance to the galleries was generally from the outside of the church.

Notes

[1]Brightman, *Liturgies*, pp. 356–67.

[2]Maximus refers to it four times as ἡ πρώτη εἴσοδος. *Mystagogia*, ch. 8, 23 and 24, *PG* 91, 688, 697, 704–5. Mateos is mistaken in placing the origin of the term in the twelfth or thirteenth century. *Evolution historique de la liturgie de saint Jean Chrysostome*, p. 47.

[3]Marco Mandalà, *La protesi della liturgia nel rito bizantino-greco* (Grottaferrata, 1935).

[4]Brightman, *Liturgies*, pp. 309–10.

[5]Brightman, *Liturgies*, p. 527; Eustratius, *Vita Eutychii Patriarchae*, ch. 10, 92, *PG* 86, 2, 2377.

[6]Hanssens, *Institutiones liturgicae*, no. 841.

[7]Theodorus Studita, *Descriptio constitutionis monasterii Studii*, *PG* 99, 1704–5; Mateos, *Typicon*, II, 84–85.

[8]*Mystagogia*, ch. 8, *PG* 91, 688; Dionysius Areopagita, *Eccl. hierarch.*, ch. 3, *PG* 3, 425.

[9]Germanus, *Hist. eccl.*, ch. 30, p. 25.

[10]Mateos, *Evolution*, pp. 1–46.

[11]Ioannes Chrysostomus, *Adversus Judaeos*, Oratio 3, 6, *PG* 48, 870; a similar text is in *De sancta Pentecoste*, Homilia 1, 4, *PG* 50, 458. Cf. van de Paverd, "Messliturgie," pp. 401–3.

[12]The most complete treatment is that of Mateos, *Evolution*, pp. 46–65.

[13]Eustratius, *Vita Eutychii*, 94, *PG* 86, 2, 2380.

[14]Brightman, *Liturgies*, p. 367.

[15]S. Salaville, *Liturgies orientales*, II, 70–73; Mateos, *Evolution*, pp. 48–49.

[16]*Mystagogia*, ch. 8, *PG* 91, 688.

[17]Ebersolt is not following his text very closely when he describes the tenth-century Entrance as having the sanctuary for its place of origin. *Sainte-Sophie*, p. 15.

[18]Prayer of Entry: *De ceremoniis*, I, 1 and I (10); ed. Vogt, pp. 11, 69.

[19]Ibid., I, 1, ed. Vogt, pp. 10–11, 24–25; I, 9, pp. 58–59; I (10), p. 69; I, 32 (23), pp. 122–23; I, 35 (26), pp. 134–35; I, 39 (30), pp. 154–55.

[20]Mateos, *Typicon*, I, 6–7 and passim.

[21]Ibid., I, 48–49.

[22]Michael Andrieu, ed., *Les Ordines Romani du haut moyen-âge*, II, *Les textes*, Spicilegium sacrum lovaniense, vol. 23 (Louvain, 1948), *Ordo romanus* I, 24–49; Mathews, *RAC* 38 (1962), 75–83.

[23]*Mystagogia*, ch. 9, *PG* 91, 688–89.

[24]Ibid., ch. 8, *PG* 91, 688.

[25]Ibid., ch. 23, *PG* 91, 697–700.

[26]Ibid., ch. 24, *PG* 91, 704.

[27]Ibid., ch. 24, *PG* 91, 705.

[28]Brightman, *Liturgies*, p. 312.

[29]Ibid.; cf. Mateos, *Evolution*, p. 54.

[30]Mateos, *Evolution*, pp. 55–56.

[31]Brightman, *Liturgies*, p. 368.

[32]Mateos, *Evolution*, p. 57.

[33]*De ceremoniis*, I, 1 and I (10); ed. Vogt, pp. 11, 69, and passim.

[34]Hanssens, *Institutiones liturgicae*, no. 1381.

[35]See above, n. 18.

[36]Germanus calls the altar the "throne of God." *Hist. eccl.*, ch. 3, p. 11. An interesting variation on the enthronement of the Gospel is prescribed by the typicon. On the vigils of Christmas and the Epiphany two Gospels are enthroned, one on the altar and a second in the bishop's throne in the apse—the bishop taking second place at one side of the throne. One wonders if this double enthronement should not be connected with the double enthronement represented in the Orthodox Baptistery of Ravenna, where the Gospel appears both on the altar and on the throne. The Epiphany in the dome reinforces the connection. Mateos, *Typicon*, I, 154 and 180.

[37]*De ceremoniis*, I, 1, ed. Vogt, p. 24 and passim.

[38]Ibid., I, 32 (23), 35 (26), 36 (27), 39 (30); ed. Vogt, pp. 122, 134–35, 139, 154.

[39]Ibid., I, 9 and I, 26 (17), 27 (18), 37 (28); ed. Vogt, pp. 58, 95, 103, 146; cf. also Vogt's commentary, I, 128.

[40]Germanus, *Hist. eccl.*, ch. 33, p. 21.

[41]*Mystagogia*, ch. 23, *PG* 91, 697–700.

[42]*De ceremoniis*, I (10) and I, 39 (30); ed. Vogt, pp. 68–69 and 154.

[43]Ibid., I, 1, ed. Vogt, p. 24.

[44]Ibid., I, 1 and I (10), 26 (17), 39 (30); ed. Vogt, pp. 24, 68–69, 95, 154.

[45]Ibid., I, 9 and I (10), 26 (17); ed. Vogt, pp. 59, 68, 95, and passim.

[46]Ibid., I, 27 (18), 32 (23); ed. Vogt, pp. 104, 122.

[47]Ibid., I, 1, ed. Vogt, p. 11.

[48]*Ordo Romanus* I, 43 and 125–26.

[49]Mathews, *RAC* 38 (1962), 76–79.

[50]Cf. A. Alföldi, "Die Ausgestaltung des monarchischen Zeremoniells am römischen Kaiserhofe," *Mitteilungen des deutschen archäologischen Instituts Röm* 49 (1934), 1–118; idem, "Insignien und Tracht der römischen Kaiser," ibid., 50 (1935), 1–171.

[51]*De ceremoniis*, I, 1 and I, 26 (17), 27 (18), 29 (20); ed. Vogt, pp. 11, 95, 104, 112, etc.

[52]See above, p. 139 and n. 11.

[53]*Mystagogia*, ch. 14, *PG* 91, 692.

[54]*Hist. eccl.*, chs. 26–27, pp. 23–24. Our translation. The passage added to ch. 26 and the bracketed, less well attested expressions in ch. 27 have been omitted.

[55]Bouyer, *Architecture et liturgie*, pp. 55–62.

[56]Conc. Laodic., canon 56, *Mansi* 2, 574.

[57]Conc. Laodic., canon 20, *Mansi* 2, 568; Conc. in Trullo, canon 7, *Mansi* 11, 944–45.

[58]See above, p. 139 and n. 13.

[59]Pierre Batiffol, *Études de liturgie et d'archéologie chrétienne* (Paris, 1919), pp. 30–83; cf. J. Braun, *Die liturgische Gewandung im Occident und Orient* (Freiburg-im-Breisgau, 1907).

[60]*De ceremoniis*, I, 2, I, 3, I, 4; ed. Vogt, pp. 31–32, 35–36, 38–39.

[61]Ibid., I, 36 (27), ed. Vogt, p. 139; see also, I, 37 (28), p. 146.

[62]*Il menologio di Basilio II, Cod. Vat. 1613* (Turin, 1907), I, 38.

[63]For bibliography see Janin, *Géographie*, pp. 161–71 and R. Krautheimer, *Early Christian and Byzantine Architecture*, pp. 79, 326, n. 8.

[64]A. Grabar, *L'empereur dans l'art byzantin* (Paris, 1936), 106–7; D. Stričević, "Iconografia dei mosaici imperiali a S. Vitale," *Felix Ravenna* 80 (1959), 5–27; A. Grabar, "Quel est le sens de l'offrande de Justinien et de Théodora sur les mosaïques de Saint-Vital?" ibid., 81 (1960), 63–77; D. Stričević, "Sur le problème de l'iconographie des mosaïques imperiales de Saint-Vital," ibid., 85 (1962), 80–100. For further bibliography on the mosaics see Viktor Lazarev, *Storia della pittura bizantina* (Turin, 1967), p. 100, n. 31. Deichmann avoids dealing with the problem. *Ravenna: Haupstadt des spätantiken Abendlandes*, I, *Geschichte und Monumente* (Wiesbaden, 1969), 234–43.

[65]O. von Simson, *Sacred Fortress* (Chicago, 1948), pp. 29–30.

[66]See below, pp. 155 ff.

[67]*Felix Ravenna* 81 (1960), 68–74.

[68]Carl-Otto Nordström, *Ravennastudien: Ideengeschichtliche und ikonographische Untersuchungen über die Mosaiken von Ravenna* (Stockholm, 1953) pp. 98–102.

[69]*De ceremoniis*, II, 31, ed. J. J. Reiske, I, 631.

[70]See above, p. 124 and n. 47.

[71]Sauget, *Bibliographie des liturgies orientales* (Rome, 1962), pp. 69–72.

[72]Ioannes Chrysostomus, *In epist. ad Hebraeos*, Homilia 8, 4, *PG* 63, 75. Other references in Hanssens, *Institutiones liturgicae*, no. 940.

[73]*Mystagogia*, ch. 10, 12 and 24, *PG* 91, 689, 705; cf. Hanssens, *Institutiones liturgicae*, no. 941.

[74]Hanssens, *Institutiones liturgicae*, no. 942.

[75]*Corpus iuris civilis*, III, *Novellae*, 3, 1, p. 21; Dölger, *Regesten* (Munich–Berlin, 1924), no. 165.

[76]Sozomenus, *Hist. eccl.*, VII, 19, *PG* 67, 1477.

[77]*Descr. ambonis*, lines 105–6; ed. Bekker, p. 52; ed. Friedländer, p. 260.

[78]Ibid., line 52; ed. Bekker, p. 50; ed. Friedländer, p. 259.

[79]Conc. Laodic., canon 15, *Mansi* 2, 567.

[80]*Mystagogia*, ch. 11, 24, *PG* 91, 689, 708.

[81]Conc. Constant. IV, canon 3, *Mansi* 16, 400.

[82]Salaville, *Liturgies orientales*, II, 82–85.

[83]Jerome, *Contra Vigilantium*, *PL* 23, 361.

[84]Altaner, *Patrology*, p. 463.

[85]*Hist. eccl.*, ch. 30, ed. Borgia, p. 25.

[86]*Descr. ambonis*, line 211; ed. Bekker, p. 55; ed. Friedländer, p. 263.

[87]See above, p. 125 and n. 53.

[88]*Mystagogia*, ch. 12, *PG* 91, 689.

[89]Joseph Bingham, *The Antiquities of the Christian Church* (London, 1870), II, ch. 4: "Of Preaching and the Usage Relating to It," pp. 705–36.

[90]Chrysostomus Baur, *Johannes Chrysostomus und seine Zeit* (Munich, 1929–30), I, 176–77, 182.

[91]*Hist. eccl.*, ch. 7, p. 13.

[92]Conc. Laodic., canon 19, *Mansi* 2, 567.

[93]Sozomenus, *Hist. eccl.*, VII, 19, *PG* 67, 1477. On sermons in Rome, see L. Duchesne, *Christian Worship, Its Origin and Evolution*, trans. M. T. McClure, 5th ed. (London, 1927), p. 55.

[94]*Theodosiani libri*, 16, 2, *De episcopis*, leg. 25, 25, ed. T. Mommsen (Berlin, 1905), I, 843.

[95]*Corpus iuris civilis*, II, *Codex Iustiniani*, IX, 29, 1, p. 385.

[96]Conc. in Trullo, canon 19, *Mansi* 11, 952.

[97]Sozomenus, *Hist. eccl.*, VIII, 5, *PG* 67, 1528.

[98]Socrates, *Hist. eccl.*, VI, 5, *PG* 67, 673.

[99]Van de Paverd, "Messliturgie," pp. 414–16; Taft also interprets the passage this way; "Notes on the Bema," *OCP* 34, pt. 2 (1968), 359.

[100]Sozomenus, *Hist. eccl.*, VIII, 18, *PG* 67, 1564, the same account appears in Socrates, *Hist. eccl.*, VI, 16, *PG* 67, 713.

[101]Sozomenus, *Hist. eccl.*, VIII, 20, *PG* 67, 1568; Socrates, *Hist. eccl.*, VI, 18, *PG* 67, 720.

[102]On the symbolism of the cathedra see H. Leclercq, "Chaire épiscopale," *DACL*, 3, 1, 19–75.

[103]Ioannes Chrysostomus, *In epist. ad Titum*; *Homilia* 2, 2, *PG* 62, 673.

[104]*Chronicon paschale*, I, 915–16.

[105]*Mystagogia*, ch. 14, *PG* 91, 692.

[106]We know next to nothing about the acoustics of Byzantine churches and the relative advantages of speaking from the apse or the ambo. CBS recently did a recording of works by Gabrieli, choirmaster of San Marco in the late sixteenth–early seventeenth century, in San Marco itself, but the director of the project informs me that this did not involve any scientific measurements of the location. He estimates the reverberation time as six or seven seconds; that in Hagia Sophia is closer to ten seconds, as the casual visitor can ascertain. This phenomenon, as well as the extraordinary size of the buildings, must have made preaching in them extremely difficult. Cf. John McClure, "How We Taped the Sound of San Marco," *High Fidelity* (February, 1968), 52–58.

[107]*Mystagogia*, ch. 14, *PG* 91, 692–93.

[108]Ibid., ch. 15, *PG* 91, 693.

[109]Brightman, *Liturgies*, p. 315; a prayer of this kind is mentioned in the Council of Laodicea, canon 19, *Mansi* 2, 567.

[110]*Corpus iuris civilis*, III, *Novellae*, 3, 1, p. 21; Dölger, *Regesten*, no. 165.

7　The Liturgy of the Faithful

The Entrance of the Mysteries

The Great Entrance—or, as we shall call it following Maximus, the "Entrance of the Mysteries"—has as its object the transportation of the Eucharistic bread and wine from their place of preparation to their place of offering on the altar. In the Byzantine ritual today it is the ceremonial climax of the liturgy and the action of greatest ceremonial embellishment, marking in a dramatic way the commencement of the Liturgy of the Faithful.

The deacon begins the Litany of the Faithful after the dismissal of the catechumens, in the present ritual, while the celebrant silently recites two prayers on their behalf. The deacon then takes the censer and incenses the altar, sanctuary, iconostasis, church and congregation. The deacon and celebrant next reverence the altar and, turning around, bow to the congregation from the Holy Doors at the center of the iconostasis; then they go to the prothesis table, which is located at the north side of the sanctuary, or in a separate chapel north of it. After reverencing and incensing the gifts, the priest gives the deacon the paten with the bread, while he himself takes the chalice of wine; holding the veiled gifts on high, they go out by the north door of the sanctuary into the body of the church, preceded by candle-bearers and incense. While the choir chants the Cherubicon Hymn, greeting the arrival of the gifts as the entrance of the King of the Universe in the company of his angels, the procession makes its way in a more or less "U"-shaped path into the church and back to the central door of the iconostasis. Before entering the Holy Door, the celebrant interrupts the Cherubicon Hymn to make a series of commemorations; then the deacon and celebrant enter and place the gifts on the altar.[1]

The symbolic import of this procession has been variously developed over the centuries by the commentators on the Divine Liturgy. For Maximus, the Entrance of the Mysteries was the beginning of that final revelation that comes at the end of time in the kingdom of heaven.[2] To other commentators it has been taken as a representation of Christ's triumphal entry into Jerusalem, his ascent to Calvary, or his being carried to the tomb by his disciples.[3] The ceremony is obviously of enormous importance in the development of the Byzantine liturgy and is one of the principal features determining its external shape.

Nevertheless, the origin of this rite and its primitive form in Early Byzantine times have not been properly investigated. In particular, the archaeological aspect of the problem has never been noticed by the liturgists, i.e., the problem of the absence of a prothesis chamber in the Early Byzantine churches of Constantinople. As we have seen, the archaeological evidence is quite consistent and clear on this point: the triple sanctuary that has traditionally been associated with the origin of Byzantine architecture simply does not occur in pre-iconoclastic Constantinople. In the fifth and sixth centuries, therefore, the Entrance of the Mysteries must have taken a different form from that which is presently observed in the Byzantine liturgy. One suspects that, like the Little Entrance in its present form, the modern Great Entrance is an abbreviation of a more elaborate procession; but we do not know the shape of that procession. One cannot suppose that a simple niche or table in the north side of the apse served for the prothesis in Early Byzantine times, as occasionally happens today; no such evidence has been found, and the apse is filled with the synthronon in the Early Byzantine plan. Instead, this arrangement is a late abbreviation of the separate prothesis chapel, an adaptation to the more straitened circumstances of the Greek church in recent centuries.

An examination of the prayers that accompany the present Entrance of the Mysteries yields no significant clues about the original form of the ceremony. The prayers for the faithful that precede the Entrance are probably a good deal older than their appearance in the ninth-century Barberini manuscript, but they are prayers of a general nature for the worthiness of the laity and ministers to take part in the ceremonies they are about to celebrate.[4] The Cherubicon Hymn that is sung as the gifts are carried in procession is traditionally dated to the reign of Justin II (573–74), but again it reveals nothing of the form of the procession it accompanied at that time.[5] One must turn, then, to the information supplied by the commentators and by occasional mentions of the Entrance in the historians.

It is safe to suppose that the Byzantine liturgy from its earliest origins always had some form of an Entrance of the Mysteries, by which the bread and wine were transferred from the place of their preparation to the altar in the sanctuary. The early Roman liturgy was unusual in that a distinct place for the preparation of the gifts did not exist, but the congregation themselves at the beginning of the Mass of the Faithful brought offerings of bread and wine to the sanctuary barrier at the eastern end of either aisle and presented these to the clergy. From these offerings a portion was simply selected and placed on the altar for the Eucharistic sacrifice without any accompanying ceremony.[6] In the Byzantine rite, however, there is not the least trace of any such custom; no historical references can be interpreted as referring to a bringing up of gifts by the faithful during the liturgy, nor can any sign of such a custom be detected in the surviving texts of the Byzantine liturgy. The offerings of the Emperor that are mentioned from time to time never specify bread and wine; rather, when they mention a specific offering it is either gold or golden vessels for the church.[7] One must suppose, then, that whatever gifts of bread and wine were offered by the congregation were received in a separate location (the prothesis) and then brought forward to the altar

when needed in the Liturgy of the Faithful, as indeed is universally the custom in the liturgies of the East.[8]

One might suppose, too, that at first the rite of bringing up the gifts to the altar was simply a practical necessity without any ceremonial embellishment, and that it only gradually assumed a ritual importance to which symbolic meaning might be attached. We have no document by which to date this process in the Byzantine rite, but if the evolution proceeded at roughly the same rate as it did in the Syrian liturgy, one would expect a rather elaborate ceremony to have already developed by the end of the fourth century. At this time Theodore of Mopsuestia was already describing the procession of the deacons carrying the bread and wine as an "awe-inspiring event" representing the appearance of Christ accompanied by angels on the way to the sacrifice of his Passion.[9]

Maximus gives us little specific information on the rite of the Entrance of the Mysteries beyond the name he attaches to the ceremony, but here, as in the instance of the First Entrance, the name is of significance.[10] Maximus' use of the term "entrance" to describe the First Entrance must be taken literally as designating not merely a ceremonial appearance of the clergy emerging from and returning to the sanctuary, but a real entrance of the clergy and people coming into the church at the start of the liturgy. One would expect, *a pari*, that the term εἴσοδος in the Entrance of the Mysteries is also seriously intended. This suggestion is strengthened by the fact that Maximus had to specify the First Entrance as "first"; he seems to have viewed the two ceremonies as somehow parallel.

By way of contrast, it should be pointed out that the term εἴσοδος seems clearly to distinguish the ceremony described by Maximus from that of the Syrian liturgy. Pseudo-Denis, Maximus' mentor, in describing the transfer of the gifts to the altar in the Syrian rite does not speak of an entrance but of a "setting out" of the gifts on the altar by the deacon, a πρόθεσις or an ἐπίθεσις.[11] Theodore of Mopsuestia in his commentary on the Syrian liturgy also speaks of the deacons as simply "bringing out" the offerings of bread and wine.[12] The use of the terms seems to imply that the gifts to be placed on the altar were already in the church and had only to be brought out from a prothesis chapel. This would agree nicely with Bandmann's and Schneider's reconstruction of the performance of the early Syrian liturgy in its architectural setting; the place of prothesis was in a chapel to the right of the sanctuary, which was also to the right of the entrance when one approached the church from the south, as was common in northern Syria.[13] The whole ceremony of presenting the gifts took place within the church itself.

In Maximus, on the contrary, the use of the term implies that the ceremony originated outside the church building and the procession carried the gifts in. The earliest references in the historians to the Entrance of the Mysteries seems to confirm this interpretation, the first one being a sermon of the patriarch Eutychius (552–65), who criticizes the custom of greeting the entrance of the unconsecrated bread and wine with a hymn of adoration. The passage is worth quoting in its entirety.

They are out of their minds who, when the order of the liturgy calls for

bringing forward (προσάγειν) to the altar the bread of the preparation and the cup freshly poured from the bottle, give the people a psalm-hymn to say which they think is useful for them, and say that they are carrying up (προσ-φέρειν) the King of Glory and greet in these terms the gifts that are carried in (εἰσφερόμενα), even though not yet consecrated by the epiclesis of the celebrant and by the splendid sanctification of them; unless perhaps they attach some other meaning to the hymn. Nevertheless, Athanasius the Great in his sermon to the baptized says, "You behold the Levites carrying the bread and the cup of wine and placing them on the table, and as long as the invocations and the prayers are not said they remain merely the bread and the cup; but once the great and marvelous prayers have been finished, then the bread becomes Body and the cup Blood of our Lord Jesus Christ."[14]

This passage is usually thought to refer to the introduction of the Cherubicon Hymn, which Cedrenus credited to Justin II[15]—but as Brightman and Schulz point out, the reference to the "King of Glory" (if intended as a quotation) is an inaccurate citation which may more likely refer to the hymn of the Entrance of the Presanctified.[16] Nonetheless, the passage clearly refers to the ceremony of the Entrance of the Mysteries, and it informs us that the gifts are not only "brought forward" to the altar but are "carried in," presumably from someplace outside the church.

Another reference to the "carrying in" of the gifts is found in the *Chronicon paschale*, in a notice of the addition of a hymn to the Liturgy of the Presanctified by the patriarch Sergios in the year 630, contemporary with Maximus.

In this year, under the patriarch Sergios of Constantinople, in the first week of Lent, the fourth indiction, there began to be sung after the "May [our prayer] be directed," at the time of the bringing in [εἰσαγέσθαι] of the presanctified gifts to the sanctuary from the skeuophylakion, after the priest had said, "According to the gift of your Christ," the people immediately began, "Now the powers of heaven worship along with us, for behold the King of Glory makes his entrance [εἰσπορεύεται]. Let us come forward in faith and fear that we may be sharers in eternal life. Alleluia." And this they sang not only at the bringing in [εἰσαγομένων] of the Presanctified during Lent, but also on other days, whenever the Presanctified was had.[17]

Three times the author refers to the presentation of the gifts and each time he uses verbs that describe an entrance: the gifts are "brought in," and the King of Glory "makes his entrance." Furthermore, we are given a new piece of information, i.e., that the procession started from the skeuophylakion. There is no reason to doubt that the skeuophylakion in question is that of the patriarch's own church, Hagia Sophia; nor is there any reason to suppose that the Entrance of the Mysteries on the days of the Presanctified differed in its form from that on other days, although obviously the antiphons which were sung differed.

One must therefore reexamine the evidence concerning the skeuophylakion at Hagia Sophia and its original purpose in connection with references to the Entrance

of the Mysteries. In Palladius' description of the fire of 404, we read of a "little building in which the many sacred vessels were kept," a building which was evidently separate from the body of the church since it went unscathed in the fire that ravished the church itself.[18] The location of the building is not specified, but, as we have seen, it is possible that it is what we now refer to as the skeuophylakion and that it antedates the Theodosian building campaign of 404–15.

The second reference to the skeuophylakion is the one just quoted from the year 630, when it is referred to as the starting point of the procession of the Entrance of the Mysteries. Under the same patriarch Sergios we find a third reference to the skeuophylakion, this time in connection with the reverse of the Entrance of the Mysteries, the return of the vessels to the skeuophylakion at the close of the liturgy. At that time an antiphon was introduced to follow the Communion psalm, "after all had partaken of the Sacred Mysteries, when the clergy was about to return the flabella, patens, chalices, and other sacred vessels to the skeuophylakion."[19] Thus at the beginning of the seventh century a skeuophylakion, apparently separate from the body of the church, was being used both to store the sacred vessels and as the starting point of the Entrance of the Mysteries, i.e., as the place where the bread and wine for the Eucharist were prepared. The two functions naturally belong together; the bread and wine are prepared on the patens and chalices and carried in together in the Entrance of the Mysteries; hence one would expect the sacred vessels to be stored in the place where they were going to be used.

Chronologically, the next reference to the skeuophylakion is that of Germanus in the eighth century, who tells us that "the preparation of the gifts, which takes place in the skeuophylakion, stands for the place of Calvary where Christ was crucified."[20] Thus in Germanus' time it was still the place of preparation of the gifts and the starting point of the Entrance of the Mysteries. While Germanus does not explicitly call the procession an "entrance," he does describe it obliquely as an entrance when he tells us that the procession of the deacons with their flabella preceding the gifts represents "the entrance of all holy and just men who are to enter in together with and in front of the Cherubic powers and heavenly hosts who invisibly precede Christ the great King on his way to the mystical sacrifice, carried in corporeal hands; with them the Holy Spirit enters in to the bloodless and reasonable sacrifice."[21] Since Christ was not accompanied to his death by holy and just men, Germanus—to avoid identifying the deacons with the executioners of Christ—makes them represent the invisible angels who must have accompanied Christ; these in turn stand for all the just who take part in the liturgy.

Germanus' account fills in a number of details missing in other Early Byzantine sources. First of all, it makes it clear that the Entrance of the Mysteries was one of the special duties of the deacons, and therefore the celebrant would not have taken part in the procession. Pseudo-Denis and Theodore of Mopsuestia assign the procession to deacons, and Eutychius' reference to "Levites carrying the bread and the cup" should be interpreted the same way, "Levites" being a synonym for deacons.[22] The Council of Laodicea had assigned the keeping of the sacred vessels specially to the deacons.[23]

In the Byzantine liturgy today, while the priest generally takes part in the procession of the Entrance of the Mysteries, at a pontifical liturgy the more primitive custom is observed—the bishop does not join the procession, but stands at the Holy Door where the lesser clergy deliver the bread and wine to him. In the Early Byzantine liturgy, the deacons, after dismissing the catechumens, went directly to the skeuophylakion to prepare and carry up the Eucharistic elements. Germanus informs us further of the use of incense, the carrying of the flabella, the covering of the gifts with veils, and the singing of the Cherubicon Hymn during the procession.[24] The only information that is really lacking in Germanus' account is a description of the route followed by the procession as it went from the skeuophylakion to the sanctuary.

In the ninth century, the skeuophylakion is mentioned in the anonymous and largely fanciful account of the owners of the property over which the various parts of Hagia Sophia were built. The author tells us that the sanctuary and the Holy Well (at the south) were the property of one Antiochus, a eunuch, while the skeuophylakion (presumably at the north) belonged to a widow named Anna.[25]

In the *De ceremoniis* one finds more precise textual evidence for identifying the location of the skeuophylakion at Hagia Sophia. On Holy Saturday the Emperors are said to enter Hagia Sophia by the southeast entrance (the entrance by the Holy Well) and go into the sanctuary, where they change the altar-cloth and leave their offering of gold. "They then go out by the left side of the sanctuary and go into the skeuophylakion, where the sovereign incenses the holy vessels; and they sit on their golden thrones while the patriarch is seated on the throne placed there for him."[26] Returning to the sanctuary, they pass through the narthex of the women's place (γυναικήτης) where the deaconesses stay.[27] The same Holy Saturday visit of the Emperor to the skeuophylakion is described in an eleventh-century typicon, with the single additional detail that there was an oven located there.[28]

Thus it is clear that the skeuophylakion of Hagia Sophia was located somewhere north of the church. The one final difficulty in simply identifying the rotunda at the northeast corner of Hagia Sophia with the skeuophylakion of the literary sources is Paul the Silentiary's report of a baptistery on the northern side of the church.[29] But as Ebersolt has argued, the *De ceremoniis* distinguishes the two baptisteries of Hagia Sophia as the Great Baptistery and the Little Baptistery,[30] and it was the Great Baptistery that was located on the north. A typicon in the library in Grottaferrata describes the situation in connection with the Holy Saturday baptismal rite: "Descending from his throne, the patriarch goes through the skeuophylakion to the vestibule of the Great Baptistery; there he changes his vestments, putting on a white stole and white shoes, and goes into the piscina."[31] The rotunda at the northeast cannot be identified with the Great Baptistery, because it is smaller than the baptistery at the southwest and because there is no evidence of any vestibule. We are therefore justified in identifying the rotunda at the northeast with the skeuophylakion of the literary sources, referred to century after century; and it is very probable that this building is in fact the "little building for the many sacred vessels" that belonged to the original Constantinian building.[32] It seems certain that this skeuophylakion served as the

starting point of the Entrance of the Mysteries in the time of Maximus and Germanus, and it is very likely that it served the same purpose much earlier—for if the sacred vessels were kept here in the Old Hagia Sophia, then it would have been the logical place from which the sacred vessels and the Eucharistic elements would have been carried up in the procession of the Entrance.

One wonders to what extent Hagia Sophia's arrangement was typical for Constantinople. Insofar as the standard liturgical plan of Constantinople omitted a prothesis chamber, and insofar as the standard liturgy described by the commentators presumes an Entrance from a skeuophylakion outside the church, one might expect that the arrangement at Hagia Sophia was typical. Two other examples of the skeuophylakion are known. As we have seen, Dirimtekin uncovered a circular structure at the northeast corner of Hag. Eirēnē, which although it postdates the sixth-century building campaigns may well belong to the rebuilding of 740.[33] The parallel of its location with that of the skeuophylakion at Hagia Sophia could indicate that it was erected in imitation of the latter, and it is possible that prior to its erection Hag. Eirēnē used the skeuophylakion of the cathedral itself, which would not have been far off. It is unfortunate that Dirimtekin's excavation does not better inform us of the structure's plan.

The other skeuophylakion concerning which we have information is that of the church of Hag. Theodōros Sphōrakios, a fifth-century church erected by the senator Sphōrakios somewhere between the Mēsē and the Forum of Constantine.[34] Concerning the fire accompanying the Nikē riot that destroyed such a large section of downtown Constantinople, the *Chronicon paschale* relates that "everything in the vicinity of Hag. Theodōros Sphōrakios was consumed in this fire, except the skeuophylakion of the oven of the church."[35] Hence we learn that Hag. Theodōros had a skeuophylakion, a separate building that stood in the vicinity of the church and contained an oven; the skeuophylakion of Hagia Sophia, as we have seen, also had an oven. It is tempting to associate the ovens with the baking of the bread for the Eucharist, but we have no text to support this connection. According to one reference, the oven in the skeuophylakion of Hagia Sophia was used to burn the Eucharistic elements that had gone bad; according to another, it was used in the annual preparation of holy chrism.[36] Neither of these uses, of course , would preclude its use also for baking bread for the Eucharist.

It seems then that the starting point for the Entrance of the Mysteries in the Early Byzantine liturgy was a skeuophylakion building located outside but in the near vicinity of the church itself. The route the procession followed to the sanctuary one can only conjecture. The closing of the doors described by Maximus must have involved at least a closing of the principal doors of the church, i.e., the entrances to the narthex. One would suppose that the procession entered one of the side doors commonly featured in Early Byzantine plans.

At Hagia Sophia the second half of the processional route can be reconstructed fairly easily from the *De ceremoniis*. When the procession was about to enter the church the Emperor would put on his *clamys* and go "through the right parts of the church" (i.e., through the right aisle) and then out into the nave to a point just behind (west of) the ambo. He would be accompanied by chamberlains, senators, scepter-bearers, and

ministers. A lamp was kept behind the ambo, which the praepositus gave to the Emperor. The scepter-bearers and other ministers "stood in their proper places," which probably meant on either side of the ambo, while the Emperor with the senators and chamberlains accompanied the procession of the gifts to the Holy Door through the solea. Here the Emperor greeted the patriarch and left his lamp at the Door, then returning to the south aisle in the company of his ministers.[37]

The picture is fairly clear, and the ceremony must have been quite impressive. Leaving the skeuophylakion, the procession would have entered the church by a side door, perhaps using the door in the center of the north aisle at Hagia Sophia. A pair of deacons would have led the procession with candles and incense, as in the representations of the subject in Late Byzantine frescoes.[38] Next would have come the deacon with the flabellum, followed by deacons carrying the veils of the chalices and patens. The gifts themselves came next, the full patens and chalices, and finally the *aēr*, the great veil that was spread over all the gifts (later called the *epitaphios*). Having entered the church by a side door, the procession would move to the center of the nave to a point just behind the ambo, where it would be met by the Emperor and court arriving from the opposite side. Thus doubled in size, the procession would then file past the ambo and up the length of the solea to the Holy Door, where the gifts would be presented to the patriarch himself. The deacons would enter the sanctuary while the Emperor returned to his place.

It is unfortunate that we do not have more information about the most important action—ceremonially and visually—in the Early Byzantine liturgy. Nevertheless, a little information is more useful than a great deal of speculation. The old theory proposed by Freshfield that relates the origin of the triple sanctuary in Byzantine architecture to the introduction of the ceremony of the Entrance of the Mysteries is untenable both archaeologically and liturgically.[39] In spite of recent attempts by Soteriou, Stričević, and Orlandos to revive this theory, the early documents of the Byzantine liturgy do not indicate an entrance procession from a prothesis chamber, and the archaeology of the capital does not indicate the existence of any such room.[40] The occasional appearance of rooms of possible prothesis purpose near the apses in churches of Greece or Yugoslavia may be explained by local liturgical usages, but not by appealing to the development of the Byzantine liturgy.

The Concealment of the Mysteries

After the Entrance of the Mysteries, the faithful greeted one another with the Kiss of Peace, a sign of that harmony of hearts and minds which, according to Maximus, is to be expected in the coming kingdom of God; they then professed this unity verbally by reciting together the Nicaean Creed.[41] These preliminaries completed, the preface of the Anaphora, or Eucharistic prayer proper, was begun. This central prayer of the liturgy, including the narrative of the words of the institution of the Eucharist and the invocation of the Holy Spirit over the gifts, belonged exclusively to the clergy and was accomplished with the greatest solemnity and the least external action. Maximus,

whose purpose was to comment on the shape of the liturgy as experienced by the laity, bypassed the Anaphora completely except for his comments on the chanting of "Holy, holy, holy," at the end of the preface.[42]

The Anaphora thus presents us with no problems of movement or procession that might be of any significance in the liturgical planning of the Early Byzantine church. However, it does present another problem of planning insofar as it raises the question of the possible concealment of the mysteries; for it is generally supposed that the liturgy, at least in its more solemn moments, was hidden from the eyes of the lay faithful. It is thought that the templon or colonnaded sanctuary barrier of the Early Byzantine church was curtained its entire length, shutting off the sanctuary as completely as the present-day iconostasis does. In addition, the ciborium itself is said by some scholars to have had curtains on all four sides to further conceal the altar, and others have even proposed that the aisles and galleries were curtained off. Thus there is a question of three sets of curtains enveloping one another and intervening as layer after layer of barriers between the faithful and the performance of the liturgy. The faithful might hear and answer the prayers, but the better part of the liturgy was removed from their observation.

Much of our stereotyped conception of the "mystic Orient" has entered into this reconstruction of the appearance of the liturgy, and the solid historical evidence deserves to be examined anew. The problem is of obvious importance architecturally, for screening curtains would entirely alter one's concept of an interior. On the other hand, the idea of the "mystery-character" of the Byzantine liturgy is also involved, as well as the degree to which such a concept is historically attested in the sources for the Early Byzantine liturgy.

The problem has not been properly studied; Carl Schneider's article provided an overall survey of curtain usages in eastern liturgies, but it is now out of date.[43] Concerning the use of curtains in the Syrian liturgy, a good deal more is now known than Schneider was aware of;[44] regarding their use in early Constantinople, he offered very little information and most of this was vitiated by his presupposition that the present type of iconostasis already existed, i.e., a solid wall with three doors. Furthermore, Schneider's reflections on the scriptural and Hellenistic background of liturgical curtain usage must be understood to represent nothing more than theorizing; at no point can he cite patristic texts to demonstrate that the associations he assigns to curtains were familiar to the Fathers.[45] The whole problem of curtains in the Early Byzantine liturgy must thus be examined anew, always with the proviso that the sources cited should refer to Constantinople and not to some other center. Because the tendency in this matter has been to confuse one curtain with another in discussing the sources, it seems best to treat the various curtains separately insofar as possible. Curtains over the doors of the church (which are well attested to in Constantinople and elsewhere) do not enter into the discussion.

The proposed outermost circle of curtains, which can be imagined to separate the nave of the church from the encircling aisles and galleries, is clearly linked to the hypothesis that the nave was reserved for the liturgy and the faithful were restricted

to the aisles and galleries.[46] Since sources indicate that the faithful stood in the nave as well as in the aisles, curtains segregating the two are quite unlikely.[47] Swift proposed that the iron tie-beams at Hagia Sophia were used as curtain rods; but they are rough, square, hammered rods permanently immured in the masonry and poorly suited to be curtain rods.[48] There is no literary evidence to support this interpretation; moreover Procopius, as we have seen, denies the existence of anything that would have separated nave and aisles.[49]

The *De ceremoniis* does mention the use of curtains, but exclusively in connection with the Emperor's vesting. There was a curtain somewhere in the narthex of Hagia Sophia behind which the Emperor removed his crown before entering the church, and there was another by the Holy Well behind which he replaced it upon leaving.[50] A curtain was also spread when he vested in the gallery.[51] It was part of Imperial showmanship that the Emperor should never be seen except when he was ready to be seen; when he disembarked at the Golden Gate on his way to Theotokos in Pēgē, lacking a room or a curtain to retire behind, he would have his chamberlains form a close circle around him while the crown was being put on his head.[52] In the middle of the fourteenth century, Cantacuzenus tells us of a temporary metatorion made of wood in which the Emperor, preparing for his coronation at Hagia Sophia, put on his purple robe and diadem.[53] But these curtains have nothing to with the concealment of the liturgy or the separation of the nave from the aisles and galleries.

Other references are often cited to demonstrate the existence of aisle and gallery curtains. In the year 923 an ambassador named Iber Curopalates was received with extraordinary ceremony in the capital, according to the chroniclers. "They decorated Hagia Sophia splendidly and hung it all about with gold cloth [πέπλοις χρυσοὐφεσι] and every kind of ornament, and only then did they let him in."[54] The gold hangings with which the text is concerned are not necessarily curtains, and it is understood that the occasion was something quite out of the ordinary. Much more explicit are two other texts, one from the tenth century and one from the fourteenth, which mention curtains in the galleries of Hagia Sophia, but their use must be carefully noticed: when Symeon Metaphrastes mentions gallery curtains in a miracle story in his life of Chrysostom, the curtains are not to conceal the celebration of the liturgy but rather to conceal the women in the galleries from the celebrants, to whom they proved a distraction.[55] Another text, an account of the coronation of Manuel II in 1391, tells us that such gallery curtains were made of silk so fine that one could easily see all that transpired below; on this occasion we are told that men were in the nave and women in the galleries, "and it is rather clever that the women stand behind silk curtains and no one can see their adorned features, but the men and everything else are visible to them."[56]

Curtains in gallery colonnades, therefore, had no connection with the concealment of the mysteries of the liturgy. On the two occasions when they are mentioned, in a period much later than that discussed here, they were intended to conceal the gallery rather than the liturgy. On the ground level, moreover, there is no evidence—early or late—for the existence of such curtains, and the fact that the faithful enjoyed free use

of the nave and aisles would make such an hypothesis pointless. Thus the outermost of the three circles of curtains around the liturgy, i.e., a circle of curtains that would have closed off the nave from the surrounding aisles and galleries, is a conjecture that can no longer be sustained.

Belief in an innermost circle of curtains, i.e., a set of hangings shutting off the ciborium on four sides, has been much more widespread. Nearly every author who describes the ciborium proposes such curtains,[57] but the primary evidence is extremely slim. Since none of the ciboria of Constantinople has survived except in a few fragments, archaeological evidence is obviously not available. We must rely on a few literary references, principally one from Paul the Silentiary, and representations in Byzantine manuscript illumination.

The evidence from Byzantine miniatures has not been properly evaluated.[58] Only two miniatures can be cited in support of the hypothesis of ciborium curtains, one from the Vienna Genesis of the sixth century (Plate 94a), and one from the Menologion of Basil II of 979–84.[59] In both cases the veils are too short to represent ciborium curtains, actually concealing nothing of the altar. In the former a single short, rectangular veil hangs in one of the arches of the ciborium above the altar; in the latter, two such veils (still smaller) appear on two sides of the ciborium. In both instances the ciboria are not represented in church interiors but are out-of-doors, as a kind of shorthand notation for the entire temple; their veils should thus probably be interpreted as temple door-hangings, as in the comparable representation of a temple in the Rossano Gospel (Plate 94b).

The bulk of the evidence from miniatures, moreover, is against ciborium curtains; one must not overlook the fact that representations of ciboria, and even of whole sanctuaries, are commonplace in Byzantine miniature painting, and the ciborium is consistently represented without curtains (Plates 95–98). Such sanctuary representations are repeated over and over in Byzantine miniature painting, reproducing the same stereotypes with only slight variations, and the prototype behind the tradition seems to be the Early Byzantine sanctuary disposition. The sanctuary barrier represented is of the low parapet type and the synthronon is high-tiered; both of these features went out of style in liturgical planning after iconoclasm. Thus the curtainless ciboria represented probably also reflect the Early Byzantine usage in this respect.[60]

Among literary sources that are used to substantiate the use of curtains on the altar ciborium, few texts are cited beyond Paul the Silentiary's description of the altar at Hagia Sophia. Mparnea, in his treatise on the Early Christian altar and its setting, cites a letter of Synesius of Cyrene (d. 414) which refers to the "mystical curtain" ($\kappa\alpha\tau\alpha\pi\acute{\epsilon}\tau\alpha\sigma\mu\alpha$ $\mu\upsilon\sigma\tau\iota\kappa\acute{o}\nu$)[61] and a reference in Theodoretus to a donation of curtains for the altar (or sanctuary).[62] However, both texts could as easily refer to the veils on the templon, and neither applies to Constantinople. The same must be said of Mparnea's citation of the *Testamentum domini*, although it is clear from other sources that the Syrian liturgy did require a curtain on the ciborium.[63] As far as the early churches of Constantinople are concerned, the case for curtains on the ciborium

rests with the single text of Paul the Silentiary; and, on closer scrutiny, not even this passage supports this interpretation.

The passage in question describes a rich hanging of silk and gold, with a representation on the front of Christ flanked by Sts. Peter and Paul standing in a triple arcade. The border showed the miraculous healings of Christ paralleled by the works of mercy of Justinian and Theodora; on one of the sides Justinian and Theodora are seen joining hands with Christ, and on the other they join hands with the Blessed Virgin.[64] Translators and commentators have generally followed the lead of Du Cange in supposing that the hanging under discussion was a curtain on the ciborium, and on the strength of this supposition rests the general acceptance of ciborium curtains as typical elements in the early Byzantine liturgy.[65] Braun, however, in his discussion of the passage fifty years ago, proposed that the reference is not to curtains but to the cloth covering the altar table itself; and Speck has recently come to the same conclusion in his investigation into the history of the altar-cloth.[66]

The passage is located in the section of the Silentiary's work describing the altar (lines 752 ff). Interrupting his description of the gold table itself, the writer enjoins the clergy in poetic apostrophe to cover the altar, since it should not be seen by profane eyes. "Unfold the mantle [$\phi\hat{\alpha}\rho o s$] and cover the slab of the table [$\dot{\epsilon}\rho\dot{\epsilon}\psi\alpha\tau\epsilon$ $\nu\hat{\omega}\tau\alpha$ $\tau\rho\alpha\pi\dot{\epsilon}\xi\eta s$]."[67] The author is referring to an altar-cloth being spread over the slab, or literally the "back" of the altar, and up to this point the text is perfectly clear. The crux of the passage lies in the following lines, which continue, ". . . and spreading the coverings [$\kappa\alpha\lambda\dot{\upsilon}\pi\tau\rho\alpha s$] straight on the four sides of silver, show to the countless multitude the abundance of gold and the brilliantly skillful workmanship." The term for the coverings, $\kappa\alpha\lambda\dot{\upsilon}\pi\tau\rho\alpha\iota$, is not the technical term for altar-cloth, $\dot{\epsilon}\nu\delta\upsilon\tau\dot{\eta}$, a word which comes into general use only later; but it is closely related to another word in early use for the altar-cloth, $\kappa\dot{\alpha}\lambda\upsilon\mu\mu\alpha$.[68] On the other hand, the proper terms for curtains, $\beta\hat{\eta}\lambda\alpha$ and $\kappa\alpha\tau\alpha\pi\epsilon\tau\dot{\alpha}\sigma\mu\alpha\tau\alpha$, are not used in the text. Since the altar slab had been said to be of gold a few lines earlier,[69] Du Cange assumed that the author was referring to the ciborium in his mention of the "sides of silver." The grammar, however, can only with difficulty bear a change of subject matter between lines 760 and 761. The discussion of the ciborium was dismissed nine lines earlier, and a return to it would have to be indicated here at least by a transitional particle. The natural reading of the passage must therefore identify the "coverings" ($\kappa\alpha\lambda\dot{\upsilon}\pi\tau\rho\alpha s$) with the "mantle" ($\phi\hat{\alpha}\rho o s$) of the preceding line. One may thus suppose that the altar table, while substantially of gold, had sides of silver, or (as Speck suggests) that the cloth that covered the top of the altar had silver borders from which the decorated sides hung down.[70] The gift of such a richly embroidered altar-cloth at Hagia Sophia would parallel donations made at the same time in Ravenna by Bishop Maximianus, a figure closely linked to Justinian. Maximianus donated three altar-cloths, two of which were decorated with figurative representations. The first featured the whole life of Christ, as well as two panels in which Maximianus appeared, and the second

bore representations of Maximianus' predecessors in office, the earlier bishops of Ravenna.[71]

No other Early Byzantine source makes reference to curtains on the altar ciborium, even though the symbolic possibilities of such veils would have been attractive. The silence of Germanus must be regarded as significant, since he does describe the ciborium and assigns it a symbolic meaning both as the mountain of Calvary and as the Ark of the Covenant.[72] He does not mention curtains.

A single reliable mention of ciborium curtains is found in the ninth century. As part of his iconophile program in cooperation with the patriarch Nicephoros, we read that Michael I in the year 811 "added rich adornment to the altar of Hagia Sophia, with vessels of gold and precious stones and with four-fold veils [τετράβηλα] of gold and purple interwoven, embroidered with marvellous holy images."[73] The term τετράβηλα (a word half Greek and half Latin, τετρα + vela) seems to be a *hapax legomenon* in Byzantine sources, but its meaning is certainly not "rectangular veils" as in Lampe's new *Patristic Greek Lexicon*. The meaning of the term is clear from its use in both Syriac and Latin liturgical sources where it refers to curtains on the four sides of the ciborium.[74] In Latin the term is used several times in the donation lists of the *Liber Pontificalis* in the eighth and ninth centuries, in contexts where there can be no mistaking its meaning, for curtains are spoken of as hanging "in ciborio" or "in circuitu altaris."[75] The term must mean the same in Theophanes. But the curtains put up by Michael I could not have lasted much beyond the accession of Leo the Armenian in 813, and certainly not beyond the Synod of 815 held in Hagia Sophia to repudiate the proceedings of Nicaea II. Moreover, further references to ciborium curtains are lacking in Middle Byzantine sources, which leads one to believe that Michael's action was not symptomatic of the liturgical usage of that period in Constantinople. The origin of ciborium curtains should probably be placed in Syria, where they seem to be the primitive tradition. Their regular use in Rome in the eighth and ninth centuries seems to point to a Syrian importation of the custom. They are first mentioned under the Syrian pope Sergius I (687–701), who—in addition to erecting ciboria in a number of the churches of Rome—donated two sets of "tetra-vela" to St. Peter's, one white and one red.[76]

Whether ciborium curtains became common in Constantinople in later Byzantine times it is impossible to say. Twice in later sources we find references to curtains on the ciborium: in Antony of Novgorod's description of Hagia Sophia and in Symeon of Thessalonike's commentary on the liturgy. It is significant, however, that in both references, as well as in the Late Byzantine representations of ciboria,[77] the curtains are not used to conceal the altar but as drapes that are drawn back to the columns, revealing the altar in the middle. Antony of Novgorod (ca. 1200), reporting on Hagia Sophia, tells us that in ancient times the curtains on the ciborium used to enclose it completely so that the celebrant would not be distracted by the congregation, and that heretics took advantage of this concealment to profane the Eucharist. "Informed of the heresy through the Holy Spirit, the Fathers fixed these curtains to

the columns of the ciborium and placed an archdeacon near the patriarch, metro-politan, and bishop to see that they served God in holiness without heresy. Thus was the veil torn asunder from the top to the bottom during the Crucifixion of the Lord. . . ."[78] The story of the defilement of the Eucharist has, of course, little historical value; all that is reliably reported is the part which the tale is meant to explain, namely, that the curtains on the ciborium were not used to conceal the altar but were drawn aside and fastened to the columns. The same arrangement is described by Symeon of Thessalonike when he tells us that the curtains hanging from the four columns (ἐκ τεσσάρων στύλων) indicate the four directions from which the faithful gather for the Eucharist.[79] In the Byzantine liturgy it does not seem that there is ever any question of curtains being drawn across the four sides of the ciborium to conceal the celebration of the liturgy.

The literary references to ciborium curtains are spotty and oblique, and not easy to interpret. Nevertheless, one must judge the situation on the basis of the data at hand, and the evidence presently available does not support the widely-held belief that the altar was concealed by curtains hanging from the ciborium. The clearest reference to ciborium curtains in Constantinople is Theophanes' reference in the ninth century, and how these curtains were used is not mentioned. In Late Byzantine times we have evidence of curtains on ciboria both in Byzantine art and in literary references, but their use is clearly decorative, not functional. They do not conceal the mysteries, but are drawn back and tied to or draped about the four columns of the ciborium.

One further set of curtains remains to be discussed. In present Byzantine usage an iconostasis or solid wall of icons pierced by three doors has replaced the templon of Early Byzantine times. A curtain is used over the central door at two relatively brief intervals in the liturgy, once just before the Creed and again during the Communion of the clergy.[80] During Easter week the central doors of the sanctuary remain open throughout the liturgy and the curtain is not drawn at all. Curtains, therefore, play a rather small part in the present liturgy. The question is whether in the Early Byzan-tine liturgy they did not play a much larger role, closing off the templon screen the way the icons now close off the iconostasis.

Earlier theories that would make the chancel screen of the sixth century "nothing but a straightforward copy of the traditional backdrop of the Byzantine theatre" have been thrown out by the archaeology of Byzantine churches;[81] the closing-off of the templon with a solid barrier is a strictly medieval development.[82] The chancel barriers of the Studios, Hag. Euphēmia, Hag. Polyeuktos, and Hagia Sophia con-sisted of a series of piers and/or colonnettes with chancel slabs between them and an architrave above. In Greece the development of this barrier has been traced through four stages from (1), a simple low parapet barrier, to (2), a low barrier with a framing arch over the central door, to (3), a barrier that is low on the sides but has columns and an architrave across the front, to (4), the final, fully developed barrier with archi-trave on all sides.[83] In Constantinople the evidence does not permit us to trace such a complete sequence; four of the churches exemplify the last stage of this series and one, the Chalkoprateia, had the low barriers of the first stage.

Two questions must be asked, though it is not always possible to separate the evidence neatly. First one must ask what kind of curtains would have been used in those churches that had a fully developed templon—whether curtains in the inter-columniations, or curtains on the door, or both. Second, how they were used—whether decoratively as hangings, or to conceal the mysteries entirely from view, or to be drawn or opened at various moments in the ceremony. Archaeologists and liturgists have generally assumed that the maximum possible concealment was intended.[84]

Again, it is impossible to appeal to archaeological evidence for a solution of the problem; the remains of templons are insufficient to tell us whether or not curtains were hung on them, or how they were used.[85] Many scholars have tried to make up for this deficiency by citing representations of curtains in Early Christian art; but the representations are never really pertinent to the question.[86] For example, the Pola casket, which is sometimes cited, does not show a Byzantine sanctuary but rather the curtains of the shrine of St. Peter's in Rome,[87] while the mosaic panel cited in S.ta Maria Maggiore shows door curtains on the tabernacle in the wilderness.[88] The Abel and Abraham panel at S. Apollinare in Classe features a curtain of indeterminate location in a scene of little historical value, and the architecture represented in Hag. Geōrgios in Thessalonike is far too fanciful to be interpreted with any kind of archaeological certainty.[89] The Early Christian artist never leaves us an archaeologically useful representation of the templon of the Early Byzantine church; therefore the literary sources are all that remain.

References to veils enclosing the sanctuary are numerous in Egypt, Syria, and Pontus from an early date,[90] but in Constantinople not a single mention has been found. Chrysostom, in his sermons delivered at Antioch, refers twice to the curtains of the sanctuary barrier, but in Constantinople he makes no mention of them.[91] Paul the Silentiary describes the construction of the templon of Hagia Sophia, the number of columns and doors, the parapet slabs of silver, the architrave with its medallions of the saints, and the clusters of lamps above; but he does not mention curtains. His description of the altar and its covering, moreover, implies that the altar was quite visible to those who stood outside the chancel barrier. "Show to the countless multitude," he tells the deacons, "the abundance of gold and the brilliantly skillful workmanship." The same kind of visibility is implied in the account of Pulcheria's donation of an altar to the Old Hagia Sophia; Sozomen says she "dedicated an altar, a most wonderful work of gold and precious stones, on behalf of her virginity and her brother's empire; and she wrote this on the face of the table so that it might be clear to all."[92] The inscription would hardly have been clear to all had the sanctuary been screened off.

Procopius refers to sanctuaries in a number of the churches of Constantinople, but never mentions separating curtains; the characteristic of the sanctuary, according to him, is that it should be "inaccessible" (ἀβέβηλος), or "a place which may not be entered."[93] It does not occur to him that it should be "unseen" (ἀόρατος) or concealed. Maximus, too, characterizes the sanctuary as a place which is accessible only to the clergy.[94] At one point when he enlarges on the symbolism of this division he

seems to imply that the sanctuary is concealed, for he says the division symbolizes the division of the whole universe between things that are seen and things that are unseen; but in the next chapter he denies such an implication, saying, "The whole church by itself is the symbol of the entire cosmos as perceived by sense alone, since it has a sanctuary like the heavens and a beautiful nave like the earth."[95] Germanus likewise describes the sanctuary as "accessible only to the priests"; according to him, the chancel barriers signify simply the exclusion of the laity.[96] If curtains did, in fact, fill the intercolumniations of the templon, it is hard to account for the complete silence of the sources regarding a feature so noteworthy and potentially symbolic. It would be quite an anomaly if the commentators should have described in detail the sanctuary furnishings which were hidden from the laity while failing to explain the one feature that was most obvious to their lay public, a curtain hiding the sanctuary. And it seems most unlikely that Germanus, who is careful to explain the meaning of each of the veils covering the chalice, would have omitted veils that covered the entire templon.[97]

Liturgical considerations also make it unlikely that the sanctuary was completely shut off during the first half of the ceremony, the Liturgy of the Catechumens. The bishop's assumption of an exalted place in the synthronon and the symbolic importance of this action, as well as his presiding there during the readings with the clergy on either side of him, his greetings of peace to the faithful, and his preaching to them from the throne—all these actions imply that the synthronon was visible to the faithful and was even a principal focus of attention during the Liturgy of the Word. Moreover, the continued survival into the sixth century and beyond of chancel barriers of the older, low kind as at Chalkoprateia must always be kept in mind. Probably the chancel barrier of Early Byzantine times in general represented an intermediate step between the low barrier that left the sanctuary quite open to view and the medieval one that largely concealed it.

It is possible, of course, that curtains were drawn across the templon for the solemn Anaphora, the central prayer of the Eucharist. The *Testamentum domini* seems to witness some such usage, at least in general terms, in one of the early forms of the Syrian liturgy. "Dum offert [episcopus] oblationem, velum portae [sanctuarii] sit expansum in signum aberrationis veteris populi, et offerat intra velum una cum presbyteris, diaconis, viduis canonicis, hypodiaconis, diaconissis, lectoribus [et] habentibus charismata."[98] This text, however, can not be easily transferred to Byzantine liturgy, and it is open to question even regarding the Syrian liturgy. As Khouri-Sarkis points out, the more precise testimony of Moïse bar Képha in the ninth century does not close the sanctuary curtain at all until the fraction and intinction ceremonies—i.e., just before the Communion of the clergy—and this is the present usage in the Syrian liturgy as well.[99]

In the Byzantine liturgy we have no mention of a closing of the curtains until Nicholas of Andida (1054–67). The text is quite significant and has not yet been

remarked upon in this connection. Immediately after the Creed, Nicholas comments:

> The shutting of the doors and the closing of the curtain over them, as they are accustomed to do in the monasteries, and the covering over of the gifts with the so-called *aēr* signifies, I believe, the night on which took place the betrayal of the disciple, the bringing [of Christ] before Caiphas, the arraignment before Annas, the false testimonies, the mockery, the blows and the rest. . . . But when the *aēr* is taken away and the curtain drawn back, and the doors opened, this signifies the dawn on which they led him away and handed him over to Pontius Pilate, the governor.[100]

The text then proceeds to comment on the Preface to the Anaphora, which follows. It is clear, then, that in the eleventh century sanctuary door curtains were closed only very briefly, shortly after the gifts had been deposited on the altar; this is true in the Byzantine liturgy today, except that now the closing and opening precedes the Creed instead of following it. It is also clear that in the eleventh century even this brief closing of the curtain was not a general practice, but was a monastic custom that was just then gaining ground. The period in which the second closing of the curtains just before Communion reached Constantinople is not known. It is not mentioned in the *Protheoria* of Nicholas, although, as we have just seen, it occurs in Syria much earlier.

The custom of concealing the liturgy with curtains in Early Byzantine churches is simply not substantiated by the existing archaeological and liturgical evidence. Most descriptions of the Early Byzantine church have been flawed by an anachronistic effort to find an early parallel for the late medieval iconostasis, but this does not seem to have existed. In explaining the purpose of chancel curtains, Mparnea proposes that they were needed for three reasons: (1) to hide the altar from the eyes of the uninitiated, (2) to show the "mystery-character" of the divine liturgy, and (3) to underscore the differences between laity and clergy.[101] The altar, however, does not seem to have been hidden from view except by rich, and occasionally finely embroidered, altar-cloths. In addition, the "mystery-character" of the Christian liturgy has been too readily confused with the mysteries of Eleusis.[102] No such connection can be documented. The mystery element in the Early Byzantine liturgy did not consist in concealing the liturgy from the faithful, but in excluding from their celebration "the catechumens and the rest who are unworthy of the sacred vision of the mysteries which are about to be shown."[103] The baptized Christian was regarded as an initiate and therefore worthy, as Maximus implies, to behold the mysteries. The lofty thrones of the clergy in the synthronon and the rigorous exclusion of the laity from the area beyond the chancel barrier impressed upon all who were present the clear distinction of clergy from laity.

Communion and Exit

In the early centuries, the Communion service concluded the Byzantine liturgy. After administering the Sacrament there was nothing left for the celebrant to do but to say a prayer of thanksgiving, bless the people, and leave the church. Today two other rites have been tacked onto the ending. After blessing and dismissing the people the celebrant has still to assist at the distribution of the ἀντίδωρον (the blessed bread), which takes place before the iconostasis. He then withdraws into the sanctuary for a formal dismissal of the assisting clergy.[104] Not a great deal is known about the concluding rite of the Early Byzantine liturgy, but indications are that it was both simpler and grander, involving a return procession of the celebrant making his exit through the nave of the church.

In the early liturgy, as in the present one, the clergy received Communion before the laity; but instead of receiving the Sacrament from a spoon, the laity would take the Bread in their hands and drink directly from the chalice. Chrysostom remarks that in partaking of Communion there is no distinction made between the bishop and the people, except that the bishop is the first to receive the Body of Christ in his hands.[105] A story in Sozomen refers to the same way of taking Communion, for the Eucharistic Bread, when placed in the hands of an heretical woman, turned to a stone.[106] The Council in Trullo found occasion to give rather explicit directions on how to receive Communion, specifying that the clergy were not to solicit fees when distributing Communion[107] and that the faithful should receive the consecrated bread directly in their hands (the left hand held under the right), and not in any precious vessel or cloth. "Thus if anyone at the time of the synaxis wishes to partake of the immaculate Body and to come forward for Communion holding his hands in the form of a cross, let him thus come forward and receive the communion of love."[108] Byzantine representations of the Communion of the Apostles are thus a faithful representation of the Early Byzantine manner of distributing the Eucharist (Plate 99).

At Communion time the faithful must have come forward to receive the Sacrament either at a location just before the Holy Door of the sanctuary as in the liturgy today, or somewhere near the solea. At Hagia Sophia, a space was left between the end of the solea and the Holy Door, but at Hag. Euphēmia the solea barriers actually joined the barriers on either side of the Holy Door.[109] Unfortunately we have no details on what sort of procession might have been formed, or how the ceremony might have looked; one presumes that men of rank preceded the common people, and that men preceded women.

When the Emperor took part in the liturgy, he naturally approached for Communion ahead of the ordinary laity. His procession followed the same route as it did for the Entrance of the Mysteries. Leaving the metatorion, he would pass through the right part of the church and out to the ambo in the center of the nave, in the company of the chamberlains and the rest of his Imperial guard. At the ambo he would enter the solea and proceed to the Holy Doors; unlike the rest of the faithful, he was allowed to enter the sanctuary itself to communicate. Going to the right-hand

side of the sanctuary, he ascended a raised platform (πουλπίτον) where he received Communion from the patriarch; he then embraced the patriarch and returned by the side entrance of the sanctuary to his place in the south aisle.[110]

How large a percentage of the congregation took part in Communion is difficult to say. The explicitness of the directions in the Council in Trullo is probably an indication that by the end of the seventh century reception of the Eucharist was more the exception than the rule, and perhaps the present practice of receiving only on three or four major feasts a year can be dated back as far as the seventh century. This might explain, too, why the commentators have so little to say about the reception of Communion, although the earlier references seem to take for granted that frequent reception of Communion was usual, as the extraordinary size of Early Byzantine liturgical vessels probably indicates.

While the faithful were receiving Communion, a psalm was sung which ended with the antiphon introduced by the patriarch Sergios in the year 630: "May our mouths be filled with your praise, O Lord."[111] Immediately after Communion a prayer of thanksgiving was said, requesting the protection of the Sacrament throughout the day; the deacon then dismissed the people and the celebrant began his exit.[112] The patriarch Eutychius (d. 582) compared the conclusion of the liturgy to the end of the Last Supper, when the disciples all sang a hymn and then went out to the Mount of Olives. "So after receiving the precious Body and Blood we say a prayer of thanksgiving, and then we go out, each one to his own home."[113] As the bishop had entered with the faithful in the First Entrance, at the conclusion of the liturgy he must have taken his departure also with them. Eutychius' expression "and then we go out" must certainly have included the celebrant. The Early Byzantine church plan, as we have pointed out, did not include a diaconicon for vesting and devesting; once the liturgy was over, the celebrant had nowhere to go except to retrace his steps back out of the church. The flabella, the patens, the chalices, and other sacred vessels were returned at this point to the skeuophylakion, as we have seen, in a sort of reverse of the Entrance of the Mysteries procession.[114] Like the carrying-in of the gifts, this task was probably assigned to the deacons. The celebrant himself, however, probably proceeded out the solea to the ambo and down the center of the nave to the Royal Door. This would explain the otherwise unaccountable position for the last prayer of the liturgy, the so-called εὐχὴ ὀπισθάμβονος, or prayer to be said "behind the ambo."[115] The prayer is a prayer for the entire assembly, invoking God's protection on the "whole body of Your church" (τὸ πλήρωμα τῆς ἐκκλησίας σου); it must have been pronounced by the celebrant when he reached the halfway point in his recessional and found himself behind the ambo and in the midst of his faithful. A parallel might be cited in the early stational liturgy of Rome, in which the bishop, on proceeding through the sanctuary and down the solea of the church, pronounced a series of blessings on each class of faithful that he passed.[116] The Early Byzantine liturgy thus closed, not with the disappearance of the clergy into the sanctuary as in the present liturgy, but with the return procession of the bishop through the nave and the general dispersal of the congregation, "each one to his own home."

Notes

[1]S. Salaville, *Liturgies orientales*, pp. 104–12.

[2]*Mystagogia*, ch. 16, *PG* 91, 693.

[3]Germanus, *Hist. eccl.*, chs. 37–39, pp. 29–31; Nicolaus Andidorum, *Protheoria*, 18, *PG* 140, 441; Sophronius Hierosolymitani, *Commentarius liturgicus*, 21, *PG* 87, 3, 4001.

[4]Brightman, *Liturgies*, pp. 316–17.

[5]H.-J. Schulz, *Die byzantinische Liturgie* (Frieburg-im-Breisgau, 1964), pp. 69–70.

[6]*Les Ordines romani*, ed. M. Andrieu, II (Louvain, 1948), *Ordo romanus*, I, 67–82. For a reconstruction of the rite, see Mathews, *RAC* 38 (1962), 87–94.

[7]Gregorius Nazianzenus, *Oratio 43*, ch. 52, *PG* 36, 561–64; Theodoretus Cyrensis, *Ecclesiasticae historiae*, V, 17, *PG* 82, 1237; Conc. in Trullo, canon 69, *Mansi* 11, 973; *De ceremoniis*, I, 1 and I, 9, ed. Vogt, pp. 27, 59, and passim. See above, ch. 6, n. 69.

[8]Hanssens, *Institutiones liturgicae*, nos. 1118–22.

[9]Theodorus Mopsuestiae, Homily 15, 23–25, in *Les Homélies catéchétiques*, ed. R. Tonneau and R. Devreesse, *Studi e testi*, 145 (Vatican City, 1949), pp. 501–5.

[10]*Mystagogia*, chs. 16 and 24, *PG* 91, 693, 704, 708.

[11]Dionysius Areopagita, *Eccl. hierarch.*, III, synopsis and 3, 8–9; *PG* 3, 425, 437.

[12]Theodore of Mopsuestia, Homily 15, 23–25, pp. 501–5. Fr. William Macomber kindly checked the French translation against the Syriac for me.

[13]See above p. 6, nn. 5–6.

[14]Eutychius, *Sermo de paschate et eucharistia*, *PG* 86, 2, 2400–1. Our translation.

[15]*Historiarum compendium*, ed. I. Bekker (Bonn, 1838–39), pp. 684–85.

[16]Brightman, *Liturgies*, p. 532, n. 9; Schultz, *Die byzantinische Liturgie*, pp. 73–74.

[17]*Chronicon paschale*, I, 705–6. Our translation, following as closely as possible the loose grammar of the Greek.

[18]See above pp. 12–13.

[19]*Chronicon paschale*, I, 714.

[20]Germanus, *Hist. eccl.*, ch. 36, pp. 28–29. The phrase "in the sanctuary, or" is an interpolation found in no other MS, according to the *apparatus criticus* on p. 28.

[21]Ibid., ch. 37, pp. 29–30.

[22]See above, p. 158.

[23]Conc. Laodic., canon 21, *Mansi* 2, 567.

[24]Germanus, *Hist. eccl.*, chs. 37 and 41, pp. 29–32.

[25]*Script. orig. Const.*, I, 78.

[26]*De ceremoniis*, I, 1, ed. Vogt, p. 27. Our translation.

[27]Ibid., I, 44 (35), ed. Vogt, p. 171.

[28]Passage quoted in A. Dmitrievskij, "Ho hagios phournos," *Vizantijskij vremennik* 24 (Leningrad, 1923–26), 139–40.

[29]*Descr. s. Sophiae*, lines 563–66; ed. Bekker, p. 28; ed. Friedländer, p. 243.

[30]*De ceremoniis*, II, 22, ed. Reiske, I, 620; Ebersolt, *Sainte-Sophie*, pp. 33–35.

[31]Jacobus Goar, *Euchologion*, p. 291. Our translation.

[32]Ebersolt, *Sainte-Sophie*, p. 35.

[33]Above, p. 85.

[34]Janin, *Géographie*, pp. 152–53.

[35]*Chronicon paschale*, I, 623.

[36]Georgius Pachymeres, *De Michaele et Andronico Palaeologis*, II, 80; Nicephorus Gregoras, *Byzantina historia*, ed. L. Schopen and I. Bekker (Bonn, 1828–55), III, 247. Cf. G. Mercati, "Notizie per la storia della teologia e della letteratura bizantina del secolo XIV," *Studi e testi*, 56 (Vatican City, 1931), 295.

[37]*De ceremoniis*, I, 1 and I, 9, ed. Vogt, pp. 12–13, 59–60.

[38]Cf. the Great Entrance in certain frescoes in churches on Mt. Athos. J. D. Stefanescu, *L'illustration des liturgies dans l'art de Byzance et de l'Orient* (Brussels, 1936), pp. 73–77.

[39]E. Freshfield, "On Byzantine Churches and the Modifications Made in their Arrangements Owing to the Necessities of the Greek Ritual," *Archaeologia* 44 (1873), 383–92.

[40]See above, Introduction, n. 6; also Djordje Stričević "Yakonikon i protezis u ranokhristianiskim tsrkvana" [The diaconicon and the prothesis in Early Christian churches], *Starinar*, n.s. 9–10 (1958–59), 59–66.

[41]*Mystagogia*, chs. 17–18, *PG* 91, 693–96.

[42]Ibid., ch. 19, *PG* 91, 696.

[43]Carl Schneider, "Studien zum Ursprung liturgischer Einzelheiten östlicher Liturgien: καταπέτασμα," *Kyrios* 1 (Königsberg, 1936), 57–73.

[44]G. Khouri-Sarkis, "Notes sur l'anaphore syriaque: Prière du voile," *Orient syrien* 5 (1960), 363–84; 7 (1962), 277–96; 8 (1963), 3–20; van de Paverd, "Messliturgie," pp. 36–42.

[45]Schneider, "Studien zum Ursprung," pp. 65–73.

[46]R. Krautheimer, *Early Christian and Byzantine Architecture*, p. 158; P. Crostarosa, *Le basiliche cristiane*, pp. 59–73; H. Selhorst, "Die Platzordnung im Gläübigenraum," pp. 45–49; Swift, *Hagia Sophia*, p. 127; Lethaby and Swainson, *Sancta Sophia*, pp. 87–88.

[47]See above, pp. 117–25.

[48]Swift, *Hagia Sophia*, p. 127.

[49]See above, p. 122.

[50]*De ceremoniis*, I, 1, ed. Vogt, pp. 10–11, 21–22; cf. Ebersolt, *Sainte-Sophie*, pp. 2, 22.

[51]*De ceremoniis*, I, 10 and I, 26 (17), ed. Vogt, pp. 70, 94.

[52]*De ceremoniis*, I, 27 (18), ed. Vogt, p. 101.

[53]Cantacuzenus, *Historia*, I, 197.

[54]*Theophanes Continuatus*, pp. 402, 894.

[55]Symeon Metaphrastes, *Vita et conversio s. Ioannis Chrysostomi*, ch. 27, *PG* 114, 1113.

[56]Since the same text later states that the Emperor and Empress used the gallery, perhaps we are not far wrong if we suppose that the curtains were hung there especially to conceal the Imperial party. Cf. Ignatius of Smolensk in B. de Khitrowo, *Itinéraires russes en Orient* (Geneva, 1889), pp. 143–44. Fr. Robert Taft checked the Russian for me in *Pravoslavnyj palestinskij sbornik* 4 (1887), fasc. 3, p. 14.

[57]For example cf. Orlandos, *Basilikē*, p. 475; Soteriou, *Hai palaiochristianikai basilikai*, pp. 241–43; Antoniadēs, *Ekphrasis*, II, 113–17; Pauline Johnstone, *The Byzantine Tradition in Church Embroidery* (London, 1967), pp. 8, 21. Further sources cited passim.

[58]Joseph Braun, *Der christliche Altar* (Munich, 1924), II, 165 and pls. 115, 146; Orlandos, *Basilikē*, pp. 474–75; Iōannēs M. Mparnea, *To palaiochristianikon thusiastērion* (Athens, 1940), p. 195; Theodor Klauser, "Das Ciborium in der alteren christlichen Buchmalerei," *Nachrichten des Akademies der Wissenschaft in Göttingen, Phil.-hist. Klassen* 7 (1961), 191–208.

[59]*Il menologio di Basilio II, Cod. Vat.* 1613 (Turin, 1907), II, 14.

[60]In late Palaeologian times curtains appear on ciboria in some of the frescoes of Mistra and occasionally in icon painting. Cf. Gabriel Millet, *Les monuments byzantins de Mistra* (Paris, 1910), pls. 112, 113, 128, 132, etc. G. and M. Soteriou, *Eikones tēs monēs sina* (Athens, 1956–58), pls. 209, 236.

[61]I. M. Mparnea, *To thusiastērion*, p. 193; Synesius Cyrensis, *Epistola* 67, *PG* 66, 1420.

[62]Theodoretus Cyrensis, *Eccl. hist.*, I, 29, *PG* 82, 988.

[63]I. Rahmani, *Testamentum domini* (Mainz, 1899), p. 25. The Latin translation reads, "Velum ex bysso pura confectum habeat altare," but the word for altar can as easily mean sanctuary. Fr. William MacComber, S. J., checked the Syriac of the passage for me. On the use of curtains in the Syrian liturgy, see G. Khouri-Sarkis, *Orient syrien* 5 (1960), 363–84; 7 (1962), 277–96; 8 (1963), 3–20.

[64]*Descr. s. Sophiae*, lines 755–805; ed. Bekker, pp. 37–39, ed. Friedländer, pp. 248–50.

[65]Du Cange, *Historia byzantina* (2nd ed.), "Ecclesia s. Sophiae," ch. 65, pp. 56–57; Lethaby and Swainson, *Sancta Sophia*, pp. 48–49; Fried-

länder, *Johannes von Gaza und Paulus Silentiarius*, p. 290.

[66]Josef Braun, *Der christliche Altar*, II, 23, n. 10; Paul Speck, "Die ΕΝΔΥΤΗ: literarische Quellen zur Bekleidung des Altars in der byzantinischen Kirche," *Jahrbuch der österreich. byz. Gesellschaft* 15 (1966), 331–33.

[67]*Descr. s. Sophia*, line 760; ed. Bekker, p. 37; ed. Friedländer, p. 248.

[68]Speck, *Jahrbuch der österreich. byz. Gesellschaft* 15 (1966), 323–75, passim.

[69]*Descr. s. Sophiae*, lines 752–53; ed. Bekker, p. 36; ed. Friedländer, p. 248.

[70]Speck, *Jahrbuch der österreich. byz. Gesellschaft* 15 (1966), 332.

[71]Agnellus, *Liber pontificalis*, pt. 2, ch. 6, *PL* 106, 610.

[72]Germanus, *Hist. eccl.*, ch. 4, pp. 11–12.

[73]Theophanes, *Chronographia*, I, 770.

[74]For its use in Syriac sources, see G. Khouri-Sarkis, *Orient syrien* 7 (1962), 277.

[75]*Liber pontificalis*, ed. L. Duchesne (Paris, 1886), I, 375; II, 166.

[76]*Liber pontificalis*, I, 375–76. On Pope Sergius, see Horace K. Mann, *Lives of the Popes in the Middle Ages*, 2nd ed. (London, 1925–29), I, 2, pp. 77–104.

[77]See above, n. 60.

[78]De Khitrowo, *Itinéraires russes en Orient*, p. 92.

[79]*De sacro templo*, ch. 133, *PG* 155, 341; cf. also ch. 139, *PG* 155, 348, and *Expositio de divino templo*, ch. 6, *PG* 155, 704.

[80]Schneider, "Studien zum Ursprung," pp. 64–65.

[81]Gregory Dix, *The Shape of the Liturgy*, 2nd ed. (London, 1945), p. 481. Cf. also K. Holl, "Die Entstehung der Bilderwand in der griechischen Kirche," *Archiv für Religionswissenschaft* 9 (1906), 365–84.

[82]A. Grabar, "Deux notes sur l'histoire de l'iconostase d'après des monuments de Yougoslavie," *XIIe Congrès International des Études Byzantines: Zbornik radova vizantoloski institut*, 7 (1961), 13–22.

[83]Orlandos, *Basilikē*, pp. 525–30.

[84]In addition to Schneider (see above, note 43) and Dix, one may cite Antoniades, *Ekphrasis*, II, pp. 84–85; Soteriou, *Hai palaiochristianikai basilikai*, pp. 241–43; J. A. Hamilton, *Byzantine Architecture and Decoration*, pp. 29–30, 59–61; R. Krautheimer, *Early Christian and Byzantine Architecture*, pp. 159–60, 212; O. von Simson, *Sacred Fortress*, pp. 112–13.

[85]In Syria, on the other hand, one can cite the sockets for curtain rods often found at either side of triumphal arches as archaeological evidence of curtains. J. Lassus, "Syrie," *DACL*, 15, 2, 1880.

[86]Soteriou, *Hai palaiochristianikai basilikai*, pp. 241–43; Mparnea, *To thusiastērion*, pp. 197–98; D. N. Moraïtes, "Βῆλα," *Thrēskeutikē kai ēthikē enkuklopaideia*, III (Athens, 1963), 837–39.

[87]T. Buddensieg, "Le coffret en ivoire de Pola, Saint-Pierre et le Latran," *CA* 10 (1959), 157–95.

[88]C. Cecchelli, *I mosaici della basilica di S. Maria Maggiore* (Turin, 1955), pl. 35.

[89]V. Lazarev, *Storia della pittura bizantina* (Turin, 1967), figs. 3–4.

[90]These references can be found in Schneider (see note 43), in Mparnea, *To thusiastērion*, pp. 196–97, or in Brightman, *Liturgies*, see glossary s.v. "veil."

[91]Ioannes Chrysostomus, *In epist. ad Ephesan.*, *Homilia* 3, 5, *PG* 62, 29; *In epist. I ad Cor.*, *Homilia* 36, 5, *PG* 61, 313; cf. van de Paverd, "Messliturgie," pp.38–42.

[92]Sozomenus, *Hist. eccl.*, IX, 1, *PG* 67, 1596.

[93]*Buildings*, I, 65, pp. 28–29; I, 4, 12, pp. 48–49; I, 6, 14, pp. 64–65; see above, pp. 122–23.

[94]See above, p. 121 ff.

[95]*Mystagogia*, ch. 3, *PG* 91, 668-72.

[96]See above, p. 122.

[97]Germanus, *Hist. eccl.*, chs. 34, 41; pp. 28, 31–32.

[98]*Testamentum domini*, ed. I. E. Rahmani, pp. 34–37.

[99]Khouri-Sarkis, *Orient syrien* 7 (1962), 282–84; cf. the quotation from Moïse bar Képha in R. H. Connolly and H. W. Codrington, *Two Commentaries on the Jacobite Liturgy* (Oxford, 1913), text, p. 60.

[100]Nicholaus Andidorum, *Protheoria*, 21, *PG* 140, 445.

[101]Mparnea, *To thusiastērion*, p. 198.

[102]One can no longer take seriously the speculations of Petrus Hendrix, "Der Mysteriencharakter der byzantinischen Liturgie," *BZ* 30 (1929), 333–39, which is cited with approval by Jantzen, *Die Hagia Sophia des Kaisers Justinian* (Cologne, 1967), p. 38.

[103]*Mystagogia*, ch. 14, *PG* 91, 692–93.

[104]Brightman, *Liturgies*, p. 399.

[105]Ioannes Chrysostomus, *In epist. II ad Thessal.*, *Homilia* 4, 4, *PG* 62, 492; cf. van der Paverd, "Messliturgie", p. 494.

[106]Sozomenus, *Hist. eccl.*,VIII, 5, *PG* 67, 1528–29; cf. van de Paverd, "Messliturgie," pp. 494–95.

[107]Conc. in Trullo, canon 23, *Mansi* 11, 953.

[108]Conc. in Trullo, canon 101, *Mansi* 11, 985–88.

[109]See above, pp. 98-99.

[110]*De ceremoniis*, I, 1, I, 9, I, 32 (23); ed. Vogt., pp. 12–13, 60–61, 124. The Emperor's custom of having Communion brought up to him in his private box in the gallery seems to be a later tradition. *De ceremoniis*, I, 10 and I, 20 (11), 27 (18), 36 (27), 39 (30); ed. Vogt., pp. 70–71, 79–80, 104–5, 139–40, 154–55.

[111]*Chronicon paschale*, I, p. 714; Brightman, *Liturgies*, p. 342; see above, p. 159.

[112]Brightman, *Liturgies*, pp. 342–43.

[113]Eutychius, *Sermo de paschate et eucharistia*, *PG* 86, 2, 2396.

[114]See above, p. 159.

[115]Brightman, *Liturgies*, pp. 343–44.

[116]*Ordo romanus*, I, 125–26; Mathews, *RAC* 38 (1962), 77–78.

Conclusion

Liturgical planning offers only one explanation of Early Byzantine architecture. The historian seeking to describe in all its complexity the architectural revolution of the fifth and sixth centuries cannot abstract from the problems of pure structural planning in terms of Strygowski's vocabulary of building types, or from questions of the evolution of Byzantine building techniques, or even from the development of Byzantine decorative and figurative arts; and beyond such purely architectural and artistic factors, we must confront the political, sociological, and economic factors that alternately ravage and revive the growth of any civilization. The complexity of the picture, however, in no way detracts from the importance of the liturgical factor in Early Byzantine architecture, for no matter what else entered into its design, the first purpose of the church building was the celebration of the liturgy.

The liturgy of the Eucharist, performed in all its brilliance and complexity, gave meaning to the new architecture in a concrete and very tangible fashion that affected the public as active participants rather than as mere spectators. The Christian in Early Byzantine times was less interested in the abstract symbolic possibilities of architectural forms than he was in the very real symbolic action which for him was entrance into divine life. His architecture was primarily designed to accommodate this mystical event, and other symbolism must always have been subordinated to this purpose. The veneration of relics of the saints, contrary to Grabar's hypothesis, played only a minor role in the liturgical plan of the Early Byzantine church. As a rule, the principal relic of a church was placed within the sanctuary where it was inaccessible to the laity; at Hag. Iōannēs in Hebdomon and Hag. Polyeuktos the laity could reach the crypt under the altar, but apparently only from outside the church itself. The enormous churches of the Savior, Hagia Sophia, and Hag. Eirēnē, seem to have been founded without any relic of importance. In the Byzantine church, martyrium devotion was far less important than devotion to the liturgy.

Our knowledge of Early Byzantine ceremonial is still far from complete, and our information concerning the plans of the early churches of Constantinople is always subject to the additions and revisions of new archaeological finds. Nevertheless, the available evidence indicates rather clearly the general patterns of church planning and the overall shape of the ceremonial, and the lines of both are different from what we had been led to expect. Somehow it has always been supposed that the Early Byzantine church and its ceremonial must have had the same features as their more

familiar medieval descendants, but in this instance parent and offspring had quite different traits. Theologically or internally, the medieval liturgy is, of course, substantially the same as the Early Byzantine one, and most of the essential prayer texts are common to both. In their external form, however, as well as in their visual impact, the two diverge rather sharply, and it is an anachronism which is no longer acceptable to try to picture the earlier churches in terms of the later ceremonial. The contrasts between early and medieval liturgy and between early and medieval church planning deserve to be underscored: the differences emphasize the close relationship of church planning to the needs of the ceremonial and the continued interaction of those two important creations of Byzantium, architecture and liturgy.

The Early Byzantine liturgy was at once simpler and grander than the medieval, larger in its feeling and more public in its celebration. Whereas the medieval liturgy was shaped around a series of appearances—the emergence of the clergy from the iconostasis for the Entrances and their return through the Holy Door—the Early Byzantine ceremony was structured around a series of full-scale processional movements. The First Entrance involved the participation not only of the clergy but of the entire congregation, accompanying the bishop with singing as they flooded into the church. The reading of the Gospel required of the deacon not just his appearance before the doors to read, but an exciting procession to and from the ambo with the faithful crowding about him. The Entrance of the Mysteries represented not a simple transfer of gifts from a neighboring chapel to the main altar, but a true entrance or bringing-in of the gifts from a skeuophylakion placed outside the church itself. Communion was received by much larger numbers in the early liturgy, and the ceremony concluded not with the disappearance of the clergy within the sanctuary, but with the celebrant's processional return down the solea and through the nave of the church.

Thus the Early Byzantine liturgy was less "dramatic" in a stage sense than the medieval one, but was more classical and more Roman in its sense of Imperial display. Its effect was not dependent on an alternation of concealment and revelation, and it showed little affinity to the Hellenistic mystery religions. The center of attention was not a screen or a play of curtains, but was either the great bank of steps in the apse where the bishop presided, surrounded by his priests, or the altar (during the Liturgy of the Faithful), which seems to have remained perfectly visible throughout. Like the planning of the church building itself, the liturgy was conceived as an open action. It involved more active participation by the faithful and was performed more publicly than the medieval liturgy.

These contrasts between early and medieval liturgy are paralleled by the contrasts between the openness of Early Byzantine church planning and the closed character of the medieval plan. In Early Byzantine churches the universal use of atria and the multiplication of entrances must be associated with the participation of the faithful in the First Entrance, going in under the leadership of the bishop—just as the disappearance of these features in later Byzantine churches must be linked to the gradual revision of this rite.[1] Once the antiphons began to preface the liturgy, i.e., in the

eighth century,[2] the entrance of the celebrant came to be postponed until after the congregation had entered for the start of the liturgy. As this happened, the classical, processional lines of the basilicas and the longitudinal axes of churches like Hag. Eirēnē and Hagia Sophia gave way to the strictly central, symmetrical plans of the Middle Byzantine period; the processional way was no longer installed in new churches,[3] and the ambo also disappeared, the deacon's Gospel procession being abbreviated to a simple appearance before the doors.[4] Prothesis and diaconicon appear in post-iconoclastic churches, where the clergy could prepare for the liturgy and retire after it, thus consolidating the properly sacred functions of the church into the triple sanctuary at the east. The later sanctuary plans cease to project into the nave, even to the extent of a solea or ambo. The more closed, self-contained character of the medieval liturgy is reflected in the withdrawal of the sanctuary from the nave and its neat division from the latter along a straight line. The barrier, which enjoyed a real transparency in the earlier liturgy, became gradually more and more opaque—and the synthronon, raised for greater visibility of the clergy in early times, was reduced to one or two steps as the sanctuary became more closed off. This reduction of the synthronon in turn left space to move the altar further east into the apse itself.[5]

With the sanctuary thus removed from the body of the nave, the latter was left free in medieval times to develop independently as a pure geometric space. At the same time, the decline of the catechumenate as a class must be tied to the changing status of galleries in later Byzantine architecture. A standard feature in Early Byzantine architecture, they became rare and reduced in size in later churches. Stairs were provided within the church itself, and the galleries, originally large areas for congregation, evolved into places of private devotion equipped with tiny chapels or oratories.[6]

The liturgical problems of medieval Byzantine architecture have yet to be attacked systematically, but the overall differences are striking enough to place Early Byzantine church planning in sharper relief. The early planning in Constantinople follows a pattern quite different from that of post-iconoclastic Constantinople. Its typical characteristics also distinguish it, as we have seen, from the plans of the other major centers of the Early Christian world. The early Constantinopolitan plan cannot be derived from those of Syria, Greece, or Asia Minor. Its individuality seems to have been well established by the fifth century and lasted through the cultural upheaval of the sixth. Like the Byzantine liturgy, it was an original product of the great creative forces, both religious and practical, which formed the first distinctively Byzantine civilization.

Notes

[1]An atrium or προπύλαια is mentioned by Photius at the Nea of Basil I, but other evidence of post-iconoclastic atria is lacking. Photius, *Logoi kai homiliae*, ed. S. Aristarches (Constantinople, 1900), II, 431; Mango, *Homilies of Photius*, p. 185.

[2]Germanus, *Hist. eccl.*, ch. 23, p. 21.

[3]The literary references we have to soleas are all to Early Byzantine churches. In addition to Hagia Sophia, one may cite Hag. Mōkios, Theotokos in Pēgē, the Holy Apostles, Theotokos in Blachernēs, and the Chalkoprateia basilica. Xydis, *AB* 29 (1947), 15–16.

[4]No evidence of post-iconoclastic ambos has turned up. The well-preserved pavements of the south church of the Pantokratōr monastery (twelfth century) and of the Studios basilica (eleventh century) show no signs either of soleas or ambos, but they had probably dropped from use much earlier. Megaw, *DOP* 17 (1963), 339 and fig. A.

[5]Cf. the south church of the Pantokratōr monastery and the south church of Constantine Lips.

Megaw, *DOP* 17 (1963), 336, fig. A; T. Macridy, "The Monastery of Lips," *DOP* 18 (1964), ground plan by Mamboury in fig. 5 after p. 278.

[6]Examples are the stairs introduced into the narthex of Hag. Sergios and Bacchos, those of Hag. Theodosia and of the parekklesion of Pammakaristos (Fethiye Camii), the tiny chapels above the prothesis and diaconicon at Hag. Theodosia, and the roof chapels of the north church of Lips.

Bibliography

Primary sources:

Agnellus. *Liber pontificalis. PL* 106, 459–750.

Anthologia graeca. *The Greek Anthology.* W. P. Paton, trans. Loeb Classical Library. London, 1916.

Anthologia graeca. H. Stadtmüller, ed. Leipzig, 1894.

Cantacuzenus, Ioannes. *Historia.* 3 vols. L. Schopen, ed. Bonn, 1828–32.

Cedrenus, Georgius. *Historiarum compendium.* 2 vols. Immanuel Bekker, ed. Bonn, 1838–39.

Chronicon paschale. 2 vols. L. Dindorf, ed. Bonn, 1832.

Codinus, Georgius. *Excerpta de antiquitatibus Constantinopolitanis.* Immanuel Bekker, ed. Bonn, 1843.

Constantinus VII Porphyrogenitus. *De ceremoniis.* 2 vols. J. J. Reiske, ed. Bonn, 1829–30.

——*Le livre des cérémonies.* 2 vols. Albert Vogt, ed. Paris, 1935–40.

Dionysius Areopagita. *Ecclesiastica hierarchia. PG* 3, 369–584.

Epistolae imperatorum pontificum aliorum. CSEL 35, pt. 2. Vienna, 1898.

Eustratius. *Vita Eutychii Patriarchae. PG* 86, 2, 2273–2390.

Eutychius Patriarcha. *Sermo de paschate et eucharistia. PG* 86, 2, 2391–2402.

Evagrius Scholasticus. *Historia ecclesiastica. PG* 86, 2, 2415–2886.

Germanus Constantinopolitanus. *Il commentario liturgico di s. Germano patriarca constantinopolitano e la versione latina di Anastasio bibliotecario.* Nilo Borgia, ed. Grottaferrata, 1912.

—— *Historia ecclesiastica.* In *Svedenija a nekotorykl liturgiecskikl rukopisjakl Vatikanskij biblioteke,* ed. Nikolai T. Transnoseltsev, pp. 323–75. Kazan, 1885.

—— *Historia ecclesiastica.* A. Galland, ed. Paris, 1779, publ. in *PG* 98, 384–453.

Glycas, Michael. *Annales.* Immanuel Bekker, ed. Bonn, 1836.

Gregorius Thaumaturgus. *Epistola canonica. PG* 10, 1019–1048.

Gregorius Nazianzenus. *Oratio 43 in laudem Basilii Magni. PG* 36, 493–606.

Gregorius Turonensis. *Libri miraculorum. PL* 71, 705–828.

Ho megas synaxaristēs. K. Dukakē, ed. Athens, 1948 ff.

Ignatius Deaconus. *Vita s. Nicephori. PG* 100, 41–168.

Ioannes Chrysostomus. *Opera. PG* 47–64.

Iustinianus I. *Corpus iuris civilis.* 3 vols. T. Mommsen, ed. Berlin, 1899–1902.

Jerome. *Contra vigilantium. PL* 23, 353–67.

Leo VI. *Les nouvelles de Leon VI le Sage.* P. Noailles and A. Dain, eds. Paris, 1944.

Leo Grammaticus. *Chronologia.* Immanuel Bekker, ed. Bonn, 1842.

Liber pontificalis. 3 vols. L. Duchesne, ed. Paris, 1886.

Marcellinus Comes. *Chronicon. PL* 51, 917–48.

Maximus Confessor. *S. Massimo Confessore, La Mistagogia ed altri scritti.* Raffaele Cantarella, ed. Testi cristiani, 4. Florence ,1931.

—— *Mystagogia. PG* 91, 657–717.

Narratio de structura templi s. Sophiae. Script. orig. Const., ed. T. Preger, I, 74–108. Leipzig, 1901.

Nicephorus Callistus. *Ecclesiastica historia. PG* 146–47.

Nicephorus Gregoras. *Byzantina historia.* 3 vols. L. Schopen and Immanuel Bekker, eds. Bonn, 1828–55.

Nicephorus Patriarcha. *Breviarium historicum. PG* 100, 875–994.

Nicolaus Andidorum. *Protheoria* = Theodorus Andidorum, *Brevis commentatio de divinae liturgiae symbolis. PG* 140, 417–68.

Nicolaus Mesarites. "Description of the Church of the Holy Apostles at Constantinople," trans. Glanville Downey. *Transactions of the American Philosophical Society,* n.s. 47 (1957), 857–924.

Notitia dignitatum, accedunt notitia urbis Constantinopolitanae et Laterculi provinciarum. O. Speeck, ed. Berlin, 1876.

Ordines romani du haut moyen-âge, II, Les textes. Spicilegium sacrum lovaniense, ed. Michael Andrieu, 23. Louvain, 1948.

Pachymeres, Georgius. De Michaele et Andronico Palaeologis. 2 vols. Immanuel Bekker, ed. Bonn, 1835.

Palladius. Dialogus de vita sancti Ioannis. PG 47, 5–82.

—— Palladii dialogus de vita s. Ioannis Chrysostomi. P. R. Coleman-Norton, ed. Cambridge, 1928.

Paulus Silentiarius. Descriptio ecclesiae sanctae Sophiae et ambonis. Immanuel Bekker, ed. Bonn, 1837.

—— Descriptio s. Sophiae et ambonis. In Paul Friedländer, Johannes von Gaza und Paulus Silentiarius, Kunstbeschreibungen justinianischer Zeit, pp. 225–65. Leipzig, 1912.

Photius. The Homilies of Photius. Cyril Mango, trans. Cambridge (Mass.), 1958.

—— Logoi kai homiliae. S. Aristarches, ed. Constantinople, 1900.

Procopius, Anecdota. H. B. Dewing, trans. Loeb Classical Library. London, 1935.

—— Buildings. H. B. Dewing and Glanville Downey, trans. Loeb Classical Library. London, 1959.

Pseudo-Codinus. Patria Kōnstantinoupoleōs. Script. orig. Const., ed. T. Preger, II, 135–289. Leipzig, 1906.

Regesten der Kaiserurkunden des oströmischen Reichs. F. Dölger, ed. Munich-Berlin, 1924.

Socrates. Historia ecclesiastica. PG 67, 30–843.

Sophronius Hierosolymitani. Commentarius liturgicus. PG 87, 3, 3981–4002.

Sozomenus. Historia ecclesiastica. PG 67, 844–1630.

Symeon Magister. Annales. In Theophanes Continuatus, ed. Immanuel Bekker, pp. 601–760. Bonn, 1838.

Symeon Metaphrastes. Vita et conversio s. Ioannis Chrysostomi. PG 114, 1046–1210.

Symeon Thessalonicensis. De sacra liturgia. PG 155 253–304.

—— De sacro templo. PG 155, 305–62.

—— Expositio de divino templo. PG 155, 697–750.

Synesius Cyrensis. Epistola 67. PG 66, 1411–32.

Testament of Our Lord. James Cooper and A. J. Maclean, trans. Edinburgh, 1902.

Testamentum domini. I. Rahmani, ed. Mainz, 1899.

Theodoretus Cyrensis. Ecclesiasticae historiae. PG 82, 879–1278.

Theodorus Lector. Excerpta ex ecclesiastica historia. PG 86, 1, 165–216.

Theodorus Mopsuestiae. Les Homélies catéchétiques. R. Tonneau and R. Devreesse, eds. Studi e testi, 145. Vatican City, 1949.

Theodorus Studita. Descriptio constitutionis monasterii Studii. PG 99, 1703–20.

Theodosius I. Theodosiani libri xvi. T. Mommsen, ed. Berlin, 1905.

Theophanes. Chronographia. 2 vols. John Classen, ed. Bonn, 1839–41.

Theophanes Continuatus. Immanuel Bekker, ed. Bonn, 1838.

Vita et acta s. Maximi confessoris. PG 90, 67–222.

Archaeological studies:

Antoniades, E. M. Ekphrasis tēs hagias Sophias. 3 vols. Athens, 1907–9.

Bittel, K. "Grabung in Hof des Topkapī Sarayī." JDAI 54 (1939), 179–82.

Bittel, K., and Schneider, A. M. "Das Martyrion des hl. Euphemia beim Hippodrom." AA 56 (1941), 296–315.

Bossert, H. T. "İstanbul akropolunde üniversite hafriyatı," Üniversite Konferanzlarī, no. 125 (1939–40), 206–31.

Buddensieg, T. "Le coffret en ivoire de Pola, Saint-Pierre et le Latran." CA 10 (1959), 157–95.

Butler, H. C. Early Churches in Syria. Princeton, 1929.

Capizzi, Carmelo. "Anicia Giuliana (462 ca–530 ca): Ricerche sulla sua famiglia e la sua vita." Rivista di studi bizantini e neoellenici, n.s. 5 (1968), 191–226.

Casson, Stanley. Preliminary Report upon the Excavations Carried out in the Hippodrome of Constantinople in 1927. London, 1928.

Cecchelli, C. I mosaici della basilica di s. Maria Maggiore. Turin, 1955.

—— The Rabbula Gospel, Olten-Lausanne, 1959.

Conant, K. J. "The First Dome of St. Sophia and its Rebuilding." AJA 43 (1939), 589–92.

Crostarosa, Pietro. Le basiliche cristiane. Rome, 1892.

de Francovich, Géza, ed. Architettura medievale armena. Rome, 1968.

Deichmann, F. W. Studien zur Architektur Konstantinopels. Deutsches Beiträge zur Altertumswissenschaft. Baden-Baden, 1956.

—— "Caratteristiche dell'architettura proto-bizantina in occidente," Corsi di cultura sull'arte ravennate e bizantina, 1957, fasc. ii.

—— *Ravenna: Haupstadt des spätantiken Abendlandes*, I, *Geschichte und Monumente*, Wiesbaden, 1969.

de Khitrowo, B. *Itinéraires russes en Orient*. Geneva, 1889.

Demangel, R. *Le quartier des Manganes*. Paris, 1939.

—— *Contribution à la topographie de l'Hebdomon*. Paris, 1945.

Diehl, Charles. *Justinien et la civilisation byzantine au VIᵉ siècle*. Paris, 1901.

—— "Les fouilles du corps d'occupation français à Constantinople." *Comptes rendues: Academie des inscriptions et belles lettres*, 1923, 241–48.

—— *Manuel d'art byzantin*. 2nd ed. Paris, 1925.

Dirimtekin, Feridun. "Le skeuophylakion de Sainte-Sophie." *REB* 19 (1961), 390–400.

—— "Le local du patriarchat à sainte Sophie." *IM* 13–14 (1963–64), 113–27.

—— "Les fouilles faites en 1946–47 et en 1958–60 entre Sainte-Sophie et Sainte-Irène à Istanbul." *CA* 13 (1962), 161–85.

—— *Saint Sophia Museum*. Istanbul, n.d.

Downey, Glanville. *Constantinople in the Age of Justinian*. Norman (Okla.), 1960.

Du Cange, Charles du Fresne. *Historia byzantina duplici commentario illustrata*. Paris, 1670. Pt. 2, bk. III, section ii, "Ecclesia s. Sophiae." Rpt. in Paulus Silentiarius, *Descriptio s. Sophiae et ambonis*, ed. I. Bekker, pp. 61–157. Bonn, 1837.

—— *Historia byzantina duplici commentario illustrata*. 2nd ed. Paris, 1680. Rpt. Venice, 1729.

Duyuran, R. "First Report on Excavations on the Site of the New Palace of Justice at Istanbul." *Yıllıc* 5 (1952), 33–38.

—— "Second Report on Excavations on the Site of the New Palace of Justice at Istanbul." *Yıllıc* 6 (1953), 74–80.

Ebersolt, Jean. *Monuments d'architecture byzantine*. Paris, 1934.

——*Les anciens sanctuaires de Constantinople*. Paris, 1951.

——*Sanctuaires de Byzance*. Paris, 1951.

Ebersolt, Jean, and Thiers, Adolphe. *Les églises de Constantinople*. Paris, 1913.

Emerson, W., and Van Nice, R. L. "Hagia Sophia: Preliminary Report of a Recent Examination of the Structure." *AJA* 47 (1943), 403–36.

—— "Hagia Sophia: The Collapse of the First Dome." *Archaeology* 4 (1951), 94–103.

—— "Hagia Sophia: The Construction of the Second Dome and Its Later Repairs." *Archaeology* 4 (1951), 162–71.

Ettinghausen, Elizabeth. "Byzantine Tiles from the Basilica in the Topkapu Sarayi and St. John of Studios." *CA* 7 (1954), 79–88.

Feld, Otto. "Beobachtungen in der Küçük Ayasofya zu Istanbul." *IM* 18 (1968), 264–69.

Fıratlı, Nezih. "Decouverte de trois églises byzantines à Istanbul." *CA* 5 (1951), 163–79.

—— *A Short Guide to the Byzantine Works of Art in the Archaeological Museum of Istanbul*. Istanbul, 1955.

Fossati, Gaspard. *Aya Sofia, Constantinople, As Recently Restored by Order of H. M. the Sultan Abdul Mediid*. London, 1852.

George, W. S. *The Church of Saint Eirene at Constantinople*. London, 1912.

Gerstinger, H. *Die Wiener Genesis*. Vienna, 1931.

Glück, H. *Das Hebdomon und seine Reste in Makriköi*. Beiträge zur vergleichenden Kunstforschung, 1. Vienna, 1920.

Grabar, A. *L'empereur dans l'art byzantin*. Paris, 1936.

—— *Martyrium: Recherches sur le culte des reliques et l'art chrétien antique*. 2 vols. Paris, 1943–46.

—— *Sculptures byzantines de Constantinople*. Paris, 1963.

—— "Etudes critiques: R. Naumann, Die Euphemia-Kirche." *CA* 17 (1967), 251–54.

Grelot, Guillaume J. *Relation nouvelle d'un voyage à Constantinople*. Paris, 1681.

Grossmann, Peter. "Zum Atrium der Irenenkirche in Istanbul." *IM* 15 (1965), 186–207.

Gurlitt C. *Die Baukunst Konstantinopels*. Berlin, 1912.

Gyllius, Petrus. *De Constantinopoleos topographia*. Lyons, 1632.

Hamilton, J. A. *Byzantine Architecture and Decoration*. 2nd ed. London, 1956.

Harrison, R. M., and Fıratlı, Nezih. "Discoveries at Saraçhane, 1964." *Yıllıc* 13–14 (1966), 128–30.

—— "Excavations at the Saraçhane in Istanbul." *DOP* 19 (1965), 230–36; 20 (1966), 222–38; 21 (1967), 272–78; 22 (1968), 195–216.

Janin, Raymond. *Constantinople byzantine*. Paris, 1950.

—— *La géographie ecclésiastique de l'empire byzantin: Constantinople, Les églises et les monastères*. 2nd ed. Paris, 1969.

Jantzen, Hans. *Die Hagia Sophia des Kaisers Justinian in Konstantinopel*. Cologne, 1967.

Johnstone, Pauline. *The Byzantine Tradition in Church Embroidery*. London, 1967.

Kähler, Heinz. *Hagia Sophia*. E. Childs, trans. London, 1967.

Kautzsch, Rudolf. *Kapitellstudien*. Studien zur spätantiken Kunstgeschichte, 9. Berlin-Leipzig, 1936.

Keck, Andrew S. "Review of E. H. Swift, *Hagia Sophia*." *AB* 23 (1941), 237–40.

Klauser, Theodor. "Das Ciborium in der alteren christlichen Buchmalerei." *Nachrichten des Akademies der Wissenschaft in Göttingen, Phil.-hist. Klassen* 7 (1961), 191–208.

Kleiss, Wolfram. "Neue Befunde zur Chalkopraten-kirche in Istanbul." *IM* 15 (1965), 149–67.

—— "Grabungen in Bereich der Chalkopraten-kirche in Istanbul, 1965." *IM* 16 (1966), 217–40.

Krautheimer Richard. *Corpus basilicarum christianarum Romae.* Vatican City, 1939 ff.

—— "Mensa-Coemeteria-Martyrium." *CA* 11 (1960), 15–40.

—— *Early Christian and Byzantine Architecture.* Pelican History of Art. Baltimore, 1965.

—— "The Constantinian Basilica." *DOP* 21 (1967), 117–40.

Lassus, Jean. "Syrie." *DACL*, 15, 2, 1855–1942.

—— *Sanctuaires chrétiens de Syrie.* Paris, 1947.

Lathoud, D., and Pezaud, P. "Le sanctuaire de la Vierge au Chalcoprateia." *Echos d'orient* 23 (1924), 36–62.

Lavin, Irving. "The House of the Lord." *AB* 44 (1962), 1–27.

Lawrence, Marion. *The Sarcophagi of Ravenna.* New York, 1945.

Lemerle, P. *Philippes et la Macédoine orientale.* Paris, 1945.

—— "Bulletin Archéologique III, 1950–51." *REB* 10 (1952), 193.

Lethaby, W. R., and Swainson, Harold. *The Church of Sancta Sophia, Constantinople.* New York, 1894.

Macridy, T., et. al. "The Monastery of Lips." *DOP* 18 (1964), 249–317.

Mainstone, R. J., "The Structure of the Church of St. Sophia, Istanbul." *Transactions of the Newcomen Society* 38 (1965–66), 23–49.

—— "Justinian's Church of St. Sophia, Istanbul: Recent Studies of its Construction and First Partial Reconstruction." *Architectural History* 12 (1969), 39–49.

Mamboury, Ernest. *Constantinople, Tourists' Guide.* 1st ed. Constantinople, 1925.

—— "Fouilles de Ste. Sophie." In Cyril Mango, *The Brazen House*, Arkaeologisk-kunsthistoriske Meddeleser, 4, pp. 182–83. Copenhagen, 1959.

Mango, Cyril. *Materials for the Study of the Mosaics of St. Sophia at Istanbul.* Washington, D.C., 1962.

Mango, Cyril, and Ševčenko, Ihor. "Remains of the Church of St. Polyeuktos at Constantinople." *DOP* 15 (1961), 243–47.

Megaw, Arthur H. "Notes on Recent Work of the Byzantine Institute in Istanbul." *DOP* 17 (1963), 335–64.

Mellink, M. J. "Archeology in Asia Minor: Istanbul—Saraçhane." *AJA* 69 (1965), 149; 70 (1966), 159; 71 (1967), 173.

Mendel, G. *Catalogue des sculptures grecques, romaines et byzantines.* 3 vols. Constantinople, 1912–14.

Il menologio di Basilio II, Cod. Vat. 1613. Turin, 1907.

Mercati, Silvio G. "Santuarii e reliquie constantinopolitane secondo il cod. ottob. lat. 169 prima della conquista latina." *Rendiconti della Pontifica accademia romana di archeologia* 12 (1936), 133–156.

Miatev, K. "Die Rundkirche von Preslav." *BZ* 30 (1929), 561–67.

Millet, Gabriel. *Les monuments byzantins de Mistra.* Paris, 1910.

—— "Sainte-Sophie avant Justinien." *OCP* 13 (1947), 597–612.

Muñoz, Antonio. *Il Codice Purpureo di Rossano.* Rome, 1907.

Naumann, Rudolf, and Belting, Hans. *Die Euphemia-Kirche am Hippodrom zu Istanbul und ihre Fresken.* Istanbuler Forschungen, 25. Berlin, 1966.

Nordström, Carl-Otto. *Ravennastudien. Ideengeschichtliche und ikonographische Untersuchungen über die Mosaiken von Ravenna.* Stockholm, 1953.

Österreichisches archäologisches Institut. *Forschungen in Ephesos*, vol. 4, 3, *Die Johanneskirche.* Vienna, 1951.

Ogan, Aziz, "Les fouilles de Topkapu Saray entreprises en 1937 par la Societé d'histoire Turque." *Belleten* 4 (1940), 318–35.

Omont, H. *Miniatures des plus anciens manuscrits grecs de la Bibliothèque Nationale.* Paris, 1929.

Orlandos, A. *Hē xylostegos palaiochristianikē basilikē.* Athens, 1950–59.

Panchenko, B. "Hag. Iōannēs Studios." *Izvetiya russkogo arkheol. instituta* 14 (Sophia, 1909), 136–52; 15 (1911), 250–57; 16 (1912), 1–359.

Paspates, A. G. *Byzantinai meletai topographikai kai historikai.* Constantinople, 1877.

Pelikanides, S. *Palaiochristianika mnēmeia Thessalonikēs.* Thessalonike, 1949.

Ramazanoğlu, Muzaffer. *Sentiren ve Ayasofyalar Manzumesi = L'ensemble Ste. Irène et les diverses Ste. Sophies.* Istanbul, 1946.

—— "Neue Forschungen zur Architekturgeschichte der Irenenkirche und des Complexes der Sophienkirche." *Actes du VIe Congrès International des Études Byzantines*, 2, 347–57. Paris, 1951.

—— "Neue Forschungen zur Architekturgeschichte der Irenenkirche und des Complexes der Sophienkirche." *Atti del VIII Congresso di Studi Bizantini*, 2, 232–35. Palermo, 1951.

Ricci, C. *Guida di Ravenna.* 2nd ed. Ravenna, 1884.

Salzenberg, W. *Altchristliche Baudenkmale von Constantinopel vom V. bis XII. Jahrhundert.* Berlin, 1854.

Sanpaolesi, Piero. "La chiesa dei ss. Sergio e Bacco a Constantinopoli." *Rivista dell'istituto nazionale d'archeologia e storia dell'arte*, n.s. 10 (1961), 116–80.

——*Santa Sofia a Constantinopoli*. Florence, 1965.

Schneider, A. M. *Byzanz: Vorarbeiten zur Topographie und Archäologie der Stadt*. Istanbuler Forschungen, 8. Berlin, 1936.

—— "Die vorjustinianische Sophienkirche." *BZ* 36 (1936), 77–85.

—— *Die Hagia Sophia zu Konstantinopel*. Berlin, 1939.

—— *Die Grabung im Westhof der Sophienkirche zu Istanbul*. Istanbuler Forschungen, 12. Berlin, 1941.

—— "Grabung im Bereich des Euphemiamartyrions zu Konstantinopel." *AA* 58 (1943), 255–89.

—— "Funde in der Büyük Reşit Paşa Caddesi." *AA* 59–60 (1944–45), 75.

—— "Bibliographie." *BZ* 45 (1952), 222–23.

Ševčenko, Ihor. "Note." *Byzantion* 29–30 (1959–60), 386.

Sheppard, Carl D. "A Radiocarbon Date for the Wooden Beams in the West Gallery of St. Sophia, Istanbul." *DOP* 19 (1965), 237–40.

Soteriou, G. and M. *Eikones tēs monēs sina*. 2 vols. Athens, 1956–58.

Soteriou, G. A. *Hai palaiochristianikai basilikai tēs Hellados*. Athens, 1931.

Swainson, H. "Monograms of the Capitals of S. Sergius at Constantinople." *BZ* 4 (1895), 106–8.

Swift, E. H. *Hagia Sophia*. New York, 1940.

Texier, Charles, and Pullan, R. P. *Byzantine Architecture*. London, 1864.

Thibaut, Jean-Baptiste. "L'Hebdomon de Constantinople." *Echos d'orient* 21 (1922), 31–44.

Underwood, Paul A. "Some Principles of Measure in the Architecture of the Period of Justinian." *CA* 3 (1948), 64–74.

van Berchem, M., and Strygowski, J. *Amida*. Heidelberg, 1910.

van Millingen, Alexander. *Byzantine Churches in Constantinople, Their History and Architecture*. London, 1912.

Van Nice, R. L. "The Structure of St. Sophia." *Architectural Forum* 118 (1963), 131–39.

—— *Saint Sophia in Istanbul: An Architectural Survey*. Washinton, D.C., 1965.

von Simson, O. *Sacred Fortress: Byzantine Art and Statecraft in Ravenna*. Chicago, 1948.

Ward Perkins, J. B. "Building Methods of Early Byzantine Architecture." In *The Great Palace of the Byzantine Emperors, Second Report*, pp. 52–104. Edinburgh, 1958.

Wulff, O. *Altchristliche und byzantinische Kunst*. Berlin, 1913–14.

Zaloziecky, W. R. *Die Sophienkirche in Konstantinopel*. Studi di antichità cristiana, Pontificio Istituto di Archeologia Cristiana, 12. Vatican City, 1936.

Studies pertaining to the liturgy:

Alföldi, A. "Die Ausgestaltung des monarchischen Zeremoniells am römischen Kaiserhofe." *Mitteilungen des deutschen archäologischen Instituts Röm* 49 (1934), 1–118.

—— "Insignien und Tracht der römischen Kaiser." *Mitteilungen des deutschen archäologischen Instituts Röm* 50 (1935), 1–171.

Altaner, Berthold. *Patrology*. H. Graef, trans. New York, 1964.

Baur, Chrysostomus. *Johannes Chrysostomus und seine Zeit*. Munich, 1929–30.

Braun, Josef. *Die liturgische Gewandung im Occident und Orient*. Freiburg-im-Breisgau, 1907.

Bingham, Joseph. *The Antiquities of the Christian Church*. 2 vols. London, 1870.

Bornert, René. *Les commentaires byzantins de la divine liturgie du VII^e^ au XV^e^ siècle*. Paris, 1966.

Brightman, F. E. *Liturgies Eastern and Western, 1, Eastern Liturgies*. Oxford, 1896.

Dalmais, I. H. "Place de la Mystagogie de saint Maxime le Confesseur dans la théologie liturgique byzantine." *Studia Patristica*, 5, 277–83. Texte und Untersuchungen zur Geschichte der altchristlichen Literatur, 80. Berlin, 1962.

de Puniet, P. "Catéchuménat." *DACL*, 2, 2, 2579–621.

Devreesse, R. "Le texte de la vita de saint Maxime et ses recensions." *Analecta Bollandiana* 46 (1928), 4–47.

Dix, Gregory. *The Shape of the Liturgy*. 2nd ed. London, 1945.

Dmitrievskij, A. "Ho hagios phournos." *Vizantijskij vremennik* 24 (Leningrad, 1923–26), 139–40.

Duchesne, L. *Christian Worship, Its Origin and Evolution*. 5th ed. M. T. McClure, trans. London, 1927.

Goar, Jacobus. *Euchologion sive rituale graecorum*. Venice, 1730. Rpt. Graz, 1960.

Hanssens, I. M. *Institutiones liturgicae de ritibus orientalibus: De missa rituum orientalium*, vols. 2 and 3. Rome, 1930–32.

Hendrix, Petrus. "Der Mysteriencharakter der byzantinischen Liturgie." *BZ* 30 (1929), 333–39.

Jacob, André. "Histoire du formulaire grec de la liturgie de saint Jean Chrysostome." Diss. Université Catholique de Louvain, 1968.

Janeres, Sebastia. *Bibliografia sulle liturgie orientali.* Rome, 1969.

Jungmann, Josef A. *Missarum Sollemnia.* 5th ed. 2 vols. Vienna, 1962.

Mandalà, Marco. *La Protesi della liturgia nel rito bizantino-greco.* Grottaferrata, 1935.

Mann, Horace K. *Lives of the Popes in the Middle Ages.* 2nd ed. 15 vols. London, 1925–29.

Mateos, Juan. *Evolution historique de la liturgie de saint Jean Chrysostome,* pt. 1. Rome, 1968. First published in *Prôche-orient chrétien* 15 (1965), 333–51; 16 (1966), 3–18; 17 (1967), 141–76.

—— *Le Typicon de la Grande Église.* 2 vols. Orientalia christiana analecta, 165–66. Rome, 1962–63.

Mercati, G. "Notizie . . . per la storia della teologia e della letteratura bizantina nel secolo XIV." *Studi e testi,* 56 (Vatican City, 1931), 295.

Raes, Alphonsus. *Introductio in liturgiam orientalem.* Rome, 1947.

Salaville, S. *Liturgies orientales.* 2 vols. Paris, 1932–42.

Sauget, J. M. *Bibliographie des liturgies orientales.* Rome, 1962.

Schulz, Hans-Joachim. *Die byzantinische Liturgie.* Freiburg-im-Breisgau, 1964.

Schwartz, E. *Busstufen und Katechumenatclasse.* Schriften der wissenschaftlichen Gesselschaft in Strassburg, 7. Strassburg, 1911.

Sherwood, Polycarp. *An Annotated Date-list of the Works of Maximus the Confessor.* Rome, 1952.

—— *The Earlier Ambigua of St. Maximus and his Refutation of Origenism.* Rome, 1955.

—— "A Survey of Recent Work on St. Maximus the Confessor." *Traditio* 22 (1964), 428–37.

Strittmatter, Anselm. "The 'Barberinum s. Marci' of Jacques Goar: Barb. gr. 336." *Ephemerides liturgicae* 47 (1933), 329–67.

Thunberg, Lars. *Microcosm and Mediator, the Theological Anthropology of Maximus the Confessor.* Lund, 1965.

van der Paverd, F. "Zur Geschichte der Messliturgie in Antiocheia und Konstantinopel gegen Ende des vierten Jahrhunderts: Analyse der Quellen bei Johannes Chrysostomos." Diss. Pontificio Istituto Orientale, Rome, 1968.

Wellesz, Egon. *A History of Byzantine Music and Hymnography.* Oxford, 1949.

Studies relating architecture to liturgy:

Allatius, Leo. *De templis graecorum recentioribus, de narthece, de graecorum hodie quorundam opinionibus.* Cologne, 1645.

—— *The Newer Temples of the Greeks.* Anthony Cutler, trans. University Park, 1969.

Bandmann, Günter. "Über Pastophorien und verwandte Nebenräume im mittelalterlichen Kirchenbau." In *Kunstgeschichtliche Studien für Hans Kauffmann,* pp. 19–56. Berlin, 1956.

Battifol, Pierre. *Études de liturgie et d'archéologie chrétienne.* Paris, 1919.

Bouyer, Louis. *Rite and Man: Natural Sacredness and Christian Liturgy.* M. J. Costelloe, trans. Notre Dame (Ind.), 1963.

—— *Architecture et liturgie.* Paris, 1967.

Braun, Josef. *Der christliche Altar.* 2 vols. Munich, 1924.

Ebersolt, Jean. *Sainte-Sophie de Constantinople: Étude de topographie d'après les cérémonies.* Paris, 1910.

Freshfield, E. "On Byzantine Churches and the Modifications Made in their Arrangements Owing to the Necessities of the Greek Ritual." *Archaeologia* 44 (1873), 383–92.

Grabar, A. "Quel est le sens de l'offrande de Justinien et de Théodora sur les mosaïques de Saint-Vital?" *Felix Ravenna* 81 (1960), 63–77.

—— "Deux notes sur l'histoire de l'iconostase d'après des monuments de Yougoslavie." *XIIᵉ Congrès International des Études Byzantines, Zbornik radova vizantoloski institut* 7 (1961), 13–22.

Heitz, Carol. *Recherches sur les rapports entre architecture et liturgie à l'époque carolingienne.* Paris, 1963.

Holl, K. "Die Entstehung der Bilderwand in der griechischen Kirche." *Archiv für Religionswissenschaft* 9 (1906), 365–84.

Khouri-Sarkis, G. "Notes sur l'anaphore syriaque: Prière du voile." *Orient syrien* 5 (1960), 363–84; 7 (1962), 277–96; 8 (1963), 3–20.

Klauser, Theodor. "Das Ciborium in der alteren christlichen Buchmalerei." *Nachrichten des Akademies der Wissenschaft in Göttingen, Phil.-hist. Klassen* 7 (1961), 191–208.

Krautheimer, Richard. "S. Pietro in Vincoli and the Tripartite Transept in the Early Christian Basilica." *Proceedings of the American Philosophical Society* 84 (1941), 353–429.

—— "Il transetto nella basilica paleocristiana." *Actes du Vᵉ congrès international d'archéologie chrétienne,* pp. 283–90. Aix-en-Provence, 1954.

Lassus, Jean. "La liturgie dans les basiliques syriennes." *Studi bizantini e neoellenici* 8 (1953), 418–28.

Leclercq, H. "Chaire épiscopale." *DACL,* 3, 1, 19–75.

Liesenberg, Kurt. *Der Einfluss der Liturgie auf die frühchristliche Basilika.* Neustadt-a.-d.-Hardt, 1928.

Mamboury, E. "Topographie de sainte-Sophie, le sanctuaire et la solea, le mitatorion, etc." *Atti del V Congresso di Studi Bizantini = Rivista di studi bizantini e neoellenici* 6, 2 (1940), 203.

Mango, Cyril. *The Brazen House.* Arkaeologisk-kunsthistoriske Meddeleser, 4. Copenhagen, 1959.

Mathews, Thomas F. "An Early Roman Chancel Arrangement and its Liturgical Uses." *RAC* 38 (1962), 71–95.

—— "Bouyer on Sacred Space: A Re-appraisal." *Downside Review* 82 (April, 1964), 111–23.

McClure, John. "How We Taped the Sound of San Marco." *High Fidelity* (February, 1968), 52–58.

Mparnea, Iōannēs M. *To Palaiochristianikon thusiastērion.* Athens, 1940.

Moraïtes, D. N. "βῆλα." *Thrēskeutikē kai ēthikē enkuklopaideia,* 3, 837–39. Athens, 1963.

Orlandos, Anastasios K. "Hē apo tou narthēkos pros to hieron metakinēsis tou diakonikou." *Deltion* (1966), 353–72.

Schneider, Alfons Maria. "Liturgie und Kirchenbau im Syrien." *Nachrichten der Akademie der Wissenschaften in Göttingen, Phil-hist. Klassen* 3 (January, 1947), 1–68.

Schneider, Carl. "Studien zum Ursprung liturgischer Einzelheiten östlicher Liturgien: 'καταπέτασμα'." *Kyrios* 1 (Königsberg, 1936), 57–73.

Selhorst, Heinrich. "Die Platzordnung im Gläubigenraum der altchristliche Kirche." Diss. Münster Universität, 1931.

Soteriou, G. A. "Hē prothesis kai to diakonikon." *Theologia* 18 (1940), 76–100.

Speck, Paul "Die 'ΕΝΔΥΤΗ': literarische Quellen zur Bekleidung des Altars in der byzantinischen Kirche." *Jahrbuch der österreich. byz. Gesellschaft* 15 (1966), 323–75.

Stefanescu, J. D. *L'illustration des liturgies dans l'art de Byzance et de l'Orient.* Brussels, 1936.

Stričević, D. "Yakonikon i protezis u ranokhristianiskim tsrkvana" [The diaconicon and the prothesis in early Christian churches.] *Starinar,* n.s. 9–10 (1958–59), 59–66.

—— "Iconografia dei mosaici imperiali a S. Vitale." *Felix Ravenna* 80 (1959), 5–27.

—— "Sur le problème de l'iconographie des mosaïques imperiales de Saint-Vital." *Felix Ravenna* 85 (1962), 80–100.

Taft, Robert F. "Some Notes on the Bema in the East and West Syrian Traditions." *OCP* 34 (1968), 326–59.

Völkl, L. " 'Orientierung' im Weltbild der ersten christlichen Jahrhunderte." *RAC* 25 (1949), 155–70.

Xydis, Stephen G. "The Chancel Barrier, Solea and Ambo of Hagia Sophia." *AB* 29 (1947), 1–24.

Lexicons:

Du Cange, Charles. *Glossarium ad scriptores mediae et infimae graecitatis.* Lyons, 1688.

Lampe, G. W. H. *Patristic Greek Lexicon.* Oxford, 1961–67.

Liddell, H. C., and Scott, R. *Greek-English Lexicon.* 9th ed. Oxford, 1940.

Index

Acem Ağa Mescidi, 28
Acoustics, 151, and ch. 6, n. 106
Aēr (*epitaphios*), 162, 171, *see also* Veils
Aisles: Old Hagia Sophia, 12, 19; Hag. Iōannēs Studios, 22–23; Hag. Theotokos Chalkoprateia, 32; Topkapī Sarayī basilica, 35; Beyazit basilica A (segregated aisles), 72, 73; Hag. Eirēnē, 83, 87; Hagia Sophia, 95–96, 133–34, *pl. 83*; congregation's use of, 117–25; not screened by curtains, 120–22, 163–65; women's place in, 130–33
Akakios, Hag., 73, 108
Allatius, Leo, 125, 130
Altar: in liturgical planning, 4, 38, 109; Old Hagia Sophia, 13; Hag. Iōannēs Studios, 19, 27; Hag. Sergios and Bacchos, 51; Hag. Polyeuktos, 54; Hag. Euphēmia, 61, 66–67; with confessio, 66–67, 109, *fig. 53*; Hag. Eirēnē, 86; Hagia Sophia, 98, 99; in First Entrance, 143, 144; place of Gospel, 148–49; in Entrance of the Mysteries, 155–58, 162; not concealed with curtains, 165–68; Middle Byzantine development, 179; representations of, *pls. 94–98*
Altar-cloth, 166–67
Ambo: in liturgical planning, 4, 110, 178; Old Hagia Sophia, 13, 19; Hag. Iōannēs Studios, 27; Topkapī Sarayī basilica, 37–38; Hag. Polyeuktos, 53; Hag. Iōannēs Hebdomon, 60, 61; Hag. Euphēmia, 66, *fig. 32*; Beyazit basilica A, 70, 73, *fig. 36, pls. 56–58*; Hag. Polyeuktos, 73; Hagia Sophia, 98; place of readings, 123–24, 147–49; laity at, 123–25; in First Entrance, 144; place for keeping the Scriptures, 148–49; Chrysostom's use for preaching, 150–51; secular uses of, 151; in Entrance of the Mysteries, 161, 162; at Communion, 172; in exit ceremony, 173; prayer behind, 173; disappearance in Middle Byzantine times, 179
Amida, 63
Anaphora, 162–63; liturgy not concealed during, 162–71

Anaplous, 151
Anastasius, emperor, 43
Andronicus Palaeologus, emperor, 97
Anna, empress, 97
Anthēmios on the Golden Horn, Hag., 73, 108, 123, and ch. 1, n. 79
Anthemius, architect, 88
Antony of Novgorod, story of ciborium curtains, 167–68
ἀντίδωρον, 172
Antoniades, E. M., 19, 126
Apostles, Church of, 47, 56, 73, 91, 109, 110, 123, 128, 133, 140
Armenia, 60
Arsenius, patriarch, 97
Atik Mustafa Paşa Camii, *fig. 52*
Atrium (or forecourt): in liturgical planning, 38, 107–8; Old Hagia Sophia, 14, 15, 18; Hag. Iōannēs Studios, 19–22, *fig. 6, pls. 3–7*; Hag. Theotokos Chalkoprateia, 28–30, 33, *fig. 12*; Topkapī Sarayī basilica, 35, 38, 39; Hag. Sergios and Bacchos and Hag. Petros and Paulos, 47, 51; Hag. Polyeuktos, 52; Hag. Iōannēs Hebdomon, 57, 61; Hag. Euphēmia, 67; Beyazit basilica A, 70–71; Hag. Eirēnē, 79–82, *figs. 38–40, pls. 59–60*; Hagia Sophia, 89, *fig. 48, pls. 72–75*; use in First Entrance, 145, 147; disappearance in Middle Byzantine times, 178

Bandmann, Günter, 6, 157
Baptistery: Hagia Sophia, 7, 89, 160; Old Hagia Sophia, 12–13, 19; Hag. Theotokos Chalkoprateia, 30; Topkapī Sarayī basilica, 35
Bases, column: Old Hagia Sophia, *pl. 1a*; Hag. Iōannēs Studios, 23; Hag. Theotokos Chalkoprateia, 32, *pl. 21*
Basil I, emperor, 28, 31–32, 61, 113
Basil II, emperor, 146, 165
Basilicas: early, 9–39; in Justinianic times, 42, 43–47, 67–73, 77, 144
Belting, Hans, 62–67 passim, 98

Bethlehem, basilica of the Nativity, ch. 1, n. 12
Beyazit basilica A, 6, 37, 57, 67–73, 91, 98, 108, 109, 120, 125, *figs. 34–37*, *pls. 54–58*
Beyazit church B, 67–69, 72, *fig. 34*
Beyazit church C, 67–69, 71, *fig. 35*
Beyazit II, sultan, 48
Bingham, Joseph, 149, 150
Bishop (celebrant or patriarch): in First Entrance, 138–47, *pls. 90–92*; place in synthronon for readings and preaching, 147, 149–51; not participant in Entrance of the Mysteries, 159–60; in Communion, 172–73; in exit ceremony, 173
Bittel, K., 27, 37
Borgia, Nilo, 115
Bornert, René, 115
Bouyer, Louis, 5, 110, 143
Brightman, F. E., 113, 138, 158
Budrum Camii, *see* Myrelaion

Candles: in First Entrance, 141; in Gospel procession, 149; in Entrance of the Mysteries, 155, 162
Cantors: place at ambo, 124; in First Entrance, 142, 146, *pl. 90*; leading psalms between the readings, 148
Capitals: Hag. Theotokos Chalkoprateia, 28, *pl. 18*; Topkapı Sarayı basilica, 35, *pl. 23*; Hag. Sergios and Bacchos, 45, *pl. 31*; Hag. Iōannēs Hebdomon, 56–57, *pls. 45–46*; Beyazit basilica A, 69, *pls. 54–55*
Catechumens: place for, 116, 125–30, 133; Liturgy of, 138–54; dismissal of, 152; decline of in Middle Byzantine times, 179
Celebrant, *see* Bishop
Chaliandros on Lesbos, basilica, 27
Chalice and paten: sacred vessels, 13, 159, 160; as gifts of the Emperor, 146–47, 156, *pls. 91–92*; in Entrance of the Mysteries, 154; at Communion, 172; returned to skeuophylakion after Communion, 159, 173
Chancel barrier: in liturgical planning, 4, 36, 38, 39, 109–10; Hag. Iōannēs Studios, 19, 25, 27, *figs. 7–9*, *pls. 13–16*; Hag. Theotokos Chalkoprateia, 32–33, *fig. 14*; Topkapı Sarayı basilica, 37, 38; Hag. Sergios and Bacchos, 51; Hag. Polyeuktos, 54, *fig. 26*, *pl. 39*; Hag. Euphēmia, 61, 65–66, 67, *figs. 31–32*, *pl. 52*; Beyazit basilica A, 72; Hagia Sophia, 96–98; use and meaning, 122–25; representations of, 165, *pls. 95–98*; Middle Byzantine development, 179
Chancel curtains, *see* Curtains on templon
Chancel piers, 25–26, 27, 32, 33, 54, 110, *figs. 9, 14, 26*, *pls. 15–16, 39, 89*

Chancel stylobates, 25, 27, 54, 65, 97, *figs. 7–9, 26, 31*, *pls. 13–14, 40, 52*
Cherubicon Hymn, 156, 158, 160
Chrysopolis (Scutari), 114
Ciborium: Hag. Polyeuktos, 54–55; Hag. Euphēmia, 66–67, *fig. 32*; Hagia Sophia, 96, 99, 166–67; not hung with curtains, 163, 165–68; representations of, 165, *pls. 94–98*
Commentators on the Divine Liturgy, 114
Communion: of laity, 112, 129, 159, 168, 170, 172–73, 178; of Emperor in the gallery, 132–33; of Apostles, 172, *pl. 99*
Confessio, 67, 109
Constantine the Great, emperor, 9
Constantine Porphyrogenitus, 6, 113
Constantius, emperor, 8, 17
Corinthius, Gabriel, 130
Courtyards flanking the church, 71–72, 89–91
Creed, 162, 168
Cross, in First Entrance, 142, 146, 147, *pls. 90, 91*
Crostarosa, Pietro, 118
Crypt: Hag. Iōannēs Studios, 27, *fig. 10*; Hag. Theotokos Chalkoprateia, 32, 33, *fig. 15*; Hag. Polyeuktos, 54; Hag. Iōannēs Hebdomon, 57, 60; in liturgical plan of Constantinople, 109, 177
Curtains: on doors at Old Hagia Sophia, 13; not used to conceal liturgy, 162–71; in aisles and galleries, 163–65; on ciborium, 163, 165–68; on templon, 163, 168–71
Cyzicus (Erdek), 114

Deacon: in First Entrance, 146–47, *pls. 90–91*; reading the Gospel, 148, 149; in Entrance of the Mysteries, 155, 160, 162; in exit ceremony, 173
De ceremoniis of Constantine Porphyrogenitus as a liturgical source, 113; and cited passim
Demangel, R., 55, 57, 60
Dēmētrios, Hag., 113
Dewing, H. B., 58
Diaconicon: absence in Constantinople explained, 141–45; mentioned, 4, 94, 179
Dirimtekin, Feridun, 16, 18, 93, 97
Divine Office, 118
Domed plans: introduction under Justinian, 3, 42; domed octagons, 42–51, 55–61; Hag. Polyeuktos probably domed, 52–53; domed hexagon, 61–67; Hag. Eirēnē, 78–88; Hagia Sophia, 88–99
Doors, closing of, 152
Du Cange, Charles Du Fresne, 117–18, 124, 126, 128, 133, 166

Ebersolt, Jean, 20, 28, 43–51 passim, 57, 94, 113

Eirēnē, Hag., 6, 7, 27, 71, 77–88, 91, 93, 96, 103, 108, 109, 120, 124, 144, 161, 177, 179, *figs. 38–47, pls. 59–69*

Emperor (Empress and Imperial Court): part in the liturgy, 6, 113; Imperial loge at Hagia Sophia, 96, 130–134, *fig. 50, pls. 87–88*; use of galleries, 129, 131, 132; in First Entrance, 140, 142–43, *pls. 91–92*; in Entrance of the Mysteries, 161–62; at Communion, 172–73

Entrances, architectural: western entrances, 12–16, 20–22, 35, 48, 52, 55, 64, 70–71, 79–83, 91: eastern entrances, 13, 19, 21–22, 30–31, 33, 35–37, 38, 64–65, 67, 72, 94, 103

Entrances, liturgical: First (Little) Entrance, 111–12, 138–47, *pls. 90–92*; Entrance of the Mysteries (Great Entrance), 111–12, 146, 155–62, 178

Entry: Prayer of, 139, 140, 141; Blessing of, 141

Ephesus, Hag. Iōannēs in, 56, 57, 69, 109, 110

Epitaphios, see Aēr

Eski Imaret Camii, *fig. 52*

Eudoxius, patriarch, 9

Euphēmia, Hag., 6, 27, 42, 56, 61–67, 73, 98, 103, 108, 109, 110, 121, 144, *figs. 29–33, pls. 48–53*

Eutychius, patriarch, 138, 139, 144, 157, 159, 173

Evagrius, 131

Exit ceremony, 173

Fenari İsa Camii (Theotokos Lips), 62, 107, *fig. 52*

Fīratlī, Nezih, 28

First Entrance, *see* Entrances, liturgical

Flabella, 160, 173

Fossati, Gaspard, 89, 97

Forecourt, *see* Atrium

Forum of Constantine, 161

Forum Tauri, 66–67

Fountains: Hag. Iōannēs Studios, 21; Topkapī Sarayī basilica, 35; Hagia Sophia, 89

Freshfield, E., 162

Galleries: Old Hagia Sophia, 13; Hag. Iōannēs Studios, 19–23, *pls. 10–12*; Hag. Theotokos Chalkoprateia, 31–32, 33; Topkapī Sarayī basilica, 38; Hag. Petros and Paulos, 47; Hag. Sergios and Bacchos, 48–49, 50, 51; Hag. Polyeuktos, 53; Hag. Iōannēs Hebdomon, 59, 61; Hag. Eirēnē, 83, 87; Hagia Sophia, 94, 95, *pls. 84–85*; use for catechumens, 128–29; love-making in, 129, 130, 133; women in, 130–32; curtains in, 163–65; in Middle Byzantine times, 179

Geōrgios, in Chalcedon, Hag., 129

Germanus, patriarch: commentary on the liturgy, 114–15; on the parts of the church, 122; meaning of the synthronon, 143; on the Entrance of the Mysteries, 159–60; on the meaning of the chancel barrier, 170; and cited passim

Gifts: presented in First Entrance, 143, 146–47, *pls. 91–92*; of bread and wine in the Entrance of the Mysteries, 155, 156–59

Glück, H., 56, 57

Goar, Jacobus, 126

Gospel: veneration at ambo, 124–25, 149; in First Entrance, 139, 141, 142, 146, 147, *pls. 90–91*; enthronement on altar, 141–42, ch. 6, n. 36; reading of, 148–49; in procession to and from ambo, 149, 178

Grabar, André, 61, 62, 65, 67, 146–47, 177

Great Entrance, *see* Entrances, liturgical

Greece, liturgical planning in, 5, 6, 23, 38, 70, 72, 106–110, 118–21, 125, 162

Gregory of Nazianzus, Homilies (Paris, B.N., ms.Gr. 510), 151–52, *pl. 95*

Gregory Thaumaturgus, 126

Grelot, Guillaume, 89, 126

Gurlitt, C., 43

Gyllius, Petrus, 47, 89

γυναικίτης, origin and definition of term, 132–33; *see also* Women, places for

Hanssens, I.M., 112, 114, 149

Heitz, Carol, 5

Heraclius, emperor, 62, 114

Hodēgētria Shrine, 7

ἱερατεῖον, definition, 121–22; *see also* Chancel barrier

Holy Door: Hag. Theotokos Chalkoprateia, 32; in Entrances, 112; in First Entrance, 140–44 passim; in Gospel procession, 149; in Entrance of the Mysteries, 155, 160, 162; at Communion, 172; in Middle Byzantine liturgy, 178

Holy Well, shrine at Hagia Sophia, 93, 94, 132

Honor Guard, 142

Iakōbos, Hag., 31

Imperial loge, *see* Emperor

Imrahor Camii, 20

Incensing: initial, 138; in First Entrance, 141, 146, 147, *pls. 90–91*; in Gospel procession, 149; in Entrance of the Mysteries, 155, 160, 162

Inlaid columns, 54–55, 56, 60, 62–63, *pls. 41, 44, 49–50*

Iōannēs in Taurus, Hag., 68

Iōannēs in Hebdomon, Hag., 6, 55–61, 62, 67, 73, 108, 177, *figs. 27–28, pls. 42–46*

Iōannēs Studios, Hag., 6, 7, 9, 17, 19–27, 28, 30, 32, 35, 37, 38–39, 57, 65, 67, 89, 93, 96, 97, 99, 109, 110, 120, 144, *figs. 5–10, 12, pls. 3–16*

Iōannēs Theologos in Hebdomon, Hag., 56, 61

Iōannēs Trullo, Hag., *fig. 52*

Isaac II, emperor, 52

Isidore, architect, 88

Janin, Raymond, 9, 28

Jantzen, Hans, 94

John II, patriarch, 123

John Chrysostom, patriarch, 12–13, 123, 127, 128, 130, 148, 150, 151, 169, 172

Jungmann, Josef, 112

Justin I, emperor, 43

Justin II, emperor, 28, 156, 158

Justinian I, emperor, 9, 42, 43, 47, 56, 88, 114, 147, 166

Kähler, Heinz, 12, 91, 95, 98

Kalenderhane Camii, ch. 4, n. 12

Karpos and Papylos, Hag., 7

κατηχούμενον, origin and definition of term, 128–29; *see also* Catechumens

Kautzsch, Rudolf, 35

Keck, Andrew S., 15

Khouri-Sarkis, G., 170

Kleiss, Wolfram, 14, 19, 28, 30

Krautheimer, Richard, 16, 119–20

Laity: in nave and aisles, 116–25; in First Entrance, 140–41, 145, 146, *pls. 90–92*; at Communion, 172

Lampe, G. W. H., 167

Lassus, Jean, 6

Lathoud, D., 28

Lavin, Irving, 61

Lectors, 148–49

Lemerle, P., 119

Leo I, emperor, 28

Leo I, pope, 123–24

Leo III, emperor, 120

Leo V the Armenian, emperor, 167

Leo VI, emperor, 113, 129

Lethaby, W. R., 94

Liesenberg, Kurt, 5

Litanies: initial, 138; of the Faithful, 155

Little Entrance, *see* Entrances, liturgical

Liturgical planning: defined, 3–4; in the early

basilicas, 38–39; in Justinianic times, 73; characteristics in Constantinople, 103–111; and cited passim

Liturgy, Byzantine: defined, 3–5; stability of, 111; general shape, 111–12; studies of, 112; sources for, 112–13; Middle Byzantine development, 177–79; and cited passim

Liturgy, Roman, compared with the Byzantine, 107, 111, 142–43, 144, 150, 156

Mamboury, Ernest, 28, 29, 30–31

Mango, Cyril, 93, 94

Mateos, Juan, 112, 139

Markos, Hag., 68, 69

Martyrium, 3, 61, 67, 177

Masonry: Old Hagia Sophia, 15–16, 16–17, *fig. 3*; Hag. Iōannēs Studios, 21, 23, *fig. 6, pls. 5–7, 11–12*; Hag. Theotokos Chalkoprateia, 28, *fig. 15, pls. 17, 19–20*; Hag. Petros and Paulos and Hag. Sergios and Bacchos, 44–47, 48, 49–50, *figs. 19–23, pls. 26–28, 33–36*; Hag. Iōannēs Hebdomon, 57, *pls. 42–43*; Hag. Euphēmia, 64, *pl. 51*; Hag. Eirēnē, 79, 81, 83, 84–86, *figs. 38–39, 44–45, pls. 61, 63–67, 69*; Hagia Sophia, 93, 95, *pls. 74–77, 79*

Maximianus, bishop of Ravenna, 147, 166–67

Maximus the Confessor: commentary on the liturgy, 114; on the parts of the church, 121–22; on catechumens, 128; in the gallery, 129; on the First Entrance, 140–41; on the meaning of the chancel barrier, 169–70; and cited passim

Mehmet Fatih II, sultan, 98

Mēnas and Mēnaios in Hebdomon, Hag., 56

Menologion of Basil II (Vat. Gr. 1613), 146, 165, *pl. 97*

Mēsē, 161

Metatorion at Hagia Sophia, 96, 132, 134

Michael I, emperor, 167

Michael III, emperor, 32, 132

Michael VIII Palaeologus, 97

Michaēl in Anaplous, Hag., 56, 73, 108

Michaēl in Byzantium, Hag., 106

Michaēl in Sinator, Hag., 73

Mōkios, Hag., 132

Mparnea, Iōannēs, 165, 171

Music: congregation's part, 124; in First Entrance, 142, 145, 146; between readings, 148; at Communion, 172; *see also* Cherubicon Hymn

Myrelaion (Budrum Camii), 57, 107, *fig. 52*

ναός, definition of term, 121–22, ch. 5, n. 28;

see also Nave

Narthex: Hag. Iōannēs Studios, 20–22, *pl. 3*; Topkapı Sarayı basilica, 35, 38; Hag. Petros and Paulos and Hag. Sergios and Bacchos, 43–44, 45, 47, 48, 51, *fig. 42, pl. 37*; Hag. Polyeuktos, 52; Hag. Iōannēs Hebdomon, 61; Beyazit basilica A, 70–71, 72; Hag. Eirēnē, 82–83; Hagia Sophia, 89, 90; liturgical use, 108, 125 ff.; in First Entrance, 139–49, 145

Naumann, Rudolf, 66, 98

Nave, use in Byzantine liturgy, 117–25; in First Entrance, 139, 140, 144; and cited passim

Nea, Church of the, 113

Nea-Anchialos: Basilica B, 27; Basilica A, 35

Nicephorus, patriarch, 129

Nicholas of Andida, 170–71

Nordström, Carl-Otto, 147

Ogan, Aziz, 33, 34, 37

Old Hagia Sophia, 6, 7, 9–19, 28, 38–39, 88, 123, 161, *figs. 1–4, pls. 1a–2*

Omophorion (stole), 145, 147, 160

Oratories: in the galleries, 51, 129, 133, 179; by the metatorion in Hagia Sophia, 134

Orientation, 13

Orlandos, A., 6, 119, 162

Oven, in the skeuophylakions, 161

Palaces: Imperial, 30; Hormisdas, 43, 47, 50; of Anicia Juliana, 52; Iucundianae and Magnaura in Hebdomon, 56; Antiochos, 61

Palladius, biographer of Chrysostom, 12, 13

Pantokratōr, 23

Paros, 27

Paspates, A. G., 45, 48

Paten, *see* Chalice and paten

Patriarch, *see* Bishop

Patriarchate, 13, 79, 145, ch. 3, n. 53

Paul the Silentiary: furnishings of Hagia Sophia, 88, 98–99; on use of the nave, 124–25; on place of women, 130; description of altar hanging, 166; description of templon in Hagia Sophia, 169; and cited passim

Pavements: Old Hagia Sophia, 14, *fig. 1*; Hag. Iōannēs Studios, 20, 23, *pl. 13*; Topkapı Sarayı basilica, 34–35, *pl. 22*; Hag. Iōannēs Hebdomon, 61; Hagia Sophia, 97–98, *pls. 81–82*

Peace: greeting at First Entrance, 139, 143, 145; during readings, 149; Kiss of, 162

Penitents, discontinuance of class in Early Byzantine times, 125–27

Petros and Paulos, Hag., 7, 42–47, 48, 51, 73, *figs. 19–21, pls. 27–28*

Philippi: Basilica A, 108, 119; Basilica B, 108, ch. 2, n. 68

Photius, patriarch, 31

Piers of chancel, *see* Chancel piers

Pola casket, 169

Polyeuktos, Hag., 6, 52–55, 56, 62, 70, 97, 103, 108, 110, 121, 177, *figs. 25–26, pls. 39–41*

Preaching, 147–52, 170, *pl. 93*

Preface to the Anaphora, 162, 171

Preslav, Round Church, 62

Priskos and Nicholas, Hag., 108

Procopius: on Hag. Sergios and Bacchos, 43–44, 46–47, 48; on Hag. Iōannēs Hebdomon, 55–56, 57–60; on Hagia Sophia, 88; on chancel barriers, 122–23; on places for women, 130–31; and cited passim

Propylaeum: Old Hagia Sophia, 13, 14–17, 18, *fig. 1, pls. 1a, 2*; Hag. Sergios and Bacchos and Hag. Petros and Paulos, 47, 51

Prothesis: supposed, at Hag. Iōannēs Hebdomon, 60; supposed, at Hagia Sophia, 94; absence in Constantinople explained, 107, 138, 155, 156, 161; appearance in Middle Byzantine architecture, 179

Pulcheria, empress, 28, 169

Ramazanoğlu, Muzaffer, 97

Ravenna: S. Vitale, 43, 60, 146–47; S. Giovanni Evangelista, 106; S. Apollinare in Classe, 146, 169; altar-cloths, 166

Readings in liturgy, 147–49, 170

Roman liturgy, *see* Liturgy, Roman

Rome: S.ta Agnese and S. Sebastiano, 12; S. Clemente and S. Pietro in Vincoli, ch. 2, n. 45; St. Peter's and S.ta Maria Maggiore, 169

Rossano Gospel, 165

Royal Door: at Hag. Iōannēs Studios, 22; at Hag. Sergios and Bacchos, 48; in First Entrance, 140, 141, 142, 144, 145, 147; in exit ceremony, 173

Russian Archaeological Institute, 19–20, 27

Salaville, S., 112, 118, 149

Salzenberg, W., 23, 89

Sanpaolesi, Piero, 43

Schneider, A. M., 6, 14–15, 67, 89, 91, 157

Schneider, Carl, 163

Schulz, Hans-Joachim, 112, 149, 158

Selhorst, Heinrich, 118

Sergios, patriarch, 129, 158, 159, 173

Sergios and Bacchos, Hag., 6, 7, 42–51, 73, 98, 109, 110, 121, 128, 133, *figs. 19–24, pls. 24–38*

Sergius I, pope, 167

Skeuophylakion: at Hagia Sophia, 13, 14, 38, 89, *figs. 2–3, pl. 1b*; at Hag. Eirēnē, 161, *fig. 44, pl. 67*; at Hag. Theodōros Sphōrakios, 161; use in the Entrance of the Mysteries, 158–59, 160–62, 178

Solea: Old Hagia Sophia, 13; Iōannēs Studios, 27; Hag. Theotokos Chalkoprateia, 32; Topkapī Sarayī basilica, 37–38; Hag. Polyeuktos, 54; Hag. Euphēmia, 61, 66, 67, 73, *figs. 31–32*; Hagia Sophia, 98–99; in Constantinopolitan liturgical plan, 110; use in Gospel procession, 124–25; in First Entrance, 140, 142, 143, 144; in Entrance of the Mysteries, 162; at Communion, 172; in exit ceremony, 173; disappearance in Middle Byzantine architecture, 178–79

Sophia, Hagia, of emperor Justinian, 6, 7, 28, 35, 43, 60, 61, 69, 70, 73, 88–99, 103, 109, 110, 121, 122, 124, 126, 128, 130, 132, 133–34, 140, 144, 158, 160, 169, 177, 179, *figs. 48–50, pls. 70–88*; see also Old Hagia Sophia

Sōtēr Christos, church of, 31

Soteriou, G., 6, 162

Speck, Paul, 166

Stair ramps: Hag. Iōannēs Studios, 23; Hag. Sergios and Bacchos, 49–50, *fig. 24, pls. 37–38*; Hag. Polyeuktos, 55; Hag. Eirēnē, 83, 87, *pl. 61*; Hagia Sophia, 91, 93–94; location outside the church, 108, 129, 152; in Middle Byzantine planning, 179

Stole (omophorion), 145, 147, 160

Stričević, D., 146, 162

Strygowski, J., 177

Stylobate of chancels, *see* Chancel stylobates

Subdeacon in First Entrance, 142

Swainson, H., 47

Swift, E. H., 88, 95, 164

Symeon of Thessalonike, on the parts of the church, 117–18

Synagogue, liturgy of, 150

Synthronon: in Constantinopolitan liturgical plan, 4, 38, 109; Hag. Iōannēs Studios, 19, 27, *figs. 8, 10*; Hag. Theotokos Chalkoprateia, 32, 33; Hag. Euphēmia, 61, 66, 67, *figs. 32–33, pl. 53*; Hag. Eirēnē, 85–86, figs. *45–47, pls. 68–69*; Hagia Sophia, 99; in First Entrance, 143, 144; bishop's place during readings, 146–48; bishop's place during preaching, 150–52; visibility of, 165, 170, 171; Middle Byzantine development, 179; representations of, *pls. 93, 96–98*

Syria, liturgical planning in, 6, 110, 120, 125, 157, 163, 165–67, 169–70

Taft, Robert, 112

Templon, curtains on, 163, 168–71; *see also* Chancel barrier

Tetrapylon of Theodosius I, 68

Texier, Charles, 48, 126

Theodora, empress, 47, 147, 166

Theodōros by the Bronze Tetrapylon, Hag., 68

Theodōros in Rhegium, Hag., 129

Theodōros in Rhesium, Hag., 108

Theodōros Sphōrakios, Hag., 161

Theodosius I, emperor, 56, 68, 123

Theodosius II, emperor, 14, 17, 28, 35, 56

Theotokos Blachernes, Hag., 73, 146

Theotokos Chalkoprateia, Hag., 6–7, 17, 27, 28–33, 34, 35, 38–39, 57, 67, 103, 109, 110, 124, 128, 132, 140, 170, *figs. 11–15, pls. 17–21*

Theotokos τὰ κουράτορος, Hag., 68, 69

Theotokos Lips (Fenari İsa Camii), 62, 107, *fig. 52*

Theotokos in Pēgē, Hag., 133

Thessalonike: Acheiropoiētos Church, 23, 108; Hag. Dēmētrios, 108; Hag. Geōrgios, 169

Thibaut, Jean-Baptiste, 56

Throne: of emperor at Hagia Sophia, 133–34, *fig. 50, pls. 87–88*; of bishop, 139, 143, 150, 151, 170, *pls. 96, 98*

Topkapī Sarayī basilica, 6, 7, 33–38, 38–39, 73, 98, 108, 109, 110, 120, *figs. 16–18, pls. 23–24*

Transept, supposed, at Topkapī Sarayī basilica, 37

Typicon of Hagia Sophia, 113, and cited passim

Underwood, Paul A., 43, 45

van de Paverd, F., 151

van Millingen, Alexander, 20, 23, 27, 43

Van Nice, R. I., 18, 88, 91, 93, 94, 95

Veils in Entrance of the Mysteries, 160, 162, 171; *see also* Curtains

Verina, empress, 28

Vienna Genesis (Vindob. Gr. 31), 165, *pl. 94*

von Simson, Otto, 146

Ward Perkins, J. B., 15, 43

Women, places for, 128–33, 164

Wulff, O., 55, 89

Xydis, Stephen G., 96–97, 110

Yugoslavia, liturgical plans in, 162

Zaloziecky, W. R., 91

Plates

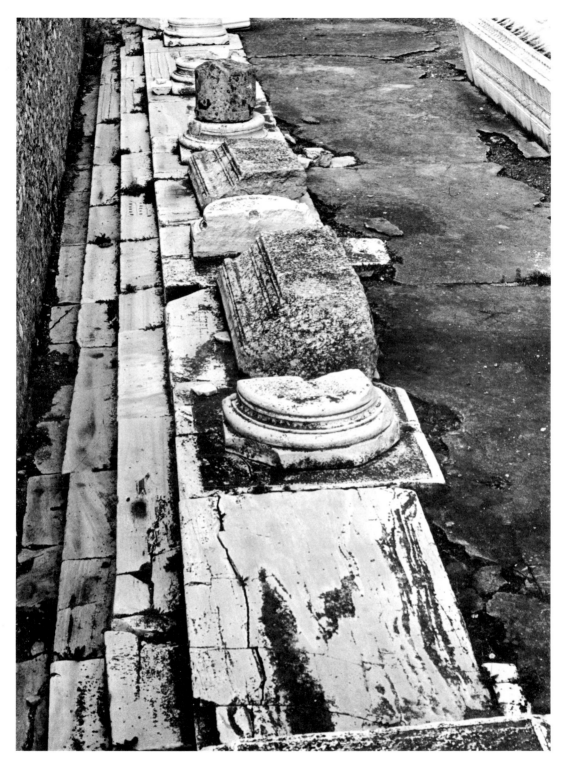

1a. Old Hagia Sophia. Stairs and column bases of propylaeum

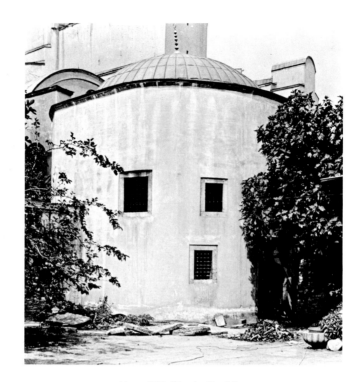

1b. Old Hagia Sophia.
Skeuophylakion, from the northeast

2. Old Hagia Sophia. Pediment of propylaeum (detail)

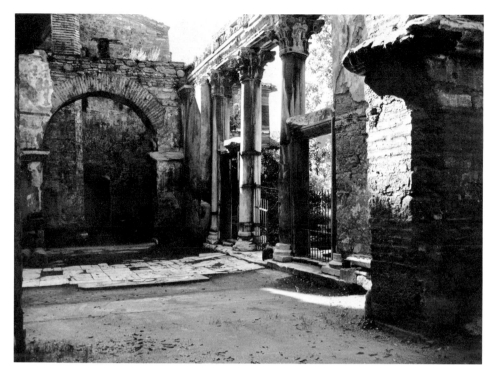

3. Studios Basilica. Eastern portion of atrium, or narthex

4. Studios Basilica. Turning of atrium entablature, north end of narthex

5. Studios Basilica. North wall of atrium

6. Studios Basilica. North wall of atrium,
first (narthex) and second entrances

7. Studios Basilica. North wall

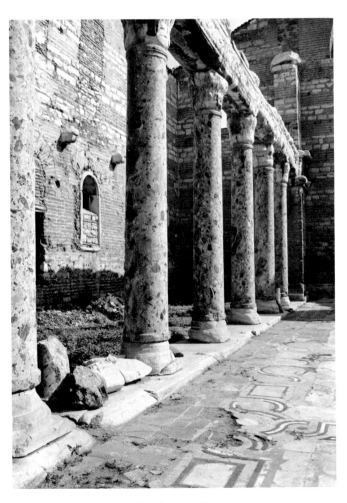

8. Studios Basilica.
North colonnade of nave from the west

of atrium, second to fifth entrances

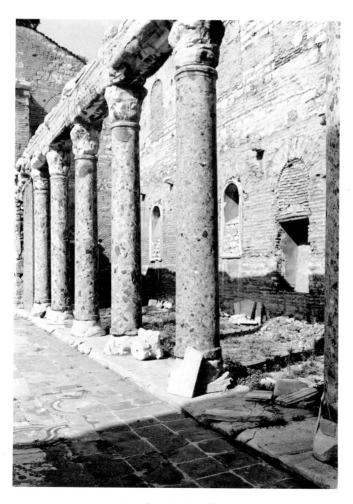

9. Studios Basilica.
North colonnade of nave from the east

10. Studios Basilica. West wall (interior)

11. Studios Basilica. North wall of narthex showing gallery entrance

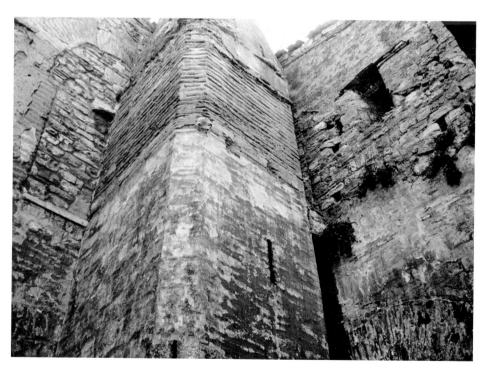

12. Studios Basilica. South wall of narthex (right) showing gallery entrance

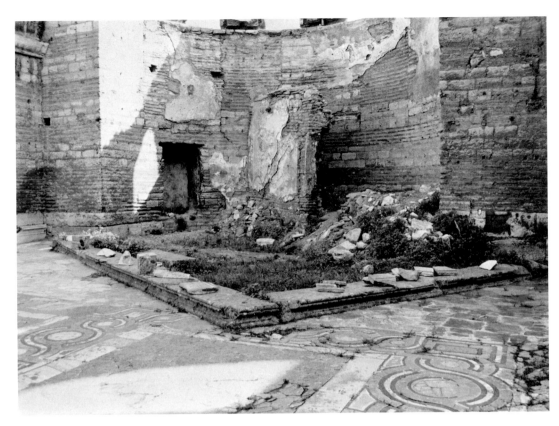

13. Studios Basilica. Chancel remains

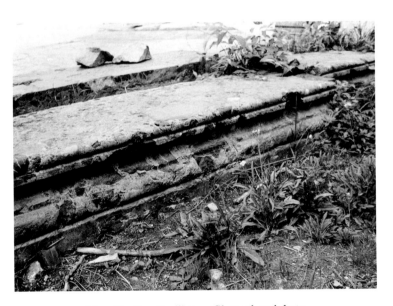

14. Studios Basilica. Chancel stylobate

15. Studios Basilica. Pier fragment

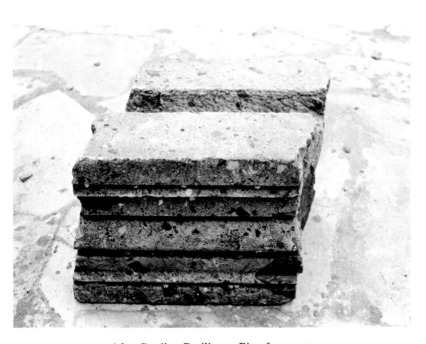

16. Studios Basilica. Pier fragment

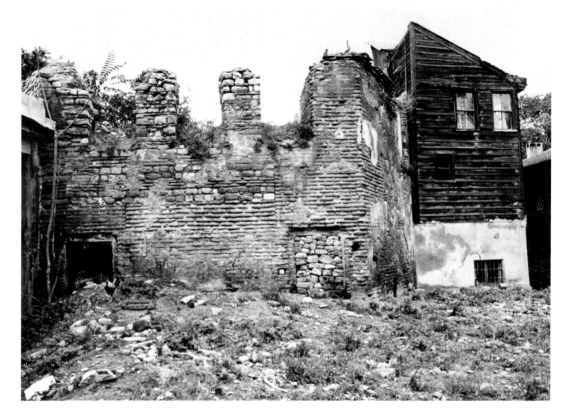

17. Chalkoprateia Basilica. Apse

18. Chalkoprateia Basilica. Capital

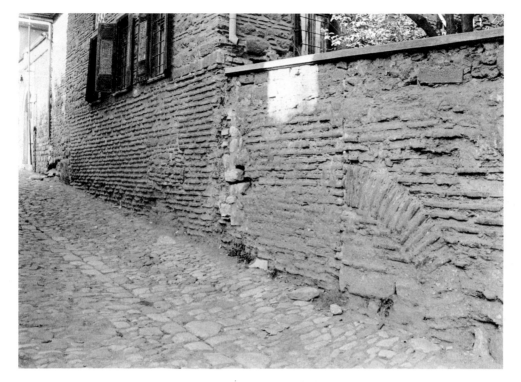

19. Chalkoprateia Basilica. North wall, from the east

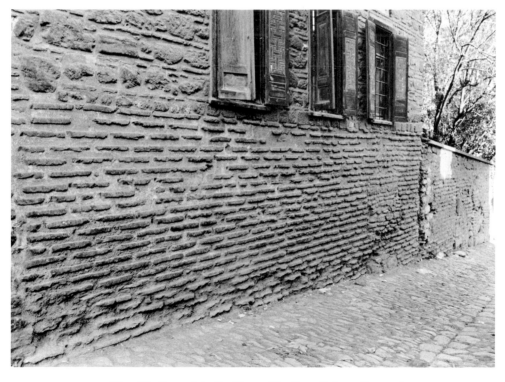

20. Chalkoprateia Basilica. North wall, from the west

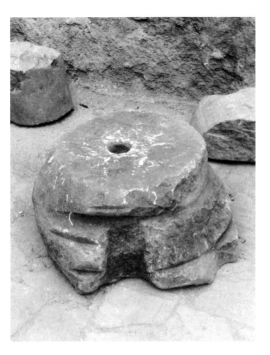

21. Chalkoprateia Basilica. Column base

23. Saray Basilica. Capital

22. Saray Basilica. Pavement

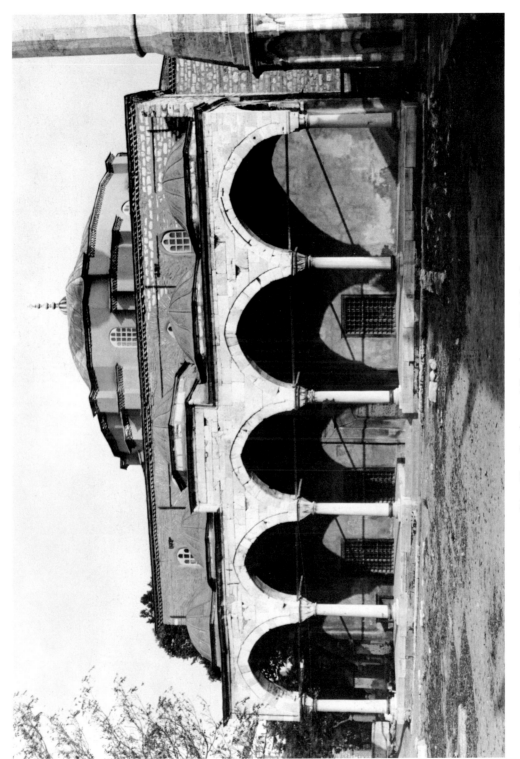

24. Hag. Sergios and Bacchos. West façade

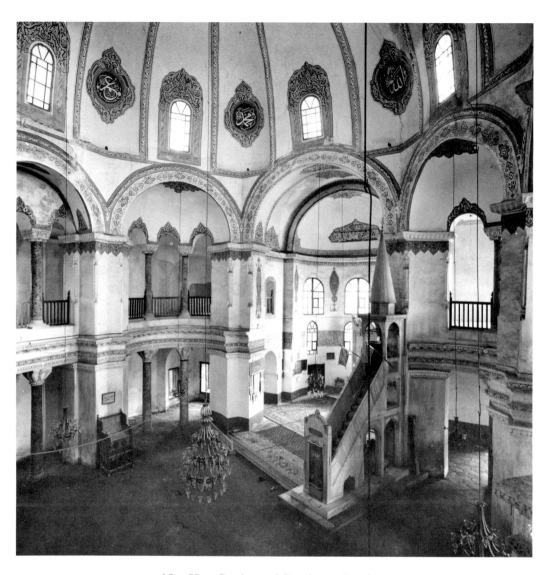

25. Hag. Sergios and Bacchos. Interior

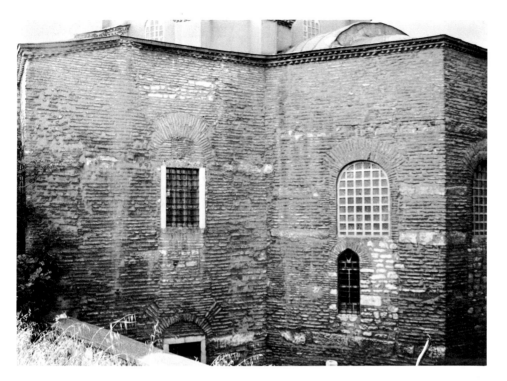

26. Hag. Sergios and Bacchos. East wall

27. Hag. Sergios and Bacchos. South wall

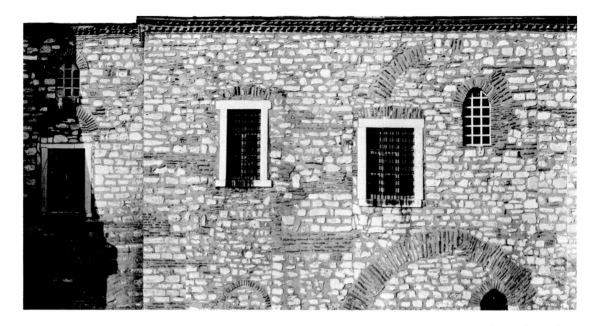

28.　Hag. Sergios and Bacchos.

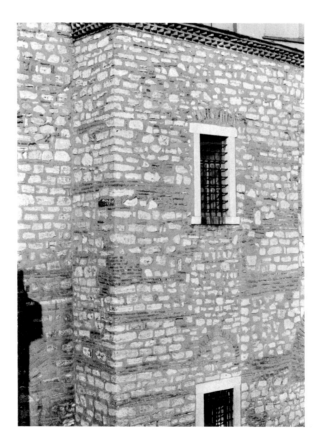

29.　Hag. Sergios and Bacchos.
Joint of narthex wall (left) with south wall

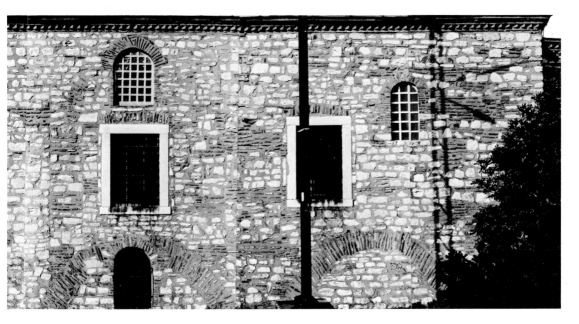

South wall

30. Hag. Sergios and Bacchos.
South ambulatory, from the west

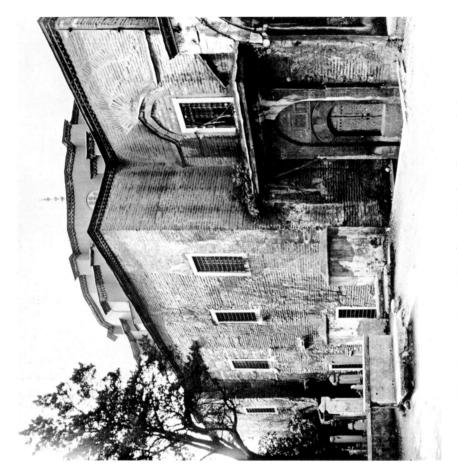

32. Hag. Sergios and Bacchos. North wall, general view

31. Hag. Sergios and Bacchos. Capital in south ambulatory

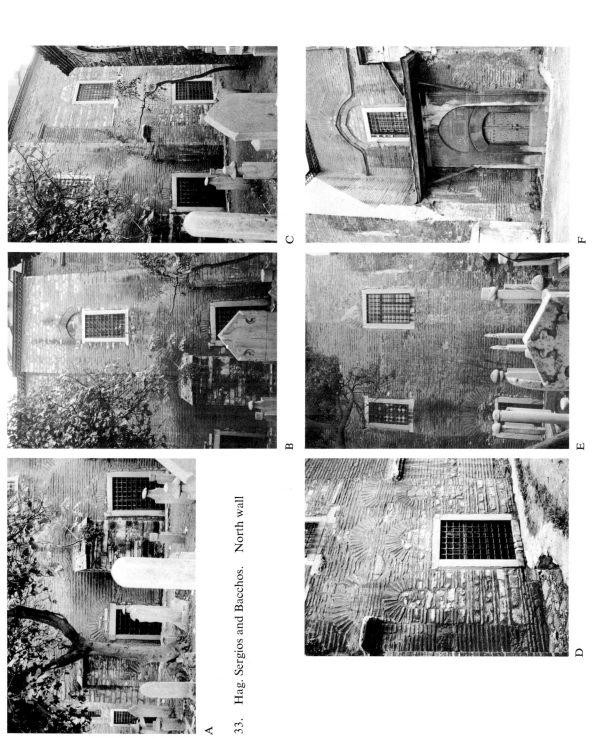

A

B

C

D

E

F

33. Hag. Sergios and Bacchos. North wall

34. Hag. Sergios and Bacchos. Northeast corner

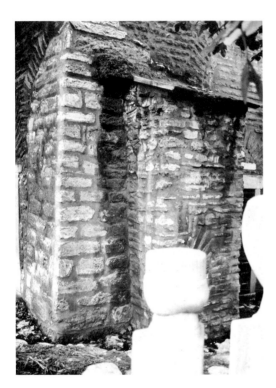

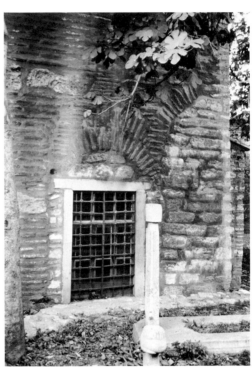

35. Hag. Sergios and Bacchos.
Northeast corner, ground floor, from the north

36. Hag. Sergios and Bacchos.
Northeast corner, ground floor, from the east

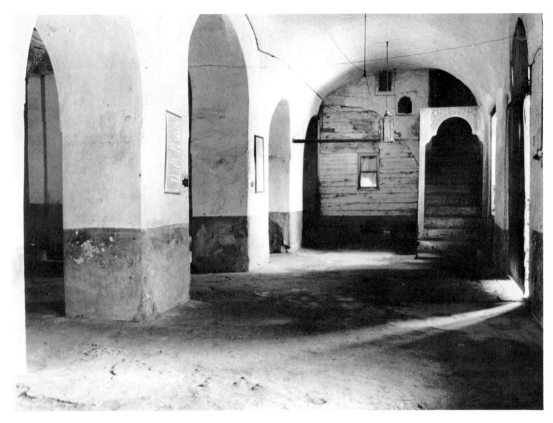

37. Hag. Sergios and Bacchos. Narthex, looking south

38. Hag. Sergios and Bacchos. Arch over narthex stair

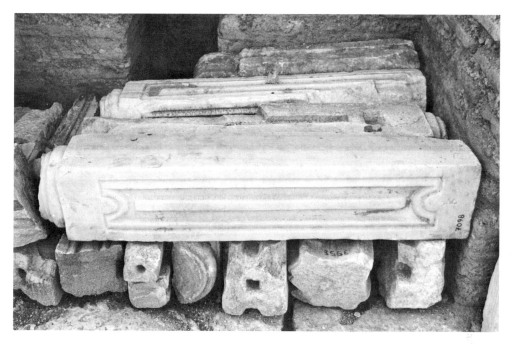

39. Hag. Polyeuktos. Chancel piers (no. 7098 nearest camera)

40. Hag. Polyeuktos.
Stylobate fragment (no. 6900)

41. Hag. Polyeuktos.
Inlaid column

42. Hag. Iōannēs in Hebdomon. Apse from the west in 1965

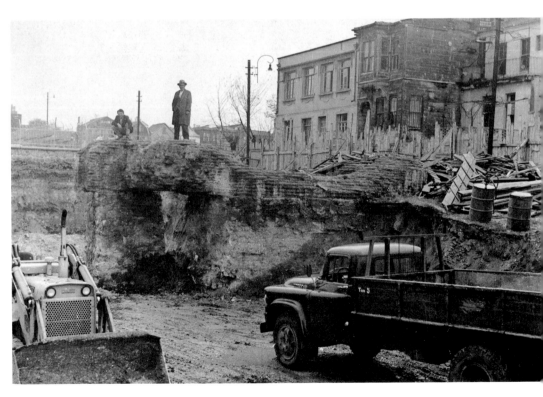

43. Hag. Iōannēs in Hebdomon. Apse from the east in 1965

45. Hag. Iōannēs in Hebdomon.
Ionic impost capital in Ayasofya Museum garden

44. Hag. Iōannēs in Hebdomon.
Inlaid column (Istanbul
Archaeological Museum, no. 3908)

46. Hag. Iōannēs in Hebdomon.
Ionic impost capital in Ayasofya Museum garden

47. Hag. Iōannēs in Hebdomon.
Slab

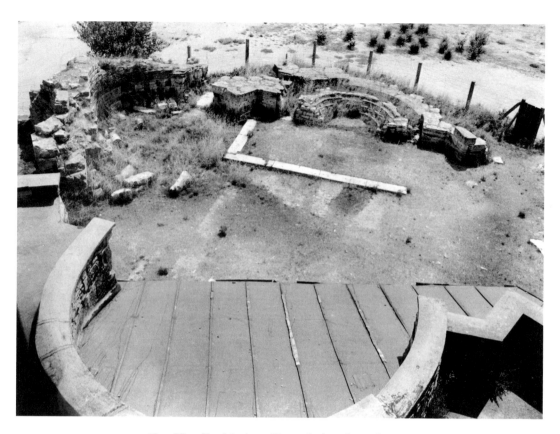

48. Hag. Euphēmia. General view, from the west

49. Hag. Euphēmia.
Inlaid column (Istanbul
Archaeological Museum,
no. 5078)

50. Hag. Euphēmia.
Inlaid column (Istanbul Archaeological
Museum, no. 5078; detail)

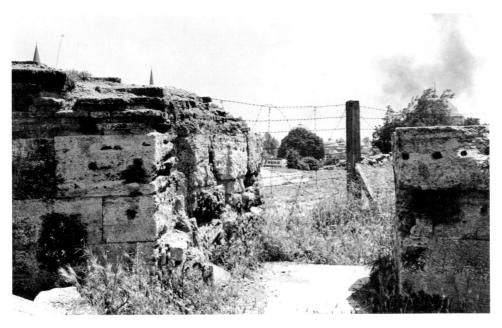

51. Hag. Euphēmia. New entrance in apse no. 3

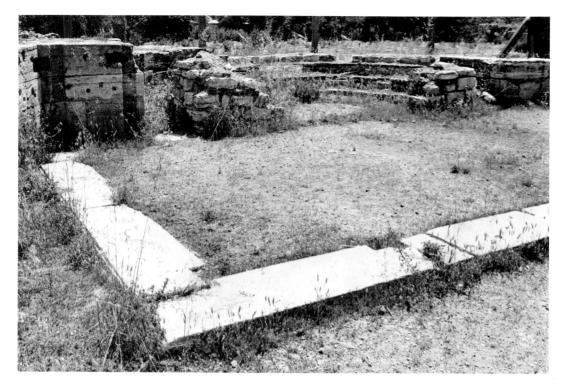

52. Hag. Euphēmia. Stylobate of chancel

53. Hag. Euphēmia. Synthronon

54. Beyazit Basilica A. Capital in Ayasofya Museum garden

55. Beyazit Basilica A.
Capital in Ayasofya Museum garden

56. Beyazit Basilica A. Ambo in Ayasofya Museum garden

57. Beyazit Basilica A.
Detail of ambo

58. Beyazit Basilica A.
Detail of ambo base

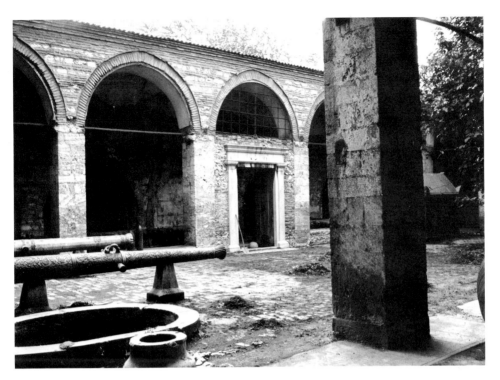

59. Hag. Eirēnē. Atrium

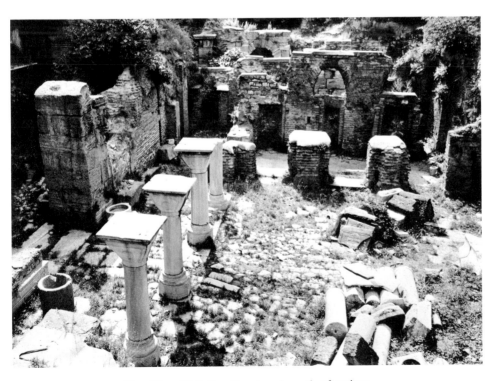

60. Hag. Eirēnē. Courtyard south of atrium

61. Hag. Eirēnē. South stair-ramp

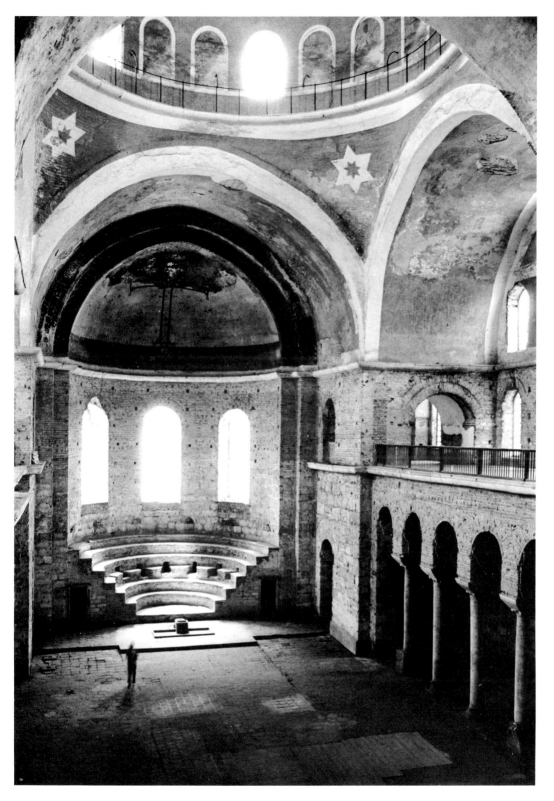

62. Hag. Eirēnē. Interior

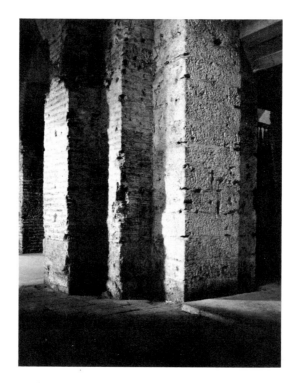

63. Hag. Eirēnē. Southwest pier, showing
addition of new narthex (brick) to earlier
church (stone)

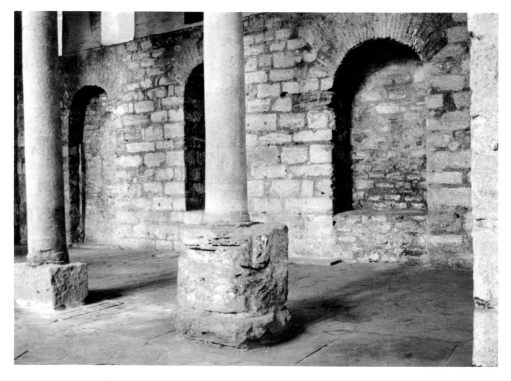

64. Hag. Eirēnē. Two entrances flanking a niche in the north aisle

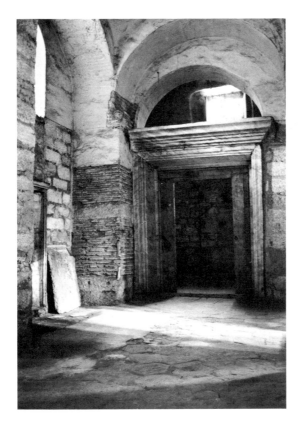

65. Hag. Eirēnē. Northeast entranceway

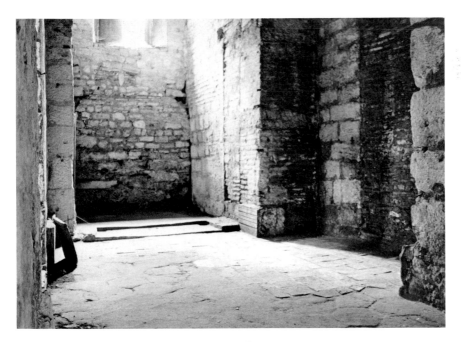

66. Hag. Eirēnē. Southeast entranceway

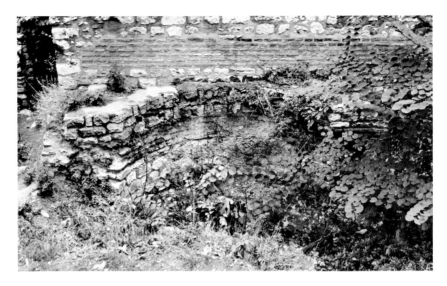

67. Hag. Eirēnē. Circular structure at northeast corner

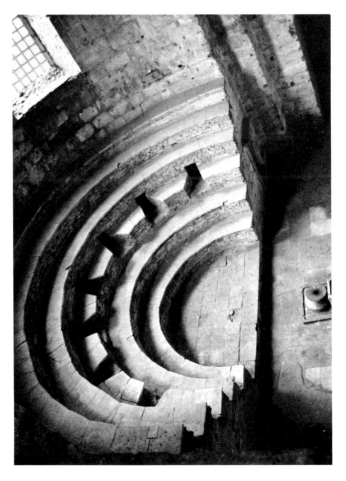

68. Hag. Eirēnē. Synthronon

69. Hag. Eirēnē. Synthronon, right side

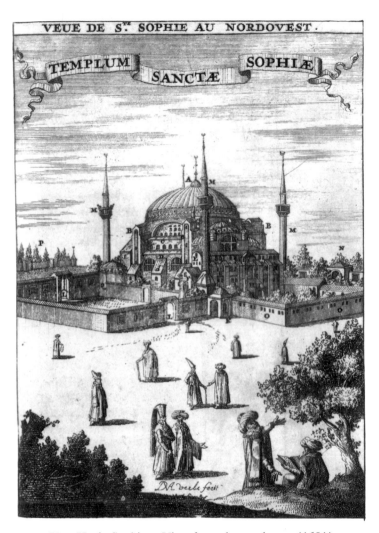

70. Hagia Sophia. View from the northwest (1681)

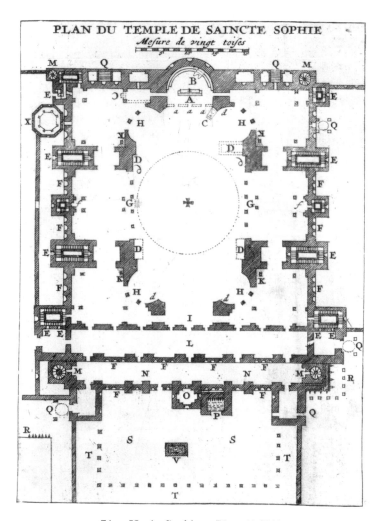

71. Hagia Sophia. Plan (1681)

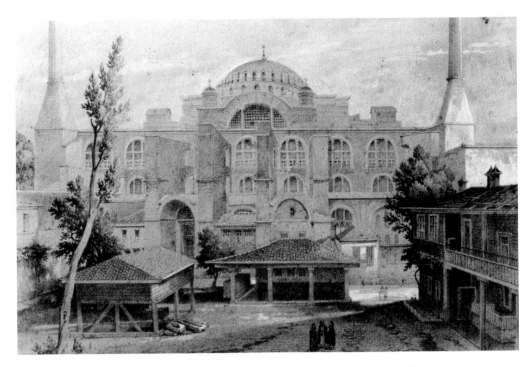

72. Hagia Sophia. West façade and medrese (1847-49)

73. Hagia Sophia. Southwest view (1847-49)

74. Hagia Sophia. Atrium, northeast corner, from the south

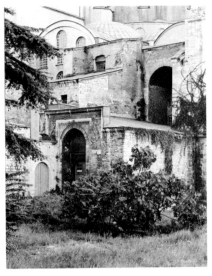

76. Hagia Sophia. Northwest vestibule, from the northwest

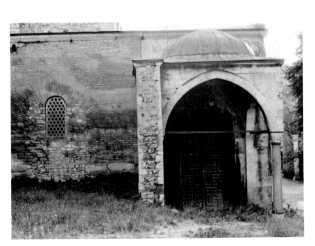

75. Hagia Sophia. Atrium, north exterior wall

77. Hagia Sophia. Northwest vestibule, from the west

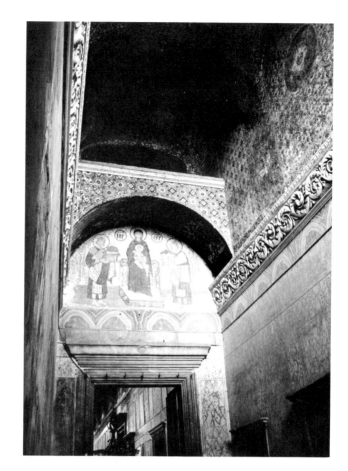

78. Hagia Sophia. Southwest vestibule,
archway over entrance to narthex

79. Hagia Sophia. Secondary
arch in southeast pier, gallery

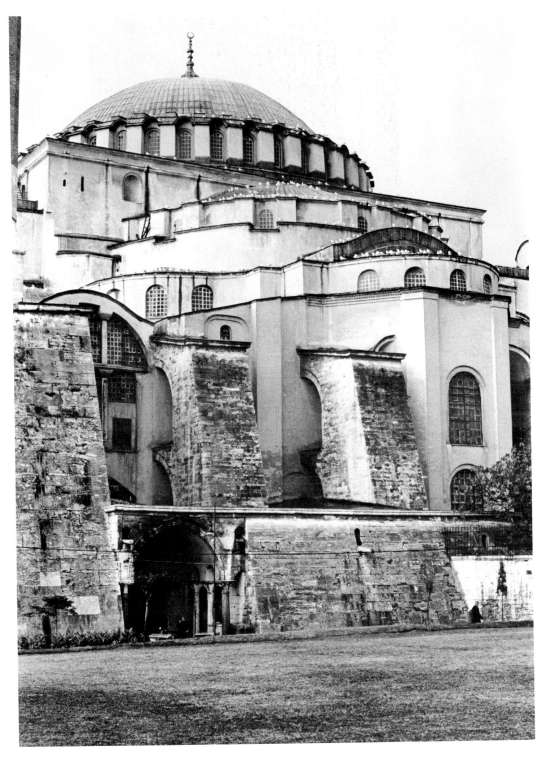

80. Hagia Sophia. East end

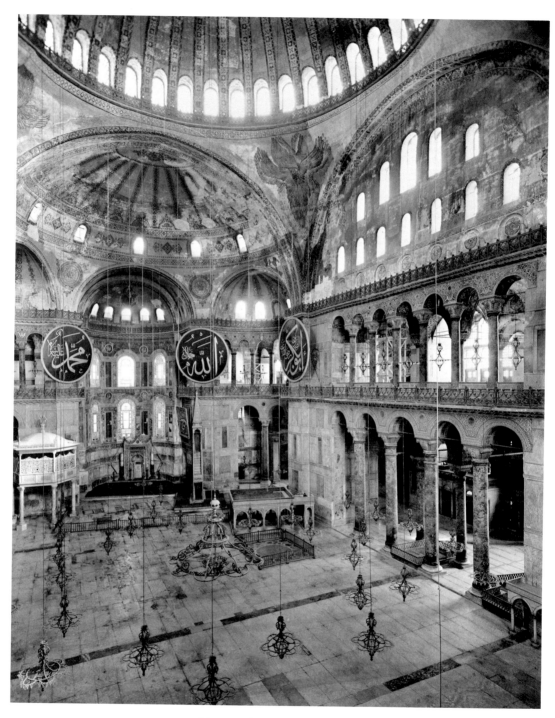

81. Hagia Sophia. Interior

82. Hagia Sophia. Paving of mihrab

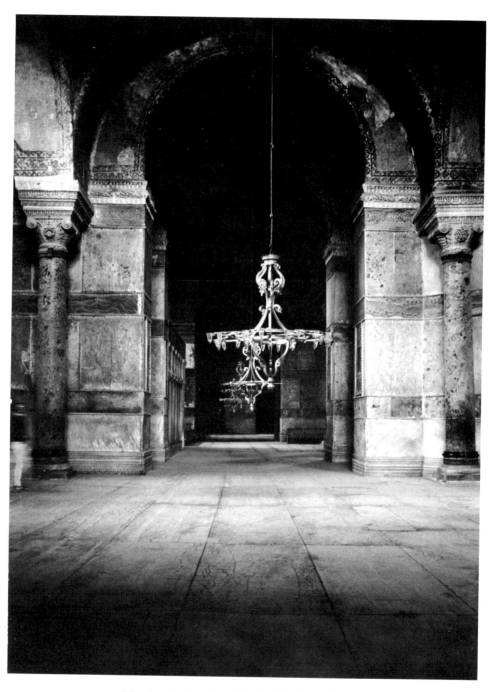

83. Hagia Sophia. North aisle, from the east

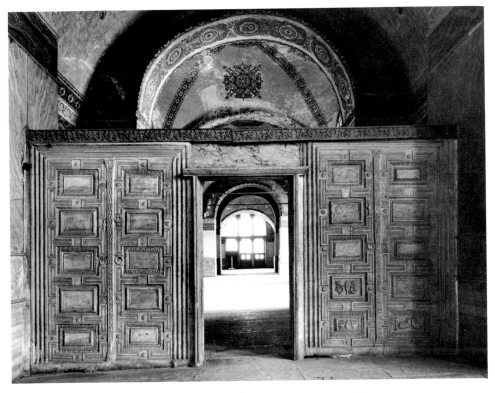

84. Hagia Sophia. Marble doors of south gallery

85. Hagia Sophia. Marble doors of south gallery, detail

86. Hagia Sophia.
Underside of window mullion in
southeast gallery

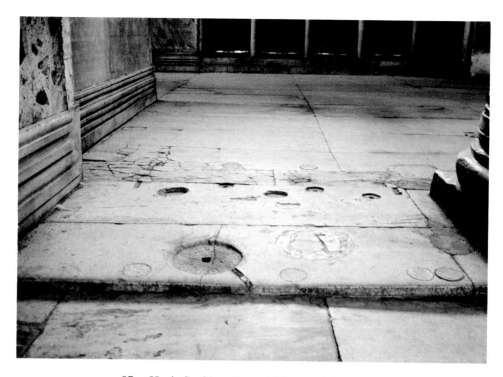

87. Hagia Sophia. Imperial loge and throne site

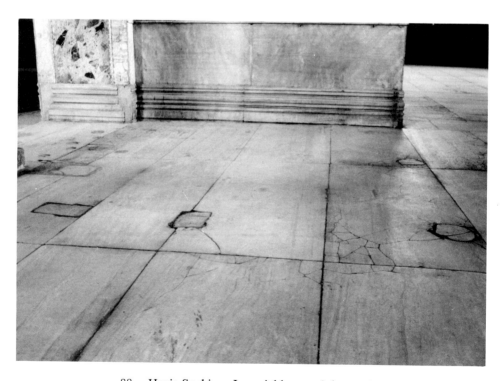

88. Hagia Sophia. Imperial loge and throne site

89. Chancel piers
(Istanbul Archaeological Museum, nos. 916, 4283)

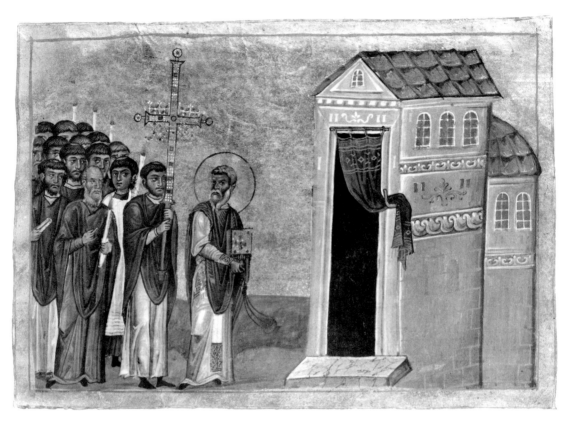

90. *First Entrance Procession.* Menologion of Basil II (Vat. Gr. 1613, fol. 142)

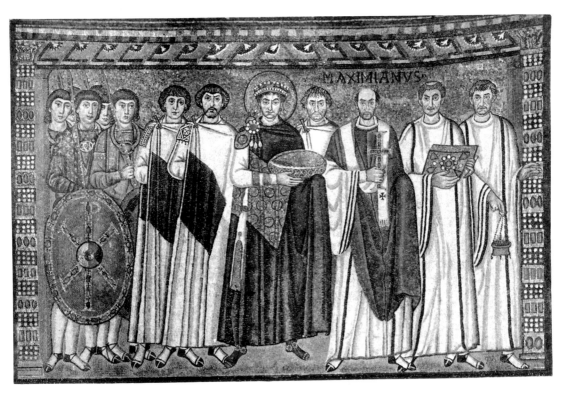

91. *First Entrance Procession.* S. Vitale in Ravenna

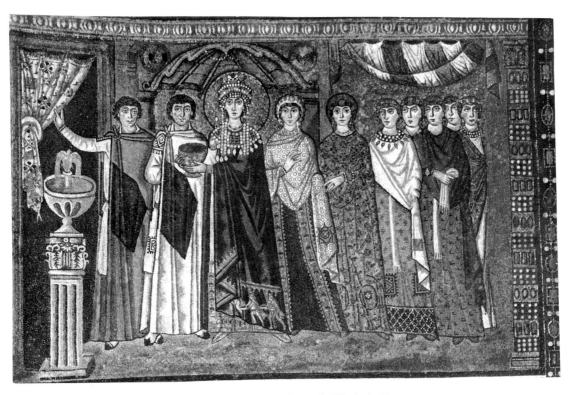

92. *First Entrance Procession.* S. Vitale in Ravenna

93. *The Preaching of the Apostles.* Homilies of Gregory of Nazianzus
(Paris, Bibliothèque Nationale, Gr. 510, fol. 301)

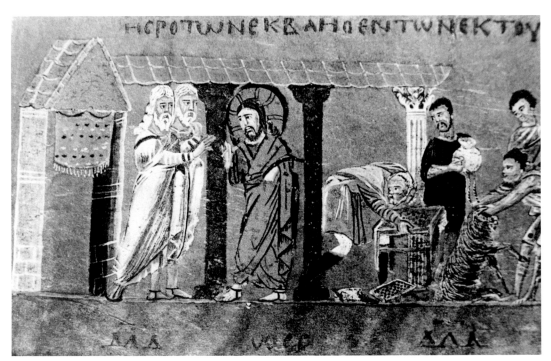

94. a. Ciborium in *Melchisedek* scene. Vienna Genesis (Vindob. Gr. 31, fol. 7)
b. *Cleansing of the Temple*. Rossano Gospel (fol. 3)

95. Ciborium and sanctuary. Homilies of Gregory of Nazianzus
(Paris, Bibliothèque Nationale, Gr. 510, fol. 367v)

96. Ciborium and sanctuary.
Octateuch (Vat. Gr. 747, fol. 135v)

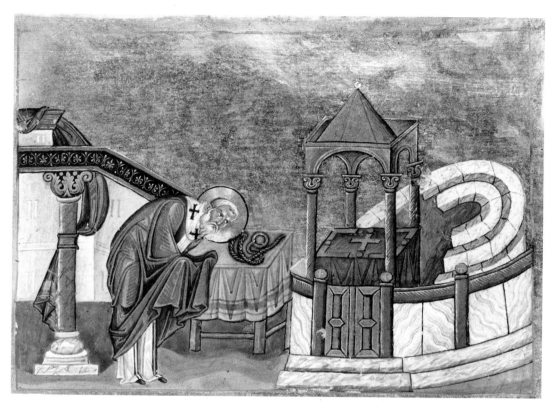

97. Ciborium and sanctuary. Menologion of Basil II (Vat. Gr. 1613, fol. 324)

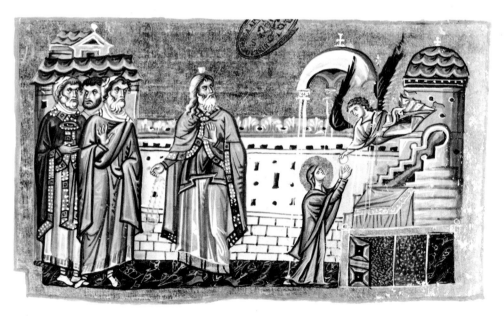

98. Ciborium and sanctuary. Homilies of James the Monk (Vat. Gr. 1162, fol. 76v)

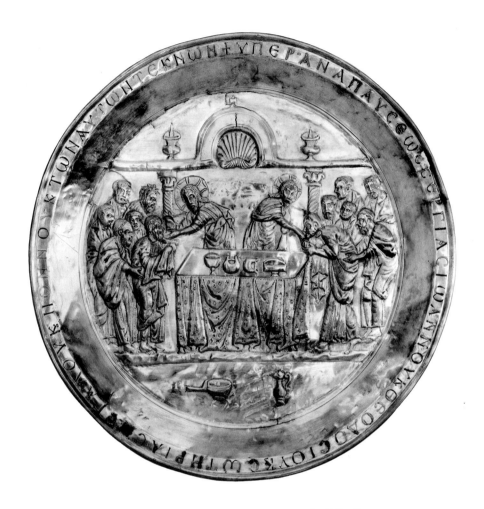

99. *Communion of the Apostles.* The Riha Paten
(Dumbarton Oaks Collection, Washington, D.C.)